To Jack—
a great doctor
a wonderful friend—
with sincere
admiration ; appreciation
Linda
12/91

My dear Wister —

My dear Wister —

The Frederic Remington-Owen Wister Letters

By Ben Merchant Vorpahl

With a Foreword by Wallace Stegner

AMERICAN WEST PUBLISHING COMPANY

PALO ALTO/CALIFORNIA

Library of Congress Card Number 76-187022

ISBN 0-910118-24-8

Contents

Foreword

by Wallace Stegner

Few books provide their readers with ringside seats for the conception and birth of a demigod. This one does. In its pages we watch the triumphant ontogeny of the cowboy hero, the most imagination-catching and durable of our mythic figures. The two men whose collaboration is the subject of Professor Vorpahl's study create him before our eyes. They begin to mold him out of the observed realities of the brief, furious, passing empire of the cattlemen. They shape him by imitation and trial and error into the hero of a romantic fiction, and in the process they are themselves shaped, as the cowboy image is, by the torque of an anonymous, public, everywhere-and-nowhere myth-making impulse. Believing they record reality, they helplessly remake it larger than life until, when they are done, their creation rides off the page into the sunset of a thousand horse operas, the free, lonely, self-reliant, skilled, eternally ambiguous embodiment of a national, indeed a human, fantasy.

In this mythifying process, Professor Vorpahl makes clear, Owen Wister had a larger part than Remington. The writer was tuned in to literary and historical wavelengths that, at least at first, made no sound on the artist's receiver. Remington—active, restless, aggressive, ironic, as romantic as Wister but in less literary ways—was primarily an eye, a quick, accurate, unsentimental eye, and a hand that could record swiftly what the eye saw. Temperamentally he was closer to a realistic reporter such as Andy Adams than he was to Wister. Not in the least a prettifier, an idealizer, or a theorizer, he saw particulars, he noted details, he recorded the thousand quick glints of the western life that fascinated him. The complaint of E. Douglas Branch, that *The Virginian* contains not one scene of cowboys working with cattle, could not be made against the drawings of Remington. They swarm with scenes of an indescribable variety, all explosive with action either kinetic or potential—cowboys roping, cowboys branding, cowboys driving cattle, cowboys fighting Indians or each other, cowboys riding broncs, cowboys standing by a corral fence swapping horses. And every other sort of western picture—a cavalry troop in full charge, scouts bending intently over hostile tracks,

Indians dragging a victim into the brush, packers tightening cinches, packmules somersaulting over cliffs, squaws breaking camp, warriors encircling wagon trains. He was after the particulars. Wister, in the long run, was after a character type. Each of the collaborators affected the other, but it was Wister's imagination more than Remington's that produced the archetypal cowboy. Remington's sketches and paintings, intended as forthright recording or illustration, a report on reality, have tended to remain just that; but that still allows them to be subordinated to the Wister idea and used as corroboration for the heightened cowboy of fantasy.

Wister made several tries, with results that satisfied him only partially, before he put together the Virginian after twenty years of effort. Lin McLean, Specimen Jones, and Scipio LeMoyne are all fumblings toward the character who, while still reflecting reality, would approximate the ideal figure that seems to have been persistently, if dimly, in Wister's mind. Because these early tries were outdone and obliterated by their triumphant successor, they have been pretty well forgotten, along with the Remington drawings that gave them visual reality. And perhaps because Remington did not illustrate *The Virginian,* the one Wister book that most moderns know, we have tended to forget how close the collaboration between them was, how intimate the exchange of ideas and experiences was, and how influential Remington was upon the creation we usually credit to Wister. This book reminds us of what we should not have forgotten, as it also reminds us of what a large part a third man, Theodore Roosevelt, to whom *The Virginian* was dedicated, had in popularizing the cowboy image.

That image, before Roosevelt, Remington, and Wister remade it, was hardly heroic or glamorous. As Henry Nash Smith points out in *Virgin Land,* the cowboy during his first decade was usually called a "herder," and through the 1870s he appeared in the public prints (and in at least one presidential message) as rough, shaggy, uncouth, barbarous, violent —at the very least a disturber of the peace and at the worst a brutal outlaw. He did not begin to take on the qualities of a hero until after the first Wild West show in North Platte, Nebraska, in 1882, when a cowboy named Buck Taylor attracted the attention of Prentiss Ingraham. Beginning in 1887, Ingraham immortalized this rodeo cowboy, first in a fictitious biography and then in a series of dime novels. He devised for him some colorful semi-Mexican garb that made him picturesque,

and he endowed him with all the skill, courage, and masculine grace that have marked every heroic expression of the folk mind from Leatherstocking to Superman.

By the time the cowboy thus made his way into literature—significantly, through the basement door of the dime novels—the great drives that had produced him were over. The transcontinental railroad, which came into the West almost simultaneously with Texas cattle, left the open range split and exposed. The Big Die-Up of the winter of 1886–1887 had bankrupted many cattle outfits, altered the feudal conditions of range life, and made the cowboy less a knight-errant and more a hired man on horseback. By 1892, the year of Owen Wister's first two western stories, the Johnson County War had discredited the cattlemen and his cowboy gun thugs in many eyes and encouraged the Populism that Wister despised. Civilization, which both Wister and Remington saw as destructive to the West and its wild freedom, meant responsibility, meant law, meant fences and homesteads and water rights and fee-simple land ownership, meant women. It was inevitably on the side of the "nesters," whom Wister and his first Wyoming host Major Wolcott called "thieves" or "rustlers," and on whom Wolcott in fact and the Virginian in fiction visited vigilante law. By the time Wister began to know the West, the open range was already passing, and he acknowledged history in his novel by letting the Virginian take up land, marry, and settle down to the tamed routines of stock farming. After the last brief flare-up of youth, wildness, and killing, it is Molly Wood, and all she stands for, who wins.

But Molly Wood does not dominate the novel. "The heroine is the failure," Wister's acidulous mother wrote him. He admitted that she had no character, and he was right: she had not grown noticeably beyond the mining-camp schoolmarm bequeathed to him by Bret Harte. But the cowpuncher himself was another matter. He had engrossed all of Wister's attention; he was the reason for the novel's existence, not the end of the drives, or the Big Die-Up, or the cattle wars, or the fencing of the range, or the coming of civilization. None of these affected the mythic horseman Wister created. The tame ending that Wister gave him does not, in fact, "take." In the reader's imagination the Virginian remains what he was before Molly threw a loop over him. He is as timeless and unchanging as Remington pictured him in "The Last Cavalier," and he is so because the national myth-making urge that obscurely guided Wister's

creation demanded that he be so.

This is no place to try to follow the wishful dream of which the Virginian is a late and very American embodiment, but one can suggest some of its forms. It is the dream of the Golden Age, the Earthly Paradise, and it is at least as old as Hesiod, who flourished in the eighth century B.C. It has as many variants as the religions with which it has often been associated, and depending on the status and condition of its dreamers, it has been a resting place for heroes, a Valhalla, or Elysium; it has been the place of lost perfection, the Garden from which we have been expelled; it has been the many utopias toward which we yearn; it has been a belly-heaven like Cokaygne or the Big Rock Candy Mountain or the railroaders' Indian Valley Line, where every day is payday. It has been the land of heart's desire, whatever that desire was, and so has taken forms that are political, social, religious, adventurous, or simply plenteous.

Through the centuries it has characteristically been located in the past, in the future, or in a far-away place difficult to reach. But with the discovery of America, it became something suddenly possible; all the wishes of oppressed, hungry, restricted, ambitious mankind clustered on the new continent like flies on a wound. All the romantic hopes of the earthly Paradise, the perfect society, the New Jerusalem, found a home here: attempts to establish them constitute a substantial part of our history. Sometimes the strength of the yearning and the persuasiveness of a tradition centuries old led actual travelers to see what was not there, as did William Bartram, whose reports of a Florida paradise bubbled up through Coleridge's opium dream and became the pleasure dome of Kubla Khan. Sometimes the unknown, with its unknown dangers, struck terror to men's hearts, as it did to the pilgrims on the Mayflower. Sometimes a great man could contemplate the New World as a little metaphor of the old one, complete with both good and evil, as Shakespeare did when he transformed a West Indies shipwreck into *The Tempest*. But even there we see in Prospero a degree of power over the threats and conditions of life that is itself part of the dream and will become increasingly a characteristic of the figures with whom the dream is peopled.

By and large, hopefulness has demonstrated itself a far stronger force in the American versions of the dream than either submission to evil or skepticism. Natural goodness has found a happier home in America than natural depravity. And it is a truism that the exploring and settling of a

wilderness continent immensely increased, both in fact and in imagination, the freedom and self-reliance of a whole people. It was the baptism in wilderness that made the American a new man. Progressively westering frontiers encouraged and reinforced both the taste for total freedom and the expectation that it could be gratified. The contact with Indians, both as enemies and as models of savage liberty, was an incitement to primitivism. There were many more white men who went Indian than Indians who went white. Hector St. John de Crèvecoeur, observing the frontier from his safe and comfortable New York farm, was led to speculate that much killing and a steady diet of wild meat turned civilized men into solitaries and savages. In much the same realistic spirit, Owen Wister after five years of experience in the West concluded that "this negligent, irresponsible wilderness tends to turn people shiftless, cruel, and incompetent."

Crèvecoeur would have been on the side of Molly Wood and civilization; he would have found the Virginian's early life not romantic but degrading. Yet it was Crèvecoeur who asked the question that lay wordless beneath America's acute consciousness of itself: "Who is this new man, the American?" Crèvecoeur answered the question in rational and optimistic terms, citing wide-open opportunity, reward for hard work, social justice, political equality, religious freedom, self-respect, and independence as some of the gifts of the new world to the human condition. But others, less speculative and articulate than Crèvecoeur, were already engaged in posing the question by the lives they led and answering it in a different way. *Letters from an American Farmer* was published in 1782. Seven years earlier Daniel Boone had led the first party of settlers across the Cumberland Gap into Kentucky, and in 1784 John Filson's *The Discovery, Settlement, and Present State of Kentucke* launched Boone as a folk hero, the first of the great American archetypes.

What Filson began, James Fenimore Cooper continued in the Leatherstocking tales, the first of which was published in 1823. Leatherstocking has come a long way from Hesiod's Age of Heroes, and the American wilderness is not automatically recognizable as one of the phases of the Golden Age. Nevertheless, the connection is traceable and has been traced: by Howard Mumford Jones in *O Strange New World,* by Henry Nash Smith in *Virgin Land,* by Perry Miller in "Errand into the Wilderness," by dozens more. Smith in particular follows the descendants of Leatherstocking in their several shapes as woodsmen, rivermen, moun-

tain men, cowboys, dime novel heroes, and badmen. He notes the places and times where the original Leatherstocking *persona,* at first low caste and hence not a suitable husband for a romantic heroine, divided in two and added to his first function as frontier expert, protector, and right-hand man the further functions of a romantic lead, as in *The Virginian.* In the nearly sixty years between Cooper's *The Pioneers* and *The Virginian,* the mythic figure has been democratized, or the story around him has. If Wister had been writing *The Virginian* in the 1820s, his dude, modeled upon his well-born self, would have had to marry Molly Wood, and the Virginian would have had to ride on into the sunset.

The fact that the cowboy hero does marry the heroine and does not ride on into the sunset is actually, as I have been suggesting, the element of the story in which factual reporting clashes with myth. Wister's cowboy is a little too close to history at the end. If he had been purified one stage further, as he has been in numerous horse operas since, he would look more like Leatherstocking—rootless, homeless, an orphan, an eternal wanderer, a celibate, and as D. H. Lawrence took pains to point out, a chronic killer.

Wister himself half recognized what his romantic love story was doing to his mythical discovery or creation of the cowboy character. He knew that the cowboy West was a predominantly masculine fact, and he half comprehended that it was also a predominantly masculine dream. In "The Evolution of the Cowpuncher," which as Professor Vorpahl demonstrates is a key document in the collaboration between Wister and Remington, Wister remarks on what almost every student of the cowboy and cowboy literature has observed: his curious indifference to women. "No soldier of fortune ever adventured with bolder carelessness, no fiercer blood ever stained a border. War they made in plenty, but not love; for the woman they saw was not the woman a man can take into his heart."

In that last clause I believe he sins not only in his historical reporting—for in fact plenty of cowpunchers did take into their hearts, when their time came, the sort of women who were available—but in his interpretation. It was not a shortage of women, or women of the right kind, that kept the cowpuncher a bachelor. It was the compulsion of the dream, which was a masculine dream of action, adventure, and danger, a hero's dream that is still potent with millions of movie and TV watchers. Women are a threat to that dream, more dangerous to male freedom

than Comanches or Apaches or rival gunfighters. And that too has its roots deep in a tradition centuries old. It is only the Mohammedans who have made Woman one of the delights of the Paradise-dream. As Frank E. and Fritzie P. Manuel point out (in "The History of Paradise"), "In the West paradise and sexual love have rarely coexisted."

It was Crèvecoeur's question that Wister set out to answer, but his answer was hurried by the swiftness with which the West changed, and it incorporated elements from the mythic, which controlled Wister, and from the actual, which had considerable influence on Wister and dominated Remington. From the moment when Wister decided to become the cowboy's chronicler, these two incompatible impulses were at work in him. In a much-quoted passage from *Roosevelt: The Story of a Friendship,* he reports the moment when he decided to write up the West. "Why wasn't some Kipling saving the sagebrush for American literature, before the sagebrush and all that it signified went the way of the California forty-niner . . . ? Roosevelt had seen the sagebrush true, had felt its poetry, and also Remington, who illustrated his articles so well. But what was fiction doing, fiction, the only thing that has always outlived fact?"

So he set out, as Remington did, to preserve and record the facts of range life. But he wanted to do it in fiction, which outlives fact. The contradiction was never fully resolved. Remington's influence was heavily on the side of the actual. It is clear that, in urging Wister to write "The Evolution of the Cowpuncher," he had in mind something far different from what Wister produced—a kind of chivalric lineage from feudal knights in armor. But Wister, though he enjoyed and carefully recorded western life through many summers, felt from the beginning an urge to define and comprehend a new culture and a new culture hero, and believed that in doing so he would define the essential American. In a sense, he did, but it was not by way of the notebook that he did it. It was from the seed of fantasy and myth that the Virginian grew. He existed in Wister's mind as a seed before Wister ever saw Wyoming. What he saw there, and what Remington taught him, was documentation, corroboration. As he said of Corporal Skirdin, whose practical joke he wrote into Chapter Three, he was not a *source* of the Virginian. He was "a sort of incarnation He ratified my imagination."

How imagination was ratified is the subject of *My Dear Wister.* It is a fascinating study in how myth and fact interweave to form the incarnate fantasies that we call culture heroes.

Acknowledgments

Many people helped make this book. The UCLA Research Committee provided me with two substantial grants to aid its preparation. In addition, Chancellor Charles E. Young granted me a fellowship to help pay the expenses for a summer of writing. I am indebted to the staffs of the UCLA Research Library, the Stanford University Library, the Manuscripts Division of the Library of Congress, the Western History Research Center at the University of Wyoming, the Henry E. Huntington Library, and the Frederic Remington Art Memorial for their helpful cooperation. I also wish to express my appreciation to Harold McCracken and to the staff of the Denver Public Library Western Collection, both of whom made available photographs of Frederic Remington, and to the Western History Research Center, for photographs of Owen Wister.

Previously unpublished Remington materials are used with the kind permission of Mrs. Ernest J. Deuval, Jr.

Among my colleagues at UCLA, Philip Durham and Leon Howard provided encouragement and advice when I needed it most. Gary Hoffman and C. Michael Pretzinger, my assistants, hunted down sources, did historical detective work, and performed innumerable bibliographical tasks. My students challenged my assumptions, generated new ideas, and beautifully demanded that I explain myself.

Last and most important, my wife Julie, for whom I began the book in the first place and without whom it could never have been completed, was throughout the whole process my most perceptive critic, my most steadfast support, and my wisest adviser. I dedicate the book to her.

Introduction

In early July 1885, a young Philadelphia gentleman armed with magnificent mustaches, a Harvard degree in music, and several months' experience at Boston banking traversed half the continent by rail, stagecoach, and horseback to spend the summer on a ranch in Wyoming Territory. His clothes were new and tasteful, his luggage impressive. Upper-class Philadelphia and all the respectability it signified were unmistakably present in his speech and manners. After two weeks in Wyoming, however, where one could "ride twenty miles . . . [with] no chance of seeing human traces . . . never a column of smoke or [a] sound except the immediate grasshoppers . . . and never go upstairs," the young man began to wonder "if there is such a place as Philadelphia—and if so, *where?*" And while he wondered where Philadelphia was, he also hunted through his trunk for a copy of Wagner's *Die Walküre*. It was the beginning of Owen Wister's struggle with the West, a region that revolted and attracted him by turns for the rest of his life.

The Big Horn Mountains, Wind River, spectacular sunsets, picturesque details of cowboy talk Wister came to terms with easily, for they appealed to his love of the fantastic—the same quality that made him thrill to Wagner's operas. As a child attending a Swiss boarding school, he had dreamed of exploring the Rockies in search of "rare eggs and everything of that kind," and when he actually encountered Wyoming, the thrill of bathing alone in Deer Creek and hunting for game in the wooded valleys partook of boyish wonder. Other aspects of the West offended him. The egalitarianism that brought Wyoming into the union as the "Equality State," ugly little towns sprinkled haphazardly along the railroad tracks, women who swore and went without stockings reminded him of "the poor classes in New York" and caused him worry about the future.

When Wister first went West in 1885, he was a romantic. When he wrote his last western story in 1928, he was still a romantic. He never surrendered his Philadelphia gentility or his love for the picturesque—and although the West changed, the unlovely details Wister hated re-

mained and proliferated. Wister's response was to participate in the creation of a western myth, a tradition of which his famous novel, *The Virginian,* comprised a major document. Within the myth the grubby towns became arenas for a struggle between good and evil, the smiles of hash-house waitresses held hidden and unspeakable promise, and most important, the cowboy himself became a chevalier for the New World, the ideal type of Thomas Jefferson's "natural aristocrat." By marveling at Wyoming's distance from the rest of the world while he searched his luggage for *Die Walküre,* twenty-five-year-old Wister conveniently acted out a miniature schema of his coming career as writer.

The same summer Wister spent in Wyoming rediscovering heroic myths, Frederic Remington, a twenty-four-year-old upstate New Yorker, performed a similarly emblematic drama at Kansas City. One warm afternoon, the largely built young man, even then inclined somewhat to heaviness, stood on a downtown street corner watching the bustle of the little western city without participating in it. He was alone. His pockets were nearly empty. The career he had planned for himself as an illustrator seemed to be going nowhere. He had sent his bride of less than a year to live with her parents in Gloversville, New York. Two years at Yale art school and five years of western wandering had picked him up and set him down again in the middle of Kansas City with no money, no prospects, and a wife, now absent, whom he loved but seemed unable to support. If elegantly dressed, carefully groomed Wister had driven by just then, Remington might well have thrown rocks at him.

Wister did not drive by. A local house painter named Shorty Reason did—in a spring wagon drawn by a rough but hardy gray mare. At that moment, Remington's eye for horseflesh coincided with his desire to move. "Want to sell?" he shouted to Reason as the rig moved past, and a trade was begun. Shorty said the mare was not for sale, but fifty dollars and much talk bought her. At dawn next day, Remington rode out of town, traveling light but traveling with all he owned. He headed west.

At the end of summer, he appeared in New York City with three dollars and a bulging portfolio of angular, lively sketches. The encounter with Shorty Reason and his gray mare had prepared the way for a first encounter with Owen Wister at Yellowstone Park eight years later. It began a career marked by extraordinary recognition and acceptance of a West that was grotesque as well as beautiful. Until his death in 1909 Remington sought to capture the region in pictures and bronzes that

were animated, wistful, violent, gay—often ugly, never pretty. Like Wister, he created a myth of the West—the same West, but not the same myth.

It may have been inevitable that Remington and Wister should eventually meet, but it was unlikely that the meeting should result in friendship. Therefore the relationship that developed over fifteen years between the two easterners who went geographically west from opposite emotional directions was full of surprises. Artistically its promise was immense, for Wister's grand vision and Remington's hard, clear glance converged on a soil waiting to have its story told, large and complex enough to demand the fullest exercise of the diverse, even opposite talents Remington and Wister brought to it. Yet although ideas and talents did meet—and often clashed—during the fifteen-year encounter, the two men themselves had first to meet at Geyser Basin and join hands of flesh and bone. One began by jogging out of Kansas City on a tough gray mare. The other brought a trunk full of books from Philadelphia.[1]

[1] Of scholars who have treated Remington and Wister, N. Orwin Rush has focused most directly on the friendship between the two men. See Rush's "Frederic Remington and Owen Wister: The Story of a Friendship," in Toole, K. Ross, ed., *Probing the American West: Papers from the Santa Fe Conference* (Museum of New Mexico Press, Santa Fe, 1962). See also Rush's "Frederic Remington and Owen Wister: The Story of a Friendship" (privately reproduced and distributed, 1961).

My dear Wister —

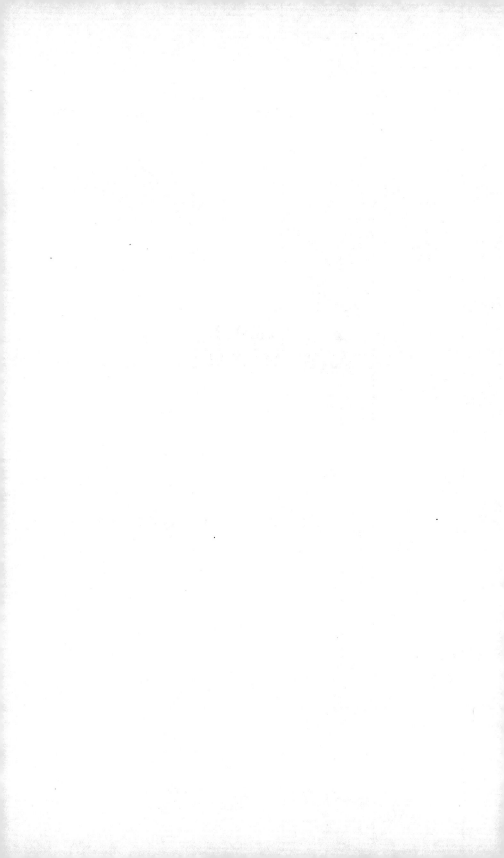

Chapter 1

Two Trails to Geyser Basin

rederic Remington said of the Yellowstone country that it had three
seasons—"July, August, and Winter."[1] Yet even August was wintry
in 1893. A ragged rim of ice lined Buffalo Fork every morning.
Frost glistened on the grass, sometimes until almost noon, and snow flur-
ries swept the highest peaks, drifting white powder in among the roots of
scrub cedar that hugged the crests. Farther down the slopes, it rained and
hailed. On the night of September 8, it snowed hard, even in the valleys.
Owen Wister and his party, having come only recently from the swelter-
ing heat that enveloped the World's Fair at Chicago, shivered as they
emerged from sleeping bags and built their breakfast fire in a canyon near
the foot of Soda Mountain. Then they loaded their pack animals and
headed for the comfort of North's Inn, where quite by coincidence 31-
year-old, 240-pound Remington had happened to alight after a breakneck
ride across Pitchstone Plateau with the park superintendent.[2]

The place, time, and climate of Wister's meeting with Remington at
North's were all appropriate: Yellowstone, poised atop the Continental
Divide, was as exciting and outlandish as the friendship that began there.
September 1893 found both Remington and Wister in search of pro-
fessional allies. The violent, unpredictable weather that brought Wister
down from Soda Mountain mirrored a national mood which made Phila-
delphia lawyer and New York illustrator doubly welcome to each other.
Like men in a blizzard, the two huddled over common opinions while
winds of change roared from Seattle to Washington City. Yet the West
itself, the business of somehow recording it in prose or pictures, even
jointly held political opinions—factors which operated to pull Remington

1

and Wister together—were balanced evenly in 1893 by other factors which tended to separate the two men.

An established success at illustrating by the time of the Geyser Basin meeting, Remington was also a profane, abrasive ironist. Wister, on the other hand, had only begun his career as western writer the year before with "Hank's Woman," a somber tale with a Wagnerian plot. Serious, sheltered, and tending a little toward snobbishness, Wister made a striking contrast to the large, humorous upstate New Yorker who had fended for himself, sometimes narrowly, since his father's death in 1880. Wister first crossed the Missouri in 1885 with a chronic nervous condition and a head full of romantic stories, but Remington's feeling about the region was immediate and visceral, his temperament fundamentally antiromantic.

The differences stretched back a long way. While Wister studied German at an Episcopal preparatory school in New Hampshire, Remington drew pictures of soldiers at a military academy in Massachusetts. While Wister studied music at Harvard, Remington played football at Yale. While Wister aspired to be a composer of operas at Bayreuth and Paris, Remington invested his inheritance in a Kansas City saloon. Wister loved the West for the same reason he loved Wagner's operas. Because the vast area between the Missouri River and the Pacific Ocean was empty and colorful, it invited him to fill it with the most fantastic shapes his imagination could devise. Remington, however, gathered all the authentic alkali and gunpowder he could find to put into his pictures. His closest kindred spirit—albeit of greater magnitude—was the Mark Twain who remarked that Wagner's music must be "better than it sounds."

Wister came to Yellowstone in 1893 with a contract, signed the month before at New York, for eight or nine stories to be illustrated by Remington and printed in *Harper's Monthly Magazine* or *Harper's Weekly*. Having already tried partnerships of various kinds with other self-appointed experts, only to find them illiterate and inclined to bicker, he came to knowledgeable, energetic Remington with great expectations.

The meeting was also a turning point for Remington. Having begun his career as interpreter of the American West, the artist was lured to Europe in 1892 by Poultney Bigelow to collaborate on a series of articles about continental life and military operations. Although the prospect seemed exciting, Remington quickly became bored with it and returned home without Bigelow, where he resumed his pursuit of western sub-

jects. He hated "parks—collars—cuffs—foreign languages—cut and dried stuff." Europe, he wrote, was "all right for most everybody but me—I am going to do America—it's new."[3] The partnership with Bigelow, however, allowed Remington to glimpse the advantages of a sustained combination with some writer. Therefore, his horse trader's sense began to work as he talked with Wister at Geyser Basin. Remington saw that Wister was young—almost his own age. He came from the upper class, eastern background with which Remington associated himself. He wanted to write about the West. Above all, he appeared to be tractable. Since he admired Remington and was eager to learn, there was reason to believe that Wister would allow himself to be guided where Remington wanted him to go.

Remington soon discovered that the studious young Philadelphian was capable of behaving as though he had a ramrod for a spinal column, and before long Wister began to feel the scrape of Remington's sandpaper wit. For the present, however, as snow fell on Soda Mountain and as the nation's financial crisis deepened, the two men sat before a fire talking about things they agreed on—the weather, politics, and art. They did not exchange biographies, for the path that stretched ahead of them seemed far more exciting than the two divergent paths that lay behind. Yet accomplished past rather than doubtful future showed why the meeting at Geyser Basin was less like a fork in the road than the convergence of two super highways, stacked one above the other.

Wister was born in Philadelphia at the top of the same furious summer Abraham Lincoln and Stephen A. Douglas chose to debate each other for the presidency. His father was Dr. Owen Jones Wister, a successful Philadelphia physician whose family had been prominent in Pennsylvania since colonial times. Yet when Owen later talked and wrote about his ancestors, the maternal side received more attention. Owen's mother was Sarah Butler Wister, a charming, beautiful, and articulate woman who loved travel, read voraciously, and was herself a writer of some skill. Sarah's father, Pierce Butler, was descended from a South Carolinian of the same name who signed the U. S. Constitution for his state in 1787. Her mother, Frances Anne Kemble, came from a long line of distinguished British actors and authors that included John Philip Kemble and Sarah Siddons. Frances Anne, or Fanny, as she preferred to be called, made an unprecedented success at dramatic readings of Shakespeare's plays throughout the United States, and her *Two Years on a Georgia Plantation*

—written in 1839, but not published until 1863—compared favorably with Frederick Law Olmsted's *Journey in the Back Country* as a chronicle of the prewar South. Only because it saw print later and was fact rather than fiction did her book miss the popularity of Mrs. Stowe's *Uncle Tom's Cabin.* Owen was thus born with a great weight on his small shoulders. Only months after he came into the world, his famous grandmother exclaimed, "My grandson is stupendous! . . . His scowl is like a Spanish play & has the making of a good farce in it."[4]

About a year later and some four hundred miles north, Frederick Remington was born to Seth Pierrepont Remington and Clara Bascomb Sackrider Remington at Canton, New York. Just as the small, isolated mill town of Canton differed from Philadelphia, the Remingtons differed from the Wisters and Butlers. With few pretentions to aristocratic background and none to literary distinction, they valued honesty, hard work, intelligence, and practical virtues. They were solidly Republican, thoroughly Protestant, and fiercely patriotic. Five years before Frederic's birth, Seth Remington helped start Canton's first newspaper, the *St. Lawrence Plaindealer,* and became its editor; but by the time he married Clara in January 1861, the young editor began to wonder if printing a newspaper was the most effective way of serving his country. In February the Confederate States of America were formed at Montgomery. Two months later General Beauregard opened fire on Fort Sumter at Charleston. By the beginning of May, Seth Remington worked feverishly to recruit men for Swain's Cavalry, which later earned a reputation as New York's "Fighting Eleventh." In December, two months after Frederic's birth, he joined the regiment himself and left home, not to return for five years.

While war raged across the South, Clara Remington took Frederic to stay with his maternal grandparents, who occupied a large, shaded house on a quiet Canton street. The Wisters lived at Butler Place, their country estate near Philadelphia. Yet the climate of catastrophe into which Frederic and Owen were born had important effects on both boys. For Frederic, news of the fighting in Tennessee and Mississippi, where his father's regiment saw action, absolutely determined the tenor of each day in his early life. And whereas Owen's involvement in the war was not so direct, it was more complicated. The oleanders, lemon trees, and other southern shrubs that lined the drive to Butler Place testified to the Wisters' southern connections. Not until long after the war did the family

sell Darien, the Georgia plantation about which Fanny Kemble wrote in 1839. Much later Henry James summed up Wister's ambivalent attitude toward the war by describing Wister as "a Northerner of Southern descent."[5] A major impulse of Wister's career was the attempt to somehow resolve this ambivalence. Nothing demonstrated the effort more thoroughly than his most famous novel, in which a "Virginian," whose ancestors fought for the Confederacy, goes to Wyoming to win the schoolmarm granddaughter of a Yankee general. Likewise, one commentator described Wister as a "Pennsylvanian who sat down in South Carolina and wrote a book about a Virginian who lived in Wyoming."[6] The geographical sweep thus facetiously stated mirrored a deep psychological concern with the rift that split the nation less than a year after Wister's birth.

Furthermore, the Civil War had much to do with sending Wister and Remington west. Seth Remington returned to Canton in 1867 to find a son who idolized him and fed hungrily on his stories of the war. The six-year-old averred that "when I grow up, I'm going to be a soldier like Father,"[7] and the father responded by sending him to Highland Military Academy at Worcester, Massachusetts, in the fall of 1876. Wister, who attended two boarding schools in Switzerland before he was ten, was sent to fashionable St. Paul's School in New Hampshire, where he wrote a poem in 1877 showing how deeply rooted was the thrust toward conciliation that finally wedded the Virginian to Molly Stark Wood.[8] It envisioned a millennium in which soldiers "both young and old" were raised from graves on either side of Mason and Dixon's line to "join their hands" before the throne of judgment. Appropriately entitled "Brothers Again," the work indicated the direction in which seventeen-year-old Wister's imagination was developing: His Philadelphia upbringing gave him a respect for history. His family's complex attitude toward the Civil War made him sensitive to sectional issues. Under the tutelage of Dr. Henry Coit, the Episcopal clergyman who headed St. Paul's School, he acquired the habit of thinking about both history and the Civil War in apocalyptic terms derived from the Bible. All three tendencies appeared together when Wister first went to Wyoming in 1885 to find a landscape that looked like "the first chapter of Genesis."[9] The West simultaneously reminded him that the Civil War was a fratricidal conflict and nourished his hope for a golden age in which the conflict would at last dissolve again into fraternity.

Remington shared none of the impulses that shaped Wister's poem. At sixteen he stated that "there is nothing poetical about me."[10] When he went west three years later, he saw neither eschatology nor history, because he was busy hunting for something else: money, so he could get married, and a fight, so he could "be a soldier like Father." While still at Highland Military Academy, Remington described himself as a thoroughly rough-and-ready type:

I don't amount to anything in particular. I can spoil an immense amount of good grub at any time in the day. . . . I go a good man on muscle. My hair is short and stiff, and I am about five feet eight inches and weigh one hundred and eighty pounds. . . .

I don't swear much, although it is my weak point, and I have to look my letters over carefully to see if there is any cussing in them. I never smoke —only when I can get treated—and I never condescend to the friendly offer of "Take something old hoss?"[11]

Already, his prose moved with the verve that later distinguished his pictures and bristled with the irony that was clearly part of his nature.

Wister, on the other hand, nearing the end of his last year at St. Paul's, altogether lacked Remington's self-assurance. He felt trapped by his sedentary life, overburdened with studies. In a wistful letter home, he identified his major dissatisfaction:

I have never camped out and gone shooting and lots of boys have and I feel a big desire to do so too. . . . I really know nothing about that sort of outdoor life which would make me stronger and healthier. I don't want to be a "house boy" and have tried not to.[12]

Boxing lessons, to which his parents reluctantly consented, helped provide Wister with some relief from study, but they were not enough. The young man remained restless when he entered Harvard the next year, 1878. The college, he said, was "not one-tenth the place"[13] St. Paul's had been. His cramped feeling rapidly became impossible to ignore.

The same fall Wister entered Harvard, Seth and Clara Remington sent Frederic to study at Yale. Unlike Wister, Remington never felt trapped by his studies because he never took them seriously. What he liked best about Yale was football. Walter Camp, later known as the game's

"father," was captain of the varsity team when Remington joined it as forward in 1879, and Remington's first printed illustration—probably a self-portrait—depicted for the *Courant* a battered player recovering amid bandages and bottles of liniment from glorious wounds.[14] The high point of Remington's college life was the Thanksgiving Day game with Princeton, played that year at Hoboken, New Jersey. An estimated ten thousand people watched the two teams batter each other without scoring until the game was called because of darkness and "accidental" injuries on both sides. Years later Remington wrote to his former captain that "football . . . is best at its worst. . . . I hope the game will not be emasculated and robbed of . . . its destructive quality."[15] Remington liked football for the same reason he later fell in love with the West: it gave him a chance to experience the possibility of getting hurt.

For a similar reason he scorned academic facets of college, resisting his parents' practical advice to take a "business course" and enrolling instead in Yale's newly established art school, inauspiciously quartered in a "dingy cellar" and presided over by a "melancholy professor" named Niemeyer. Under such circumstances his enthusiasm quickly vanished, and he grew not only to hate his classes but also to doubt his own ability. Poultney Bigelow, the only other occupant of the basement classroom, described him as a "big, burly blond undergraduate who played in the football eleven, and cursed Praxiteles and left Yale disgusted with art and its New Haven exponents."[16]

While Remington cursed Yale and New Haven, Wister grew to love Harvard and Boston. His early decision to become a composer of operas did not limit his study of other subjects or diminish his interest in literature. Yet the pace Wister set for himself was too great. His eyes, weak since the St. Paul's days, now bothered him frequently, and he also suffered severe headaches and insomnia. On Easter, 1880, the young man's doubts about himself mingled with impressions of the religious season and images from his reading to produce a frightful vision:

Last night the opium in some powders I took gave me a ludicrous and dreadful dream. I dreamt that Dr. Coit was sitting lecturing to a lot of us over a platform across which hung a clothes line loaded with pocket handkerchiefs of different sizes and colors. These he explained he had in the course of his life hung upon this line one every time he committed a sin. He then took them up one by one. Finally he came to two stained

with blood. He said unnatural and horrible as it was, he, even he, had committed two murders. One was that of the Prince of Wales and the other of his young brother, Arthur. Everything then became lurid. Dr. Coit's hair grew long and black like an Indian's; he became more and more agitated; his eyes glared and finally his long hair flew up all over his head and he shrieked that although there was no substance of the murdered men upon the pocket handkerchiefs he now saw both of them standing on the platform in front of him. I looked and saw nothing. It was like Macbeth and Duncan. And I woke up feeling most unpleasant.[17]

Throughout that spring and summer the terrifying dreams continued, and an injured knee, which made it impossible for Wister to exercise, made his insomnia worse. His physician father, who from the beginning opposed Wister's musical aspirations, began to speak of "mental illness" brought on by too much unwholesome study, but Owen ascribed the difficulty to being "merely used up" and stubbornly stuck to his convictions: "I am more determined than I ever have been to take up music as a profession."[18]

Although Remington's parents also disapproved of their son's impractical course of study at New Haven, an argument over professional goals never had a chance to develop. Shortly after the scoreless Yale-Princeton football game of 1879, Seth Remington became seriously ill, and consequently Frederic did not return to college after Christmas vacation. Early in February, Seth died. During the months that followed, Frederic worked intermittently as a grocery clerk at Canton and as an office boy at the state capitol in Albany. Whatever plans he had for a career remained unformed. Yale had bored him; dusty offices bored him no less. Even the transitory action football offered could be purchased only by enrolling in dull classes.

By fall Clara Remington had become alarmed for Frederic's future— but lethargy combined with the young man's native stubbornness to produce an iron resistance to worldly ambition. He didn't *want* to be a success. At loose ends one day, Remington drove down to Ogdensburg, a town some eighteen miles from Canton, to see the county fair—but instead, he met Eva Caten, a pretty girl from nearby Gloversville, who was the house guest of a family Frederic knew. Tradition has it that the young man fell in love at once. Certainly, he began to court Eva very soon. But whatever vine-covered cottages Remington built on air soon

dissolved, for as he courted Eva, the youngest of five children, he discovered that a steady job, money, and some degree of demonstrable stability were among the requirements for winning her. It was a bitter pill indeed the suitor had to swallow when Lawton Caten refused to allow his daughter's marriage.

At this point, when Remington's prospects looked dark indeed, success seemed probable for Wister. By the time he graduated *summa cum laude* from Harvard in the spring of 1882, he had written a series of burlesque sketches for the *Lampoon* which S. W. Sever and Co. of Cambridge brought out several months later as a book entitled *The New Swiss Family Robinson.* The work had little to recommend it, but it was a beginning at commercial publication and even in some sense suggested the fascination with far places which more fully informed the western tales. Wister, however, was still three years away from discovering the West. On July 2, 1882, he began a journey in the opposite direction, sailing from New York harbor for Rome. A fortnight later he was in England, where he attended much opera, called on his mother's old friend Henry James, and played poker with British actors. For the most part, Wister remained scornful and patriotic. The "English female flesh" he saw everywhere displayed offended him. "One good specimen of an American girl" seemed to him worth "twenty of these rabid manhunters."[19] Switzerland, with its carnival atmosphere and mobs of American visitors, he called "the Coney Island of Europe."[19] Even the Alps failed to impress him. Standing on a mountain top, with glaciers all around, he felt "like a stony rock among the conies."[20]

Part of Wister's disdain for things European was doubtless a pose, part a genuine feeling that the great cities and spectacular landscapes seemed somehow florid in comparison with the relative austerity of Philadelphia and Boston. But one aspect of the European tour was by definition exempt from the young American's judgment: the great concert hall at Bayreuth, Wagner's showplace of opera. This was the destination of Wister's pilgrimage and climax of the years he spent studying music at Harvard. The young musician's experience there was brief, but so intensely sweet that he never forgot it. On August 25—which was also King Ludwig's birthday and the wedding day of one of Wagner's daughters—Wister saw *Parsifal.* The next day he spent an hour alone with brilliant and kindly Franz Liszt, who listened approvingly while Wister played a composition of his own at the piano. Afterward, as

Wister glowed with pride, the old man told him that he had *"un talent prononce"*[21] for music and urged him to attend the *Conservatoire* in Paris. No other praise could have so voluptuously fed Wister's hungry ego. Liszt's words promised fortune, prestige, and a life of romantic fulfillment. Wister seemed launched on a career that could lead him only to greater and greater success.

Aboard a train between Bayreuth and Nuremburg, however, with Liszt's praise still ringing in his ears, Wister remembered vividly an incident of several days before. High in the Swiss Alps he and a friend had entered a small, dark tavern on the bank of the Aar. Hungry from hiking, they ordered lunch, which seemed "rather too primitive," but this small annoyance sank to triviality while another feature of the tavern etched itself on Wister's mind:

My eyes pasted on some colored prints of the prodigal son hung on the walls. . . . The father in a long blue coat and white trousers was receiving the apologies of the prodigal, who knelt. . . . To the right of a sumptuous mahogany table on which many volumes neatly bound were lying stood the elder son and his wife—evidently dressed for the afternoon . . . and looking polite and displeased—I think a very fat calf was appearing on the background near a bookcase.[22]

Wister thought the prints "excellent" as art. Whether or not his judgment was justified, his fascination was surely significant. "How Lin McLean Went East," one of his first Western tales, used the prodigal as its central metaphor. Furthermore, it was uniquely appropriate that Wister's talk with Liszt at Bayreuth and his discovery of the prodigal at the tavern on the Aar should be so closely conjoined in time and space, for the two incidents conveniently exemplified the possibilities of two diverging paths that lay before him. Taking Liszt's advice might lead him to European concert halls. Following the prodigal would take him to another crossroads at Geyser Basin. At that moment, of course, Wister failed to see that there was any choice involved. He was on his way to Paris to study music.

Likewise, Remington thought he knew why he was going west in 1881: to make money. In much the same way as Liszt's praise floated Wister to Paris on a rosy cloud, the refusal of Eva Caten's hand shot Remington to the Rocky Mountains with the vague intention of "becoming a million-

Owen Wister at Harvard in 1880, costumed for one of several roles he played in college theatricals.

aire" through some process as yet undiscovered. Yet the somewhat disheartening fact was that he found himself unprepared to do anything but draw pictures. Late in the year, while he drifted aimlessly across Wyoming Territory, he seized a piece of brown wrapping paper and quickly covered it with a sketch of cowboys hurriedly emerging from their sleeping bags. At the nearest post office he shoved it into an envelope and sent it off to *Harper's Weekly* at New York. Like many of the things Remington did, this was a long chance that happened to succeed. The journal carried his picture, redrawn by staff artist W. A. Rogers, in February 1882. It was a beginning.

More than two decades later, after his success was firmly established, Remington recalled the incident which gave shape to the vague desires he carried with him out of Canton.

Evening overtook me one night in Montana and I by good luck made the campfire of an old wagon freighter who shared his bacon and coffee with me. I was 19 years of age and he was a very old man. Over the pipes it developed that he was born in western New York and had gone West at an early age. His West was Iowa. Thence during his long life he had followed the receding frontiers, always further and further West. . . .

I knew the railroad was coming. I saw men already swarming into the land. . . . I knew the wild riders and the vacant land were about to vanish forever—and the more I considered the subject, the bigger the forever *loomed.*

Without knowing exactly how to do it, I began to try to record some facts around me, and the more I looked the more the panorama unfolded. . . . I saw the living, breathing end of three American centuries of smoke and dust and sweat. . . .[23]

The significance Remington assigned his evening with the wagon driver in Montana doubtless became more clear as the experience itself became more distant. Liwe Wister's encounter with the prodigal, the frugal Montana supper was a symbol which served better to explain the meaning of events already past than to indicate the shape of things to come.

The fact was that neither Remington nor Wister had any clear idea in 1882 of where his life was going. Instead of devoting himself to the task of recording the panoramic "facts" of western life, Remington used part of the money his father left him to buy a small ranch at Peabody, Kansas, and halfheartedly applied himself to raising mules. Wister's plans

**Frederic Remington as a young man, probably about 1879, when
he played as forward on the Yale football team.**

for a musical career were quickly and thoroughly dashed by a parental edict, which dragged him back across the Atlantic and put him to work as a clerk in the State Street offices of Union Safe Deposit Vaults at Boston. The Kansas ranch was never more than a hobby, for Remington spent most of his time drinking with friends, hunting, playing poker, and characteristically following his inclination to do what was easiest. Yet his unusually jovial manner hid an acute uneasiness. One acquaintance called him "moody beyond anything I had ever seen in man."[24] Similarly, Wister's clerkship was intended to prepare him for rapid advancement, but its routine of "figuring interest at three per cent" from nine to three, five days a week, constituted an almost unbearable affliction.[25] Both Wister and Remington were trapped by economic necessities they detested. Both felt youth slipping away; neither knew what to do about it.

In 1883, Remington decided to pull up stakes and move. The decision, however, was marked by its vagueness as merely a gesture of dissatisfaction, a temperamental shrug. The place he wanted to go to was "somewhere else." The activity he wanted to engage in was "some business . . . stock, mercantile . . . hardware . . . whiskey—or anything."[26] Remington was still drifting. Yet for a man who didn't like physical work, was not educated for business or the professions, lacked an independent income, and had one undeveloped but outstanding talent, the direction and extent of drift were limited. When Remington finally succeeded in selling his ranch in the spring of 1884, he headed for the Southwest to make his first sustained effort at sketching subjects in the field. Late that summer he returned to Kansas City, where he painted oils from a number of his sketches and sold them. Some went to art dealers, some to saloons and other places of business. None brought high prices, but it was good to be paid for doing something that was fun.

Remington cleared two hundred fifty dollars from the venture and gained new confidence in himself. Not surprisingly, he also began to think once more about marriage to Eva Caten. Looking for a safe and profitable way to invest what was left of his inheritance, he stumbled on a scheme that looked as though it would provide him with a small but steady income for the rest of his life: a "silent partnership" in one of Kansas City's most prosperous saloons. He jumped at the chance, putting into it both the money he had left from the sale of his property and the remaining money from his father's estate. So wise an investment, certain to bring gratifying profits, would surely win Lawton Caten's approval.

Therefore, Remington began immediately to make plans for going east. His spirits soared when the saloon moved to larger and finer quarters in a better part of town, for this could only mean that he would make more money. Shortly before his departure for Gloversville, however, he was informed by the saloon's proprietors that the venture he had invested in no longer existed. The new establishment was precisely that— a *new* establishment which had no legal connection with the old.

For the first time in his life Remington faced the absolute necessity of working to hold body and soul together. His initial response was predictable: he took a loaded pistol and went hunting for the men who had cheated him, fortunately encountering on the way a friend who argued restraint. His second response, however, contained a surprise. Understanding that his inheritance was now irretrievably gone, Remington shrugged his shoulders and left the whole unpleasant episode behind. He boarded an eastbound train and shortly afterward stepped off at Gloversville, New York, where he resumed his suit of Eva Caten. The result of his decision was even more surprising than the decision itself, for whereas the young vagabond with an inheritance had failed to find favor with Lawton Caten four years before, the aspiring painter without a penny to his name now succeeded. On October 1, 1884, Remington's twenty-third birthday, he married Eva at her father's house. Before winter set in, the couple was back at Kansas City building a domestic establishment on the as yet untested hope that Frederic could make a living from his pictures.

At the same time Wister was discovering that even though there might be money in banking, the profession was not one to which he was suited. While his college friends made names for themselves in business and politics, Wister felt trapped by the routine of office work. Since he made no effort to keep his dissatisfaction a secret, his old headmaster at St. Paul's School offered him a teaching position—a stinging reminder that he was twenty-four years old and without a vocation. Matters came to a head when Wister's health, delicate from time to time for years, began to deteriorate with alarming rapidity. Early in April 1884, his face became sore and swollen. A specialist advised him that the condition might last as long as a month—but even that prognosis proved unjustifiably optimistic. As spring and summer dragged on, the illness grew more and more oppressive. A brief vacation at Bedford, Maine, in August provided some relief, but by September Wister again felt dangerously depressed.

Boston seemed to him "schoolgirlish . . . gauche, shy and wooden." He
sharply curtailed his social life, staying home much of the time to read
history. When people spoke to him of a successful future, he disconso-
lately noted that being called "a person of great promise" was "the most
undesirable thing in the world . . . unless you could die."[27] Even his old
love, the opera, failed to please him. At the end of the season, he called
it "the usual rigamarole," spitefully adding, "I hope they all lost money."[28]
New Year's Day, 1885, found him back at the bank and buried in dull
work. The year just over had promised much but ended in failure. The
year to come promised little.

At Kansas City prospects were not much brighter. The Remingtons
quickly discovered that monetary returns from Frederic's painting could
not support them. Remembering the precarious beachhead established
two years earlier in 1882, when *Harper's Weekly* printed his picture of
Wyoming cowboys over the title, "Cow Boys of Arizona," Remington
began sending sketches off to eastern magazines. During the winter of
1884 he probably produced a number of these sketches and offered them
to several journals. The results were meager: a single illustration, redrawn
by T. de Thulstrup and printed in the March 28, 1885, number of
Harper's Weekly. That summer, less than a year after her wedding, Eva
Remington tearfully departed for an extended visit with her parents at
Gloversville. Remington mounted Shorty Reason's gray mare and pointed
her toward Arizona Territory, where a Chiricahua Apache named
Geronimo, having escaped from the San Carlos Indian Reservation with
forty-two warriors and twice that many women and children, was playing
a desperate game of cat and mouse with General George Crook and the
United States Third Cavalry. Remington did not encounter Geronimo in
Arizona or even come close to him, but the outlaw Indian's newsworthy
presence in the Southwest during the summer Remington spent there was
a happy coincidence, for when Remington arrived at New York in the
fall, editors and publishers were beginning to feel a new curiosity about
the West as news.

Remington's portfolio of sketches made in Arizona had an interest
largely derived from an illusion that the sketches were *of* Arizona. The
sketches were finally used to illustrate accounts of what Arizona was
like—and in that context, there was perhaps some sense in which they
acquired a specific geographical designation from the prose that sur-
rounded them. Yet the sketches themselves were *not* of Arizona. In the

entire portfolio there was not a single landscape that served as anything more than the most perfunctory background. In a great many instances the background was stylized to the degree that it ceased to be a landscape at all. Often, it vanished altogether. The pictures had as much of Arizona in them as they did of other regions, but the plain truth was that they did not represent *any* place. Even the figures of soldiers, horses, and Indians which Remington put into the sketches seemed almost incidental, for what the sketches really represented was action. Mules with all four legs in the air, a scout straining off balance to tighten a cinch, Indians slanted against a body they dragged into the brush—all moved even while they stood still. Pictures like the one entitled "Putting a Carbine Bullet Through Its Brain" were even more arresting, for while they caught a stillness, it was always anticipation rather than repose. Whether or not Remington went southwest in 1885 to discover Arizona, he discovered there something quite different: a way to use the same restlessness that made him a football player at Yale and prevented him from making a success of ranching at Peabody, Kansas.

Similarly, Wister went west that same summer, not to explore a section of the country, but to find a large, empty space which served him better by receiving the impressions he carried in his imagination than by providing him with new ones. In January 1885, while Frederic and Eva Remington were still living at Kansas City, Wister experienced a severe breakdown in health. Diagnosis was difficult, for Wister's symptoms were diverse; they consisted primarily of intense headaches that often lasted weeks without abatement, vertigo, terrifying dreams, and sometimes even optical and auditory hallucinations. Whatever their origins, they were of a type known at the time as "hysterical." Regardless of what they indicated medically, they did the same thing to Wister's life as that unwise investment in the Kansas City saloon did to Remington's—forced a radical redefinition of goals.

A treatment commonly prescribed for mysterious nervous maladies like Wister's was European travel—often to pleasant regions such as the Italian coast or the south of France—but circumstances combined to send him in the opposite direction. Wister's father blamed Europe for many of his son's difficulties and doubtless advised against another trip there. More important, Wister was consigned to the care of Dr. S. Weir Mitchell of Philadelphia, a well-known neurologist who also happened to be a family friend of long standing. Dr. Mitchell's specialty was ner-

vous disorders of a "hysterical" nature. In 1885 he had only recently completed devising a treatment he called the "rest cure." He supplied a patient with plenty of pencils and paper, transported him to some place where he could enjoy protracted isolation, and told him to get plenty of rest and to write or draw as much as he wished. One of Mitchell's friends, also a physician, was Amos W. Barber, then governor of Wyoming Territory. A friend of Barber's, Major Frank Wolcott, owned a ranch in the Big Horn Basin. It was decided that Wister should spend the summer there.

Early in July the young man set out from Philadelphia with two maiden ladies, twenty years his senior, to take care of him. At Burlington, Iowa, he noted that "we begin to feel out of the reach of sea breezes from the Atlantic."[29] He found Omaha "altogether a new sort of thing."[30] The prairies near Cheyenne he thought "not unlike the country between Burfos and Madrid, only more so."[31] On Independence Day, Wister and his little party left Cheyenne by stagecoach, traveling north across the open plains. That evening Wister wrote to his mother from Point of Rocks, a stage station on Chugwater Creek:

When I've been most crazily myself, I've laughed and likewise shuddered to think how you would have probably hated every minute. Everything that you most particularly abhor in practice, no matter how much you may think it theoretically and democratically beautiful, has happened at least twice. Going to bed with your brothers and sisters, rising with them, talking with them, walking with them, eating & drinking with them . . . and of course the character of the said brothers & sisters has grown steadily more occidental each new day, till now here we 3 are, sitting in a log cabin lined with newspapers & stuffed with mud, around a small, hot stove, with the door open for ventilation. In the next room is the family—Mr. & Mrs. Morgan from Virginia—laboring people. She down with a trifle malaria—he making the beds and being more gentle to her & us than words can say—We dined with cowboys & stagecoach drivers . . . we're 8200 feet up in the air, & it's cold. The air is better than all other air. Each breath you take tells you no one else has ever used it before you—the scenery would not please you except now & then. It's very wild & desolate.[32]

The social and physical rigors of the new experience aside, Wister's condition improved rapidly. Wolcott's Deer Creek ranch, where he ar-

rived on July 6, surprised Wister by its comfort, and the Wolcotts them-
selves proved excellent hosts. Only two days after his arrival, Wister
noted that "this existence is heavenly in its monotony and sweetness."[33]
There was a creek to bathe in, magnificent scenery, plentiful game, books
to read—even a piano in the parlor. Yet as the blank pages of Wister's
notebook filled, it became increasingly evident that the Wyoming sojourn
was enabling Wister to remember rather than to forget himself. Wister's
job at Union Safe Deposit Vaults had comprised a nightmare because
the mechanical activity it required was truly opaque, expressing nothing
but itself. Conversely, the Wyoming experience reverberated with all the
heroic echoes Wister thought he had left behind forever at the Paris *Con-
servatoire*. When the landscape didn't look like Europe, it reminded
Wister of the Old Testament or Wagner's operas. Major Wolcott's dispute
with some squatters over a forty-acre plot of land recalled "Lot and Isaac
and Uncle Laban and the rest."[34] Even the wind, which Wister called
the "one thing about this country I don't like," led him to observe that
"never did breeze fulfill the scripture so completely." Dr. Mitchell's rest
cure worked for Wister in a most remarkable fashion: Wyoming's "new"
land enabled the young Philadelphian to make contact once more with
the oldest elements of his European heritage. For the moment at least,
cowboys and keepers of stagecoach stations paradoxically seemed more
within humanist traditions than the "gauche, shy, and wooden" society of
Boston.

The reason was simple enough. Bostonian achievement was precisely
that—achievement—an established society containing churches, a col-
lege, and other institutions that stood for just what they were. The West,
however, having achieved nothing, therefore promised everything. Its
face was blank indeed, but beyond the blankness Wister sensed a gleam
that eclipsed, not only Harvard College, but even the concert hall at
Bayreuth:

*We Atlantic coast people, all varnished with Europe and some of us
having a good lot of Europe in our marrow besides, will vanish from the
face of the earth. We're no type, no race—we're transient. The young
New Yorker of today is far different from the man his grandfather was—
and where the grandfather was a gentleman—the young Englishman of
today is not so different from his grandfather,—for the Englishman is a
completed specimen, a permanent pattern. Now each generation of us*

*is a new experiment. All the patriotism of the war doesn't make us an
institution yet, but the West is going to do it. I wish I could come back
in 200 years and see a town full of real Americans. And not a collection
of revolutionary scions of English families and immigrants arrived yes-
terday from Cork and Bremmen for that is what our eastern cities are
today.*[35]

At times, however, even Wister doubted his vision. Its brightness was
dimmed by a haunting fear that the prairies would "slowly make room
for your Cheyennes, Chicagos, and ultimately inland New Yorks, every-
thing reduced to the same flat . . . level of utilitarian civilizations."[36]

By itself, Wister's speculation about the future of the West expressed
only optimistic idealism—but when that future encountered the threat
of "inland New Yorks," it suddenly changed into something altogether
different, and thus designated a central feature of his imagination. Wis-
ter's love for grand opera, the book of Genesis, and the parable of the
prodigal son were all involved in a process that caused him to see the
West not so much as a *place* but as a *stage*—the huge arena in which
Light and Darkness struggled for ascendancy. While Remington thought
he was drawing pictures of Arizona at San Carlos, Wister thought he
was recording his impressions of Wyoming at Wolcott's ranch. Yet
Remington's sketches ignored topography to capture a kinetic whirl;
Wister's notebook identified the details of ranch life with cosmic battles.
Ironist and romantic were finally squared off, ready to have a go at each
other.

His health recovered, Wister entered Harvard Law School in the fall
and began to seriously consider becoming a writer. Remington, after drift-
ing south from San Carlos to the Mexican border, and east to Fort Sill in
Oklahoma, worked his way back to New York City, where he trudged
from one publisher's office to another with his bulging portfolio. Editors
looked and were interested but refrained from buying. The roughness of
the sketches' subjects seemed to be duplicated in their execution and
indeed in the appearance of the young man who tried to sell them. He
had talent but obviously needed training in technique. Cowed and dis-
couraged, Remington finally succumbed, borrowed a small amount of
money from his uncle, and began attending classes at the Art Students'
League.

Yet Remington still had his portfolio and still tried to sell pictures from

"The Government Guide Looking for Tracks." In this picture, as in a number of others, Remington has achieved a stylized, decorative quality by eliminating background details.

it. The fact that *Harper's Weekly* had already bought two of his rough sketches gained him a sympathetic hearing with kindly Henry Alden, that journal's editor, who bought a third sketch and used it—signed by Remington—on the cover of the January 9, 1886, number. Although the sketch was not distinguished, getting it printed on the cover of the nation's most popular magazine was cause for real elation. More good fortune came when Remington wandered into the Nassau Street offices of *Outing,* a new journal devoted primarily to outdoor sports and adventure stories. The editor, none other than the same Poultney Bigelow who chafed with Remington under Professor Niemeyer's tutelage at Yale, recalled years later that overwork, the rush to put a new issue together, and worry about financial woes began that happy day inauspiciously:

Feeling cross and weary, I did not even look up at the huge visitor, but held out a hand for the drawings. He pushed one at me, and it was as though he had given me an electric shock. Here was the real thing. No stage heroes these; no carefully pomaded hair and neatly tied cravats; these were the men of the

real rodeo, parched in alkali dust, blinking out from barely opened eyelids under the furious rays of an Arizona sun. . . . I looked at the signature—*Remington*. There was nothing, however, to suggest the work of my homonymous fellow-student of Yale.

I was delighted at my discovery, and said to him, "It's an odd coincidence, I had a classmate at Yale. . . ." But before I could add another word out he roared: "Hell! Big—is that you?"[37]

Bigelow immediately bought every picture Remington had, and assigned him to illustrate "every manuscript likely to interest such a pencil." During the following year, seventy-one Remington illustrations appeared in the pages of *Outing*.

The flood of orders that followed rapidly raised Remington to national prominence. In 1888, 177 of his pictures were printed in *Harper's Weekly, Outing, Youth's Companion*, and the *Century*. In addition, he exhibited at the American Water Color Society and won two prizes at the Annual Exhibition of the National Academy. Happily reunited now, and with plenty of money coming in, the Remingtons moved into spacious quarters on 58th Street, just off Columbus Circle, and began to enjoy success.

"Packer Hitching Up a Cinch."

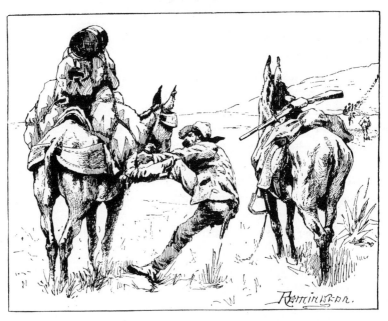

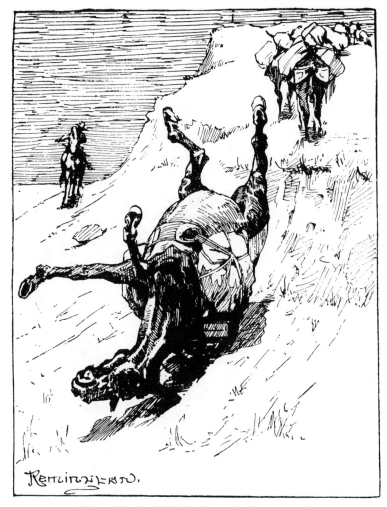

"One of the Pack Mules Turned a Somersault."

Meanwhile, Wister had some success at writing—but not much. In 1886, he took time from his studies at Harvard Law School to write an essay called "Some Remarks on the Greek Play," which was rejected by both *The Atlantic* and the *Harvard Monthly. The Atlantic* for April 1887 printed his unsigned essay on "Republican Opera" in its "Contributor's Club," and Wister, although he called the piece "a literary catastrophe," said he was "proud to be able to get it into such a magazine."

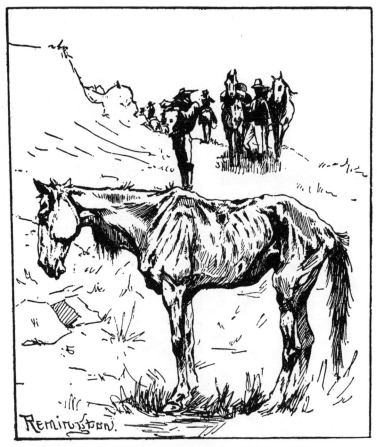

"By Putting a Carbine Bullet Through Its Brain." A U.S. cavalry
sergeant dispatches a horse abandoned by the Indians. The
gaunt horse allows Remington a study in equine anatomy.

That summer he embarked on his second trip west, which took him
north to Toronto, across Canada to Vancouver, down the coast to San
Francisco, and then east again through the Wind River Mountains to
Yellowstone Park. Sunset on Wind River reminded him of the Styx.
Shortly afterward, he felt "like a murderer" when he killed his first bear.
He was obviously delighted, though, recording in his notebook that "I'm
writing this by [the] bloody carcass," and perhaps intentionally managing
to smear the page with blood in corroboration.[38]
 August 25 found him at Yellowstone. "I hate this steaming, stenchy

place," he wrote.[39] And again: "The air has drafts of stenches through it sometimes like sulphur, sometimes like a stale marsh. The ground is drilled with hissing puddles and sounds hollow as you walk, and all healthy plants and grass keep at a prudent distance."[40] Although he disliked it, Geyser Basin obviously had its place on the dark side of Wister's developing western myth. Later he wrote several stories about it, the most notable of which was "Lone Fountain," the curious tale of a "dead" geyser summoned back to life by a beautiful Sicilian sorceress. Even Wister's first published western tale, "Hank's Woman," contained a place called Pitchstone Cañon, where poisonous fumes breathed out from the underworld through fissures in gray rock. Wister used the diabolism long connected with Yellowstone in his own romantic fashion, representing it as a mythic manifestation of the same evil force that expressed itself in

An early Remington illustration: Geronimo's followers drag Robert Lloyd, an Arizona rancher, into the brush after shooting him in the back.

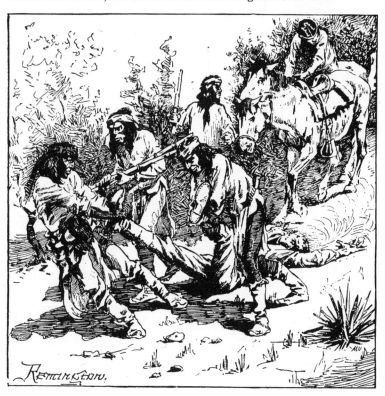

history by threatening "inland New Yorks."

By September Wister was back in Pennsylvania and returned to law school shortly thereafter. Remington, meanwhile, began work on ninety-nine drawings for Theodore Roosevelt's *Ranch Life and the Hunting Trail,* published serially by the *Century* and later brought out as a book. He rose early every morning and drew steadily until mid-afternoon. Long walks or horseback rides in Central Park filled the rest of the day. Evenings were often spent with friends, for although Remington was by nature a loner, New York made available to him close association with many people he liked and admired. A number of these were writers and journalists like Richard Harding Davis, editors like Henry Alden and Richard Watson Gilder. Nothing was more predictable, therefore, than that the young artist, whose talents as illustrator were augmented by a gift for colorful and lively speech, should become interested in writing.

Remington's work with the *Century* on Roosevelt's book led directly to a successful career in journalism. Gilder sent him to Arizona in the summer of 1888 to cover the Tenth Cavalry's control of Apaches in that district. Out of the trip came four illustrated articles, published the next year.[41] In 1889 he went to Mexico. In 1890, after completing more than four hundred drawings, twenty-two of them full-page plates, for an illustrated edition of Longfellow's *Hiawatha,* he journeyed to Dakota. There he joined a scouting party of General Nelson A. Miles's Tenth Cavalry in pursuit of the Sioux army of six thousand mounted warriors, armed with rifles, in the last sustained campaign of the American Indian wars.

The summer of 1888 found Wister in Wyoming again. Camp life made a welcome relief from the rigors of law school, where he had worked seven days a week "from nine till one, from three till six thirty, and from eight till ten thirty or eleven." Indeed, the diversion was so pleasant that Wister began to plan the rest of his life around yearly trips west. In the spring of 1889, however, he moved into the Philadelphia offices of Francis Rawle on Walnut Street to practice law. At the beginning of May he admitted an "irresistible impulse . . . to board the next train, and dissolve out of sight in that country far off."[42] Neither large nor difficult, Wister's law practice surely could have been arranged to make room for a hunting trip had it not been for the fact that he suddenly found himself "grinding all my spare hours tooth and nail in the domain of art."[43] His main project was an opera about Montezuma, which he pushed to

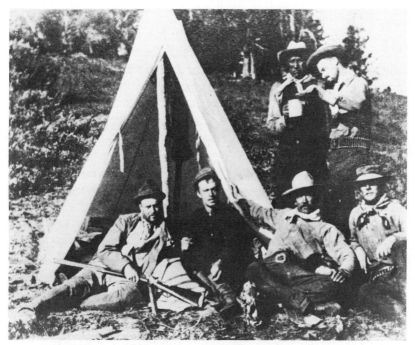

**Owen Wister and hunting party in Wyoming, 1887. Wister is at
upper right, pouring whisky for Indian guide, Tigee.**

finish before theatrical managers made their plans for the next season.
He promised himself a few days at New Brunswick in August, hoping
that this would provide "some substitute for Wyoming."[44] But by the
beginning of August his health was bothering him again. "Cutting out
pleasure entirely," he wrote, "[made the difference] between how I felt
a year ago today and how I feel now—and it's wide."[45] By the end of
the month, it was clear that producers were not interested in his opera.
On October 9, he boarded a westbound train.

The following weeks Wister spent at Fort Washakie, listening to cow-
boys and soldiers talk and exploring Horse Creek, Del Norte Creek, and
other tributaries of the Big Horn River. He had little success at hunting,
but when the time came for him to leave, he wistfully speculated on how
pleasant it would be "to spend the winter with the DuBois gang—hunting
—fishing—and playing cards at night—bed by nine; breakfast by seven,
and scanty changes of raiment."[46] Boarding the eastbound train at Raw-

lins on November 25, Wister noted that "I wish it were going the other way to the Golden Gate and the wild Californians." Instead, the train took him back to Philadelphia, where he worked on the index of a law book and walked "down Walnut Street in the A.M. and up Walnut Street in the P.M."[47] Yet this routine was augmented by another and more exciting activity: Wister was working on a story about the West.

While Remington hunted, and was hunted by, Sioux warriors in the Dakota bad lands, Wister groped toward his vocation at Philadelphia. By the spring of 1891 several western tales were partially completed, and he enthusiastically jotted down ideas for more as they occurred to him. When he went to Wyoming in June, he did so with the specific intention of gathering material for stories:

The only thing I do is to jot down all shreds of local colour and all conversations and anecdotes decent or otherwise that strike me as native wild flowers. After a while I shall write a great fat book about the whole thing.[48]

Back at Philadelphia by the middle of September, Wister held the "great fat book" at a distance while he worked on two short stories. Dr. Mitchell advised him to send them off to Henry Alden at *Harper's.* In January Alden accepted them—"Hank's Woman" for the weekly and "How Lin McLean Went East" for the monthly, enclosing a check for $175. The former story, said Wister, "makes its effect by means of loud orchestration, cymbals, kettledrum, etc." The latter was *"andante sostenuto . . .* without a single brass instrument."[49] Not only had he finally found the road to Geyser Basin; he also seemed to realize, at least implicitly, that it stretched back somehow to Bayreuth. And in making Lin McLean a young man who discovers his identity by reading the parable of the prodigal son, Wister also designated the point at which his own life veered west toward Yellowstone from a dingy tavern on the Aar.

The same month Wister got his good news from Henry Alden, Remington's illustrated articles on the Sioux uprising began publication in *Harper's Weekly.* Later that year the artist moved out of New York City to New Rochelle, where he bought a large house with spacious grounds and a view of Long Island Sound. In 1892, while Wister gloried in the publication of his first western stories, Remington allowed Poultney Bigelow, who had since resigned from *Outing,* to convince him that a trip across the Atlantic, under contract with the house of Harper, would

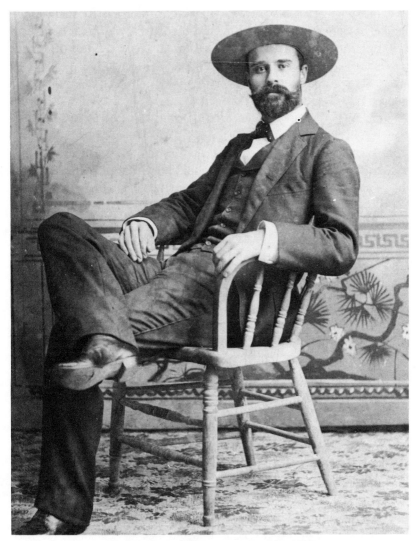

Owen Wister at Yellowstone Park in 1887.

be both profitable and fun. They traveled first to North Africa, where Remington enthusiastically drew pictures of Arabian horses in the Sahara Desert. In June they were at St. Petersburg, where they planned an extended journey up the Volga River to study the Cossacks. Russian officials refused to sanction the trip, however, and when Bigelow persisted

in requesting permission to travel in the interior, he and Remington were politely escorted to the border by armed guards.

After Russia, Remington was eager to go home. He left Bigelow in Germany and headed for England. In London he saw Buffalo Bill's Wild West Show, which led him to comment ironically that "one should no longer ride the deserts of Texas or the rugged uplands of Wyoming to see the Indians and . . . pioneers."[50] Down the coast at Aldershot, he saw the British army playing "war games," and cursed "all these miserable machinating staff and ordnance officers and inventors" who substituted "the pitiless, all-penetrating, rapid-firing rifle"[51] for swords and bows and arrows. By the end of summer Remington was back at New Rochelle. In January of the next year, 1893, he held his first public exhibition and sale at New York. In June, Wister signed a contract with *Harper's* and immediately headed west. Remington illustrated "Balaam and Pedro," Wister's next story, before going west again himself. On September 8 he galloped across Pitchstone Plateau in Geyser Basin. When Wister came in from the cold, Remington was seated by the fire.

After lunch the two men who had come so far to find each other drove to Mammoth Springs, where they dined together and talked far into the night. Wister, who felt that only a "huge and bloody disaster"[52] could save the country from sinking into a political and economic morass, found in Remington a kindred spirit:

Remington is an excellent American; that means, he thinks as I do about the disgrace of our politics and the present asphyxiation of all real love of country. He used almost the same words that have of late been in my head, that this continent does not hold a nation any longer but is merely a strip of land on which a crowd is struggling for riches.

Because he himself was "a thin and despondent man" but Remington "weighs about 240 pounds and is a huge rollicking animal," it surprised Wister to hear the artist "more caustic in his disgust and contempt at the way we Americans are managing ourselves than I have ever been."[53]

Remington, eager for a new start after his disappointing trip to Europe, found in Wister a partner who showed no signs of trying to drag him away from western subjects. On the train to St. Paul, Minnesota, the next day, he sat with Wister and pushed the idea of "collaboration." His criticism of Wister's unfinished manuscript for "The Promised Land,"

another western story, led Wister to comment that "Remington's artistic insight is quick and clear and forcible."[54] Two months later the artist had enthusiastic praise for "A Kinsman of Red Cloud," which he was illustrating. Yet even though he was clearly attracted to Remington, Wister remained standoffish. In a letter to his mother, he described the artist merely as "a good sort." Like the West itself, Remington promised Wister everything, but Wister, as he himself admitted, was not yet fully confident of his own abilities. The partnership with Remington would have to be tested. The test Wister waited for was "Balaam and Pedro," his first story to appear with a Remington illustration. He felt the tale contained a "big swallow of Wyoming" but also noted that "the event related is cruel." "This," he worried, "is not the kind of thing the general public likes."[55]

"Balaam and Pedro" appeared in *Harper's Monthly* just before Christmas, carrying Remington's full-page drawing of a horse trade. Wister, on the last leg of a transcontinental trip, got off his train at Harrisburg, Pennsylvania, and bought a copy at the newsstand. After reading it, he was joined by a friendly young businessman from Superior, Wisconsin, who asked if he happened to have the latest number of *Scribner's*. Wister offered him the *Harper's* instead. While the young Wisconsinite turned pages "looking at the illustrations," Wister waited apprehensively:

When he came to Remington's of the horse deal, he stopped and looked at it three times as long as at the others. Then he read a few sentences in the text opposite and, turning some more leaves, finished all the illustrations the number contains. Then he returned and looked at Remington again. After that he found the beginning of the story and began to read it.[56]

Remington had passed the test. The chance meeting in fantastic Yellowstone at the end of an outlandish summer suddenly looked like the beginning of a practical union. Noting that his companion on the train was "a matter of fact youth," Wister remarked that "if such as this will read me, I am secure," adding, "I think I owe it to Remington's picture."

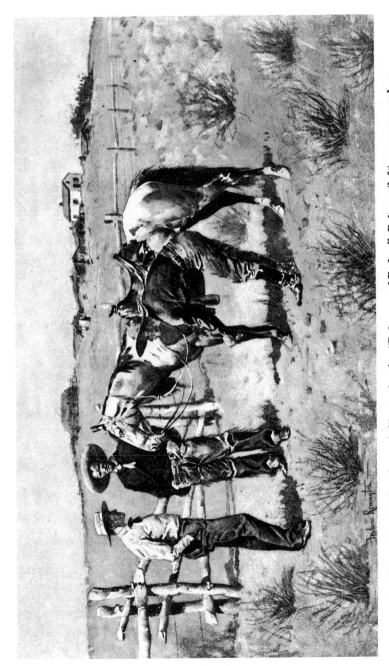

"The Horse Trade," Remington's illustration for "Balaam and Pedro." Balaam (left), an unscrupulous rancher, attempts to buy the horse Pedro from Shorty (stooping, right). The Virginian watches.

Chapter 2

Evolving "The Evolution"

W ister didn't ask the young Wisconsin businessman why he looked at Remington's picture of the horse trade "three times as long as at the others," but he must have looked at the picture himself and seen the reason, for what fairly stared out from the page was the very paradox responsible for Wister's own fascination with the West. The figures in the foreground were well executed and interesting, but easily disposed of. What caught and held one's eye was the line of the pole fence behind them, and beyond that the top of the ridge along which house and haystack stood against a blank sky as thought teetering on the edge of the world, ready to fall over. The question one asked as he looked at the picture was not "What are those men doing?" but "What does that space mean?" Even the young businessman, whose interests ran to "banking, real estate and fire insurance," was puzzled by it, probably without knowing why.

Because Remington had a talent for ironic seeing, stating the question seemed to him better than trying to explain it. Wister, however, insisted on an answer. The question first confronted him when he went West to Major Wolcott's ranch in 1885. Looking away from the ranch house in one direction, he saw a wall of mountains "standing up long, regular and blue." In the opposite direction, beyond the huddle of outbuildings, lay a range of "strangely shaped hills with their tops sheared off," which reminded him of "grass-grown books." Beyond that, a plain stretched into an immensity of space Wister felt went "further than . . . imagination."[1] The ranch buildings made a meaningless speck between mountains and prairie, and Wister could not read the hills that looked like

33

books. From the beginning, he saw that the landscape conveyed a power-ful sense of antiquity. His problem was that he wanted a *historical* record, the only kind he was equipped to understand. Lacking that, he began at once to speculate about the region's *future* history—which he hoped would produce "real Americans" two centuries hence. It was as though he looked at Remington's picture of the horse trade and imagined a tree-lined street instead of the pole fence, tidy cottages in place of the haystack and ranch buildings.

Clearly, this left the question of meaning untouched. An imaginary town had nothing to do with the ancient look of the skyline in Reming-ton's picture. Yet Wister clung to his vision of the West as a place where "real Americans" would someday live. Trying to explain who the "real Americans" would be and what identified them with the West, he forged the puzzling landscape in Remington's picture into a link between the distant future he anticipated and the distant past to which he found him-self romantically attracted: the blank face of the land became "a space across which Noah and Adam might have come straight from Genesis."[2] Wister had little difficulty linking the western landscape with a legendary past, or speculating about its future. But the point in the middle was harder. How did one get from Genesis to "a town full of real Americans"? Wister's answer was contained in a supposition that future "real Ameri-cans" would be products of an evolutionary chain determined in large part by the western land itself. By the time he met Remington in Yellow-stone, he had already decided that the western landscape had a permanent spiritual effect on the people who lived in it. The "real" American's moral superiority would derive somehow from his environment. Conversely, moral inferiority would be destroyed. Wister's first two western tales showed how this hypothetical evolution worked.

"Hank's Woman," published in August 1892, tells the story of a mus-cular, religious Austrian servant girl stranded in the Yellowstone country and cruelly victimized by "little black Hank," a shiftless and insensitive cowboy. Despite her humble origins, the servant girl was "a completed specimen, a permanent pattern." Hank, on the other hand, was dangerous because he was unstable. Clearly, he was "a new experiment"—a hybrid type rather than a "real" American. The girl's durable moral code ex-pressed her cultural stability. Hank's failure to believe in anything re-flected his cultural rootlessness. The story represents Wister's attempt to come to terms with morally unattractive facets of the evolutionary proc-

ess, and in it Hank, unfit for survival, appropriately met his end.

But Wister's next story, "How Lin McLean Went East," introduces a "real" American type who survived. To find himself, Lin must travel away from an East "varnished all over with Europe" toward the Rocky Mountains, where heroic past and heroic future intersect. After a disappointing trip to his native Boston, Lin correctly recognizes that "it weren't home I . . . went to back East." Return to Wyoming brings another realization: "Now this country here, seein' it wunst more, I know where my home is."[3] The journey to Boston was a mistake, the return to the plains a true homecoming. Yet Lin's most important realization strikes a somber note: after his fruitless trip east and return west, he looks out across the prairie and disconsolately comments, "I ain't got no father watching for me to come up Wind River." Precisely. Lin was a "real" American *because* he was fatherless. If his home was that "space across which Noah and Adam might have come straight from Genesis," there was no more use searching for relatives on Wind River than at Boston. The Wind River country was empty. The "real" American as represented by Lin McLean was a prodigal for whom no fatted calf waited.

"Hank's Woman" and "How Lin McLean Went East" posited the notion that there was some particular point in time and space at which European became American. The former story took place just before that point, the latter just after it; but the point at which the transformation actually occurred remained untouched. Wister doubtless understood this, for while he still worked on both stories, he tried to define the cowboy's role as "American" in a series of historical "studies" concerning the western experience. His goal was an essay, tentatively entitled "The Course of Empire," about the cowpuncher's part in the process of civilization.

In 1892 Henry Alden told Wister that "The Course of Empire" would be welcome at *Harper's Monthly*. By 1893, however, after seeing some of Wister's historical studies, Alden expressed doubt about the wisdom of pursuing them. On his way to Yellowstone and his first meeting with Remington, Wister walked out of the editor's New York office with mixed feelings:

Alden wants my studies to pause for a while and says that after a series of pure adventure the studies will have a wider popularity. I insisted that I believed in my studies and had no wish to be interrupted or discouraged

in my road through them to the final goal of "The Course of Empire,"
and he entirely assented to the desirableness of the scheme, saying those
others would merely put it in abeyance meanwhile. So now my next
duty is to hunt material of adventure voraciously.[4]

This meant simply that the historical impulse Wister acquired at St.
Paul's and carried west with him in 1885 was temporarily thwarted by
editorial edict. In no way did it reflect the deep sense of disillusionment
that threatened Wister's historical vision even as he set out for Geyser
Basin.

Although Wister's newly signed contract with the house of Harper
called upon him to write adventure stories rather than historical studies,
he still felt he must reconcile the tales he wrote with his fundamentally
optimistic historical theory. The task was difficult, for large numbers
of European immigrants pouring into cities along the eastern seaboard
made Wister fearful that the "real" American values he cherished would
be destroyed. Furthermore, the economic and social unrest characterized
by Populism and trade unionism augured changes Wister regarded with
dismay. The course America seemed to be taking failed to match the
"course of empire" Wister wanted to write about, and if his historical
vision was false, Wister could see no reason for writing it down. Only
days before his meeting with Remington, he took gloomy inventory:

I see no way out of the saturnalia into which politics are hurrying. Some-
thing worse is being done each year, and the American people have been
looking on at lying and stealing for so long that we have lost the power
of being shocked. Our country and its government are now two separate
things, not greatly unlike a carcass and vulture. . . . Honesty is so un-
successful now in anything that people imagine they do not want it. This
. . . has happened to nations before, and contains its own remedy—which
is the caving in of all business credit so that no man can trust another.
After experiencing this for awhile, the communities have generally come
to their senses and the atmosphere is cleared once more. I hope this earth-
quake will come as soon as possible . . . for this is our only hope. No
preaching or protest, no honest young men entering politics are going to
be of the slightest avail now. The stage coach has got going down the
slide too quickly for any brake to hold it and the passengers inside have
got so deep in their game of poker that they are blind and deaf to what

is happening. . . . That is about the standard of our American nation in the year of grace 1893.[5]

Because he could find "very few Americans" in his transcontinental travels, Wister feared the "great Experiment of Equality" was failing. At Yellowstone, however, he found what he was looking for: Remington seemed to him "an excellent American."

Two days later, when Wister and Remington parted at St. Paul, the idea of a historical essay about the cowboy seemed once more viable. Yet, though Wister didn't know it, the idea had changed, for if Remington provided a catalyst for the study by being "an excellent American," he also shaped it with his own experience and perceptions. Indeed, when he left Wister at St. Paul, Remington began immediately to see a new direction for the project. From St. Paul, Remington went to New Mexico, where he hunted bear with his old friend General Miles on the SU ranch of Montague Stevens. Stevens was a graduate of Trinity College, Cambridge, who first encountered the American West in 1880 on a trip to Wyoming. Two years later, he started ranching in New Mexico and by 1893 was one of the largest landowners in the region. Remington described him as "a tall, thin young man, very much bronzed, and with the set, serious face of an Englishman.[6] His foreman, Dan Gatlin, was "shrewed-eyed, little, square-built . . . always very much preoccupied with the matter in hand."[7] The hunt itself impressed Remington, causing him to wonder what mysterious force it was that sent a man "3,000 miles to kill a bear—not for love or fear or hate or meat."[8] Yet Stevens and the SU ranch impressed him even more, for they represented a survival, tough, insular and picturesque, of "the wild riders and the vacant land" he found when he first went west from Canton in 1881. He wrote an article about the bear hunt, but realizing that Stevens and his ranch were more complex, Remington stored his impressions of them away for something bigger—which culminated two years afterward in "The Evolution of the Cow-puncher."

While Remington hunted in New Mexico, Wister journeyed from St. Paul to Chicago, where he again visited the World's Fair, this time seeing the Wild West Show of Buffalo Bill. For the remainder of 1893 he traveled through Arizona, Texas, New Mexico, and California, collecting material and writing. On December 25, the same day he saw Remington's picture work its magic on the young businessman from Wisconsin, Wister

returned to Philadelphia. January 15 found him at Remington's house in New Rochelle, where the artist, his head still full of Stevens and the SU ranch, was illustrating one of Wister's stories, probably the recently completed "Little Big Horn Medicine." Thirty-four years afterward, Wister remembered what happened that day.

Remington . . . said with his customary genial profanity: "Your text holds me down too close. Write me something where I can turn myself loose. Tell the story of the cow puncher, his rise and decline."[9]

In his 1928 account, Wister noted merely that he "obeyed" Remington's order for an article.

Actually, though, a good deal more was involved. Remington's desire for an essay on the cowpuncher was attractive to Wister because it reaffirmed the value of a long-standing ambition. When Henry Alden challenged that ambition in 1893, Wister laid it aside. "Little Big Horn Medicine," "The General's Bluff," and "The Kinsman of Red Cloud," the stories he wrote in the spring of 1894, forsook the quest for a "real" American begun in his first two western tales. And when Remington demanded an article on the "rise and decline" of the cowpuncher, Wister may not have immediately recognized the opportunity thus presented to revive his studies. In April, however, he began to understand that the essay Remington requested resembled the studies Alden had rejected. The catalyst this time was an article on "Americanism" by Theodore Roosevelt, which appeared in that month's *Forum*. "Nothing," wrote Roosevelt, "will more quickly or more surely disqualify a man from doing good work in the world than the acquirement of that flaccid habit of mind which its possessors style cosmopolitanism." His thesis was that despite the genetic diversity which characterized the United States, a distinctive American type was possible.

Furthermore, Roosevelt argued, the process that created such a type involved the evolution of already existing types into something new: "It is not only necessary to Americanize the immigrants of foreign birth who settle among us, but it is even more necessary for those among us who are by birth and descent already Americans not to throw away our birthright."[10] Both those Americans who acquired their nationality by birth and those who became "Americanized" shared qualities which separated them from Europe and united them with each other. Both had undergone

the same transformation Wister bracketed between "Hank's Woman" and "How Lin McLean Went East." Wister had not been able to deal with the transformation itself, but he now found that Roosevelt stated its meaning: "It is always better to be an original than an imitation, even when the imitation is of something better than the original."[11] Roosevelt's pronouncement suggested to Wister that the "real" Americans he had posited for the future might derive their superiority directly from being "original." Lin McLean's failure to find a father in either East or West thus became the cowboy's peculiar virtue: to be American, he had to remain alien, even in America. With this notion in his head, Wister departed for the West, where he spent the summer and began writing "The Second Missouri Compromise," a story in which even members of the Idaho Territorial Legislature, all unreconstructed southerners, demonstrate their "Americanism" by refusing to acknowledge allegiance to the federal government. Although Wister still put off writing the historical essay, these themes were again finding their way into his fiction.

As Wister's stories began to appear regularly, they were given a mixed reception by reviewers, some of whom thought them derivative from Bret Harte. Wister was offended by this, for while he admitted that Harte's "best first stories" were "divinely true and touching" because they dealt with "the type of courageous ruffian, single-minded and generous on large occasions," he also maintained that this type was "at present a bygone fact" and attempted to deal in his own fiction with "transition stages" between it and later types.[12] Warmer praise came from E. S. Martin, who recognized in his August 11 column for *Harper's Weekly* that Wister's work represented a significant departure from Harte's:

Mr. Wister's West is nearly twenty years older than Mr. Harte's, and is a country of cowboys instead of miners. Moreover, it is not the West of the Pacific, which the hand of man has already tamed, but the mid-West of the great plains, which is still sparsely settled and rudely peopled. Mr. Wister has not merely been there, but has lived there, persistently and conscientiously, with his eyes and ears open, and his intellectual faculties alert. What he has brought back is valuable matter, and he sets it forth for all it is worth. He gets into his stories the indispensable human interest, without which stories cannot take hold as they should. His wild Western background is a background, as it should be, and not the main reliance of his picture. . . .

A man who can see men in the West can see them everywhere. Mr. Wister may swap skies, but if he continues to use the same mind he took with him to cowboy land he may be expected to deal with the concerns of polite life as successfully as with the beefy West.[13]

This was not only recognition of Wister's success as a writer; it also seemed to obliquely ascribe to him an Americanism of the sort defined by Roosevelt's essay. Wister was still Wister, east or west. His main subject was not a region but a type of humanity.

Wister, having returned from the West to Philadelphia only days before Martin's comments appeared, read them delightedly. Remington, however, regarded them with outrage at New Rochelle, for they directly negated his own experience and threatened his professional objectives. Having swapped skies himself only two years before, he returned to paint the American West. If Wister decided to write about "the concerns of polite life," Remington would lose him as a partner. In short, Remington resented the whole tenor of Martin's last paragraph. Immediately after reading it, he dashed off a note to Wister:

My dear Wister—

In the last Harpers Weekly—a piece of office furniture fell on you— the upholstery of a library chair sprang all over you.

The first concern of polite society is not to be a d— snob & if one finds that he is one he ought to try like the devil to conceal it—Just write to Mr. Martin or Harpers to that effect, old man. Jump on 'em heavily—
yours faithfully
AUGUST 2, 1894 *Frederic Remington*

Part of Remington's vehemence was a matter of temperament, but part doubtless resulted from the artist's increasing anger with the "polite" society Martin spoke of. The summer of 1894 was marked by labor disputes and riots in major cities across the nation. When Martin's column appeared, Remington had just returned from covering the worst of them —the Chicago railroad strikes—for *Harper's Weekly*. He associated the strikers and rioters with Europe and the large American cities of the East. Conversely, the soldiers called in to quell the trouble were Indian fighters from the "beefy West":

On the green of the Lake Front before the Auditorium Hotel burned the

camp-fires of the troops. . . . There was Captain Capron, standing in front of his battery park, as natural when I had last seen him at Pine Ridge, just after Wounded Knee.

And again:

Well, it is a great change of air for the Seventh Cavalry. The regiment was born on the Platte River, pretty far up stream, and it has never been far enough East until the last few years to buy a fine tooth comb or hear a hand organ, but it is East now, and right in the middle of civilization . . . and there are things in Chicago it doesn't like, and if you want the recreated spirit of Homer you ought to hear a Seventh Cavalry trooper tell what he thinks of Chicago's mob.[14]

Despite the fact that Populism, unionism, and Free Silver agitation were largely associated with the West, Remington saw the Chicago riots as a war between European anarchists and American frontiersmen. Throughout his observations on the riots there lurked an unstated assumption that the American West, because culturally and geographically farther from Europe, was also more American and closer to "the spirit of Homer" than the American East. By this logic, E. S. Martin's "office furniture" became somehow un-American.

Meanwhile, in the wake of serious disturbances at Chicago and Sacramento—and still in the shadow of the Homestead, Pennsylvania, riots of 1892—the Pennsylvania National Guard held its annual summer encampment at Gettysburg. Since Remington had drawn and written about the Chicago military operations, he was also assigned to cover the Gettysburg encampment. Since Wister was a Pennsylvanian, just come from the West, where he saw strikers marching in California, he was asked to collaborate. Remington eagerly accepted. Wister, however, demurred. On August 10, still seething with resentment for E. S. Martin, Remington wrote from New Rochelle, urging Wister to reconsider.

My dear Wister—

[Albert Bigelow] Paine—editor of Harpers W says I must do your work—Had alloted on meeting you at Penna State Camp. I want to see how you can wrestle the military proposition. Sorry you dont go. I was going down next Wednesday to do pictures. Better reconsider it—go down—tell how much better red-blooded soldiers are than little stinking library upholstry such as Martin of Harpers is. Great opportunity.

<div align="right">

Yours faithfully

Frederic Remington
</div>

AUGUST 10, 1894

Either Remington's letter or something else succeeded in changing Wister's mind. A week later, on August 17, he and Remington met at Gettysburg. The result was "The National Guard of Pennsylvania," an illustrated article printed in the September 1 number of *Harper's Weekly*.

The part-time soldiers Remington and Wister saw at Gettsyburg were not frontiersmen or Indian fighters. They were farmers and businessmen, most of whom had never crossed the Mississippi River. Yet the pictures Remington drew of them were interchangeable with his earlier pictures of the Seventh Cavalry at Chicago. By itself, of course, this was not surprising, for military uniforms look much the same everywhere—but the text that accompanied Remington's pictures gave them a peculiar force. Wister's essay derived its orientation from two sources: Remington's articles on the Chicago riots of 1894 and his own efforts to define "real Americans." The first paragraph came directly from Remington:

Two Chicago rioters who had their opinion of militia were busy at unhindered destruction of other men's property some weeks ago, when a sudden and novel stillness in the air caught their attention, and they turned round. They saw some dingy objects moving up the street. These were United States troops, just come from fighting Indians. They were dirty and dogged, and looked straight ahead. The rioters gazed at them a moment. "Let's you and me get out," said one of them to the other; "them fellers don't carry bokays in their guns."[15]

Thus, the connection between the Pennsylvania militia and the U. S. regulars, between Chicago and Gettysburg—and most importantly, between western and eastern "Americans"—was firmly and briefly established.

From that point the essay quickly traced the Pennsylvania Guard's important engagements. First, there was the Pittsburgh strike of 1877, in which ill-prepared troops "sat for shelter in a round house" while "the public enemy burned freight cars." Next there was the Homestead strike of 1892, when "the rats came out of their holes again," only to be met this time with force. Finally, Wister came to the relevance of the 1894 encampment: "I have had a recent experience in California, . . . and Sacramento in '94 was worse than Pittsburgh in '77." And again: "Vigilance is the price of liberty not only from foreign but domestic foes." The point Wister's essay made was identical with the point Remington's pictures, by being interchangeable with his pictures of Chicago, illustrated: the National Guard in Pennsylvania, like the Seventh Cavalry at

Chicago, was a bulwark between "real Americans" and "the rats." The lines were sharply drawn and apparently static. Only months before, Wister had enthusiastically agreed with Theodore Roosevelt's contention that it was possible to "Americanize" people who came to this country from abroad. Before that, he saw the West as a place where opposites could be reconciled. Now, however, the process seemed more difficult.

Clearly, the disturbances of 1894 caused Wister to reassess his faith in the American landscape's ability to transform Europeans into something new. His vision of the American past thus radically shifted its orientation as Wister came to regard conflict rather than conciliation as the central fact of American life. Shortly after "The National Guard of Pennsylvania" appeared, he pessimistically observed to Roosevelt that "were I asked what our first 100 years had demonstrated I should be obliged to say an already ancient truth, about silk purses &c."[16] Remington, in a September letter about some shoes he had left at Gettysburg, accurately noted the nature and extent of change in Wister's attitude:

My dear War Eagle—

I left a pair of crocodile shoes in Col. McClellan's tepee—got letter from him "Phila Club"—awful signature—couldn't be sure of it—said he had "spoke" to you about them—I wrote him—do not hear—want to go West—can't go without my crocodiles—can you help a fellow. Do you ever see him—Does he live there or in Harrisburg?—

How goes it—war eagle—how do you like your self in your new role —look out for the "Rats"—they may get next to you.

SEPTEMBER 1894 *Frederic.—*

Remington's broadly humorous caricature of Wister as a war correspondent with big feet, baggy pants, and an old fashioned helmet made a point of its own, for the crude figures it showed in the background were no Sunday soldiers come to Gettysburg for drill. They were men enveloped in the dust and smoke of a real battle.

A few days later, Colonel McClellan sent Remington's shoes, and the artist prepared for a pilgrimage into the West, where he received a hearty reception from the officers of Fort Grant, New Mexico, to whom he had made the present of a painting. Just before leaving, he wrote Wister on stationery left over from his stay the summer before at Chicago's Auditorium Hotel:

My dear War Eagle —

I left a pair of crocodile shoes in Col. McClennan's tepee — got letter from him "Phila Club" — awful signature — couldn't be sure of it — said he had "spoke" to you about them — I wrote him — do not hear — want to go West — cant go without my crocodiles — can you help a fellow. Do you ever see him — Does he live there or in Harrisburgh?

How goes it — war eagle — how do you like yourself in your new role — look out for the "Rats" — they may get next to you.

Frederic. —

My dear Wister—

Have gotten the "crocodiles"—don't bother—

I am off on Tuesday—for Chicago—Leavenworth—Riley—Wingate —New Mexico—Hope to meet Speciman Jones.—

I sent an "ile paintin' "—Mexican cavalry—to Grant—officer's mess —nice of me, wasn't it?

Keep me informed when you discharge M.S. at Alden.—

Yours faithfully

SEPTEMBER 1894 *Frederic Remington*

The Auditorium Hotel, of course, was the same place from which Remington watched his friends of the Seventh Cavalry subdue the Chicago strikers and remembered simultaneously their performance in the Dakota badlands against the Sioux. Its picture, printed neatly at the top of the page, was all square corners and elaborate archways towering impressively above the tiny figures of men and horses in the foreground. By contrast, Remington's sketch of himself, entitled "New Mexican Fantasia," gave an impression of lightness and space even while it commented on Remington's own increasing girth. Juxtaposed against the sinister bulk of the hotel, it communicated an unmistakable sense of escape, designating its central figure as a man leaving enemy territory for more friendly regions.

"Specimen Jones," hero of several of Wister's early tales, first appeared in "The Second Missouri Compromise," begun in the summer of 1894. When Wister and Remington met at Gettysburg in August, this story was one of the things they talked about. Remington therefore wanted to know when Wister sent the finished manuscript to Henry Alden so that he could be ready to draw the pictures for it. Wister finished the piece on September 18. In his letter to Remington, he observed that it was a masculine story, not likely to attract the attention of female readers. When the letter reached New Rochelle on September 20, however, Remington had already departed for New Mexico, and Eva answered:

My dear Mr. Wister,

Your letter to Frederic has just reached me & unless its contents are important I'll keep it here until his return as I am not sure now that his mail will reach him as he is to be but a short time in any one place. We

New Rochelle — Saturday

My dear Wister —
 Have gotten the "Crocodiles" — dont bother —
I am off on Tuesday — for Chicago —
Leavenworth - Riley — Wingate — New Mexico — Hope to
meet Specimen Jones. —
 I sent an "ile pantin" — Mexican cavalry
to Grant — officers mess — nice of me, wasn't it?
 Keep me informed when you discharge
McS at Aldew. —

 Yours faithfully
 Frederic Remington

New Mexican fantasia. —

shall hope for a visit from you when he returns. You are one of the few
men who he loves & he cannot see too much of you. When I see you I'll
tell you how much many *women are interested in all you write.*

I trust this will find you very well. With kind regards & best wishes
<div align="center">

Most Cordially,
</div>

SEPTEMBER 20, 1894 *Eva A. Remington*

A postscript timidly asked Wister what he thought of *Trilby*, George Du
Maurier's romantic novel in which Eva confessed herself "much in-
terested," then being serialized by *Harper's Monthly*.

Wister's manuscript of "The Second Missouri Compromise" awaited
Remington at New Rochelle when he returned early in October from
Montague Stevens' ranch and New Mexico. After reading the story and
beginning to illustrate it, Remington summoned Wister, who was spend-
ing that fall in Philadelphia, for a conference. Their meeting of October
20 and 21 was an important one, for Remington pressed hard in favor
of the cowboy article he had first mentioned the year before. Wister went
home to Philadelphia on the twenty-second convinced that it was time
for him to resume the role of historian. Remington, quick to pursue his
advantage, immediately furnished a set of facts for Wister to work from:

Say Wister—Go ahead please—make me an article on the evolution of
the puncher—"the passing" as it were—I want to make some pictures
of the ponies going over the hell roaring mal-pai after a steer on the jump.
I send you a great story by [Montague] Stevens of the S.U. ranche—
"front name Dick".

I will give some notes.—
Title "The Mountain Cow-boy—a new type"—
—this idea can be worked in

The early days 1865 to 1878 he was a pure Texan &c—cattle boom
he was rich—got $75 a month—wore fine clothes—adventurous young
men from all parts went into it—just as they would be Kuban Cassacks
if they got $100 a month. Cheyenne saddles—fine chaps—$15 hats
fringed gloves—$25 boots &c. With the crash of the boom—Yankee
ingenuity killed the cattle business as much as anything.—the Chicago
packers—the terrible storms, the draught &c.—then the survival of the
Stevens cowboys—run down a hill like as fast as a steer—over the
mal-pai—through juniper.—they fall and are hurt—they run into bear—

Endion.
New Rochelle, N.Y.

Say Wister — Go ahead please — make me
an article on the evolution of the puncher —
"the passing" as it were — I want to make
some pictures of the ponies going over the hell
roaring mal-pai after a steer on the jump.
I send you — a great story by Slevins of the
S. V. ranche — "front name Dick".
I will give some nots —

Title "The Mountain Cow-boy — a new type" —
— this idea can be worked in

The early days 65 to 1878 he was a pure
Texan te — Cattle boom he was rich — got $75
a month — wore fine clothes — adventurous young
men from all parts went into it — just as they
would be Kuban Cossacks if they got $100 — a
month. Cheyenne saddle — fine chaps $105 hats

prized glees — $25. boots . &c. With the crash of the boom
— Yankee ingenuity killed the cattle business as much as any
thing . — the Chicago packers — the terrible storms . the
drought &c . — then the removal of the

Stevens cow-boys — ran down a hill like
as fast as a steer — over wash-pan — through
juniper. — they fall + are hurt — they
run into bear — they are all Texans — do not
drink now — get 30 a month — work the year
round — the country is deserted by whites — a great
waste (N.E. New Mexico.) Stevens had a hell
of a time killing off + running out thieves — Had
5000. — in bank — to go to the man who killed
the man who killed him. — they used to bushwhack —
14 men killed over a maverick. — they dress
poorly , wear very wide chaps. — have 3 mounts
7 horses to a mount. are in saddle all the time.
"ramuda" horse herd —

2 horses bred in mountains — great lung power —+ hoofs
like iron. —

To hold cattle.

— bunch of cattle

— cow boys.

they bog in the alkali puddles — the cattle — are as wild as
deer — do not count for punches but pull in as quick
as deer — are killed by bear + wolves — maverick
in bunches — some 8 + 9 + 10 year old.

Jdan roped steer
over cliff — it ran over after
being roped — rope tied to
saddle horn — pony set back on
edge of cliff. — hell of a position
Stevins had new rope — 60 ft.
horse fell on mountain side — rope

Caught on stub — horse fell over cliff — so did Stevens — d — near killed him — when woke up found pair hanging — the rope was new — springy & did not break.

———— edge of cliff

Jokes —
"I understand you went up a tree with the bear just behind you"
— "The bear was not ahead of me"

3

Speaking of good horse "a meal a day is enough
for a man who gets to ride that horse".

Well go ahead — will you do it. —
get a lot of ponies" just a smokin" in
it.

Cheap are caught by two buckles otherwise they

fly here — Frederic Remington

they are all Texans—do not drink now—get 30 a month—work the year round—the country is deserted by whites—a great waste (N.E. New Mexico). Stevens had a hell of a time killing off & running out thieves—had 5000 in bank—to go to the man who killed the man who killed him. They used to bushwhack—14 men killed over a maverick. They dress poorly, wear very wide chaps.—have 3 mounts 7 horses to a mount, are in saddle all the time "Ramuda" horse heard—

Horses bred in mountains—great lung power—& hoofs like iron.— They bog in the alkali puddles—the cattle—are as wild as deer—do not wait for punchers but pull out as kuick as deer—are killed by bear and wolves—mavericks in bunches—some 8 & 9 & 10 years old.

Dan roped steer over cliff—it ran over after being roped—rope tied to saddle horn—pony set back on edge of cliff.—hell of a position. Stevens had new rope—60 ft. horse fell on mountain side—rope caught on stub—horse fell over cliff—so did Stevens—d— near killed him— when he woke up found pony hanging.—the rope was new—sprung & did not break.

Jokes—

"I understand you went up a tree with the bear just behind you"— "The bear was not ahead of me" Speaking of good horse "A meal a day is enough for a man who gets to ride that horse".

Well go ahead—will you do it.—get a lot of ponies "just a smokin" in it. Chaps are caught by two buckles. Otherwise they fly loose—

<div align="right">*Frederic Remington*</div>

SOMETIME IN SEPTEMBER OR OCTOBER, 1894

"Front Name Dick," the manuscript story Remington brought with him from New Mexico and now sent to Wister, was the delightful tale of a chuckwagon cook with a price on his head; it was published three years later in *Cosmopolitan* with Remington's illustrations.[17] Dan, the cowboy who roped the steer over a cliff, was, of course, Dan Gatlin, Stevens' foreman. Stevens' gambit of depositing five thousand dollars in the bank "to go to the man who killed the man who killed him" was a detail Wister much later made use of in "Little Old Scaffold," his grisly narrative of murder and political intrigue in the fictional community of O'Neil, Texas. Such topical references entirely aside, however, Remington's letter was remarkable for the intensity expressed in its spelling, punctuation, sketches—even its holography. The letter's first page ex-

hibited about as much restraint as the unconventional prose of Remington's letters usually did—but as the idea of "an article on the evolution of the puncher" possessed the artist, his enthusiasm obviously grew. Sentences disintegrated, words gave way to hasty sketches executed with the quickness of writing, order vanished altogether, leaving only the urgent injunction to "do it.—get a lot of ponies 'just a smokin' in it.' "

At Philadelphia, Wister caught Remington's enthusiasm but also felt confused about how to use it. If Remington felt at a loss for words, he merely drew a picture—which was easier for him than writing—but if Wister was to write an article, he needed facts and definitions. Specifically, he wanted to know how the horses with "great lung power & hoofs like iron" got into the New Mexico mountains, what a "cheyenne saddle" was, and whether—since Remington called Stevens' "mountain cow-boy" a "new type"—there was an older type from which he evolved. Before the end of October, Remington shot back the answers, beginning with Wister's question about the horses.

I wrote an article in "The Century"—The Horse of the Plains '87—I went into that—I cant find the article.—

Cortez had horses but they must have been all killed—subsequent importations—stolen and lost—the Sioux have a legend of the first horses —they were stolen from Mexico.—

"Cayuse"—a north western indian tribe who raised good horses—the term grew and is localized in the north west.—

"Mustang"—a California word for a steed.—much used by '49 but never established in use (out of story books) East of Mountains.—

"Broncho"—"wild" Spanish—means anything north of where the people don't understand Spanish.—

Cheyanne saddle—made in city of cheyenne from California models— are so called all over—there are many forms of California saddle & also Cheyenne. Are made in St. Louis I believe.

Mexican Tree—Dont know how [the cowboy] was affected by the Mex. war.—he did not exist as an American type—[illegible] was later a combination of the Kentucky or Tennessee man with the Spanish.

In Civil War he sold cattle to Confederate Armies—but was a soldier in Confed army

but as a pure thing he grew up to take the cattle through the Indian country from Texas to meet the R.R.—at Abilene—or before that even

he drove to Westport Landing—These were his palmy days—when he literly fought his right of way—he then drove to the north and stocked the ranges—then the thing colapsed and he turned "rustler"—and is now extinct except in the far away places of the Rocky Mountains.—Armor killed him.—Don't mistake the nice young men who amble around wire fences for the "wild rider of the Plains."—

And incidentally speak of that puncher who turned horse & cattle theif after the boom slumped and who was incidentally hung and who still lives and occasionally in the most delicate way goes out into the waste of land and ship theirs to Kansas City—after driving a great many miles to avoid livestock inspectors. &c &c

<div align="center">

F.R.
</div>

SOMETIME BETWEEN OCTOBER 20 AND OCTOBER 30, 1894

On the back page, Remington added another note:

Have a good start on a big oil (I couldn't monkey with it) on The Second Missouri [Compromise].—

Got a side face of Speciman [Jones]. I will fix him for all time—unless you give me a back view.

Who looks like this in life—

<div align="center">

F. R
</div>

"Fire and Sword" is the greatest book I ever read where Fallstaff says "I will die with my fleas"

The fact that the 1890s produced several books entitled *Fire and Sword* indicates something about the spirit of the decade, but the book Remington referred to was one written by a British colonel, R. Slatin; it described the author's adventures as a captive of the fierce Mahdi tribe in Sudan. "Falstaff" was a Sudanese chieftain named Hassan Bey Om

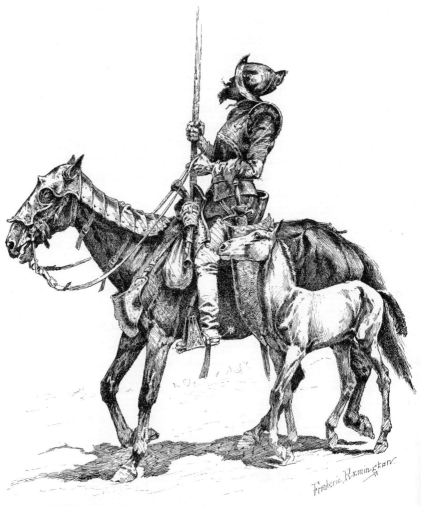

"The First of the Race." In a lively series of drawings Remington traced the American "bronco" to Barbary horses first brought to the continent by Spanish conquistadors.

Kadok, who resembled the Shakespearian character in his size and love for good living. The "big oil" was Remington's picture of Specimen Jones, which later went into Wister's story "The Second Missouri Compromise." Besides these details and the superbly suggestive sketches which graced its fifth page, Remington's letter contained two things of

great consequence to Wister. One was the idea of the cowboy as a distinct historical type that could be traced from a union of "the Kentucky or Tennessee man with the Spanish" in the early nineteenth century to "delicate" cattle rustlers of the present day. The other was the reference to "Horses of the Plains," Remington's essay on American "broncos."

"Horses of the Plains" appeared in the January *Century*, 1889—not 1887 as Remington remembered. But the shape "The Evolution of the Cow-puncher" finally took leaves no doubt about whether Wister found

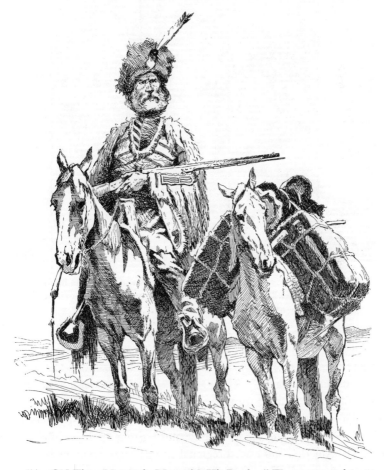

"An Old-Time Mountain Man with His Ponies." The most persistent quality of the "barb" was adaptability. It served as either mount or pack animal, in either hot or cold climates.

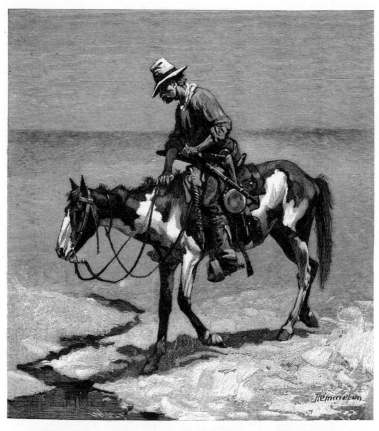

"A Texan Pony." Remington described this variety of the barb
as "hard to break, because he has any amount of latent devil in his
disposition"—and drew him accordingly.

Remington's essay and read it, for just as Remington's articles on the
Chicago riots of 1894 provided a historical framework for "The National
Guard of Pennsylvania," Remington's 1889 essay on horses showed
Wister the most suitable form for "The Evolution of the Cow-puncher."
Remington began with the discovery by Spaniards of the Barbary horse
in North Africa during the fifteenth century. From there, he followed the
"barb" to America and traced regional and genetic variations of the type
as they developed. The history related was interesting, but the essay's
truly significant feature was its way of handling the problem Wister him-
self wrestled with in 1894: how, in a narrative of the heroic past, to

regard the humdrum everyday of the present.

Wister believed that rioters, Populists, and anarchists could fundamentally change the United States from something he loved to something he was certain he would despise, for he regarded historical processes as truly "evolutionary" by ascribing to them the power to change one thing —nation, man, or even horse—into another. Yet the story told by Remington's illustrations for "Horses of the Plains" was quite different. The initial illustration, appropriately called "The First of the Race," showed a Barbary colt trotting beside its heavily armored dam, which bore a

"Spanish Horse of Northern Mexico"—an animal that resembled the Texan pony but was larger and stronger.

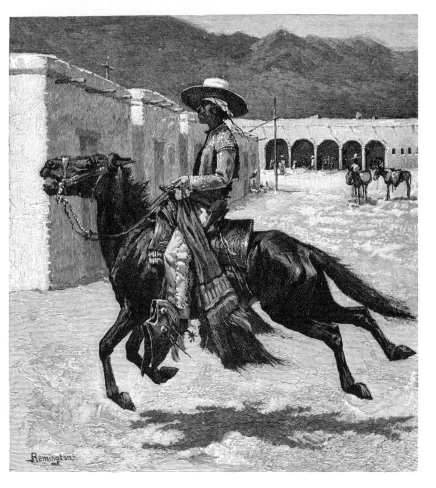

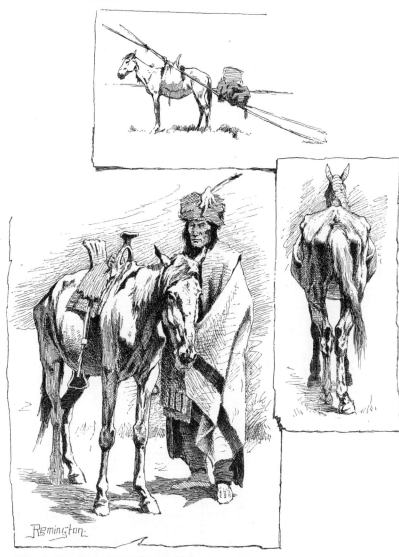

"The Indian Pony." Remington insisted that this was not a bronco type, but was transported from the East into Arkansas and Missouri. Of all American wild horses, it was the most easily domesticated.

Spanish conquistador. Then there were pictures of mountain men, cowboys, Indians, and Mexican vaqueros, all with types of the same animal. One full-page plate represented a herd of wild horses fighting off timber wolves. The point was the similarity all bore to "the first of the race."

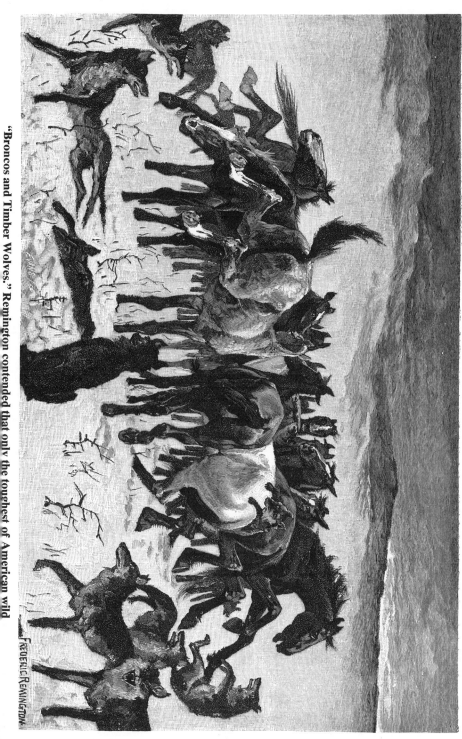

"Broncos and Timber Wolves." Remington contended that only the toughest of American wild

"A Bronco in Central Park," Remington's fanciful representation of how the wild horse might look trimmed and curried.

Wherever he went, whoever rode him there, the "barb" kept his "cat hams, ewe neck and thin little shoulders . . . for in his perversity he resisted the regenerating process."[18] The essay's thesis, then, was the *antithesis* of evolution, for the barb himself never changed at all. Remington's last picture of him, entitled "A Bronco in Central Park," showed the same Barbary horse, mane trimmed and tail cropped, bearing a bederbied New Yorker and his English saddle sedately down a bridle path. The message was impossible to miss: the horse of the plains was a creature whose adaptability enabled him to survive historical change untouched.

The text of Remington's essay conveyed the same idea. Commenting that "the golden age of the bronco was ended some twenty years ago when the great tidal wave of Saxonism reached his grassy plains," Remington conceded that the horse had been "brought under the yoke." Yet

he also insisted that "the act of subjugation was more implied than real," for "to this day . . . there is little difference between the wild horse of old and his enslaved progeny." Only the context changed. The bronco was still bronco—which meant mostly being tough enough to survive anything:

He graces the Western landscape, not because he reminds us of the equine ideal, but because he comes of the soil, and has borne the heat and burden and the vicissitudes of all that pale of romance which will cling about the Western frontier. . . . He has borne the Moor, the Spanish conqueror, the red Indian, the mountain man, and the vaquero through all the glories of their

"Cayuse," largest and strongest of the broncos, originating in the high valleys of the northern Rockies.

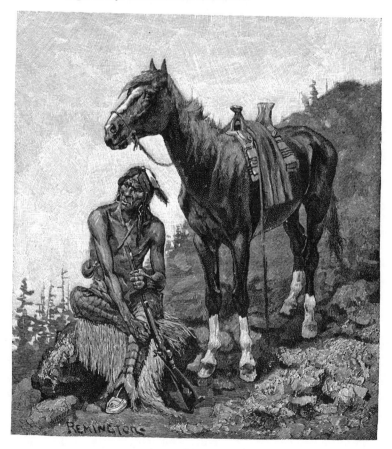

careers; but they will soon be gone, with all their heritage of gallant deeds. The pony must meekly enter the new regime. He must wear the collar of the new civilization and earn his oats by the sweat of his flank.[19]

Whatever Remington and Wister chose to call it, this was not evolution, for while Remington's essay admitted the power of historical events to change circumstances, it explicitly denied that history could change essences.

Furthermore, by denying history as a modifying force, it acquired precisely what Wister had been hunting for since 1892: a chronological sweep which showed how past, present, and future were all connected. If the Barbary horse could make its way from fifteenth-century Africa to modern New York City without losing more than the sand burs in its tail, then surely a "real" American should be able to survive the social changes of 1894—if he were just adaptable enough. Wister liked Remington's essay because it reassured him. Ironically, however, the essay in no way solved Wister's problem concerning the historical significance of the American West. Instead, it merely substituted an essentially romantic ideal of stasis for an evolutionary theory of history. By thus disposing of evolution altogether, it freed Wister to write "The Evolution of the Cowpuncher," at best a *mythical* history that groped toward the form Wister and Remington developed between them: a combination of contradictory elements which might be called *historical romance.*

While Wister began at Philadelphia to forge Remington's observations into an anti-evolutionary essay on "The Evolution," the Remingtons prepared for a Florida vacation. Shortly before leaving Remington used another piece of his leftover Auditorium Hotel stationery to send Wister some encouragement:

Great and rising demand for—a cowboy article.—"The Evolution & the Survival of the Cowboy" by O. Wister with 25 illustrations by the eminent artist, Fredrico Remintonio.*—just out.*
SEPTEMBER 1894

As usual, his sketch expressed far more than the perfunctory note that accompanied it. The comical figure on the rocking horse bore no resemblance to the rugged profile of the cowboy-turned-rustler "who was incidentally hung & who still lives," which Remington had included in his previous letter. Whereas the earlier sketch represented the cowboy "in life," this one deftly touched the heart of commercial publication about

Great & rising demand for — a cow-boy article — "The Evolution & the Survival of the Cow-boy" by O. Wister with 25 illustrations by the eminent artist Frederico Remintonio. — Just on.

the West by suggesting that it catered to rocking-chair cowboys.

The same note of self-parody was present in Remington's next letter, written from Jacksonville in January 1895.

My dear Wister—

Old lady has grip and we have detained here until Thursday morning when we go to Punta Gorda—where the festive tarpon monkeys and the quail and jacksnipe range.

We expect you. It is summer here—I have gotten my nerve back already.

<div align="right">

Yours faithfully

</div>

JANUARY 1895 *Frederic R——*

Another invitation in the same vein arrived at Philadelphia in February, promising "bear, tarpon, red snapper, ducks, birds of paradise" and even "curious cow boys who shoot up the rail road trains."

Wister, however, could not be budged. He had a big backlog of writing to be done and no money to spend on pleasure trips. On February 12, he wrote to his mother, who was vacationing in the South, explaining.

I don't suppose you have run across Remington in Florida. He writes me from Punta Gorda; but as I told you, he is not the sort of person you would find available to talk with. . . . I hope you will see him, for if he drops his nonsense he can be most interesting. I should rather like to come to Florida but do not at all think of it. Income, if no other reason, warns me to make no outlay in journeys that will not ultimately yield a return through writing, and I have all the writing I can possibly attend to without Florida.[20]

The writing most on his mind at the moment was "The Evolution." He got a start on the essay and sent a portion of it to Remington that same month, along with the news that he could not come to Florida himself.

Remington, meanwhile, was discovering to his surprise that cowboys survived not only in the New Mexico Rockies, but also on the dismal pine barrens of Florida. Yet the contrast between Montague Stevens' "Mountain cow boys" and these "crackers" was disappointing. The crackers were slovenly, drunken, dishonest, unromantic. They preferred shotguns to rifles or six-shooters, used military saddles instead of the

western type, wore ungainly farmer's shoes instead of boots, and carried no lariat. All in all, Remington found them "revolting," for they retained none of the romance "which used to characterize the easy days in West Texas and New Mexico, when every man tossed his life away to the crackle of his own revolver."[21] Here, if anywhere, was a chance for Remington to show that he was interested in understanding an evolutionary process. These cowboys were *different* from any he had seen before. The obvious question was *why*? Yet Remington was clearly not interested in evolution at all. Instead, he was interested in the romance of a single type, the type he encountered in the West. Therefore, although he called the crackers "cowboys," he dismissed them as insignificant. Comparing them with their western counterparts, he noted that "while some of the tail feathers were the same, they would easily classify as new birds."[22]

The closest Remington came to explaining the crackers was his observation that they seemed to blend in with their "sad" environment, "truly not a country for a high spirited race or moral giants." Conversely, Wister noted in "The Evolution" that the western cowpuncher was "no new type, no product of the frontier, but just the original kernel of the nut with the shell broken."[23] The statement directly repudiated Wister's earlier efforts to define "real Americans" and pinpoint the moment of their transformation from Europeans. Furthermore, it accurately reflected the tenor of "The Evolution." Since the assumptions which informed this new tack in Wister's thinking came directly from Remington, the painter was pleased with the portion of "The Evolution" Wister sent him to read in February. Returning the manuscript, he urged Wister to continue:

My dear Wis—

Sorry you can't come—I am like a sixteen year old school girl now. The "cow boys" are all right. Tell of the settlement and decline of the cattle business and of the survival—such as we find it in the mountains.

There is a man down on this neck of land who owns 90,000 head of cattle—but that's another story.—

Mrs. R. wishes you were coming & sends regards.

Yours

FEBRUARY 1895 *Frederic R.*

By calling Florida ranching "another story," Remington suggested the romantic integrity of his vision. By urging Wister to write about the

"decline of the cattle business" and "the survival" of the cowboy, he designated that vision's central feature—the same feature expressed in his description of the puncher as one who "was incidentally hung & . . . still lives": the cowboy's connection with raising cattle was a historical accident of little consequence, but his heroic affinity for action defined him in much the same way as "cat hams, ewe neck and thin little shoulders" defined the Barbary horse.

February 20, 1895, found Remington home at New Rochelle, eager to see more of Wister's essay. His own first book, a collection of illustrated essays called *Pony Tracks*, was in preparation, and his impatience to have "The Evolution" finished steadily grew. As his dismissal of the Florida cowboys clearly showed, his vision of the West resembled Wister's in certain of its romantic tendencies, but the elegiac tone that crept into much of Wister's writing still worried him:

My dear Wister—
 Back again—where its warm. No tarpon—good shooting and all well.
 When will you have in the rest of your cow-boy article? Don't forget to tell about the survival *of the fittest 'way down in the back reaches of New Mexico and Arizona.*

 Yours
FEBRUARY 20, 1895 *Frederic*

In order to satisfy Remington, the article had to contain an optimistic sense of continuity. "Survival of the fittest" was the single aspect of evolutionary theory that made any sense to him, for it was the only one that justified his heroic ideal. As he put it elsewhere, "one can thresh the straw of history until he is well worn out."[24] Only when the past said something about the present did studying it become worthwhile.

Shortly after receiving Remington's note of February 20, Wister sent a completed draft of "The Evolution" to New Rochelle for approval. It was a curious document, incorporating large chunks of information from several sources. The "slumbering untamed Saxon" Wister posited as the cowboy's ancestor came straight from the pages of Sir Walter Scott. Wister's comments on the "hordes of encroaching alien vermin" he felt were turning "our citizenship into a hybrid farce" were derived from his own worries about contemporary American civilization. The notion of the cowboy as prodigal was left over from "How Lin McLean

Portrait of Owen Wister, age thirty-five.

Went East." Recognition that the West was at present "beneath the notice of polite writers" clearly recalled E. S. Martin's comment of the year before in *Harper's Weekly*. Details of ranch life came directly from Remington's description of Stevens' SU ranch. The essay's framework, which traced the cowboy back to fighting "Saxon ancestors" and finally concluded about him that "he has never made a good citizen, but only a good soldier," was doubtless suggested by "Horses of the Plains." Remington liked it as a whole, for it handled a subject he was interested in, but he also criticized some of its parts:

Dear Wistie—

I send back M.S.—Its all right. Tell me when you present it [to Alden] I want cavalry charge.

I think "chaps" comes from "chaparajos"—what that came from d—— if I know.

Strikes me there is a good deal of English in the thing—I never saw an English cow-boy—have seen owners.—

you want to credit the Mexican with the inventing [of] the whole business—he was the majority of the "boys who first ran the steers to Abiline Kansas.—

I have just written article on "Cracker Cow Boys of Florida" [for Harper's] Weekly—

<div align="right">

yours

Frederic R.
</div>

FEBRUARY 1895

What Remington wanted most at the moment was to have the essay finished and submitted to Alden so that illustrations could be assigned. He became increasingly impatient with Wister for fussing over details like the origins of terms.

Yet Wister remained uncertain about "The Evolution." Because the piece was rather long, he wondered whether he should send it to *Harper's Weekly* or *Harper's Monthly*. Doubtless aware of the essay's conglomerate nature, he wanted time to polish it. Remington, meanwhile, was trying his hand for the first time at sculpting, working enthusiastically on the clay model from which his first bronze, "The Bronco Buster," would be cast. His reply to Wister's hesitant questions was friendly but contained a sarcastic note that expressed annoyance:

My dear Wistie.—

I want the "essay" for the Magazine—of course—My Florida article is in the Weekly.

No particular hurry about sending it in only would like it as soon as you can without throwing a spasm.

The article is all right—I would make more scenes and less essay— if you can see your way to do it. Make more of the 14 men and the maverick &c.

You just ought to see the "great model" I am making. Its a "lolle."

<div align="center">

yours

Frederic R.

</div>

SOMETIME BETWEEN FEBRUARY 25 AND FEBRUARY 28, 1895

Wister was still the historian who wanted to produce a perfect work. Remington, as his letters increasingly showed, was in a hurry to get on to something else.

At the end of 1893 Wister had given thanks for "the beginnings of a success that I pray the power be granted me to make more worthy."[25] Now, in 1895, he found the pursuit of such success a burden. Although his first collection of short western fiction, *Red Men and White*, would appear in November, in March he still called his writing "dull and feeble."[26] At the same time, he wrote to his mother, "I am finishing a sensational comic story, having finished an essay on cowboys and intending to begin too on Offenbach and Wagner." There was something calvinistic in Wister's aspirations to be "more worthy" of success, something compulsive in the way he drove himself from one project to another. These traits were in themselves annoying to Remington, who prized spontaneity and hated weakness—but early in March, Wister did something that annoyed Remington even more: he lost his manuscript of "The Evolution." The tongue-lashing Remington subsequently administered was a masterpiece:

Dear Wister—

Well you are a Derby winner—you ought to get a small cheap man with just ordinary good sense to act as your guardian—some fellow to kind of look out and see that you don't starve to death in a resteraunt or go to bed with your hat on—little precautions which are usual for

persons to take.

I hope you find the M.S. but you had better watch out or you'll have a jury of lunacy sitting on your spine.

Some fellow will paint a liver pill sign on your back if you are not more alert.

My "Cracker Cow Boys" went into the Magazine.

<div style="text-align:center">*yours*</div>

MARCH 1895 *Frederic R.*

The letter had an edge, but its bantering tone rendered it harmless. Indeed, when Wister found his manuscript of "The Evolution" several days later, he still delayed sending it to Alden, for he wanted to examine it again and was now busy writing a poem for *The Atlantic* in memory of Robert Louis Stevenson, who had died late in 1894.

Wister's reply, therefore, contained only news of another delay. Probably, it also responded in kind to Remington's bantering criticism, for

Frederic Remington painting in his studio at New Rochelle, probably about 1895, when his reputation was already established.

Remington's answer of March 9 carried on the mock feud:

My dear Wister—
 I am to attend a dinner on the night of the 13th in Philadelphia—by the Nameless Club—an art club as they say. Wish you were invited— rustle around and get an invitation.
 Go ahead with your d—— Epic poem—My model is said by competent judges to be immortal.—Your sneers will live to haunt you.—
 When oh when is the cow-boy to come.
<div align="right">*Yours*</div>

MARCH 9, 1895 *Frederic Remington*

The banter aside, Wister was anxious to see Remington, probably to talk about "The Evolution." Accordingly, he asked by return post where Remington would lodge in Philadelphia. Remington replied that his own well-known love for food and drink might make a business conference difficult.

Dear Wister—
 Dont know what hotel—will try Bellvue—Thursday I shall be under a Doctor's care—but you can come in and look at the remains before they are shipped back to New York for burial
<div align="right">*Yours truly*</div>

MARCH 11, 1895 *Frederic Remington*

Remington did stay at the Bellvue and did see Wister on the fourteenth. Whether or not that conference was fruitful, the two men spent several days together at New Rochelle the next month, when "The Evolution" comprised a major topic of their conversation.
 Remington drew, painted, sculpted, and wrote at a furious pace through the summer that followed. Wister departed at the end of April for an extended tour into the West, reflecting as he set out on the fact that a decade had passed since he first saw the Big Horn Basin:

I went west that July day to cure a headache I had waked and slept with since February; I was very near despair—I hope what my cup still holds

for me may not be in any part of that bitterness I knew between 1883 and 1885 . . . I am a wholesomer creature today—but—deliver us from evil! . . . No longer for headaches but material and to see men whom I regard [do I journey] in that country.[27]

Fourteen of his western stories had been printed by *Harper's Monthly* as well as numerous essays and poems in *Harper's* and elsewhere. At the end of summer, however, he was still restive. From Fort Logan, Colorado, a "well kept surburb of Denver" which he found "utterly commonplace," he wrote that he dreaded return to the East and the grind of writing. "Damn material hunting!" he exclaimed; "I'm filled and sick with it!"[28] Before he arrived home at Philadelphia, Wister told Remington that others might make a success of writing, but he was unsure whether he ever would. Still, he resolved to continue trying and requested a conference with Remington to talk about possible uses for the information he gathered on his western tour.

Remington, who had meanwhile finished his "mud" of "The Bronco Buster" and had discussed "The Evolution" and its illustrations with Henry Alden, replied elatedly from New Rochelle.

My dear Wistie—

You ought to strike Phila—more often in your orbit—you are a d—— eccentric commet—

Yes pleas Mister you may come next Sunday. I "charged" on the "Evolution" & the enemy broke before every forward movement. They did not wait for the "shock action" but pulled immediately when they heard my bugles—I captured 5 pages [of illustrations]—& Wister if we can't lug you into the immortal band with 5 pages you had better turn lawyer & done with it—

I want you to see my model—I am afraid it will be cut up this week—

You talk about fellows who have arrived—all they have got to do is keep my name in stereotype in printer's cases—they will have to use it right along because if my model wont do I am going to be the most eminent market gardner in the suburbs of New York

<div align="right">

Yours

Frederic R.

</div>

SOMETIME BETWEEN AUGUST 18 AND AUGUST 22, 1895

On August 19, Wister was home. On the twenty-fourth, he saw Remington at New Rochelle. The evening of the twenty-fifth found him back at Philadelphia eagerly pouring over "The Evolution of the Cow-puncher" in the new *Harper's Monthly.*

Besides marking the culmination of a two-year effort, the essay's publication marked the beginning of a new phase in Wister's career. As he wrote to Remington in a flush of excitement, Wister also suggested both the way he had come and the way he was going:

Dear Remington:

Home again and fresh from the September Harper. I want to say at once that nothing I know of yours seems to reach what you have done this time. And other people seem as enthusiastic as I am. The last Cavalier, though it brought tears very nearly to my eyes, is not quite so good as you intended not quite so good as its idea: I'm not sure the idea can be adequately stated short of a big canvas—but What an unbranded cow has done is not only vast, but states itself utterly. It struck me dumb. So much has never before been put on any page of Harper—that I've seen anyhow. The level of the whole five is up in the air—away up. To me personally, The Last Cavalier comes home hardest, and I love it & look at it—It's so very sad and so very near my private heart. But you must do it again—you must get that idea expressed with the same perfection that the unbranded cow is done with. Then we shall have a poem much better and much more national than Hiawatha or Evangeline. There ought to be music for The Last Cavalier—Only you wouldn't understand it.

I have done nothing except note and think. Now I'm ready to go ahead with a lot of things. But The Last Cavalier will haunt me forever. He inhabits a Past into which I withdraw and mourn. In a measure there is compensation. for the Lime Light glares no longer, nor the noon sun— But the shadows are long, and a veil of twilight makes the figures tender as they move across the hills.

> *Yours sincerely*
> *Owen Wister*

AUGUST 25, 1895

It was not surprising that Wister should like "The Last Cavalier," for it beautifully expressed the tenor of his essay. "The Evolution" argued

that the most important factor in defining the cowboy was neither what he did for a living nor his location in time or space; it was his *spirit*. Remington's picture of a lean figure riding his pony across a shadowy background of armored knights, plumed gentry, and bearded mountain men represented the spirit more attractively than Wister's prose. And just as there was an odd dislocation of meaning between the substance of Wister's essay and its title, the title assigned to Remington's picture served it in a most peculiar fashion. Wister's essay purported to concern the development of a type, but in fact stated that the type never underwent development. Likewise, Remington's picture clearly represented the process of a continuity—yet its title paradoxically suggested a termination. The picture showed what happened when Remington and Wister tried to work together, for Remington was at his best with continuous actions, Wister with unchanging concepts. Although "The Last Cavalier" had to be called "last" in order to generate the romantic feeling Wister mentioned in his letter, it obviously represented, not the last, but the latest avatar of a type anything but terminal.

A better example of Remington's talent was "What an Unbranded Cow Has Cost," the other picture Wister mentioned. In this work the distant hills and opaque sky stated the same insoluble riddle that stared out of "The Horse Trade." It contrasted sharply with "The Last Cavalier," where eliminating the skyline altogether translated inexplicable space into accomplished time—which Wister in turn regarded as "a Past into which I withdraw and mourn." Wister was clearly attracted to "What an Unbranded Cow Has Cost," but by stating the retrospective turn of mind that made him see "The Last Cavalier" as a termination, he also reaffirmed his initial desire to explain the West as history. Therefore, he found himself back where he started: the language of the hills that looked like "grass grown books" still eluded him. Remington's mocking skylines still attracted his eye and defied his intellect. With "The Evolution" finally completed, he was ready to pursue his old concern with new vigor.

The Evolution of the Cow-Puncher
by Owen Wister

TWO men sat opposite me once, despising each other so heartily that I am unlikely to forget them. They had never met before—if they can be said to have met this time—and they were both unknown to me. It happened in a train by which we journeyed together from Leamington to London. The cause of their mutual disesteem was appearance; neither liked the other's outward man, and told him so silently for three hours; that is all they ever knew of each other. This object-lesson afterward gained greatly by my learning the name and estate of one of these gentlemen. He was a peer. He had good rugs, a good umbrella, several newspapers—but read only the pink one,—and a leather and silver thing which I took to be a traveling-bag beside him. He opened it between Banbury and Oxford, and I saw, not handkerchiefs and ivory, but cut-glass bottles with stoppers. I noticed further the strong sumptuous monogram engraved here and there. The peer leisurely took brandy, and was not aware of our presence. But the point of him is that he garnished those miles of railroad with incomparably greater comfort than we did who had no rugs, no cut glass, no sandwich-box, no monogram. He had understood life's upholstery and trappings for several hundred years, getting the best to be had in each generation of his noble descent.

The enemy that he had made, as a dog makes an enemy of a cat by the mere preliminary of being a dog, sat in the other corner. He wore a shiny silk hat, smooth new lean black trousers, with high boots stiff and swelling to stove-pipe symmetry beneath, and a tie devoid of interest. I did not ascertain if the pistol was in his hip pocket, but at stated intervals he spit out of his window. By his hawk nose and eye and the lank strength of his chin he was a male who could take care of himself, and had done so. One could be sure he had wrested success from this world somehow, somewhere; and here he was, in a first-class carriage, on a first-class train, come for a first-class time, with a mind as complacently shut against being taught by foreign travel as any American patriot of to-day can attain or recommend, or any Englishman can reveal in his ten-day book about our continent and people. Charles Dickens and Mark Twain have immortalized their own blindness almost equally; and the sad truth is that enlightenment is mostly a stay-at-home creature, who crosses neither ocean nor

frontier. This stranger was of course going to have a bad time, and feel relieved to get home and tell of the absence of baggage-checks and of the effete despot who had not set up the drinks. Once he addressed the despot, who was serenely smoking.

"I'll trouble you for a light," said he; and in his drawl I heard plainly his poor opinion of feudalism.

His lordship returned the drawl—not audibly, but with his eye, which he ran slowly up and down the stranger. His was the Piccadilly drawl; the other made use of the trans-Missouri variety; and both these are at bottom one and the same—the Anglo-Saxon's note of eternal contempt for whatever lies outside the beat of his personal experience. So I took an observation of these two Anglo-Saxons drawling at each other across the prejudice of a hundred years, and I thought it might come to a row. For the American was, on the quiet face of him, a "bad man," and so, to any save the provincial eye, was the nobleman. Fine feathers had deceived trans-Missouri, whose list of "bad men" was limited to specimens of the cut of his own jib, who know nothing of cut-glass bottles. But John gave Jonathan the light he asked, and for the remainder of our journey ceased to know that such a person existed.

Though we three never met again, my object-lesson did not end when we parted at Paddington. Before many seasons were sped the fortunes of the nobleman took a turn for the scandalous. He left cut glass behind him and went to Texas. I wish I could veraciously tell that he saw the stranger there—the traveller between whose bird-of-freedom nostrils and the wind his luxurious nobility had passed so offensively. But I do know that his second and more general skirmish with democracy left both sides amicable. In fact, the nobleman won the Western heart forthwith. Took it by surprise: democracy had read in the papers so often about the despot and his effeteness. This despot vaulted into the saddle and stuck to the remarkably ingenious ponies that had been chosen with care to disconcert him. When they showed him pistols, he was found to be already acquainted with that weapon. He quickly learned how to rope a steer. The card habit ran in his noble blood as it did in the cowboy's. He could sleep on the ground and rough it with the best of them, and with the best of them he could drink and help make a town clamorous. Deep in him lay virtues and vices coarse and elemental as theirs. Doubtless the windows of St. James Street sometimes opened in his memory, and he looked into them and desired to speak with those whom he saw inside. And the whiskey was not like the old stuff in the cut-glass bottles; but he never said so; and in time he died, widely esteemed. Texas found no count against him save his pronunciation of such words as bath and fancy—a misfortune laid to the accident of his birth; and you will hear to-day in that flannel-shirted democracy only good concerning this aristocrat born and bred.

Now, besides several morals which no pious person will find difficult to draw

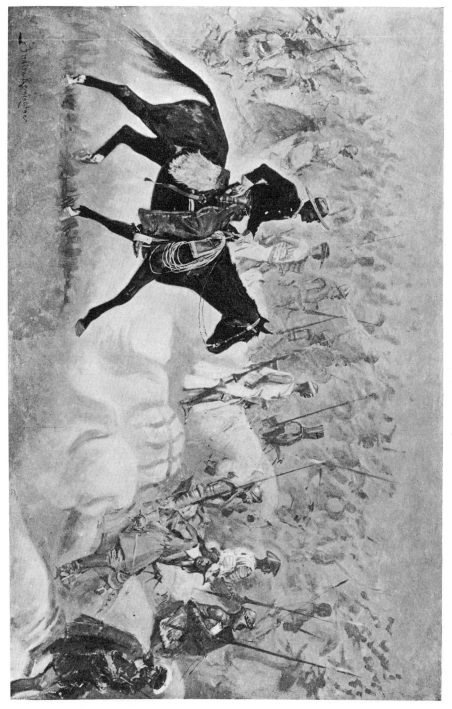

from the decline and fall of this aristocrat, there is something more germane to my democratic contemplation: after all, when driven to flock with Texas, he was a bird of that wild feather. That is the object-lesson; that is the gist of the matter. Directly the English nobleman smelt Texas, the slumbering untamed Saxon awoke in him, and mindful of the tournament, mindful of the hunting-field, galloped howling after wild cattle, a born horseman, a perfect athlete, and spite of the peerage and gules and argent, fundamentally kin with the drifting vagabonds who swore and galloped by his side. The man's outcome typifies the way of his race from the beginning. Hundreds like him have gone to Australia, Canada, India, and have done likewise, and in our own continent you may see the thing plainer than anywhere else. No rood of modern ground is more debased and mongrel with its hordes of encroaching alien vermin, that turn our cities to Babels and our citizenship to a hybrid farce, who degrade our commonwealth from a nation into something half pawn-shop, half broker's office. But to survive in the clean cattle country requires spirit of adventure, courage, and self-sufficiency; you will not find many Poles or Huns or Russian Jews in that district; it stands as yet untainted by the benevolence of Baron Hirsch. Even in the cattle country the respectable Swedes settle chiefly to farming, and are seldom horsemen. The community of which the aristocrat appropriately made one speaks English. The Frenchman to-day is seen at his best inside a house; he can paint and he can play comedy, but he seldom climbs a new mountain. The Italian has forgotten Columbus, and sells fruit. Among the Spaniards and the Portuguese no Cortez or Magellan is found to-day. Except in Prussia, the Teuton is too often a tame, slippered animal, with his pedantic mind swaddled in a dressing-gown. But the Anglo-Saxon is still forever homesick for out-of-doors.

Throughout his career it has been his love to push further into the wilderness, and his fate thereby to serve larger causes than his own. In following his native bent he furthers unwittingly a design outside himself; he cuts the way for the common law and self-government, and new creeds, polities, and nations arise in his wake; in his own immense commonwealth this planless rover is obliterated. Roving took him (the Viking portion of him) from his Norse crags across to Albion. From that hearth of Albion the footprints of his sons lead to the corners of the earth; beside that hearth how inveterate remains his flavor! At Hastings he tasted defeat, but was not vanquished; to the Invincible Armada he proved a grievous surprise; one way or another he came through Waterloo—possibly because he is inveterately dull at perceiving himself beaten; when not otherwise busy at Balaklava or by the Alma, he was getting up horse-races, ready for sport or killing, and all with that silver and cut-glass finish which so offends our whistling, vacant-minded democracy. Greatest triumph and glory of all, because spiritual, his shoulders bore the Reformation when its own originators had tottered. Away from the hearth the cut-glass stage will not generally have been attained by him, and in Maine or Kentucky you can recognize at sight

the chip of the old rough block. But if you meet him upon his island, in the shape of a peer, and find him particular to dress for dinner seven days of the week, do not on that account imagine that his white tie has throttled the man in him. That is a whistling Fourth-of-July misconception. It's no symptom of patriotism to be unable to see a man through cut glass, and if it comes to an appraisement of the stranger and the peer, I should say, put each in the other's place, and let us see if the stranger could play the peer as completely as the nobleman played the cowboy. Sir Francis Drake was such a one; and Raleigh, the fine essence of Anglo-Saxon, with his fashionable gallant cloak, his adventure upon new seas, and his immediate appreciation of tobacco. The rover may return with looted treasure or incidentally stolen corners of territory to clap in his strong-box (this Angle is no angel), but it is not the dollars that played first fiddle with him, else our Hebrew friends would pioneer the whole of us. Adventure, to be out-of-doors, to find some new place far away from the postman, to enjoy independence of spirit or mind or body (according to his high or low standards)—this is the cardinal surviving fittest instinct that makes the Saxon through the centuries conqueror, invader, navigator, buccaneer, explorer, colonist, tiger-shooter; lifts him a pilgrim among the immortals at Plymouth Rock, dangles him a pirate from the gallows on the docks of Bristol. At all times when historic conditions or private stress have burst his domestic crust and let him fly out naturally, there he is, on Darien's peak, or through Magellan, or across the Missouri, or up the Columbia, a Hawkins, a Boone, a Grey, or a nameless vagrant, the same Saxon, ploughing the seas and carving the forests in every shape of man, from preacher to thief, and in each shape changelessly untamed. And as he has ruled the waves with his ship from that Viking time until yesterday at Samoa, when approaching death could extract no sound from him save American cheers and music, so upon land has the horse been his foster-brother, his ally, his playfellow, from the tournament at Camelot to the round-up at Abilene. The blood and the sweat of his jousting, and all the dirt and stains, have faded in the long sunlight of tradition, and in the chronicles of romance we hear none of his curses or obscenity; the clash of his armor rings mellow and heroic down the ages into our modern ears. But his direct lineal offspring among our Western mountains has had no poet to connect him with the eternal, no distance to lend him enchantment; though he has fought single-handed with savages, and through skill and daring prevailed, though he has made his nightly bed in a thousand miles of snow and loneliness, he has not, and never will have, the ''consecration of memory.'' No doubt Sir Launcelot bore himself with a grace and breeding of which our unpolished fellow of the cattle trail has only the latent possibility; but in personal daring and in skill as to the horse, the knight and the cowboy are nothing but the same Saxon of different environments, the nobleman in London and the nobleman in Texas; and no hoof in Sir Thomas Mallory shakes the crumbling plains with quadruped sound more valiant than

the galloping that has echoed from the Rio Grande to the Big Horn Mountains. But we have no Sir Thomas Mallory! Since Hawthorne, Longfellow, and Cooper were taken from us, our flippant and impoverished imagination has ceased to be national, and the rider among Indians and cattle, the frontiersman, the American who replaces Miles Standish and the Pathfinder, is now beneath the notice of polite writers.

From the tournament to the round-up! Deprive the Saxon of his horse, and put him to forest-clearing or in a counting-house for a couple of generations, and you may pass him by without ever seeing that his legs are designed for the gripping of saddles. Our first hundred years afforded his horsemanship but little opportunity. Though his out-of-door spirit, most at home when at large, sported free in the elbow-room granted by the surrender of Cornwallis, it was on foot and with an axe that he chiefly enjoyed himself. He moved his log cabin slowly inward from the Atlantic, slowly over the wooded knolls of Cumberland and Allegheny, down and across the valley beyond, until the infrequent news of him ceased, and his kinsfolk who had staid by the sea, and were merchanting themselves upwards to the level of family portraits and the cut-glass finish, forgot that the prodigal in the backwoods belonged to them, and was part of their United States, bone of their bone. And thus did our wide country become as a man whose East hand knoweth not what his West hand doeth.

Mr. Herndon, in telling of Lincoln's early days in Illinois, gives us a complete picture of the roving Saxon upon our continent in 1830. "The boys were a terror to the entire region—seemingly a necessary product of frontier civilization. They were friendly and good-natured. . . . They would do almost anything for sport or fun, love or necessity. Though rude and rough, though life's forces ran over the edge of their bowl, foaming and sparkling in pure deviltry for deviltry's sake, . . . yet place before them a poor man who needed their aid, . . . a defenseless woman, . . . they melted into sympathy and charity at once. They gave all they had, and willingly toiled or played cards for more. A stranger's introduction was likely to be the most unpleasant part of his acquaintance. . . . They were in the habit of 'cleaning out' New Salem." Friendly and good-natured, and in the habit of cleaning out New Salem! Quite so. There you have him. Here is the American variety of the Saxon set down for you as accurately as if Audubon himself had done it. A colored plate of Robin Hood and the Sheriff of Nottingham should go on the opposite page. Nothing but the horse is left out of the description, and that is because the Saxon and his horse seldom met during the rail-splitting era of our growth. But the man of 1830 would give away all that he had and play cards for more. Decidedly nothing was missing except the horse—and the horse was waiting in another part of our large map until the man should arrive and jump on his back again.

A few words about this horse—the horse of the plains. Whether or no his forefathers looked on when Montezuma fell, they certainly hailed from Spain.

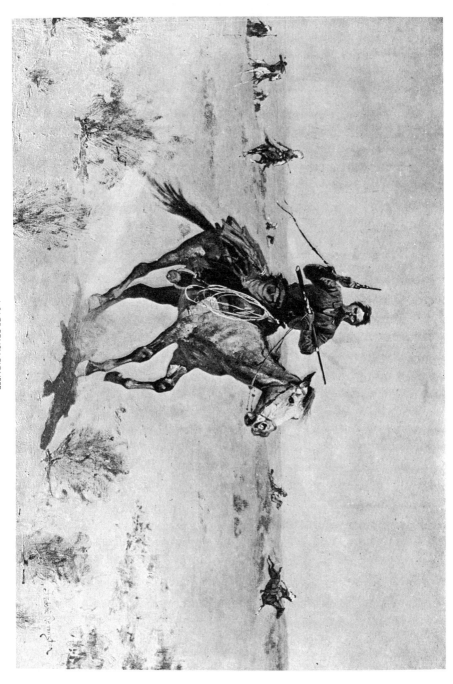

A SAGE-BRUSH PIONEER

And whether it was missionaries or thieves who carried them northward from Mexico, until the Sioux heard of the new animal, certain it also is that this pony ran wild for a century or two, either alone or with various red-skinned owners; and as he gathered the sundry experiences of war and peace, of being stolen, and of being abandoned in the snow at inconvenient distances from home, of being ridden by two women and a baby at once, and of being eaten by a bear, his wide range of contretemps brought him a wit sharper than the street Arab's, and an attitude towards life more blasé than in the united capitals of Europe. I have frequently caught him watching me with an eye of such sardonic depreciation that I felt it quite vain to attempt any hiding from him of my incompetence; and as for surprising him, a locomotive cannot do it, for I have tried this. He relishes putting a man in absurd positions, and will wait many days in patience to compass this uncharitable thing; and when he cannot bring a man to derision, he contents himself with a steer or a buffalo, helping the man to rope and throw these animals with an ingenuity surpassing any circus, to my thinking. A number of delighted passengers on the Kansas Pacific Railway passed by a Mexican vaquero, who had been sent out from Kansas City to rope a buffalo as an advertisement for the stock-yards. The train stopped to take a look at the solitary horseman fast to a buffalo in the midst of the plains. José, who had his bull safely roped, shouted to ask if they had water on the train. "We'll bring you some," said they. "Oh, I come get," said he; and jumping off, he left his accomplished pony in sole charge of the buffalo. Whenever the huge beast struggled for freedom, the clever pony stiffened his legs and leaned back as in a tug of war, by jumps and dodges so anticipating each move of the enemy that escape was entirely hopeless. The boy got his drink, and his employer sent out a car for the buffalo, which was taken in triumph into Kansas City behind the passenger train. The Mexican narrated the exploit to his employer thus: "Oh, Shirley, when the train start they all give three greata big cheers for me, and then they give three mucha bigger cheers for the little gray hoss!"

Ah, progress is truly a wonder! and admirable beyond all doubt it is to behold the rapid new square miles of brick, and the stream rich with the contributions of an increased population, and tall factories that have stopped dividends just for the present, and long empty railroads in the hands of the receiver; but I prefer that unenlightened day when we had plenty of money and cheered for the little gray hoss. Such was the animal that awaited the coming of the rail-splitter. The meeting was a long way off in 1830. Not the Mexican war, not the gold on the Pacific in '49 (though this, except for the horse, revealed the whole Saxon at his best and worst, and for a brief and beautiful moment waked once more the American muse), not any national event until the war of the rebellion was over and we had a railroad from coast to coast, brought the man and his horse together. It was in the late sixties that this happened in Texas. The adventurous sons of Kentucky and Tennessee, forever following the native bent to roam,

and having no longer a war to give them the life they preferred, came into a new country full of grass and cattle. Here they found Mexicans by the hundred, all on horses and at large over the flat of the world. This sight must have stirred memories in the rail-splitter's blood, for he joined the sport upon the instant. I do not think he rode with bolder skill than the Mexican's, but he brought other and grittier qualities to bear upon that wild life, and also the Saxon contempt for the foreigner. Soon he had taken what was good from this small, deceitful alien, including his name, *Vaquero,* which he translated into Cowboy. He took his saddle, his bridle, his spurs, his rope, his methods of branding and herding—indeed, most of his customs and accoutrements—and with them he went rioting over the hills. His play-ground was two thousand miles long and a thousand wide. The hoofs of his horse were tough as iron, and the pony waged the joyous battle of self-preservation as stoutly as did his rider. When the man lay rolled in his blankets sleeping, warm and unconcerned beneath a driving storm of snow, the beast pawed through to the sage-brush and subsisted; so that it came to be said of such an animal, "A meal a day is enough for a man who gets to ride that horse."

The cow-puncher's play-ground in those first glorious days of his prosperity included battle and murder and sudden death as every-day matters. From 1865 to 1878 in Texas he fought his way with knife and gun, and any hour of the twenty-four might see him flattened behind the rocks among the whiz of bullets and the flight of arrows, or dragged bloody and folded together from some adobe hovel. Seventy-five dollars a month and absolute health and strength were his wages; and when the news of all this excellence drifted from Texas eastward, they came in shoals—Saxon boys of picked courage (none but plucky ones could survive) from South and North, from town and country. Every sort and degree of home tradition came with them from their far birthplaces. Some had known the evening hymn at one time, others could remember no parent or teacher earlier than the street; some spoke with the gentle accent of Virginia, others in the dialect of baked beans and codfish; here and there was the baccalaureate, already beginning to forget his Greek alphabet, but still able to repeat the two notable words with which Xenophon always marches upon the next stage of his journey. Hither to the cattle country they flocked from forty kinds of home, each bringing a deadly weapon.

What motlier tribe, what heap of cards shuffled from more various unmatched packs, could be found? Yet this tribe did not remain motley, but soon grew into a unit. To begin with, the old spirit burned alike in all, the unextinguished fire of adventure and independence. And then, the same stress of shifting for self, the same vigorous and peculiar habits of life, were forced upon each one: watching for Indians, guarding huge herds at night, chasing cattle, wild as deer, over rocks and counties, sleeping in the dust and waking in the snow, cooking in the open, swimming the swollen rivers. Such gymnasium for mind and body

develops a like pattern in the unlike. Thus, late in the nineteenth century, was the race once again subjected to battles and darkness, rain and shine, to the fierceness and generosity of the desert. Destiny tried her latest experiment upon the Saxon, and plucking him from the library, the haystack, and the gutter, set him upon his horse; then it was that, face to face with the eternal simplicity of death, his modern guise fell away and showed once again the mediæval man. It was no new type, no product of the frontier, but just the original kernel of the nut with the shell broken.

This bottom bond of race unified the divers young men, who came riding from various points of the compass, speaking university and gutter English simultaneously; and as the knights of Camelot prized their armor and were particular about their swords, so these dusty successors had an extreme pride of equipment, and put aside their jeans and New York suits for the tribal dress. Though each particle of gearing for man and horse was evoked from daily necessity, gold and silver instantly stepped in to play their customary ornamental part, as with all primitive races. The cow-puncher's legs must be fended from the thorny miles of the Rio Grande, the thousand mongrel shrubs that lace their bristles together stiff over the country—the mesquite, the shin-oak, the cat's claw, the Spanish-dagger; widespreading, from six inches to ten feet high, every vegetable vicious with an embroidery of teeth and nails; a continent of peevish thicket called *chaparral,* as we indiscriminately call a dog with too many sorts of grandfathers a cur. Into this saw-mill dives the wild steer through paths and passages known to himself, and after him the pursuing man must also dive at a rate that would tear his flesh to ribbons if the blades and points could get hold of him. But he cases his leg against the hostile *chaparral* from thigh to ankle in chaps—leathern breeches, next door to armor; his daily bread is scarcely more needful to him. Soon his barbaric pleasure in finery sews tough leather fringe along their sides, and the leather flap of the pocket becomes stamped with a heavy rose. Sagging in a slant upon his hips leans his leather belt of cartridges buckled with jaunty arrogance, and though he uses his pistol with murderous skill, it is pretty, with ivory or mother-of-pearl for a handle. His arm must be loose to swing his looped rope free and drop its noose over the neck of the animal that bounds in front of his rushing pony. Therefore he rides in a loose flannel shirt that will not cramp him as he whirls the coils; but the handkerchief knotted at his throat, though it is there to prevent sunburn, will in time of prosperity be chosen for its color and soft texture, a scarf to draw the eye of woman. His heavy splendid saddle is, in its shape and luxury of straps and leather thongs, the completest instrument for night and day travel, and the freighting along with you of board and lodging, that any nomad has so far devised. With its trappings and stamped leather, its horn and high cantle, we are well acquainted. It must stand the strain of eight hundred sudden pounds of live beef tearing at it for freedom; it must be the anchor that shall not drag

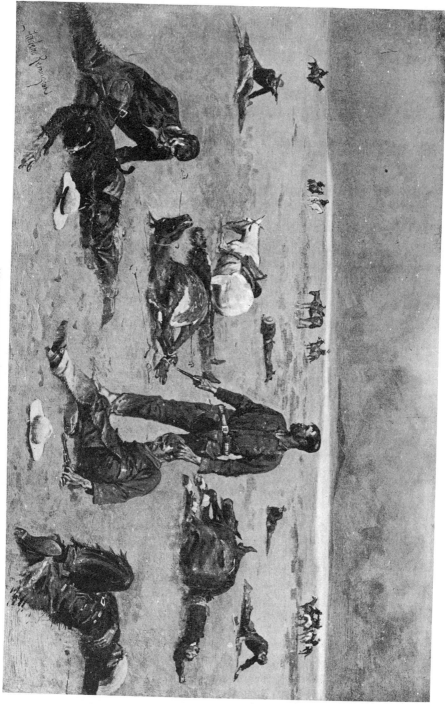

during the furious rages of such a typhoon. For the cattle of the wilderness have often run wild for three, four, and five years, through rocks and forests, never seeing the face of man from the day when as little calves they were branded. And some were never branded at all. They have grown up in company with the deer, and like the deer they fly at the approach of the horseman. Then, if he has ridden out to gather these waifs from their remote untenanted pastures and bring them in to be counted and driven to sale, he must abandon himself to the headlong pursuit. The open easy plain with its harmless footing lies behind, the steep valley narrows up to an entering wedge among the rocks, and into these untoward regions rush the beeves. The shale and detritus of shelving land-slides, the slippery knobs in the beds of brooks, the uncertain edges of the jumping-off place, all lie in the road of the day's necessity, and where the steer goes, goes the cow-puncher too—balancing, swaying, doubling upon his shrewd pony. The noose uncoiling flies swinging through the air and closes round the throat—or perhaps only the hind leg—of the quarry. In the shock of stopping short or of leaning to circle, the rider's stirrups must be long, and his seat a forked pliant poise on the horse's back; no grip of the knee will answer in these contortions; his leg must have its straight length, a lever of muscle and sinew to yield or close vise-like on the pony's ribs; and when the steer feels that he is taken and the rope tightens from the saddle horn, then must the gearing be solid, else, like a fisherman floundering with snapped rod and tangled line, the cow-puncher will have misfortunes to repair and nothing to repair them with. Such a thing as this has happened in New Mexico: The steer, pursued and frantic at feeling the throttle of the flung rope, ran blindly over a cliff, one end of the line fast to him, the other to the rider's saddle horn, and no time to t think once, much less twice, about anything in this or the next world. The pony braced his legs at the edge, but his gait swept him onward, as with the fast skater whose skate has stuck upon a frozen chip. The horse fell over the mountain, and with him his rider; but the sixty-foot rope was new, and it hooked over a stump. Steer and horse swung like scales gently above the man, who lay at the bottom, hurt nearly to death, but not enough to dull his appreciation of the unusual arrangement.

It is well, then, to wear leathern armor and sit in a stout saddle if you would thrive among the thorns and rocks; and without any such casualty as falling over a mountain, the day's common events call for uncommon strength of gear. Not otherwise can the steer be hooked and landed safely, and not otherwise is the man to hoist resisting beeves up a hill somewhat as safes are conducted to the sixth story, nor could the rider plunge galloping from the sixth story to the ground, or swerve and heavily lean to keep from flying into space, were his stirrup leathers not laced, and every other crucial spot of strain independent of so weak a thing as a buckle. To go up where you have come down is another and easier process for man and straps and everything except the horse. His

breath and legs are not immortal. And in order that each day the man may be hardily borne over rough and smooth he must own several mounts—a "string"; sometimes six and more, either his own property, or allotted to him by the foreman of the outfit for which he rides. The unused animals run in a herd—the *ramuda;* and to get a fresh mount from the ramuda means not seldom the ceremony of catching your hare. The ponies walk sedately together in the pasture good as gold, and eying you without concern until they perceive that you are come with an object. They then put forth against you all the circus knowledge you have bestowed upon them so painfully. They comprehend ropes and loops and the law of gravity; they have observed the errors of steers in similar cases, and the unattractive result of running inside any enclosure, such as a corral, they strategize to keep at large, and altogether chasing a steer is tortoise play to the game they can set up for you. They relish the sight of you whirling impotent among them, rejoice in the smoking pace and the doublings they perpetrate; and with one eye attentive to you and your poised rope, and the other dexterously commanding the universe, they will intertangle as in cross-tag, pushing between your design and its victim, mingling confusedly like a driven mist, and all this with nostrils leaning level to the wind and bellies close to the speeding ground. But when the desired one is at last taken and your successful rope is on his neck, you would not dream he had ever wished for anything else. He stands, submitting absent-mindedly to bit and blanket, mild as any unconscious lamb, while placidity descends once more upon the herd; again they pasture good as gold, and butter would not melt in the mouth of one of these conscientious creatures. I have known a number of dogs, one crow, and two monkeys, but these combined have seemed to me less fertile in expedient than the cow-pony, the sardonic cayuse. The bit his master gave him, and the bridle and spurs, have the same origin from necessity and the same history as to ornament. If stopping and starting and turning must be like flashes of light, the apparatus is accordingly severe; and as for the spurs, those wheels with long spikes cease to seem grotesque when you learn that with shorter and sharper rowels they would catch in the corded meshes of the girth, and bring the rider to ruin. Silver and gold, when he could pay for them, went into the make and decoration of this smaller machinery; and his hat would cost him fifteen dollars, and he wore fringed gloves. His boots often cost twenty-five dollars in his brief hour of opulence. Come to town for his holiday, he wore his careful finery, and from his wide hat-brim to his jingling heels made something of a figure—as self-conscious and deliberate a show as any painted buck in council or bull-elk among his aspiring cows; and out of town in the mountains, as wild and lean and dangerous as buck or bull knows how to be.

As with his get-up, so it went with his vocabulary; for any manner of life with a rule and flavor of its own strong enough to put a new kind of dress on a man's body will put new speech in his mouth, and an idiom derived from

the exigencies of his days and nights was soon spoken by the cow-puncher. Like all creators, he not only built, but borrowed his own whenever he found it. *Chaps,* from *chapparajos,* is only one of many transfers from the Mexican, one out of (I should suppose) several hundred; and in *lover-wolf* is a singular instance of half-baked translation. *Lobo,* pronounced *lovo,* being the Spanish for wolf, and the coyote being a sort of wolf, the dialect of the southern border has slid into this name for a wolf that is larger, and a worse enemy to steers than the small coward coyote. Lover-wolf is a word anchored to its district. In the Northwest, though the same animal roams there as dangerously, his Texas name would be as unknown as the Northwest's word for Indian, *siwash,* from *sauvage,* would be along the Rio Grande. Thus at the top and bottom of our map do French and Spanish trickle across the frontier, and with English melt into two separate amalgams which are wholly distinct, and which remain near the spot where they were moulded; while other compounds, having the same Northern and Southern starting-point, drift far and wide, and become established in the cow-puncher's dialect over his whole country. No better French specimen can be instanced than *cache,* verb and noun, from the verb *cacher,* to conceal. In our Eastern life words such as these are of no pertinent avail; and as it is only universal pertinence which can lift a fragment of dialect into the dictionary's good society, most of them must pass with the transient generation that spoke them. Certain ones there are deserving to survive; *cinch,* for instance, from *cincha,* the Mexican girth. From its narrow office under the horse's belly it has come to perform in metaphor a hundred services. In cinching somebody or something you may mean that you hold four aces, or the key of a political crisis; and when a man is very much indeed upper-dog, then he is said to have an air-tight cinch; and this phrase is to me so pleasantly eloquent that I am withheld from using it in polite gatherings only by that prudery which we carry as a burden along with the benefits of academic training. Besides the foreign importations, such as *arroya* and *riata,* that stand unchanged, and those others which under the action of our own speech have sloughed their native shape and come out something new, like quirt—once *cuerta,* Mexican for rawhide—is the third large class of words which the cowboy has taken from our sober old dictionary stock and made over for himself. Pie-biter refers not to those hailing from our pie belt, but to a cow-pony who secretly forages in a camp kitchen to indulge his acquired tastes. Western whiskey, besides being known as tonsil varnish and a hundred different things, goes as benzine, not unjustly. The same knack of imagery that upon our Eastern slope gave visitors from the country the brief, sure name of hayseed, calls their Western equivalents junipers. Hay grows scant upon the Rocky Mountains, but those seclusions are filled with evergreens. No one has accounted to me for *hobo.* A hobo is a wandering unemployed person, a stealer of rides on freight-trains, a diner at the back door, eternally seeking honest work, and when brought face to face with it eternally retreating. The

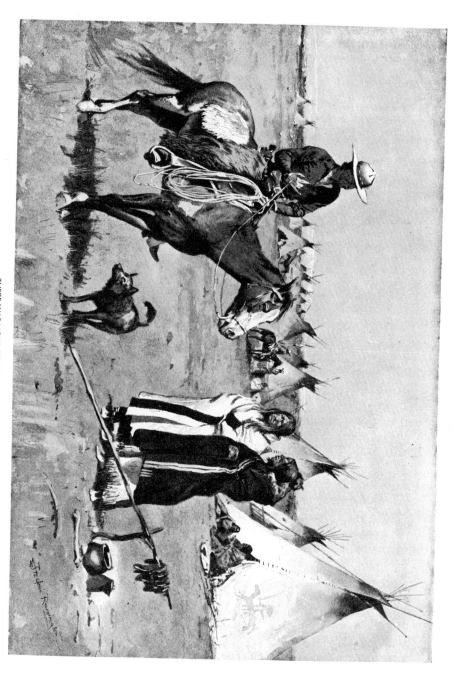

THERE WAS NO FLORA McIVOR

hobo is he against whom we have all sinned by earning our living. Perhaps some cowboy saw an Italian playing a pipe to the accompaniment of the harp, and made the generalization; oboe may have given us hobo. Hobo-ken has been suggested by an ingenious friend; but the word seems of purely Western origin, and I heard it in the West several years before it became used in the East. The cow-puncher's talent for making a useful verb out of anything shows his individuality. Any young strong race will always lay firm hands on language and squeeze juice from it; and you instantly comprehend the man who tells you of his acquaintances, whom you know to be drunk at the moment, that they are *helling* around town. Unsleeping need for quick thinking and doing gave these nomads the pith of utterance. They say, for instance, that they intend *camping on a man's trail,* meaning, concisely, "So-and-so has injured us, and we are going to follow him day and night until we are quits." Thus do these show his unpremeditated art of brevity, varying in aptness, but in imagination constant; and with one last example of his fancy I shall leave his craft of wordmaking.

It is to be noted in all peoples that for whatever particular thing in life is of frequent and familiar practice among them they will devise many gradations of epithet. *To go* is in the cattle country a common act, and a man may go for different reasons, in several manners, at various speeds. For example:

"Do I understand you went up the tree with the bear just behind you?"

"The bear was not in front of me."

Here the cowboy made ordinary words suffice for showing the way he went, but his goings can be of many sorts besides in front of and behind something, and his rich choice of synonyms embodies a latent chapter of life and habits. To the several phases of going known to the pioneer as vamose, skip, light out, dust, and git, the cowboy adds, burn the earth, hit, hit the breeze, pull your freight, jog, amble, move, pack, rattle your hocks, brindle, and more, very likely, if I knew or could recall them; I think that the observer who caught the shifting flicker of a race or a pursuit, and said brindle first, had a mind of liveliness and art.

It may be that some of these words I have named as home-bred natives of our wilderness are really of long standing and archaic repute, and that the scholar can point to them in the sonnets of Shakespeare, but I, at least, first learned them west of the Missouri.

With a speech and dress of his own, then, the cow-puncher drove his herds to Abilene or Westport Landing in the Texas times, and the easy abundant dollars came, and left him for spurs and bridles of barbaric decoration. Let it be remembered that the Mexican was the original cowboy, and that the American improved on him. Those were the days in which he was long in advance of settlers, and when he literally fought his right of way. Along the waste hundreds of miles that he had to journey, three sorts of inveterate enemies infested the

road—the thief (the cattle-thief, I mean), who was as daring as himself; the supplanted Mexican, who hated the new encroaching Northern race; and the Indian, whose hand was against all races but his own immediate tribe, and who flayed the feet of his captives, and made them walk so through the mountain passes to the fires in which he slowly burned them. Among these perils the cow-puncher took wild pleasure in existing. No soldier of fortune ever adventured with bolder carelessness, no fiercer blood ever stained a border. If his raids, his triumphs, and his reverses have inspired no minstrel to sing of him who rode by the Pecos River and the hills of San Andreas, it is not so much the Rob Roy as the Walter Scott who is lacking. And the Flora McIvor! Alas! the stability of the clan, the blessing of the home background, was not there. These wild men sprang from the loins of no similar father, and begot no sons to continue their hardihood. War they made in plenty, but not love; for the woman they saw was not the woman a man can take into his heart. That their fighting Saxon ancestors awoke in them for a moment and made them figures for poetry and romance is due to the strange accidents of a young country, where, while cities flourish by the coast and in the direct paths of trade, the herd-trading interior remains mediæval in its simplicity and violence. And yet this transient generation deserves more chronicling than it will ever have. Deeds in plenty were done that are all and more than imagination should require. One high noon upon the plains by the Rio Grande the long irons lay hot in the fire. The young cattle were being branded, and the gathered herd covered the plain. Two owners claimed one animal. They talked at first quietly round the fire, then the dispute quickened. One roped the animal, throwing it to the ground to burn his mark upon it. A third came, saying the steer was his. The friends of each drew close to hear, and a claimant thrust his red-hot iron against the hide of the animal tied on the ground. Another seized it from him, and as they fell struggling, their adherents flung themselves upon their horses, and massing into clans, volleyed with their guns across the fire. In a few minutes fourteen riders lay dead on the plain, and the tied animal over which they had quarrelled bawled and bleated in the silence. Here is skirmishing enough for a ballad. And there was a certain tireless man in northern New Mexico whose war upon cattle-thieves made his life so shining a mark that he had in bank five thousand dollars to go to the man who killed the man who killed him. A neighborhood where one looks so far beyond his own assassination as to provide a competence for his avenger is discouraging to family life, but a promising field for literature.

Such existence soon makes a strange man of any one, and the early cow-punchers rapidly grew unlike all people but each other and the wild superstitious ancestors whose blood was in their veins. Their hair became long, and their glance rested with serene penetration upon the stranger; they laughed seldom, and their spirit was in the permanent attitude of war. Grim lean men of few topics, and not many words concerning these; comprehending no middle between

the poles of brutality and tenderness; indifferent to death, but disconcerted by a good woman; some with violent Old Testament religion, some avowing none, and all of them uneasy about corpses and the dark. These hermited horsemen would dismount in camp at nightfall and lie looking at the stars, or else squat about the fire conversing with crude sombreness of brands and horses and cows, speaking of *humans* when they referred to men.

To-day they are still to be found in New Mexico, their last domain. The extreme barrenness of those mountains has held tamer people at a distance. That next stage of Western progress—that unparalleled compound of new hotels, electric lights, and invincible ignorance which has given us the Populist—has been retarded, and the civilization of Colorado and silver does not yet redeem New Mexico. But in these shrunk days the cow-puncher no longer can earn money to spend on ornament; he dresses poorly and wears his chaps very wide and ungainly. But he still has three mounts, with seven horses to each mount, and his life is in the saddle among vast solitudes. In the North he was a later comer, and never quite so formidable a person. By the time he had ridden up into Wyoming and Montana the Indian was mostly gone, the locomotive upon the scene, and going West far less an exploration than in the Texas days. Into these new pastures drifted youths from town and country whose grit would scarcely have lasted them to Abilene, and who were not the grim long-haired type, but a sort of glorified farm hand. They too wore their pistols, and rode gallantly, and out of them nature and simplicity did undoubtedly forge manlier, cleaner men than what our streets breed of no worse material. They galloped by the side of the older hands, and caught something of the swing and tradition of the first years. They developed heartiness and honesty in virtue and in vice alike. Their evil deeds were not of the sneaking kind, but had always the saving grace of courage. Their code had no place for the man who steals a pocket-book or stabs in the back.

And what has become of them? Where is this latest outcropping of the Saxon gone? Except where he lingers in the mountains of New Mexico he has been dispersed, as the elk, as the buffalo, as all wild animals must inevitably be dispersed. Three things swept him away—the exhausting of the virgin pastures, the coming of the wire fence, and Mr. Armour of Chicago, who set the price of beef to suit himself. But all this may be summed up in the word Progress. When the bankrupt cow-puncher felt Progress dispersing him, he seized whatever plank floated nearest him in the wreck. He went to town for a job; he got a position on the railroad; he set up a saloon; he married, and fenced in a little farm; and he turned "rustler," and stole the cattle from the men for whom he had onced worked. In these capacities will you find him to-day. The ex-cowboy who set himself to some new way of wage-earning is all over the West, and his old courage and frankness still stick to him, but his peculiar independence is of necessity dimmed. The only man who has retained that wholly is the outlaw,

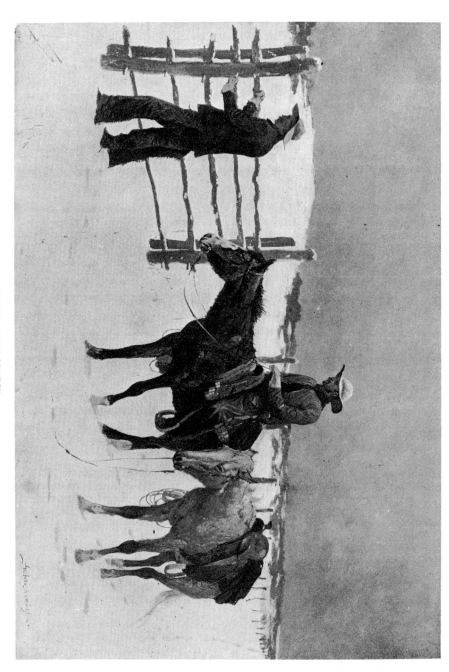

THE FALL OF THE COWBOY

the horse and cattle thief, on whose grim face hostility to Progress forever sits. He has had a checkered career. He has been often hanged, often shot; he is generally "wanted" in several widely scattered districts. I know one who used to play the banjo to me on Powder River as he swung his long boots over the side of his bunk. I have never listened to any man's talk with more interest and diversion. Once he has been to Paris on the proceeds of a lengthy well-conducted theft; once he has been in prison for murder. He has the bluest eye, the longest nose, and the coldest face I ever saw. This stripe of gentleman still lives and thrives through the cattle country, occasionally goes out into the waste of land in the most delicate way, and presently cows and steers are missed. But he has driven them many miles to avoid live-stock inspectors, and it may be that if you know him by sight and happen to be in a town where cattle are bought, such as Kansas City, you will meet him at the best hotel there, full of geniality and affluence.

Such is the story of the cow-puncher, the American descendant of Saxon ancestors, who for thirty years flourished upon our part of the earth, and, because he was not compatible with Progress, is now departed, never to return. But because Progress has just now given us the Populist and silver in exchange for him, is no ground for lament. He has never made a good citizen, but only a good soldier, from his tournament days down. And if our nation in its growth have no worse distemper than the Populist to weather through, there is hope for us, even though present signs disincline us to make much noise upon the Fourth of July.

Chapter 3

Red Men and White

emington's boast that he could "lug [Wister] into the immortal band" by illustrating (and supervising) "The Evolution of the Cow-puncher" was not strictly accurate, but so intimately bound up was "The Evolution" with the process through which Wister's first western volume, *Red Men and White*, came into being that the essay's major argument found its way unchanged into the book's preface. Just as Wister earlier had called the cowboy a "medieval man" transplanted somehow into the modern world, he here noted that "while portions of New York, Chicago, and San Francisco are of this nineteenth century, we have many ancient periods surviving among us." The American West, he argued, was "a sprout of the Middle Ages." The stories that made up *Red Men and White* concerned "the past thirty years of our development" yet also suggested the simultaneous presence of "ancient surviving centuries."[1]

Wister obviously recognized that "The Evolution" constituted a credo for *Red Men and White*, even appending the complete essay to the preface for a subsequent edition of the book—and since the book's first publication followed appearance of "The Evolution" by only two months, others quickly recognized the same thing. Theodore Roosevelt, who stubbornly refused to regard *Red Men and White* as fictional, called it "a new page in that form of contemporary historical writing which consists in the vivid portrayal, once for all, of types that should be commemorated."[2] Yet according to William Dean Howells, the fact that Wister's portrayal of the West was "true enough" did not make it "important." Howells was particularly bothered by Wister's attraction for the "blue fire" of melo-

drama, which he felt belonged with "the muted music and other devices of the theater." Significantly, Howells also mentioned Remington, observing that Wister's stories were "almost as sensible" to the West as Remington's pictures.[3]

Roosevelt's comment touched the strain in Wister's work that came most clearly and directly from Remington's descriptions of Montague Stevens and the SU ranch. This was the strain Remington himself best expressed in pictures like "What an Unbranded Cow Has Cost." Yet Howells was annoyed by the same tendency which led Wister to tell Remington that "there ought to be music" for "The Last Cavalier"—a tendency to rhapsodize. It remained for an unnamed reviewer, writing in *The Atlantic Monthly* for February 1896, to show how these views constituted two sides of a single observation. Wister's work, he said, occupied "a no-man's land between the novel and the drama." The "blue fire" Howells found objectionable, this writer described as the result of a confusion about goals: "The life which Mr. Wister portrays is so real to him in its actual material as to confound a little his own creation, and the very vividness of his actual sight arrests the operation of the sight behind the eye." Similarly, the "vivid portrayal" Roosevelt loved of "types that should be commemorated" was never quite successful because Wister never quite acknowledged its value:

There used to be, and may still be in old houses in Connecticut, representations of the Charter Oak,—lithographs, perhaps,—which were made more sensible by small strips of the bark of the historic tree gummed upon the trunk in the picture. Mr. Wister is not quite so simple in his art, but this confusion of the real and the actual is nevertheless to be seen in his work.[4]

Although the reviewer knew that Wister was "on the highroad to the heights of fictitious literature," he felt compelled "to call him back and beg him to devote his powers to narrative and history."

In 1893 Wister had been told by Henry Alden to abandon the writing of history and take up adventure stories. Having followed Alden's advice, he was now told that returning to the field of history could make him "master in a territory of his own." The borderline region he occupied was no-man's-land indeed. Empty as the Wind River country where Lin McLean knew he couldn't find a father, outlandish as Geyser Basin with its blending of heaven and hell, it was not quite a home for "the immortal band," but it was the place Remington had led Wister with "The Evolution."

When Wister met Remington at Yellowstone in 1893, he had begun none of the stories that went into *Red Men and White*. Two months afterward, at San Francisco, he began the first of them, "Little Big Horn Medicine." By the end of the same month he was in Idaho, listening to stories about General George Crook's Indian campaigns against the Bannocks. One episode in particular struck his fancy, and he made a note of it under the title "The General's Bluff." It concerned how General Crook took a small party of soldiers from Boise barracks in the dead of winter to subdue a much larger Indian force, commanded by Chief E-egante. By encouraging the Indians to believe that a massive force of U.S. regulars waited nearby, Crook managed to achieve a bloodless victory, but E-egante himself escaped with the aid of a female interpreter. As Wister outlined it in his notebook, the story had possibilities for humor, love interest, and adventure—all the things that made magazine fiction popular—but it lacked immediacy. He and Remington discussed the story in a meeting January 15, 1894, at New Rochelle, recognizing that the episode it related had certain similarities with episodes of the Civil War. Crook's ability to carry out his bluff reminded them of Colonel James Mulligan, a famous border soldier who fought in both the Twenty-third Illinois Infantry and Missouri "Home Guards" when fighting broke out between the states in 1861. Mulligan's expertise at deceiving the enemy led President Lincoln to offer him a brigadier generalship, but he turned it down because accepting would mean leaving his regiment. In 1864 he was killed at the battle of Winchester, Virginia.

Yet the trouble with the Civil War analogy was twofold. First, it applied to both sides, for if General Crook resembled James Mulligan, so did E-egante. Second, it involved serious thematic complications, which would make the story more difficult to write and probably diminish its acceptability for *Harper's*. Early in 1894, of course, Wister was still in love with the idea that the West would provide a reconciliation between North and South. Yet Remington disliked reconciliation and mistrusted attempts to speculate about history. Therefore, he wrote to Wister on January 20, five days after the New Rochelle meeting, suggesting that an incident from another Indian campaign rather than an analogy with the Civil War should inform "The General's Bluff."

Story told me by Army officer—

Nevada—Old Winnemucka going to break out—three officers—con-

tract doctor.—30 men—one officer agt.—heard of job from friendly indian to murder them next day at ration issue.—Said to other officers I am going to get Winniemucka—couldn't give him escort—troops got ready for action.—Cap. Summerhays rode with contract doctor in early morning right into old Winn's camp.—no dogs no women—wickeups— saw big lodge rode right up—"hold horse Dr. and if I shoot pull out"— jumped right into wickeup—pulled dem shot gun on Winniemucka—said "all stand up drop blankets—if any one does anything you die Winnee muckee—" dozen men gave up arms.—told half breed interpreter to take em out to Dr.—then went himself—cowed old Winniemucka and no row—talk about your Mulligan Guards how can you beat that for desperate sand.

<div style="text-align:center">*Yours truly*</div>

JANUARY 20, 1894 *Frederic Remington*

Captain Summerhays, now a major, had told Remington this story at the military base on David's Island, near New York City. When Remington sent it to Wister, Wister was at work on a story called "Specimen Jones," but on February 13 he began to write "The General's Bluff." Although he kept an oblique reference to Mulligan's Guards by having one of Crook's troopers remember the battle of Winchester, Wister built his story around the account sent him by Remington.

"The General's Bluff" was printed in the September 1894 number of *Harper's Monthly*, after Wister's summer of travel and writing, and Remington's sojourns at Chicago and the SU ranch. When it appeared, Remington was working on illustrations for Wister's "Salvation Gap," the story of how a California gold miner murders his mistress. "The National Guard of Pennsylvania" appeared concurrently in the September 1 number of *Harper's Weekly*. Wister told Remington that the pictures for "The General's Bluff" pleased him, and Remington replied that he had not had time to do justice to "Salvation Gap." Alden could give him only limited space in the magazine, and he rushed to get ready for his bear hunting trip in New Mexico with General Miles.

Dear Wister—

I had to have all my stuff in Tuesday night and couldn't do Hoodo. *Only had page & half as it was—poor business.*

Don't know just when I go West—will let you know soon as hear from

Opening illustration for "The General's Bluff." General George Crook (right) talks with two cavalry privates.

Miles

Am writing "Bicycle Infantry"
Penna. Squad great—greater as d—— further off. It grows on me.
Glad you like genl Bluff

 Yours
SEPTEMBER 1894 *Frederic Remington*

On a separate sheet Remington recalled E. S. Martin's earlier comment in *Harper's Weekly*, noting of the gory "Salvation Gap"—which he liked precisely because it was gory—that: "As a rather noteworthy piece of library upholstery once said on his first sight of red blood in text—it does not concern polite society."

Remington's "Bicycle Infantry," entitled "The Colonel of the First Cycle Infantry" when it appeared in *Harper's Weekly* the next year, grew directly from "The National Guard of Pennsylvania." At Gettysburg, Remington and Wister encountered some horseplay and much talk about

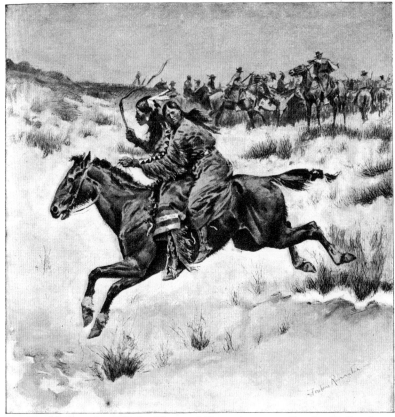

"He Hesitated to Kill the Woman." E-egant escapes Crook with Sarah,
the female interpreter who has fallen in love with the chief.

citizen revolts. Remington combined the two in his fanciful dialogue
between a cavalry officer named Ladigo and Colonel Pedal of the "First
Bikes." The humorous names Remington chose for his characters and
the tricks of speech he had them indulge in only thinly veiled the grisly
subject of the sketch, For Colonel Pedal's narrative concerned the re-
capture of sections of Pennsylvania taken over by "armed insurgents."
Bicycles, because of their speed, silence, and maneuverability, made ideal
weapons for the kind of war in which it was necessary to penetrate
country towns by night and blow them up. More than anything else,
Remington's sketch showed how little stock the artist put in Wister's
notion that "real Americans" might someday be bound by their common
nationality into a peaceful union.

Thus, there was a certain irony in the fact that while Remington wrote "The Colonel of the First Cycle Infantry," Wister slaved to finish "The Second Missouri Compromise." In Remington's sketch, unconventionally mounted troops subdued rebellion in the conventional way—with guns, explosives, and fire. But in Wister's story, former members of Price's Left Wing, an irregular Confederate regiment from Missouri, became the territorial legislature of Idaho in 1867; and when they refused to acknowledge federal authority, they had to be dealt with in a manner that avoided

Specimen Jones leads his five troopers down a Boise street, to confront the Southern legislators at the territorial capitol.

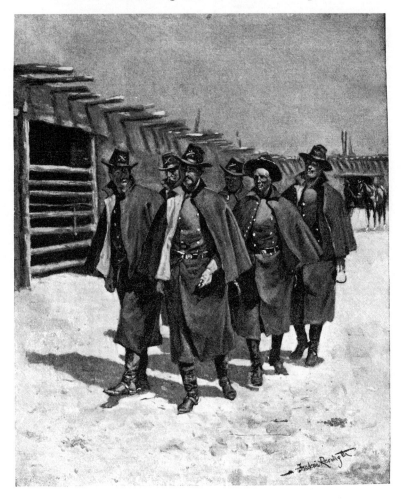

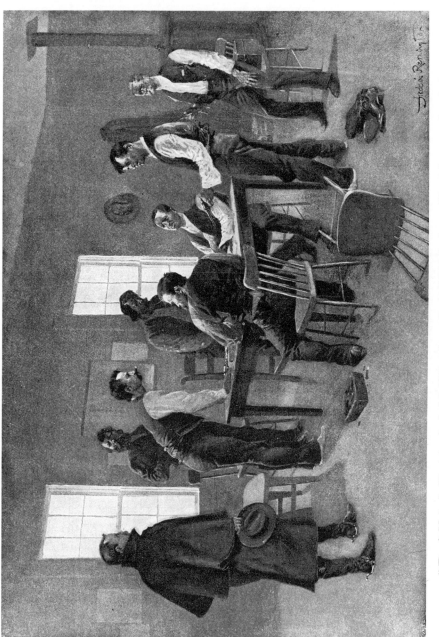

" 'Don't Nobody Hurt Anybody,' Said Specimen Jones." This is the profile of Jones as sketched
by Remington in his New Rochelle studio while Augustus Thomas watched.

bloodshed and affirmed everyone's identity as "real Americans." The governor was a northerner; the legislators, southerners. But the tale's real hero, a corporal named Specimen Jones, whose orders were to "stop trouble and make none," was allied with neither North nor South. When violence threatened to erupt between the unreconstructed legislators, who demanded their salary, and the governor, who refused to give it to them until they swore allegiance to the United States, Jones carried out his orders by arresting not the rebels, but the governor—and the cash box— until tempers had time to cool. The point Wister made in "The Second Missouri Compromise" was simple but important: commitment to constitutional law made it impossible for a northern governor to meet the demands of southern legislators. The southerners, later recognizing that "a little thing" like an oath "should nevah stand between friends," could afford to be somewhat more flexible—but the range of action available to Specimen Jones was even greater. "His habits," wrote Wister, "were by no means exemplary; and his frontier personality, strongly developed by six years of vagabonding before he enlisted, was scarcely yet disciplined into the military machine." Because Jones was a *westerner*, his only allegiance was to the American uniform he wore.

Wister's virtual abandonment of historical themes in "The General's Bluff" made that story relatively easy for him to write and for Remington to illustrate. The "bluff" that constituted its central incident was valuable precisely because it was so dramatic—and drama was something Remington knew how to represent. With a study of the wily General Crook, a picture of a cavalry charge, and a final picture of E-egante's escape, Remington managed to encompass the story's whole action. "The Second Missouri Compromise" was far more difficult. There was no shooting, no running—not even any horses. Wister recognized the difficulty of the tale as he wrote it. Whereas "The General's Bluff" took him only two weeks to complete, he spent five months wrestling with the "Compromise." When he finished it on September 18, 1894, he wrote in his daybook: "Heaven be praised! It has been a weary grind."[5] Remington was likewise perplexed when he returned from New Mexico to find the story waiting for him. In October he wrote to Wister asking for help.

My dear Wister—
 Well—old man—what's the matter of your coming out here next Sun-

day. Why, also, can't you come so that we can have a ride Saturday
afternoon. Leave Phila. early and that will make it. Better bring your
boots and breeches—it may be nasty.

I have the "Second Mo. Com"—and its bothering me to know just
how to illustrate. We will "raise our voices" in the matter.

Write if you'l come and when.

<div align="right">

Yours faithfully

Frederic Remington.
</div>

SOMETIME BETWEEN OCTOBER 13 AND OCTOBER 18, 1894

On October 20, Wister went to New Rochelle. As we have seen, this
meeting was important for Wister because it constituted the real be-
ginning of "The Evolution of the Cow-puncher." As we shall see shortly,
it was equally important for Remington, because the artist's difficulty in
illustrating "The Second Missouri Compromise" was one of the factors
that caused him to take up sculpting soon afterward. For the present,
however, both Remington and Wister continued to be involved in proj-
ects related to *Red Men and White*.

Only days before the meeting at New Rochelle, Wister began writing
"La Tinaja Bonita," a story which had had its inception four months
earlier when he had first visited a place called Bonita Canyon in southern
New Mexico. On that occasion Wister "enjoyed" himself but also found
it difficult "to love a land where no water is." Describing his experience
in the desert, he noted a vivid incident later incorporated almost un-
changed into "La Tinaja":

Fifteen miles through Sulphur Springs Valley over dry flat dust and then into
the stony hills, Sergeant Poindexter and I set a cow on her legs. She had
fallen from exhaustion and lay with her head tangled under her front legs
in a curious and pitiful way. We thought her dead till we saw her tongue
move. She had a little calf that was wandering round her, helpless, hungry
and bewildered.[6]

Wister's use of this actual experience as an element of his fictional tale
demonstrated close observation and an ability to recognize "material"
when it occurred, for "La Tinaja" was a story which derived much of
its force from a judicious use of narrative detail. It was, in other words,
a geographical adventure story such as Henry Alden told Wister he
should write.

Yet the story also made use of more complex historical themes like those that informed "The Second Missouri Compromise." Wister gave its hero, a Kentuckian called Russ Genesmere, who named his mules after Confederate generals, "a bronzed Saxon face" and a chilly, suspicious personality to match. The story's heroine, a pretty Mexican girl named Lolita, was Latin in temperament as well as physiognomy. The union of these two types in Arizona fascinated Wister for the same reason as did the member's of Price's Left Wing who became territorial legislators in Idaho: it demonstrated the startling possibilities of the West. Speaking of the lovers in "La Tinaja," Wister observed that "never had a woman been for [Genesmere] like Lolita, conjuring the Saxon to forget himself and bask openly in that Southern joy and laughter of the moment."

The difference between the "Compromise" and "La Tinaja" was that the former tale, because it dealt with union easily accomplished among Americans of northern European ancestry, was comic and historically optimistic, while the latter story, clearly intended as a tragedy, brought the Saxon Genesmere and his Latin mistress truly together only in the grave. Like so many other elements of Wister's work, this difference had a distinctly geographical origin. On the same trip that gave him the idea for "La Tinaja," Wister noted that "this southwest corner of our country is a forlorn and wretched place, and we should be better off if we had never got it from Mexico."[7] Similarly, Genesmere, whose name meant "born of water," reflected as he rode across the Arizona desert that "man could not be meant to live here." For both Wister and Genesmere, however, the otherwise repulsive desert exerted a curious attraction. Wister called it a "lingering Spanish charm" which appealed to his "aesthetic sensibilities."[8] For Genesmere, it was embodied in Lolita herself, who denied any Spanish connection and asserted in a song that she was "pure" Mexican—"*soy purita mejicana.*" Lolita's innocence made her capable of love and the final sacrifice of life that love required, but Genesmere, torn by a more personal manifestation of the same doubt that made Wister want to give the Southwest back to Mexico, became "a man divided against himself."

By describing his hero through a metaphor of such particularity, Wister unmistakably identified "La Tinaja's" star-crossed lovers with larger themes of American history, deftly turning the tale into a western commentary on Lincoln's famous speech at Gettysburg. Unquestionably, it

was his finest accomplishment to date, and Remington was quick to recognize its excellence when Alden sent it to him at New Rochelle for illustrations. Early in November 1894, he wrote to Wister with his customary humor—and the highest praise he had yet offered.

Mr. Nerve Cell—
That's what you are—Have just read the Tinaja and its enormous—
it's just so—that's what the people in it would say and you are right on
to "dobe holes"—and of course that's just the way Arizona is but after
its published you can't go down there any more or the real estate fellows
will hang you. Only ½ pages but I could do 3000—It's a whole book
on Arizona. It's pretty fine for a dude who' has never been in A. to
follow you but it will just make fellows who have "slap each other on
the back."—
You have an air tight cinch on the West—Others may monkey but
you arrive with a horrible crash every pop.
 Frederic R.
"What size hat are you now wearing?"
SOMETIME BETWEEN NOVEMBER 1 AND NOVEMBER 10, 1894

"La Tinaja" was melodramatic, historical, and a love story—three things Remington disliked—but it also captured the emptiness and heat of Arizona. That made up for everything else.

Flattered by Remington's praise, Wister told the artist that Alden might be persuaded to allow more space for illustrations, possibly making room for a full-page plate. Accordingly, Remington presented himself to Alden at New York and made his plea. Afterwards he elatedly wrote to Wister of his success:

Dear Broncho Quill—
Muy gracia—linde Tinajas. I stood on the collar bone of the great
magazine maker and demanded my American rights and he passed his
word for it.
When does the puncher come O—thing of Truth—Veil raiser of the
Past—story teller of the desert—let on
 Yours faithfully
 "Bear"

P.S. Harvard can try but she can't get thar.
 Eli
LATE NOVEMBER 1894

Remington's final note referred to the Yale-Harvard football game played on November 24 and won twelve to four by Yale. Caspar Whitney, the artist's friend, wrote a whole page about the contest in the December 1 *Harper's Weekly*, calling it "dirty, cowardly work," and remarking that it showed "the most vicious spirit I have ever seen displayed."[9] But if the game was "football at its worst," it was exactly the kind of football Remington liked best.

By signing himself "Bear," Remington recalled his recent hunting trip in New Mexico with Montague Stevens—the same trip about which he wrote "Bear Chasing in the Rocky Mountains." As he began to prepare "Bear Chasing," he wrote Stevens for advice, praising Wister and expressing hope that the three of them could meet sometime to talk about the West. Stevens, who was even then planning a trip east, thought Remington meant for Wister to write the hunting essay and replied that although this might be difficult, he was willing to help all he could:

November 29, 1894
My dear Remington,

 Just a line to acknowledge your last letter. I am now on my way to Alburq. for a few days & then hope to start East stopping with friends in Chicago & Buffalo en passant. I would expect breach New York somewhere about the 20th Dec. As regards the writing of the article you are of course the best judge & if you would prefer Wister to write it I will cordially do my level best to aid him in any way that I can. Of course it will be a handicap for him to accurately describe a hunt in which he did not participate & for that reason I would think that it would not be a bad plan if we were all three to enter a sort of triple alliance whereby an article might be evolved that would at once be artistic accurate & immortal. I would therefore suggest that you arrange a meeting either at N.Y. or Philadelphia (whichever is most convenient to yourself & Wister) for the purpose of collaborating. How does this idea strike you?

 As there will hardly be time for me to receive an answer from you before I leave Albuquerque please address in care of Edward H. Reed

Esq. Corner Maple & Lake, Evanston Illinois, where I shall be staying about Dec 12th.
>*With kind regards*
>>*In great haste*
>>>*yours ever*
>>>>*Montague Stevens*

When he received it, Remington immediately sent Stevens' letter on to Wister with a note of his own:

My dear

>*You must come to New York when I send for you—to meet Stevens—he's game for you Will you.—*
>>*Frederic R.*
SOMETIME BETWEEN DECEMBER 1 AND DECEMBER 5, 1894

While he waited for Stevens' arrival, Remington finished his pictures for "La Tinaja Bonita." There were two relatively undistinguished half-page drawings; one showed Lolita and Genesmere glaring at Luis, the story's third principal character, and the other displayed Genesmere talking with frontier acquaintances at Tucson. The latter picture was typical Remingtoniana—the sort of thing the artist could now dash off almost without thinking about it. The former was somewhat anachronistic, for it constituted one of the rare instances in which Remington drew women other than Indian squaws. Yet there was also another illustration, the full-page plate Remington earlier "demanded" from Henry Alden. In it, Genesmere, going mad from thirst, stood among dead cattle at a dried up adobe water hole, talking to himself. The other two pictures were merely concessions to the plot of Wister's story, but this one captured the story's essence—the loneliness of Arizona's desert. It stated the same puzzling bareness, asked the same derisive question later present in "What an Unbranded Cow Has Cost."

As Remington prepared to send his illustrations for "La Tinaja" off to Alden early in December, Stevens wrote from Chicago that he had been delayed and consequently would arrive at New York somewhat later than initially planned. Remington accordingly passed the news on to Wister, also mentioning his now completed pictures for "La Tinaja."

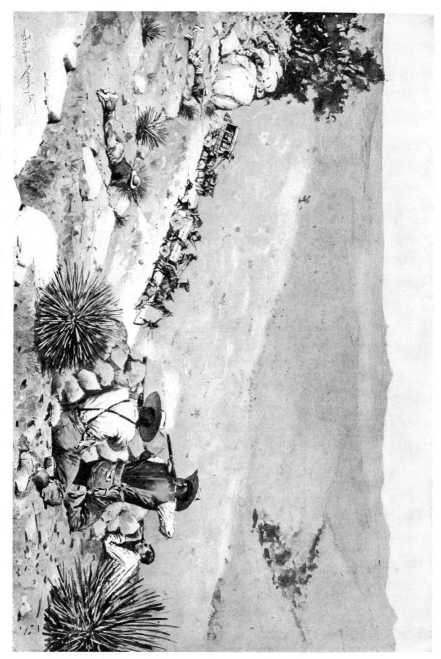

"Holding Up the Pay Escort," from "A Pilgrim on the Gila." Remington drew this picture from a photograph of the famous Wham stagecoach robbery of 1892.

My dear Wister—

Stevens—cow baron of N. Mex. writes that he hits this clearing about the 22nd and wants to meet you.

Will you come over any day I send for you bar Xmas of course? Since I don't know how long S. will stay. He is probably heading for Hengland.

<div style="text-align:center">*Yours*
Frederic</div>

Just turned in Tijana—

Man in "dobe hole" talking to ravens.—

how's that hit you.

Didn't get the girl "pretty" as the second word [of the story] unfortunately says she was—but no one can expect that of me. But I got the dobe hole dry.

EARLY DECEMBER 1894

When he got Remington's letter, Wister was glad that the illustrations for "La Tinaja" were finished, but understandably confused about what part Remington seemed to be assigning him, without previous consultation, in producing the bear hunting article. He wrote to Remington, addressing him as "O Bear," to find out, and Remington replied with an explanation, some sketches, and much praise for Stevens.

My dear Wister—

Stevens thought (he misunderstood me) that you were to do the bear hunt—*which I have written and which I can do much better than you because it was a lot of little things which happened and very little* bear *and you were not there anyway—but this Stevens is a character (not a sergeant with a hat knocked back) but a most impossible combination of English "Ahs! Ahs" and the best kind of horse sense (American standpoint) and* sand—*say O.W.—more* sand *than you could get in a freight car. Well, he is billed for Dec last week of it and we must make a talk— guess we will have to do it in my room here—one night and downe towne the other—the two kinds of discussion differing in the degrees of "bottled sun-light" which occupies the center while we sit around.*

Stevens like any bonifide Englisher has got to be thawed out—he is thin and nervous but eleven or twelve hundred generations of fog inhalers can't be overcome in one short lift of life—say 35. He don't look like this but this is the way a physiognomy sharp would feel the curves, just

Endion.
New Rochelle, N.Y.

My dear Wister —

Stevens thought (he misunderstood me)
that you were to do the bear hunt — which I have written
and which I can do much better than you because it
was a lot of little things which happened and very
little bear and you were not there anyway — but this
Stevens as a character (not a sergeant with a hat
knocked back) but a most impossible combination
of English "ah's: ah's" and the best kind of
horse sense (American standpoint) and sand — say
O.W. — more sand than you could get in a
freight car. Well, he is billed for Dee last
work of it — and we must make a talk —
guess we will have to do it in my room
here — one night and divine towns the other —
the two kinds of discussion differing in the
degrees of "bottled sun-light" which occupies
the center while we sit around.

OWW

Slevins like any bonifide Englisher has got to be thawed out — he is their and nervous but eleven or twelve hundred generations of fog inhalers can't be overcome in one short lift of life — say 35.

He don't look like this but this is the way a physiogomy shape would feel the canvas

just the same as he would (with sombrero & Bad land background) feel yours.

I often wonder how I look — and every man sees with his own eyes — otherwise how could an oculist get rich — hence the expression "Come off the grass" —

yours feelingly
Fredric (O Bear

P.S. By the way never use that "O Bea" again — & use instead (let for my worse idea — I have used up bea which "O Bea". — R

the same as he would (with sombrero & Bad land background) feel yours.
I often wonder how I look—and every man sees with his own eyes—
otherwise how could an oculist get rich—hence the expression "come off
the grass"—

<div align="center">

yours feelingly
Frederic (O Bear)

</div>

P.S. By the way never use that "O Bear" again—I will trade that for
my wooden indian—I have ended my bear article "O Bear."

<div align="center">

R.

</div>

SOMETIME BETWEEN DECEMBER 20 AND DECEMBER 30, 1894

Remington was correct in describing "Bear Chasing" as "a lot of little things . . . and very little bear," but the essay was interesting, for it also confirmed Stevens as "a bona fide Englisher" who made good in New Mexico. It was no accident that Remington's rough sketch of him so closely resembled the pictures of Saxon Genesmere which accompanied "La Tinaja." Indeed, Remington's characterization of New Mexico in "Bear Chasing" as a region where "the White race has given up the contest with nature"[10] closely paralleled Wister's description of Arizona as a place where "men could not be meant to live" but nonetheless harbored *"puritas mejicanas"* like Lolita and Luis. The preface to *Red Men and White* stated that "many sorts of Americans live in America," but both Wister's "La Tinaja" and Remington's "Bear Chasing" flirted with a slightly different notion: there were parts of America where *no* Americans could live. It was this notion which most fully informed "A Pilgrim on the Gila," the last story in *Red Men and White*.

Wister got the idea for "A Pilgrim" during the same southwestern trip of 1894 that led to "La Tinaja." Yet whereas "La Tinaja" managed its dramatic sectional theme with no reference to politics, "A Pilgrim" was openly political, even partisan. Its ostensible story line, derived from Wister's study of the famous 1892 Wham stagecoach robbery near Phoenix, served merely as the vehicle for an argument against Arizona statehood. Much to Wister's outrage, Democrats led by William Jennings Bryan urged statehood for Arizona in 1893, when the territory, 113,000 square miles in area, contained only 60,000 people. Wister's response was to put Bryan into his story as "Boy Orator of the Rio Grande" and to depict Arizona Territory as a vast waste inhabited exclusively by criminals and scheming, illiterate politicians. "Boom in Tucson," his

original title for the story, referred to the brief period of relative prosperity brought to the region by subsequently abandoned Camp Lowell, a military base where "soldier people," the only "good men and women" in the territory, resided.

As Wister was beginning to write "A Pilgrim," Montague Stevens arrived at New York as scheduled on December 22. A week later Remington wrote to apologize for not inviting Wister for the occasion, also asking about "The Evolution."

My dear Wister—

Stevens came through here on the run—going to England—Saturday— no time to get together.

How is the Cow boy article coming on?

I may take a run up to Canada soon for a couple of weeks. When do you go West.

Frederic R——

New Ro——
Friday
DECEMBER 29, 1894

The reference to a Canadian trip in December was probably facetious, although Remington did like snowshoeing and winter camping. At any rate, it was to Florida that he went in the winter of 1894–1895.

Wister, busy with his writing of both "The Evolution" and "A Pilgrim," did not plan to go west until May. Meanwhile, the latter project gained new impetus when Wister read Theodore Roosevelt's essay on "True American Ideals" in *The Forum* for February 1895. Although Roosevelt did not explicitly touch on the Arizona statehood controversy, he did comment that the dishonest legislator "who to catch votes denounces the judiciary and the military" was "a real peril" to national greatness.[11] Similarly, Wister observed in "A Pilgrim" that "I can think of no threat more evil for our democracy [than] unthinking sons of the sagebrush [who] ill tolerate . . . discipline, good order and obedience."[12] Appropriately, Roosevelt later acknowledged that the "immediate suggestion" for writing "True American Ideals" came from Wister's article on "The National Guard of Pennsylvania."[13]

When Wister wrote to Roosevelt, then Civil Service commissioner, praising "True American Ideals," Roosevelt replied with praise for "The

Second Missouri Compromise," published in March. Significantly, he also noted that his main interest in the story was "political," and went on to anticipate discussing the questions it raised in his mind:

I wish you were going to be on here in Washington. There is much I should like to talk over with you. I am an optimist, but I hope I am a reasonably intelligent one. I recognized that all the time there are evil forces at work, and that in places and at times they outweigh the forces that tend for good. Hitherto, on the whole, the good have come out ahead, and I think that they will in the future."[14]

A month later, at the end of March, he invited Wister, Remington, and Rudyard Kipling, who was at that time living in New England, to Washington for a dinner party to be held at his house on the evening of April 5.

On April 2, Wister noted in his journal that he had at last finished "A Pilgrim on the Gila," but "in vain," for "I don't think the thing goes."[15] That same afternoon he received a note from Remington concerning the Roosevelt dinner:

Dear Dan—
 I am going to Washington Friday morning to dine with Theo. Roosevelt—He said Dan Wister was coming—are you Dan—if so you have been trifling with me.
 Still if you are Dan—why can't you meet me in Phila and go on the same train—
<div style="text-align:right">*Yours faithfully*</div>
MARCH 31, 1895 *Frederic Remington*

Wister was Dan—but only to his college friends from Harvard, where he had acquired the nickname as an undergraduate in the 1880s.

Wister and Remington did not correspond about what went on at the Washington dinner, but Wister later wrote to Roosevelt that it was a great success, the most prominent feature of which turned out to be Kipling. Kipling and Remington debated genially about the relative merits of the English and American climates. Kipling and Wister talked about the stories for *Red Men and White*. "A Pilgrim," which Wister was still unsatisfied with, comprised the major topic of their conversation as all three rode north by train from Washington on April 6, and Wister,

having put to work the suggestions offered by Kipling and Remington, gratefully noted on April 9 that the story was ready to send to Henry Alden.

Shortly afterward, Alden sent the piece, still called "Boom in Tucson," to Remington, specifying only one illustration, to be made from a photograph Wister had taken of the site of the famous Wham robbery. Though disappointed by the small assignment, Remington was elated by the story. His letter to Wister contained no sketches, but it expressed through its graphic qualities an enthusiasm which words alone could not communicate:

> D. Wis—
>
> *I am by nature a sceptic—I would not recognize the Second Coming if I saw it—I have long held* you *in* mental reserve—*In the market place I have said "Behold you d—— ignorant gold besodden rum bloated mugs—"Wister—not Kipling"—not* King—*Wister is* doing it *The* Boom in Tucson *fairly tells me that* we *have reached the* ideal *stage—we have long forgotten the* things *we* know *and are now going to do the* rally—*I am simply lost in the immensity of space with the "Evolution" & I am going to get* "lost" *on* Tucson
>
> *Aside from your d—— lady—you are Welcome, you desert air—*
>
> APRIL 1895 *Frederic R——*

Despite his objection to widow Sproud, the "lady" Wister put into "A Pilgrim," Remington clearly regarded Wister's story as an important breakthrough, but not for its political statement—not even for its statement about Arizona and its citizens. Whereas he recognized that the earlier "La Tinaja" might offend "real estate fellows," he saw mainly an "immensity of space" when he looked at "A Pilgrim." Arriving at "the *ideal* stage" meant abandoning both the forms of romantic fiction and the discipline of history to discover the exhilarating mystery of "space" Remington could only describe as "*it*."

Part of Remington's pride in "A Pilgrim" was doubtless due to the fact that his own first book, a collection of fifteen western essays brought together under the title of *Pony Tracks*, was printed that April. On the twentieth, shortly before *Pony Tracks* went on sale, Wister visited Remington at New Rochelle and agreed on a second picture for "A Pilgrim." It was to depict the figure of an Apache brave walking away

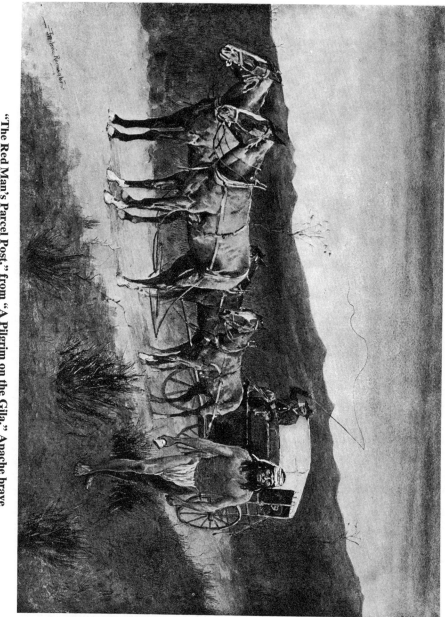

"The Red Man's Parcel Post," from "A Pilgrim on the Gila." Apache brave (foreground) picks up tobacco from stage.

from a stagecoach he had stopped to pick up a package of tobacco. After the meeting, Remington wrote with thanks, enclosing an invitation to the party being given in his honor on the evening of April 29. First there would be a small dinner at the Players' Club, then a "deluge" at the Alpine Club on Fifth Avenue.

My dear Wister.—
 You are a crackajack—giving me the Apache to do—Way no—hell of a heap good
 More nice fellows are going to waste Monday evening than you are like to meet every day—If you will dine at the Players' [Club] I will be there & then the Deluge—Enclosed invitation
<div align="center">

Yours

Frederic R
</div>
Of course you have one before this. [General] Miles—me—you—Roosevelt—etc etc

SOMETIME BETWEEN APRIL 21 AND APRIL 27, 1895

Wister planned to leave for New Mexico on April 30, the morning after Remington's party. Yet business kept him in the East until May 9, when he finally embarked on a transcontinental journey that kept him away until nearly the end of August.

Shortly after Wister's return from the West, "The Evolution of the Cow-puncher" appeared in the September number of *Harper's Monthly.* Two months later, in November, the same journal printed "A Pilgrim." Critics accorded the story no special notice, but "real estate fellows" from Arizona did. One called the tale "the most outrageously slanderous libel ever uttered against a law abiding people."[16] Another asserted that " 'A Pilgrim on the Gila' . . . will in the future do this territory greater injury than all the adverse publications heretofore made."[17] This, of course, was just what Wister wanted. He was delighted when the Arizona Territory Republican Central Committee later requested permission to publish the story in pamphlet form for campaign purposes.[18] Meanwhile, Harpers finally printed *Red Men and White.*

Theodore Roosevelt's unqualified praise on one hand and Howells' cautious dislike on the other bracketed critical opinion of the work. Yet another measure of the book's success was the public attention it focused on Wister's own unusual life. No one could help seeing that the stories

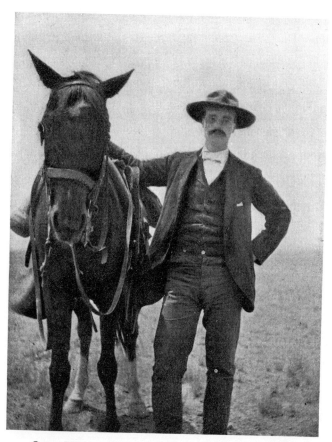

**Owen Wister and the "govt. hoss." This photograph
appeared in *The Bookman* with Nancy Huston Banks'
laudatory review of *Red Men and White*, providing a
target for Remington's irony.**

were not only historical but in a certain sense autobiographical as well.
Therefore, Wister soon became known not only as a writer, but also as
a Philadelphia gentleman, educated in Europe and at Harvard, who wrote
stories about the West *because* he had been there. In other words, *Red
Men and White*, quite apart from any literary merit it contained, turned
Wister into something of a celebrity. A December article for *The Book-
man* called the author "a product of Philadelphia's highest civilisation
for more than two hundred years" who came under "the spell of the
West" and subsequently succeeded better than anyone else in "com-

Dear Wis—

Just got the Book dealer — you & the
gvt. hoss - his head is bigger than yours
and that's a good sign—

Do you propose to dream with me
in the Rio Grande' ———?

Why Kant you come up here
any old Sunday—

yrs
Frederic Remington

municating the impression made by the great sand sea."[19] The article was accompanied by a photograph of Wister himself, wearing rumpled clothes and standing beside a cavalry mount.

Remington, planning a southwestern trip at New Rochelle, read *The Bookman* article with mixed feelings. Although he was glad to see a reviewer praising *Red Men and White*, he objected to the mincing remarks about Wister's biography. Yet the awkwardly posed photograph, showing Wister's serious face and the horse's side-by-side redeemed a great deal. Appearing next to the column of print in which Wister was called a "product of Philadelphia's highest civilisation," it said something Remington liked all the better for its being unintentional. The point of forgetting "the *things* we *know*" was precisely to leave "two hundred years" of Philadelphia behind forever:

Dear Wis—

Just got the Book dealer—you & the govt. hoss—his head is bigger than yours and that's a good sign—

Do you propose to dream with me on the Rio Grande—?

Why kant *you come up here any old Sunday—*

<div style="text-align:right">*yours*</div>

DECEMBER 1895 *Frederic Remington*

Remington's caricature of Wister, which appeared at the bottom of the sheet, wore a monocle and a comic frown in concession to Philadelphia gentility—but a strong, clear line held the whole thing fast to Frederic Remington's name.

La Tinaja Bonita.

by Owen Wister.

"And it came to pass after a while that the brook dried up, because there had been no rain in the land."–1 Kings, xvii. 7.

A PRETTY girl was kneeling on the roof of a flat mud cabin, a harvest of red peppers round her knees. On the ground below her stood a swarthy young man, the bloom on his Mexican cheeks rich and dusky, like her own. His face was irresponsible and winning, and his watching eyes shone upon her with admiration and desire. She on the roof was entertained by her visitor's attention, but unfavorable to it. Through the livelong sunny day she had parried his love-talk with light and complete skill, enjoying herself, and liking him very well, as she had done since they were two children playing together in the Arizona desert. She was quite mistress of the situation, because she was a woman, and he as yet merely a boy; he was only twenty-two; she was almost sixteen. The Mexican man at twenty-two may be as experienced as his Northern brother of thirty, but at sixteen the Mexican woman is also mature, and can competently deal with the man. So this girl had relished the thoughtless morning and noon as they passed; but twice lately she had glanced across the low tree-tops of her garden down the trail, where the cañon descended to the silent plain below.

"I think I must go back now," said the young man, not thinking so. He had a guitar from the cabin.

"Oh!" said she, to whom he was transparent. "Well, if you think it so late." She busied herself with the harvest. Her red handkerchief and strands of her black hair had fallen loosely together from her head to her shoulders. The red peppers were heaped thick, hiding the whole roof, and she stooped among them, levelling them to a ripening layer with buckskin gloves (for peppers sting sharper than mustard), sorting and turning them in the bright sun. The youth looked at her most wistfully.

"It is not precisely late—yet," said he.

"To be sure not," she assented, consulting the sky. "We have still three hours of day."

He brightened as he lounged against a water-barrel. "But after night it is so very dark on the trail to camp," he insincerely objected.

"I never could have believed you were afraid of the dark."

"It is for the horse's legs, Lolita. Of course I fear nothing."

"Bueno! I was sure of it. Do you know, Luis, you have become a man quite suddenly? That mustache will be beautiful in a few years. And you have a good figure."

"I am much heavier than last year," said he. "My arm—"

"I can see, I can see. I am not sure I shall let you kiss me any more. You didn't offer to when you came this morning—and that shows you men perceive things more quickly than we can. But don't go yet. You can lead your horse. His legs will come to no harm, eased of your weight. I should have been lonely to-day, and you have made it pass so quickly. You have talked so much that my peppers are not half spread."

"We could finish them in five minutes together," said the youth, taking a step.

"Two up here among all these peppers? Oh no, Luis. We should tread on them, and our ankles would burn all night. If you want to help me, go bring some fresh water. The barrel is almost empty."

But Luis stood ardently gazing up at the roof.

"Very well, then," said Lolita. "If you like this better, finish the peppers, and I'll go for the water."

"Why do you look down the trail so often?" said the baffled love-maker, petulantly.

"Because Uncle Ramon said the American would be coming to-day," the girl replied, softly.

"Was it Uncle Ramon said that? He told you that?"

"Why not?" She shaded her eyes, and looked where the cañon's widening slit gave view of a slant of sand merging fan-spread into a changeless waste of plain. Many watercourses, crooked and straight, came out of the gaps, creasing the sudden Sierra, descending to the flat through bushes and leaning margin trees; but in these empty shapes not a rill tinkled to refresh the silence, nor did a drop slide over the glaring rocks, or even dampen the heated cheating sand. Lolita strained her gaze at the dry distance, and stooped again to her harvest.

"What does he come here for?" demanded Luis.

"The American? We buy white flour of him sometimes."

"Sometimes! That must be worth his while! He will get rich!" Luis lounged back against his water-barrel, and was silent. As he watched Lolita, serenely working, his silver crescent ear-rings swung a little with the slight tilting of his head, and his fingers, forgotten and unguided by his thoughts, ruffled the strings of the guitar, drawing from it gay purposeless tendrils of sound. Occasionally, when Lolita knew the song, she would hum it on the roof, inattentively, busy rolling her peppers:

> "Soy purita mejicana;
> Nada tengo español."

("I am pure Mexican. I have nothing Spanish about me.") And this melodious inattention of Lolita's, Luis felt to be the extreme of slight.

"Have you seen him lately?" he asked, sourly.

"Not very. Not since the last time he came to the mines from Maricopa."

"I heard a man at Gun Sight say he was dead," snapped Luis.

But she made no sign. "That would be a pity," she said, humming gayly.

"Very sad. Uncle Ramon would have to go himself to Maricopa for that white flour."

Pleased with this remark, the youth took to song himself; and there they were like two mischievous birds. Only the bird on the ground was cross with a sense of failure. "El telele se murió," he sang.

> "The hunchback is dead.
> Ay! Ay! Ay!
> And no one could be found to bury him except—"

"Luis, aren't you going to get my water for me?"

"Poco tiempo: I'll bring it directly."

"You have to go to the Tinaja Bonita for it."

The Pretty Spring—or water-hole, or tank—was half a mile from the cabin.

"Well, it's not nice out there in the sun. I like it better in here, where it is pleasant.

> "And no one could be found to bury him except
> Five dragoons and a corporal
> And the sacristan's cat."

Singing resentfully, young Luis staid in here, where it was pleasant. Bright green branches of fruit trees and small cottonwoods and a fenced irrigated square of green growing garden hid the tiny adobe home like a nut, smooth and hard and dry in their clustered midst. The lightest air that could blow among these limber ready leaves set going at once their varnished twinkling round the house. Their white and dark sides gleamed and went out with chasing lights that quickened the torpid place into a holiday of motion. Closed in by this cool green, you did not have to see or think of Arizona, just outside; you could forget, and play at love-making, and be spiteful about hunchbacks.

"Where is Uncle Ramon to-day?" inquired Luis, dropping his music.

She sighed. "He has gone to drive our cattle to a new spring. There is no pasture at the Tinaja Bonita. Our streams and ditches went dry last week. They have never done so in all the years before. I don't know what is going to happen to us." The anxiety in the girl's face seemed to come outward more plainly for a moment, and then recede to its permanent abiding-place.

"There cannot be much water to keep flour-sellers alive on the trail to Maricopa," chirped the bird on the ground.

She made no answer to this. "What are you doing nowadays?" she asked.

"I have been working very hard on the wood contract for the American soldiers," he replied, promptly.

"By Tucson?"

"No. Huachuca."

"Away over there again? I thought you had cut all they wanted last May."

"It is of that enterprise of which I speak, Lolita."

"But it's October now!" Lolita lifted her face, ruddy with stooping, and broke into laughter.

"I do not see why you mock me. No one has asked me to work since."

"Have you asked any one for work?"

"It is not my way to beg."

"Luis, I don't believe you're quite a man yet, in spite of your mustache. You complain there's no money for Mexicans in Arizona because the Americans get it all. Why don't you go back to Sonora, then, and be rich in five minutes? It would sound finely: 'Luis Romero, Merchant, Hermosillo.' Or perhaps gold would fall more quickly into your lap at Guaymas. You would live in a big house, perhaps with two stories, and I would come and visit you at Easter—if your wife would allow it." Here Lolita threw a pepper at him.

The guitar grated a few pretty notes; otherwise there was silence.

"And it was Uncle Ramon persuaded them to hire you in May. He told the American contractor you owned a strong burro good for heavy loads. He didn't say much about you," added the little lady.

"Much good it did me! The American contractor-pig retained my wages to pay for the food he supplied us. They charge you extra for starvation, those gringos. They are all pigs. Ah, Lolita, a man needs a wife, so he may strive to win a home for her."

"I have heard men say that they needed a home before they could strive to win a wife for it. But you go about it the other way."

"I am not an American pig, I thank the Virgin! I have none of their gringo customs."

"You speak truly indeed," murmured Lolita.

"It is you who know about them," the boy said, angry like a child. He had seen her eye drawn to the trail again as by a magnet. "They say you prefer gringos to your own people."

"Who dares say that?"

The elated Luis played loudly on the guitar. He had touched her that time.

But Lolita's eye softened at the instant of speaking, and she broke into her sweet laugh. "There!" she said, recapturing the situation; "is it not like old times for you and me to be fighting?"

"Me? I am not fighting."

"You relieve me."

"I do not consider a gringo worth my notice."

"Sensible boy! You speak as wisely as one who has been to school in a large city. Luis, do you remember the day Uncle Ramon locked me up for riding on the kicking burro, and you came and unlocked me when uncle was gone? You took me walking, and lost us both in the mountains. We were really only a little, little way from home, but I thought we had got into another country where they eat children. I was six, and I beat you for losing me, and cried, and you were big, and you kissed me till I stopped crying. Do you remember?"

"No."

"Don't you remember?"

"I don't remember child's tricks."

"Luis, I have come to a conclusion. You are still young enough for me to kiss quite safely. Every time you fight with me—I shall kiss you. Won't you get me some fresh water now?"

He lounged, sulky, against his barrel.

"Come, querido! Must I go all that way myself? Well, then, if you intend to stand and glare at me till the moon rises— Ah! he moves!"

Luis laid the guitar gradually down, and gradually lifting a pail in which the dipper rattled with emptiness, he proceeded to crawl on his journey.

"You know that is not the one we use, muchacho, little boy," remarked Lolita.

"Keep your kisses for your gringo," the water-carrier growled, with his back to her.

"I shall always save some for my little cousin."

The pail clattered on the stones, and the child stopped crawling. She on the roof stared at this performance for an open-mouthed moment, gloves idle among the spicy peppers. Then, laughing, she sprang to her feet, descended, and catching up the water-jar, the olla de agua, overtook him, and shook it in his face with the sweetest derision. "Now we'll go together," said she, and started gayly through the green trees and the garden. He followed her, two paces behind, half ashamed, and gazing at her red handkerchief, and the black hair blowing a little; thus did they cross the tiny cool home acre through the twinkling pleasantness of the leaves, and pass at once outside the magic circle of irrigation into Arizona's domain, among a prone herd of carcasses upon the ground. Dead cattle, two seasons dead now, hunted to this sanctuary by the drought, killed in the sanctuary by cold water.

A wise quiet man, with a man's will, may sometimes after three days of thirst still hold grip enough upon his slipping mind to know, when he has found the water, that he must not drink it, must only dampen his lips and tongue in a drop-by-drop fashion until he has endured the passing of many slow insidious hours. Even a wise man had best have a friend by his side then, who shall fight and tear him from the perilous excesses that he craves, knock him senseless if he cannot pin him down; but cattle know nothing of drop by drop, and you cannot pin down a hundred head that have found water after three days. So

these hundred had drunk themselves swollen, and died. Cracked hide and white bone they lay, brown, dry, gaping humps straddled stiff askew in the last convulsion; and over them presided Arizona—silent, vast, all sunshine everlasting.

Luis saw these corpses that had stumbled to their fate, and he remembered; with Lolita in those trees all day, he had forgotten for a while. He pointed to the wide-strewn sight, familiar, monotonous as misfortune. "There will be many more," he said. "Another rainy season is gone without doing anything for the country. It cannot rain now for another year, Lolita."

"God help us and our cattle, and travellers!" she whispered.

Luis musingly repeated a saying of the country about the Tinaja Bonita,

> "When you see the Black Cross dry,
> Fill the wagon cisterns high"

—a doggerel in homely Spanish metre, unwritten mouth-to-mouth wisdom, stable as a proverb, enduring through generations of unrecorded wanderers, that repeated it for a few years, and passed beneath the desert.

"But the Black Cross has never been dry yet," Luis said.

"You have not seen it lately," said Lolita.

"Lolita! do you mean—" He looked in her troubled eyes, and they went on in silence together. They left behind them the bones and the bald level on which they lay, and came to where the cañon's broader descent quickened until they sank below that sight of the cattle, and for a while below the home and trees. They went down steeply by cactus and dry rock to a meeting of several cañons opening from side rifts in the Sierra, furrowing the main valley's mesa with deep watercourses that brought no water. Finding their way in this lumpy meeting-ground, they came upon the lurking place of the Tinaja Bonita. They stood above it at the edge of a pitch of rock, watching the motionless crystal of the pool.

"How well it hides down there in its own cañon!" said Luis. "How pretty and clear! But there's plenty of water, Lolita."

"Can you see the Black Cross?"

"Not from here."

They began descending around the sides of the crumbled slate-rock face that tilted too steep for foothold.

"The other well is dry, of course," said Lolita. In the slaty, many-ledged formation a little lower down the cañon, towards the peep of outlying open country which the cloven hills let in, was a second round hole, twin of the first. Except after storms, water was never in this place, and it lay dry as a kiln nine-tenths of the year. But in size and depth and color, and the circular fashion of its shaft, that seemed man's rather than nature's design, it might have been the real Tinaja's reflection, conjured in some evil mirror that gave all of its likeness except alone the living water that made it precious.

"It must have been a real well once," said Luis.

"Once, yes."

"And what made it go dry?"

"Who knows?"

"How strange it should be the lower well that failed, Lolita!"

The boy and girl were climbing down slowly, drawing near each other as they reached the bottom of the hollow. The peep of open country was blocked, and the tall tops of the mountains were all of the outer world they could see, choked in down here below the mesa's level, amid a silence more ancient than the spheres.

"Do you believe it ever can go dry?" asked Luis. They were now on the edge of the Tinaja.

"Father Rafael says that it is miraculous," said the girl, believingly.

Opposite, and everywhere except where they were, the walls went sheer down, not slate-colored, but white, with a sudden upcropping formation of brick-shaped stones. These also were many-layered and crumbling, cracking off into the pool if the hand hung or the foot weighed on them. No safe way went to the water but at this lower side, where the riven, tumbled white blocks shelved easily to the bottom; and Luis and Lolita looked down these natural stairs at the portent in the well. In that white formation shot up from the earth's bowels, arbitrary and irrelevant amid the surrounding alien layers of slate, four black stones were lodged as if built into the wall by some hand—four small stones shaping a cross, black against the white, symmetrical and plain beyond need of imagination.

"It has come further—more uncovered since yesterday," Lolita whispered.

"Can the Tinaja sink altogether?" repeated Luis. The arms of the cross were a measurable space above the water-line, and he had always seen it entirely submerged.

"How could it sink?" said Lolita, simply. "It will stop when the black stones are wholly dry."

"You believe Father Rafael," Luis said, always in a low voice; "but it was only Indians, after all, who told the mission fathers at the first."

"That was very long ago," said she, "and there has always been water in the Tinaja Bonita."

Boy and girl had set the jar down, and forgotten it and why they had come. Luis looked uneasily at the circular pool, and up from this creviced middle of the cañon to the small high tops of the mountains rising in the free sky.

"This is an evil place," he said. "As for the water—no one, no three, can live long enough to be sure."

But it was part of Lolita's religion. "I am sure," said she.

The young Mexican's eyes rested on the face of the girl beside him, more beautiful just then with some wave of secret fear and faith.

"Come away with me, Lolita!" he pleaded, suddenly. "I can work. I can be a man. It is fearful for you to live here alone."

"Alone, Luis?" His voice had called her from her reverie back to her gay, alert self. "Do you consider Uncle Ramon nobody to live with?"

"Yes. Nobody—for you."

"Promise me never to tell that to uncle. He is so considerate that he might make me marry somebody for company. And then, you know, my husband would be certain to be stupid about your coming to see me, querido."

"Why do you always mock me, Lolita?"

"Mock you? What a fancy! Oh, see how the sun's going! If we do not get our water, your terrible Tinaja will go dry before supper. Come, Luis, I carried the olla. Must I do everything?"

He looked at her disconsolate. "Ah!" he vibrated, revelling in deep imaginary passion.

"Go! go!" she cried, pushing him. "Take your olla."

Upon any passing puff of sentiment the Southern breast can heave with every genuine symptom of storm except wreck. Of course she stirred his gregarious heart. Was she not lovely and he twenty-two? He went down the natural stairs and came slowly up with the water, stopping a step below her. "Lolita," he said, "don't you love me at all? not a very little?"

"You are my dearest, oldest friend, Luis," she said, looking at him with such full sweetness that his eyes fell. "But why do you pretend five beans make ten?"

"Of course they only make ten with gringos."

She held up a warning finger.

"Oh yes, oh yes! Strangers make fine lovers!" With this he swelled to a fond, dangerous appearance, and muttered, "It is not difficult to kill a man, Lolita."

"Fighting! after what I told you!" Lolita stooped and kissed her cousin Luis, and he instantly made the most of that chance.

"As often as you please," he said, as she released herself angrily, and then a stroke of sound struck their two hearts still. They jumped apart, trembling. Some of the rock slide had rattled down and plunged into the Tinaja with a gulping resonance. Loitering strings of sand strewed after it, and the boy's and girl's superstitious eyes looked up from the ringed waving water to the ledge. Lolita's single shriek of terror turned to joy as she uttered it.

"I thought—I thought you would not come!" she cried out.

The dismounted horseman above made no sign of understanding her words. He stepped carefully away from the ledge his foot had crumbled, and they saw him using his rifle like a staff, steadying its stock in successive niches, and so working back to his horse. There he slid the rifle into its leather sling along the left side of his saddle.

"So he is not dead," murmured Luis, "and we need not live alone."

"Come down!" the girl called, and waved her hand. But the new-comer stood by his horse like an apparition.

"Perhaps he is dead, after all," Luis said. "You might say some of the Mass, only he was a heretic. But his horse is Mexican and a believer."

Lolita had no eyes or ears for Luis any more. He prattled away on the stone stairs of the Tinaja, elated into flippancy after a piercing shock of fear. To him, unstrung by the silence and the Black Cross and the presence of the sinking pool, the stone had crashed like a clap of sorcery, and he had started and stared to see—not a spirit, but a man, dismounted from his horse, with a rifle. At that his heart clutched him like talons, and in the flashing spasm of his mind came a picture—smoke from the rifle, and himself bleeding in the dust. Costly love-making! But why else that rifle on the ledge? For a staff merely? Luis thanked the Virgin for the stone that fell and frightened him. He had chattered himself cool now, and ready. Lolita was smiling at the man on the hill, glowing without concealment of her heart's desire.

"Come down!" she repeated. "Come round the side." And lifting the olla, she tapped it, and signed the way to him.

"He has probably brought too much white flour for Uncle Ramon to care to climb more than he must," said Luis. But the man had stirred at last from his sentinel stillness, and began leading his horse down. Presently he was near enough for Luis to read his face. "Your gringo is a handsome fellow certainly," he commented. "But he does not like me to-day."

"Like you? He doesn't think about you," said Lolita.

"Ha! That's your opinion?"

"It is also his opinion—if you'll ask him."

"He is afraid of Cousin Luis," stated the youth.

"Cousin grasshopper! He could eat you—if he could see you."

"There are other things in this world besides brute muscle, Lolita. Your gringo thinks I am worth notice, if you do not."

"How little he knows you!"

"It is you he does not know very well," the boy said, with a pang.

The scornful girl stared.

"Oh, the innocent one!" sneered Luis. "Grasshopper, indeed! Well, one man can always recognize another, and the women don't know much."

But Lolita had run off to meet her chosen lover. She did not stop to read his face. He was here; and as she hurried towards him she had no thought except that he was come at last. She saw his eyes and lips, and to her they were only the eyes and lips that she had longed for. "You have come just in time," she called out to him. At the voice, he looked at her one instant, and looked away; but the nearer sight of her sent a tide of scarlet across his face. His actions he could control, his bearing, and the steadiness of his speech, but not the coursing of his blood. It must have been a minute he had stood on the ledge above, getting a grip of himself. "Luis was becoming really afraid that he might have to do some work," continued Lolita, coming up the stony

hill. "You know Luis!"

"I know him."

"You can fill your two canteens and carry the olla for us," she pursued, arriving eagerly beside him, her face lifted to her strong tall lover.

"I can."

At this second chill of his voice, and his way of meeting her when she had come running, she looked at him bewildered, and the smile fluttered on her lips and left them. She walked beside him, talking no more; nor could she see his furtive other hand mutely open and shut, helping him keep his grip.

Luis also looked at the man who had taken Lolita's thoughts away from him and all other men. "No, indeed, he does not understand her very well," he repeated, bitter in knowing the man's suspicion and its needlessness. Something —disappointment, it may be—had wrought more reality in the young Mexican's easy-going love. "And she likes this gringo because—because he is light-colored!" he said, watching the American's bronzed Saxon face, almost as young as his own, but of sterner stuff. Its look left him no further doubt, and he held himself forewarned. The American came to the bottom, powerful, blue-eyed, his mustache golden, his cheek clean-cut, and beaten to shining health by the weather. He swung his blue-overalled leg over his saddle and rode to the Tinaja, with a short greeting to the watcher, while the pale Lolita unclasped the canteen straps and brought the water herself, brushing coldly by Luis to hook the canteens to the saddle again. This slighting touch changed the Mexican boy's temper to diversion and malice. Here were mountains from mole-hills! Here were five beans making ten with a vengeance!

"Give me that," said the American; and Luis handed up the water-jar to him with such feline politeness that the American's blue eye filled with fire and rested on him for a doubtful second. But Luis was quite ready, and more diverted than ever over the suppressed violence of his Saxon friend. The horseman wheeled at once, and took a smooth trail out to the top of the mesa, the girl and boy following.

As the three went silent up the cañon, Luis caught sight of Lolita's eyes shining with the hurt of her lover's rebuff, and his face sparkled with further mischief. "She has been despising me all day," he said to himself. "Very well, very well.—Señor Don Ruz," he speechified aloud, elaborately, "we are having a bad drought."

The American rode on, inspecting the country.

"I know at least four sorts of kisses," reflected the Mexican trifler. "But there! very likely to me also they would appear alike from the top of a rock." He looked the American over, the rifle under his leg, his pistol, and his knife. "How clumsy these gringos are when it's about a girl!" thought Luis. "Any fool could fool them. Now I should take much care to be friendly if ever I did want to kill a man in earnest. Comical gringo!—Yes, very dry weather, Don Ruz. And

the rainy season gone!"

The American continued to inspect the country, his supple, flannel-shirted back hinting no interest in the talk.

"Water is getting scarce, Don Ruz," persisted the gadfly, lighting again. "Don Ramon's spring does not run now, and so we must come to the Tinaja Bonita, you see. Don Ramon removed the cattle yesterday. Everybody absent from home, except Lolita." Luis thought he could see his Don Ruz listening to that last piece of gossip, and his smile over himself and his skill grew more engaging. "Lolita has been telling me all to-day that even the Tinaja will go dry."

"It was you said that!" exclaimed the brooding, helpless Lolita.

"So I did. And it was you said no. Well, we found something to disagree about." The gadfly was mirthful now at the expression of the flannel shirt. "No sabe cuantos son cinco," he whispered, stepping close to Lolita. "Your gringo could not say boo to a goose just now." Lolita drew away from her cousin, and her lover happened to turn his head slightly, so that he caught sight of her drawing away. "But what do you say yourself, Don Ruz?" inquired Luis, pleased at this slight coincidence—"will the Tinaja go dry, do you think?"

"I expect guessing won't interfere with the water's movements much," finally remarked Don Ruz—Russ Genesmere. His drawl and the body in his voice were not much like the Mexican's light fluency. They were music to Lolita, and her gaze went to him once more, but got no answer. The bitter Luis relished this too.

"You are right, Don Ruz. Guessing is idle. Yet how can we help wondering about this mysterious Tinaja? I am sure that you can never have seen so much of the cross out of water. Lolita says—"

"So that's that place," said Genesmere, roughly.

Luis looked inquiring.

"Down there," Genesmere explained, with a jerk of his head back along the road they had come.

Luis was surprised that Don Ruz, who knew this country so well, should never have seen the Tinaja Bonita until to-day.

"I'd have seen it if I'd had any use for it," said Genesmere.

"To be sure, it lay off the road of travel," Luis assented. And of course Don Ruz knew all that was needful—how to find it. He knew what people said—did he not? Father Rafael, Don Ramon, everybody? Lolita perhaps had told him? And that if the cross ever rose entirely above the water, that was a sign all other water-holes in the region were empty. Therefore it was a good warning for travellers, since by it they could judge how much water to carry on a journey. But certainly he and Lolita were surprised to see how low the Tinaja had fallen to-day. No doubt what the Indians said about the great underground snake that came and sucked all the wells dry in the lower country, and in consequence was nearly satisfied before he reached the Tinaja, was untrue.

To this tale of Jesuits and peons the American listened with unexpressed con-
tempt, caring too little to mention that he had heard some of it before, or even
to say that in the last few days he had crossed the desert from Tucson and
found water on the trail as usual where he expected. He rode on, leading the
way slowly up the cañon, suffering the glib Mexican to talk unanswered. His
own suppressed feelings still smouldered in his eye, still now and then knotted
the muscles in his cheeks; but of Luis's chatter he said his whole opinion in
one word, a single English syllable, which he uttered quietly for his own benefit.
Luis, however, understood that order of English, and, overhearing, was glad,
and commended himself for playing so tellingly the lover who but ill conceals
his successes. He would sustain this part to a last delicate finish.

They passed through the hundred corpses to the home and the green trees,
where the sun was setting against the little shaking leaves.

"So you will camp here to-night, Don Ruz?" said Luis, perceiving the American's
pack-mules. Genesmere had come over from the mines at Gun Sight, found
the cabin empty, and followed Lolita's and her cousin's trail, until he had suddenly
seen the two from that ledge above the Tinaja. "You are always welcome to
what we have at our camp, you know, Don Ruz. All that is mine is yours also.
To-night it is probably frijoles. But no doubt you have white flour here." He
was giving his pony water from the barrel, and next he threw the saddle on
and mounted. "I must be going back, or they will decide I am not coming
till tomorrow, and quickly eat my supper." He spoke jauntily from his horse,
arm akimbo, natty short jacket put on for to-day's courting, gray steeple-hat
silver-embroidered, a spruce pretty boy, not likely to toil severely at wood contracts
so long as he could hold soul and body together and otherwise be merry, and
the hand of that careless arm soft on his pistol, lest Don Ruz should abruptly
dislike him too much; for Luis contrived a tone for his small-talk that would
have disconcerted the most sluggish, sweet to his own mischievous ears, healing
to his galled self-esteem. "Good-night, Don Ruz. Good-night, Lolita. Perhaps
I shall come tomorrow, mañana en la mañana."

"Good-night," said Lolita, harshly, which increased his joy; "I cannot stop
you from passing my house."

Genesmere said nothing, but sat still on his white horse, hands folded upon
the horns of his saddle, and Luis, always engaging and at ease, ambled away
with his song about the hunchback. He knew that the American was not the
man to wait until his enemy's back was turned.

> "El telele se murió
> A enterrar ya le llevan—"

The tin-pan Mexican voice was empty of melody and full of rhythm.

> "Ay! Ay! Ay!"

Lolita and Genesmere stood as they had stood, not very near each other,
looking after him and his gayety that the sun shone bright upon. The minstrel

truly sparkled. His clothes were more elegant than the American's shirt and overalls, and his face luxuriant with thoughtlessness. Like most of his basking Southern breed, he had no visible means of support, and nothing could worry him for longer than three minutes. Frijoles do not come high, out-of-doors is good enough to sleep in if you or your friend have no roof, and it is not a hard thing to sell some other man's horses over the border and get a fine coat and hat.

> "Cinco dragones y un cabo,
> Oh, no no no no no!
> Y un gato de sacristan."

Coat and hat aere getting up the cañon's side among the cactus, the little horse climbing the trail shrewdly with his light-weight rider; and dusty unmusical Genesmere and sullen Lolita watched them till they went behind a bend, and nothing remained but the tin-pan song singing in Genesmere's brain. The gadfly had stung more poisonously than he knew, and still Lolita and Genesmere stood watching nothing, while the sun—the sun of Arizona at the day's transfigured immortal passing—became a crimson coal in a lake of saffron, burning and beating like a heart, till the desert seemed no longer dead, but only asleep, and breathing out wide rays of rainbow color that rose and expanded over earth and sky.

Then Genesmere spoke his first volunteered word to Lolita. "I didn't shoot because I was afraid of hitting you," he said.

So now she too realized clearly. He had got off his horse above the Tinaja to kill Luis during that kiss. Complete innocence had made her stupid and slow.

"Are you going to eat?" she inquired.

"Oh yes. I guess I'll eat."

She set about the routine of fire-lighting and supper as if it had been Uncle Ramon, and this evening like all evenings. He, not so easily, and with small blunderings that he cursed, attended to his horse and mules, coming in at length to sit against the wall where she was cooking.

"It is getting dark," said Lolita. So he found the lamp and lighted it, and sat down again.

"I've never hurt a woman," he said presently, the vision of his rifle's white front sight held steady on the two below the ledge once more flooding his brain. He spoke slowly.

"Then you have a good chance now," said Lolita, quickly, busy over her cooking. In her Southern ears such words sounded a threat. It was not in her blood to comprehend this Northern way of speaking and walking and sitting, and being one thing outside and another inside.

"And I wouldn't hurt a woman"—he was hardly talking to her—"not if I could think in time."

"Men do it," she said, with the same defiance. "But it makes talk."

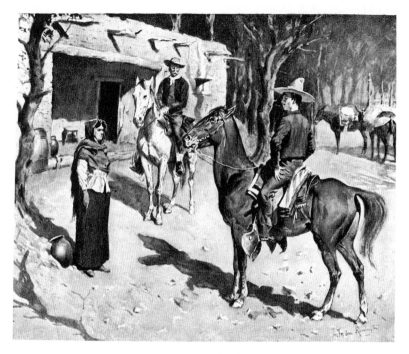

"GOOD NIGHT! PERHAPS I SHALL COME TO-MORROW."

"Talk's nothing to me," said Genesmere, flaming to fierceness. "Do I care for opinions? Only my own." The fierceness passed from his face, and he was remote from her again. Again he fell to musing aloud, changing from Mexican to his mother-tongue. "I wouldn't want to have to remember a thing like that." He stretched himself, and leaned his elbows on his knees and his head in his hands, the yellow hair hiding his fingers. She had often seen him do this when he felt lazy; it was not a sign by which she could read a spiritual standstill, a quivering wreck of faith and passion. "I have to live a heap of my life alone," the lounger went on. "Journey alone. Camp alone. Me and my mules. And I don't propose to have thoughts a man should be ashamed of." Lolita was throwing a cloth over the table and straightening it. "I'm twenty-five, and I've laid by no such thoughts yet. Church folks might say different."

"It is ready," said Lolita, finishing her preparations.

He looked up, and seeing the cloth and the places set, pulled his chair to the table, and passively took the food she brought him. She moved about the room between shelves and fire, and when she had served him, seated herself at leisure to begin her own supper. Uncle Ramon was a peon of some substance, doing business in towns and living comparatively well. Besides the shredded

spiced stew of meat, there were several dishes for supper. Genesmere ate the meal deliberately, attending to his plate and cup, and Lolita was as silent as himself, only occasionally looking at him; and in time his thoughts came to the surface again in words. He turned and addressed Lolita in Mexican: "So, you see, you saved his life down there."

She laid her fork down and gave a laugh, hard and harsh; and she said nothing, but waited for what next.

"You don't believe that. You don't know that. He knows that."

She laughed again, more briefly.

"You can tell him so from me."

Replies seemed to struggle together on Lolita's lips and hinder each other's escaping.

"And you can tell him another thing. He wouldn't have stopped. He'd have shot. Say that. From me. He'd have shot, because he's a Spaniard, like you."

"You lie!" This side issue in some manner set free the girl's tongue. "I am not Spanish. I care nothing for Spaniards or what they may do. I am Mexican, and I waited to see you kill him. I wanted to watch his blood. But you! you listened to his false talk, and believed him, and let him go. I save his life? Go after him now! Do it with this knife, and tell him it is Lolita's. But do not sit there and talk any more. I have had enough of men's talk to-day. Enough, enough, enough!"

Genesmere remained in his chair, while she had risen to her feet. "I suppose," he said, very slowly, "that folks like you folks can't understand about love—not about the kind I mean."

Lolita's two hands clinched the edge of the table, and she called upon her gods. "Believe it, then! Believe it! And kill me, if that will make you contented. But do not talk any more. Yes, he told me that he loved me. Yes, I kissed him; I have kissed him hundreds of times, always, since before I can remember. And I had been laughing at him to-day, having nothing in my heart but you. All day it had rejoiced me to hear his folly and think of you, and think how little he knew, and how you would come soon. But your folly is worse. Kill me in this house to-night, and I will tell you, dying, that I love you, and that it is you who are the fool."

She looked at her lover, and seeing his face and eyes she had sought to bring before her in the days that she had waited for him, she rushed to him.

"Lolita!" he whispered. "Lolita!"

But she could only sob as she felt his arms and his lips. And when presently he heard her voice again murmuring brokenly to him in the way that he knew and had said over in his mind and dwelt upon through the desert stages he had ridden, he trembled, and with savage triumph drew her close, and let his doubt and the thoughts that had chilled and changed him sink deep beneath the flood of this present rapture. "My life!" she said. "Toda mi vida. All my

life!" Through the open door the air of the cañon blew cool into the little room that the fire and the lamp oppressed, and in time they grew aware of the endless rustling of the trees, and went out and stood in the darkness together, until it ceased to be darkness, and their eyes could discern the near and distant shapes of their world. The sky was black and splendid, with four or five planets too bright for lesser stars to show, and the promontories of the keen mountains shone almost as in moonlight. A certain hill down towards the Tinaja and its slate ledge caught Genesmere's eye, and Lolita felt him shudder, and she wound her arm more tightly about him.

"What is it?" she said.

"Nothing." He was staring at the hill. "Nothing," he replied to himself.

"Dreamer, come!" said Lolita, pulling him. "It is cold here in the night—and if you choose to forget, I choose you shall remember."

"What does this girl want now?"

"The cards! our cards!"

"Why, to be sure!" He ran after her, and joy beat in her heart at the fleet kiss he tried for and half missed. She escaped into the room, laughing for delight at her lover's being himself again—his own right self that she talked with always in the long days she waited alone.

"Take it!" she cried out, putting the guitar at him so he should keep his distance. "There! now you have broken it, songless Americano! You shall buy me another." She flung the light instrument, that fell in a corner with a loud complaint of all the strings together, collapsing to a blurred hollow humming, and silence.

"Now you have done it!" said Genesmere, mock serious.

"I don't care. I am glad. He played on that to-day. He can have it, and you shall give me a new one. 'Yo soy purita mejicana; nada tengo español,' " sang the excited, breathless Lolita to her American, and seated herself at the table, beginning a brisk shuffle of a dim, dog-eared pack. "You sit there!" She nodded to the opposite side of the table. "Very well, move the lamp, then." Genesmere had moved it because it hid her face from him. "He thinks I cheat! Now, Señor Don Ruz, it shall be for the guitar. Do you hear?"

"Too many pesos, señorita."

"Oh, oh! the miser!"

"I'm not going broke on any señoritas—not even my own girl!"

"Have you no newer thing than poverty to tell me? Now if you look at me like that I cannot shuffle properly."

"How am I to look, please?" He held his glance on her.

"Not foolish like a boy. There, take them, then!" She threw the cards at him, blushing and perturbed by his eyes, while he scrambled to punish her across the table.

"Generous one!" she said. "Ardent pretender! He won't let me shuffle because

he fears to lose."

"You shall have a silk handkerchief with flowers on it," said he, shuffling.

"I have two already. I can see you arranging those cards, miser!"

It was the custom of their meetings, whether at the cabin or whether she stole out to his camp, to play for the token he should bring for her when he next came from town. She named one thing, he some other, and the cards judged between them. And to see Genesmere in these hours, his oldest friend could not have known him any more than he knew himself. Never had a woman been for him like Lolita, conjuring the Saxon to forget himself and bask openly in that Southern joy and laughter of the moment.

"Say my name!" he ordered; and at the child effort she made over "Russ" he smiled with delight. "Again!" he exclaimed, bending to catch her *R* and the whole odd little word she made. "More!"

"No," pouted the girl, and beat at him, blushing again.

"Make your bet!" he said, laying out the Mexican cards before him. "Quick! Which shall it be?"

"The caballo. Oh, my dear, I wanted to die this afternoon, and now I am so happy!"

It brought the tears to her eyes, and almost to his, till he suddenly declared she had stolen a card, and with that they came to soft blows and laughing again. So did the two sit and wrangle, seizing the pack out of turn, feigning rage at being cheated, until he juggled to make her win three times out of five; and when chance had thus settled for the guitar, they played for kisses, and so forgot the cards at last. And at last Genesmere began to speak of the next time, and Lolita to forbid such talk as that so soon. She laid her hand over his lips, at which he yielded for a little, and she improvised questions of moment to ask him, without time for stopping, until she saw that this would avail no longer. Then she sighed, and let him leave her to see to his animals, while she lighted the fire again to make breakfast for him. At that parting meal an anxiety slowly came in her face, and it was she that broke their silence after a while.

"Which road do you go this time, querido?" she asked.

"Tucson, Maricopa, and then straight here to you."

"From Maricopa? That is longer across the desert."

"Shorter to my girl."

"I—I wish you would not come that way."

"Why?"

"That—that desert!"

"There's desert both ways—all ways. The other road puts an extra week between you and me."

"Yes, yes. I have counted."

"What is all this, Lolita?"

Once more she hesitated, smiling uneasily beneath his scrutiny. "Yo no sé. I don't know. You will laugh. You do not believe the things that I believe. The Tinaja Bonita—"

"That again!"

"Yes," she half whispered. "I am afraid."

He looked at her steadily.

"Return the same road by Tucson," she urged. "That way is only half so much desert, and you can carry water from Poso Blanco. Do not trust the Coyote Wells. They are little and shallow, and if the Black Cross— Oh, my darling, if you do not believe, do this for me because you love me, love me!"

He did not speak at once. The two had risen, and stood by the open door, where the dawn was entering and mixing with the lamp. "Because I love you," he repeated at length, slowly, out of his uncertain thoughts.

She implored him, and he studied her in silence.

Suddenly hardness stamped his face. "I'll come by Tucson, then—since I love you!" And he walked at once out of the door. She followed him to his horse, and there reached up and pulled him round to her, locking her fingers behind his neck. Again his passion swept him and burned the doubt from his eyes. "I believe you love me!" he broke out.

"Ah, why need you say that?"

"Adios, chiquita." He was smiling, and she looked at his white teeth and golden mustache. She felt his hands begin to unlock her own.

"Not yet—not yet!"

"Adios, chiquita."

"O mi querido!" she murmured; "with you I forget day and night!"

"Bastante!" He kissed her once for all.

"Good-by! good-by! Mis labios van estar frios hasta que tu los toques otra vez. My lips will be cold until you touch them again."

He caught her two hands, as if to cling to something. "Say that once more. Tell me that once more."

She told him with all her heart and soul, and he sprang into his saddle. She went beside him through the cold pale-lighted trees to the garden's edge, and there stood while he took his way across the barren ground among the carcasses. She watched the tip of his mustache that came beyond the line of his cheek, and when he was further, his whole strong figure, while the clack of the hoofs on the dead ground grew fainter. When the steeper fall of the cañon hid him from her she ran to the house, and from its roof among her peppers she saw him come into sight again below, the wide foreshortened slant of ground between them, the white horse and dark rider and the mules, until they became a mere line of something moving, and so vanished into the increasing day.

Genesmere rode, and took presently to smoking. Coming to a sandy place, he saw prints of feet and of a shod horse in the trail heading the other way.

That was his own horse, and the feet were Lolita's and Luis's—the record and the memory of yesterday afternoon. He looked up from the trail to the hills, now lambent with violet and shifting orange, and their shapes as they moved out into his approaching view were the shapes of yesterday afternoon. He came soon to the forking of the trails, one for Tucson, and the other leading down into the lumpy country, and here again were the prints in the sand, the shod horse, the man and the woman, coming in from the lumpy country that lay to the left; and Genesmere found himself stock-still by the forking trails, looking at his watch. His many-journeyed mules knew which was the Tucson trail, and not understanding why he turned them from their routine, walked asunder, puzzled at being thus driven in the wrong direction. They went along a strange up-and-down path, loose with sliding stones, and came to an end at a ledge of slate, and stood about on the tricky footing looking at their master and leaning their heads together. The master sat quiet on his horse, staring down where a circular pool lay below; and the sun rose everywhere, except in his mind. So far had he come yesterday with that mind easy over his garnered prosperity, free and soaring on its daily flight among the towers of his hopes—those constructions that are common with men who grow fond: the air-castle rises and reaches, possessing the architect, who cherishes its slow creation with hourly changes and additions to the plan. A house was part of Genesmere's castle, a home with a wife inside, and no more camping alone. Thus far, to this exact ledge, the edifice had gone forward fortunately, and then a blast had crumbled house and days to come into indistinguishable dust. The heavy echo jarred in Genesmere, now that he had been lured to look again upon the site of the disaster, and a lightning violence crossed his face. He saw the two down there as they had stood, the man with his arms holding the woman, before the falling stone had startled them. Were the Mexican present now in the flesh, he would destroy him just for what he had tried to do. If she were true— She was true—that was no thanks to the Mexican. Genesmere was sorry second thoughts had spared that fellow yesterday, and he looked at his watch again. It was time to be starting on the Tucson trail, and the mules alertly turned their steps from the Tinaja Bonita. They could see no good in having come here. Evidently it was not to get water. Why, then? What use was there in looking down a place into a hole? The mules gave it up. Genesmere himself thought the Tinaja poorly named. It was not pretty. In his experience of trail and cañon he knew no other such hole. He was not aware of the twin, dried up, thirty yards below, and therefore only half knew the wonders of the spot.

He rode back to the forks across the rolling steepness, rebuilding the castle; then, discovering something too distant to be sure about, used his glass quickly. It was another rider, also moving slowly among the knolls and gullies of the mesa, and Genesmere could not make him out. He was going towards the cabin, but it was not the same horse that Luis had ridden yesterday. This proved nothing,

and it would be easy to circle and see the man closer—only not worth the trouble. Let the Mexican go to the cabin. Let him go every day. He probably would, if she permitted. Most likely she would tell him to keep away from her. She ought to. She might hurt him if he annoyed her. She was a good shot with a pistol. But women work differently from men—and then she was Mexican. She might hide her feelings and make herself pleasant for three weeks. She would tell him when he returned, and they would laugh together over how she had fooled this Luis. After all, shooting would have been too much punishment. A man with a girl like Lolita must expect to find other men after her. It depends on your girl. You find that out when you go after other men's girls. When a woman surely loves some other man she will not look at you. And Lolita's love was a sure thing. A woman can say love and a man will believe her—until he has experienced the genuine article once; after that he can always tell. And to have a house, with her inside waiting for you! Such a turn was strange luck for a man, not to be accounted for. If anybody had said last year—why, as late as the 20th of last March—that settling down was what you were coming to—and now— Genesmere wondered how he could ever have seen anything in riding a horse up and down the earth and caring nothing for what next. "No longer alone!" he said aloud, suddenly, and surprised the white horse.

The song about the hunchback and the sacristan's cat stirred its rhythm in his mind. He was not a singer, but he could think the tune, trace it, naked of melody, in the dry realm of the brain. And it was a diversion to piece out the gait of the phantom notes, low after high, quick after slow, until they went of themselves. Lolita would never kiss Luis again; would never want to—not even as a joke. Genesmere turned his head back to take another look at the rider, and there stood the whole mountains like a picture, and himself far out in the flat country, and the bare sun in the sky. He had come six miles on the road since he had last noticed. Six miles, and the air-castle was rebuilt and perfect, with no difference from the old one except its foundation, which was upon sand. To see the unexpected plain around him, and the islands of blue sharp peaks lying in it, drove the tune from his head, and he considered the well-known country, reflecting that man could not be meant to live here. The small mountain-islands lay at all distances, blue in a dozen ways, amid the dead calm of this sand archipelago. They rose singly from it, sheer and sudden, toothed and triangled like icebergs, hot as stoves. The channels to the north, Santa Rosa way, opened broad and yellow, and ended without shore upon the clean horizon, and to the south narrowed with lagoons into Sonora. Genesmere could just see one top of the Sierra de la Quitabac jutting up from below the earthline, splitting the main channel, the faintest blue of all. They could be having no trouble over their water down there, with the Laguna Esperanca and the Poso de Mazis. Genesmere killed some more of the way rehearsing the trails and waterholes of this country, known to him like his pocket; and

by-and-by food-cooking and mule-feeding and the small machine repetitions of a camp and a journey brought the Quijotoa Mountains behind him to replace Gun Sight and the Sierra de la Naril; and later still the Cababi hid the Quijotoa, and Genesmere counted days and nights to the good, and was at the Coyote Wells.

These were holes in rocks, but shallow, as Lolita said. No shallower than ordinary, however; he would see on the way back if they gave signs of failing. No wonder if they did, with this spell of drought—but why mix up a plain thing with a lot of nonsense about a black cross down a hole? Genesmere was critically struck with the words of the tune he now noticed steadily running in his head again, beneath the random surface of his thoughts. "Cinco dragones y un cabo y un gato de sacristan." That made no sense either; but Mexicans found something in it. Liked it. Now American songs had some sense:

> "They bathed his head in vinegar
> To fetch him up to time,
> And now he drives a mule team on
> The Denver City line."

A man could understand that. A proud stage-driver makes a mistake about

"BUSINESS AND PLEASURE WERE WAITING IN TUCSON."

a female passenger. Thinks he has got an heiress, and she turns out to peddle sarsaparilla. "So he's naturally used up," commented Genesmere. "You estimate a girl as one thing, and she—" Here the undercurrent welled up, breaking the surface. "Did she mean that? Was that her genuine reason?" In memory he took a look at his girl's face, and repeated her words when she besought him to come the longer way and hesitated over why. Was that shame at owning she believed such stuff? True, after asking him once about his religion and hearing what he said, she had never spoken of these things again. That must be a woman's way when she loved you first—to hide her notions that differed from yours, and not ruffle happy days. "Return the same road by Tucson!" He unwrapped a clean, many-crumpled handkerchief, and held Lolita's photograph for a while. Then he burst into an unhappy oath, and folded the picture up again. What if her priest did tell her? He had heard the minister tell about eternal punishment when he was a boy, and just as soon as he started thinking it over he knew it was a lie. And this quack Tinaja was worse foolishness, and had nothing to do with religion. Lolita afraid of his coming to grief in a country he had travelled hundreds, thousands of miles in! Perhaps she had never started thinking for herself yet. But she had. She was smarter than any girl of her age he had ever seen. She did not want him back so soon. That was what it was. Yet she had looked true; her voice had sounded that way. Again he dwelt upon her words and caresses; and harboring these various thoughts, he killed still more of the long road, until, passing after a while Poso Blanco, and later Marsh's ranch-well at the forks where the Sonora road comes in, he reached Tucson a man divided against himself. Divided beyond his will into two selves—one of faith besieged, and one of besieging inimical reason—the inextricable error!

Business and pleasure were waiting in Tucson, and friends whose ways and company had not been of late for him; but he frequented them this time, tasting no pleasure, yet finding the ways and company better than his own. After the desert's changeless unfathomed silence, in which nothing new came day or night to break the fettering spell his mind was falling under, the clink and knocking of bottles was good to hear, and he listened for more, craving any sound that might wake him from his looming doubt. Abstaining himself, he moved his chair near others who sat lively in saloons. His boots, that for days had trod upon the unwatered earth beneath sun and stars, stepped now in spilled liquids on floors, and so beneath a roof among tobacco smoke he hid himself from the exorcism of the desert. Later the purring tinkle of guitars reminded him of that promised present, and the next morning he was the owner of the best instrument that he could buy. Leaving it with a friend to keep until he should come through again from Maricopa, he departed that way with his mules, finding in the new place the same sort of friends and business, and by night looking upon the same untasted pleasures. He went about town with some cattlemen, carousing bankrupts, who remembered their ruin in the middle of whiskey, and broke

off to curse it and the times and climate, and their starved herds that none would buy at any price. Genesmere touched nothing, yet still drew his chair among these drinkers.

"Aren't you feeling good to-night, Russ?" asked one at length.

And Genesmere's eyes roused from seeing visions, and his ears became aware of the loud company. In Tucson he had been able to sit in the smoke, and compass a cheerful deceit of appearance even to himself. Choosing and buying the guitar had lent reality to his imitated peace of mind; he had been careful over its strings, selecting such as Lolita preferred, wrapt in carrying out this spiritual forgery of another Genesmere. But here they had noticed him; appearances had slipped from him. He listened to a piece of late Arizona news some one was in the middle of telling—the trial of several Mormons for robbing a paymaster near Cedar Springs. This was the fourth time he had heard the story, because it was new; but the present narrator dwelt upon the dodgings of a witness, a negress, who had seen everything and told nothing, outwitting the government, furnishing no proofs. This brought Genesmere quite back.

"No proofs!" he muttered. "No proofs!" He laughed and became alert. "She lied to them good, did she?"

They looked at him, because he had not spoken for so long; and he was told that she had certainly lied good.

"Fooled them clean through, did she? On oath! Tell about her."

The flattered narrator, who had been in court, gave all he knew, and Genesmere received each morsel of perjury gravely with a nod. He sat still when the story was done.

"Yes," he said, after a time. "Yes." And again, "Yes." Then he briefly bade the boys good-night, and went out from the lamps and whiskey into the dark.

He walked up and down alone, round the corral where his mules stood, round the stable where his bed-blankets were; and one or two carousers came by, who suggested further enjoyments to him. He went to the edge of the town and walked where passers would not meet him, turning now and then to look in the direction of Tucson, where the guitar was waiting. When he felt the change of dawn he went to the stable, and by the first early gray had his mules packed. He looked once again towards Tucson, and took the road he had promised not to take, leaving the guitar behind him altogether. Besieged faith scarcely stirred in protest, starved in the citadel; victorious, well-fed reason hit upon the mockery that he had "come by Tucson," according to his literal word. It is a comfort to be divided no longer against one's self. Genesmere was at ease in his thraldom to the demon with whom he had wrestled through the dark hours. As the day brightened he wondered how he had come to fool a night away over a promise such as that. He took out the face in the handkerchief, and gave it a curious defiant smile. She had said waiting would be long. She should have him quickly. And he was going to know about that visitor at the

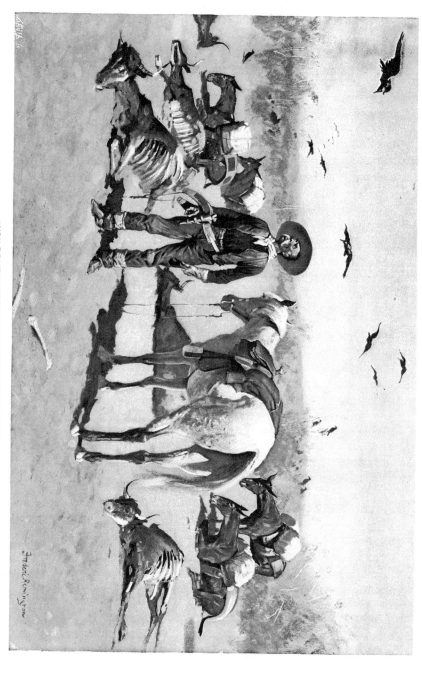

"YOU DON'T WANT TO TALK THIS WAY. YOU'RE ALONE."

cabin, the steeple-hatted man he saw in his visions. So Maricopa drew behind him, small, clear-grouped in the unheated morning, and the sun found the united man and his mules moving into the desert.

By the well in the bottom of the Santa Cruz River he met with cattle and little late-born calves trying to trot. Their mothers, the foreman explained, had not milk enough for them, nor the cursed country food or water for the mothers. They could not chew cactus. These animals had been driven here to feed and fatten inexpensively, and get quick money for the owner. But, instead, half of them had died, and the men were driving the rest to new pastures, as many, that is, as could still walk. Genesmere knew, the foreman supposed, that this well was the last for more than a hundred miles? Funny to call a thing like that Santa Cruz a river! Well, it was an Arizona river; all right enough, no doubt, somewhere a thousand feet or so underground. Pity you weren't a prairie-dog that eats sand when he gets a thirst on him. Got any tobacco? Good-by.

Think of any valleys that you know between high mountains. Such was southern Arizona once—before we came. Then fill up your valleys with sand until the mountains show no feet or shoulders, but become as men buried to the neck. That is what makes separate islands of their protruding peaks, and that is why water slinks from the surface whenever it can and flows useless underneath, entombed in the original valley. This is Arizona now—since the pterodactyls have gone. Nor does no rain to speak of for three years help things. In such a place the traveller turns mariner, only, instead of the stars, he studies the water-wells, shaping his course by these. Not seagulls, but ravens, fly over this waste, seeking their meal. Some were in front of Genesmere now, settled black in the recent trail of the cattle. He did not much care that the last well was gone by, for he was broken in by long travel to the water of the 'dobe-holes that people rely upon through this journey. These 'dobe-holes are occasional wallows in clayey spots, and men and cattle know each one. The cattle, of course, roll in them, and they become worn into crcular hollows, their edges tramped into muck, and surrounded by a thicket belt of mesquite. The water is not good, but will save life. The first one lay two stages from the well, and Genesmere accordingly made an expected dry camp the first night, carrying water from the well in the Santa Cruz, and dribbling all of it but a cupful among his animals, and the second night reached his calculated 'dobe-hole. The animals rolled luxuriously in the brown dungy mixture, and Genesmere made his coffee strong. He had had no shade at the first camp, and here it was good under the tangle of the mesquite, and he slept sound. He was early awakened by the ravens, whose loose dislocated croaking came from where they sat at breakfast on the other side of the wallow. They had not suspected his presence among the mesquite, and when he stepped to the mudhole and dipped its gummy fluid in his coffee-pot they rose hoarse and hovering, and flapped twenty yards away, and sat watching until he was gone into the desert, when they clouded back

again round their carrion.

This day was over ground yellow and hard with dearth, until afternoon brought a footing of sifting sand heavy to travel in. He had plenty of time for thinking. His ease after the first snapping from his promise had changed to an eagerness to come unawares and catch the man in the steeple-hat. Till that there could be no proofs. Genesmere had along the road nearly emptied his second canteen of its brown-amber drink, wetting the beasts' tongues more than his own. The neighborhood of the next 'dobe-hole might be known by the three miles of cactus you went through before coming on it, a wide-set plantation of the yucca. The posted plants deployed over the plain in strange extended order like legions and legions of figures, each shock-head of spears bunched bristling at the top of its lank, scaly stalk, and out of that stuck the blossom-pole, a pigtail on end, with its knot of bell-flowers seeded to pods ten feet in the air. Genesmere's horse started and nearly threw him, but it was only a young calf lying for shade by a yucca. Genesmere could tell from its unlicked hide that the mother had gone to hunt water, and been away for some time. This unseasonable waif made a try at running away, but fell in a heap, and lay as man and mules passed on. Presently he passed a sentinel cow. She stood among the thorns guarding the calves of her sisters till they should return from getting their water. The desert cattle learn this shift, and the .sentinel now, at the stranger's approach, lowered her head, and with a feeble but hostile sound made ready to protect her charge, keeping her face to the passing enemy. Further along gaunt cows stood or lay under the perpetual yuccas, an animal to every plant. They stared at Genesmere passing on; some rose to look after him; some lifted their heads from the ground, and seeing, laid them down again. He came upon a calf watching its mother, who had fallen in such a position that the calf could not suck. The cow's fore leg was caught over her own head, and so she held herself from rising. The sand was rolled and grooved into a wheel by her circlings; her body heaved and fell with breathing, and the sand was wet where her pivot nostrils had ground it. While Genesmere untangled her and gave her tongue the last of his canteen the calf walked round and round. He placed the cow upon her feet, and as soon as he moved away to his horse the calf came to its mother, who began to lick it. He presently marked ahead the position of the coming 'dobe-hole by the ravens assembled in the air, continually rising and lighting. The white horse and mules quickened their step, and the trail became obliterated by hundreds of hoof-marks leading to the water. As a spider looks in the centre of an empty web, so did the round wallow sit in the middle of the plain, with threaded feet conducting from everywhere to it. Mules and white horse scraped through the scratching mesquite, and the ravens flapped up. To Genesmere their croaking seemed suddenly to fill all space with loud total clamor, for no water was left, only mud. He eased the animals of their loads and saddles, and they rolled in the stiff mud, squeezing from it a faint ooze, and getting a sort of

refreshment. Genesmere chewed the mud, and felt sorry for the beasts. He turned both canteens upside down and licked the bungs. A cow had had his last drink. Well, that would keep her alive several hours more. Hardly worth while; but spilled milk decidedly. Milk! That was an idea. He caught animal after animal, and got a few sickly drops. There was no gain in camping at this spot, no water for coffee; so Genesmere moved several hundred yards away to be rid of the ravens and their all-day long meal and the smell. He lay thinking what to do. Go back? At the rate he could push the animals now that last hole might be used up by the cattle before he got there—and then it was two stages more to the Santa Cruz well. And the man would be gaining just so many more days unhindered at the cabin. Out of the question. Forward, it was one shortish drive to the next hole. If that were dry, he could forsake the trail and make a try by a short-cut for that Tinaja place. And he must start soon, too, as soon as the animals could stand it, and travel by night and rest when the sun got bad. What business had October to be hot like this? So in the darkness he mounted again, and noon found him with eyes shut under a yucca. It was here that he held a talk with Lolita. They were married, and sitting in a room with curtains that let you see flowers growing outside by the window, as he had always intended. Lolita said to him that there was no fool like an old fool, and he was telling her that love could make a man more a fool than age, when she threw the door open, letting in bright light, and said, "No proofs." The bright light was the real sun coming round the yucca on his face, and he sat up and saw the desert. No cows were here, but he noticed the roughened hides and sunk eyes of his own beasts, and spoke to them.

"Cheer up, Jeff! Stonewall!" He stopped at the pain. It was in his lips and mouth. He put up his hand, and the feel of his tongue frightened him. He looked round to see what country he was in, and noted the signs that it was not so very far now. The blue crags of the islands were showing, and the blue sterile sky spread over them and the ceaseless sunlight like a plague. Man and horse and mules were the only life in the naked bottom of this caldron. The mirage had caught the nearest island, and blunted and dissolved its points and frayed its base away to a transparent fringe.

"Like a lump of sugar melts in hot tod," remarked Genesmere, aloud, and remembered his thickened mouth again. "I can stand it off for a while yet, though—if they can travel." His mules looked at him when he came—looked when he tightened their cinches. "I know, Jeff," he said, and inspected the sky. "No heaven's up there. Nothing's back of that thing, unless it's hell."

He got the animals going, and the next 'dobe-hole was like the last, and busy with the black flapping of the birds. "You didn't fool me," said Genesmere, addressing the mud. "I knew you'd be dry." His eye ran over the cattle, that lay in various conditions. "That foreman was not too soon getting his live-stock out of your country," he continued to the hole, his tongue clacking as it made

his words. "This live-stock here's not enjoying itself like its owners in town. This live-stock was intended for Eastern folks' dinner.—But you've got ahead of 'em this trip," he said to the ravens. He laughed loudly, and hearing himself, stopped, and his face became stern. "You don't want to talk this way, Russ Genesmere. Shut your head. You're alone.—I wish I'd never known!" he suddenly cried out.

He went to his animals and sat down by them, clasping and unclasping his hands. The mules were lying down on the baked mud of the wallow with their loads on, and he loosed them. He stroked his white horse for some little while, thinking; and it was in his heart that he had brought these beasts into this scrape. It was sunset and cool. Against the divine fires of the west the peaks towered clear in splendor impassive, and forever aloof, and the universe seemed to fill with infinite sadness. "If she'll tell me it's not so," he said, "I'll believe her. I will believe her now. I'll make myself. She'll help me to." He took what rest he dared, and started up from it much later than he had intended, having had the talk with Lolita again in the room with the curtains. It was nine when he set out for the short-cut under the moon, dazed by his increasing torture. The brilliant disk, blurring to the eye, showed the mountains unearthly plain, beautiful, and tall in the night. By-and-by a mule fell and could not rise, and Genesmere decided it was as well for all to rest again. The next he knew it was blazing sunshine, and the sky at the same time bedded invisible in black clouds. And when his hand reached for a cloud that came bellying down to him, it changed into a pretzel, and salt burned in his mouth at the sight of it. He turned away, and saw the hot unshaded mountains wrinkled in the sun, glazed and shrunk, gullied like the parchment of an old man's throat; and then he saw a man in a steeple-hat. He could no more lay the spectre that wasted his mind than the thirst-demon which raged in his body. He shut his eyes, and then his arm was beating at something to keep it away. Pillowed on his saddle, he beat until he forgot. A blow at the corner of his eye brought him up sitting, and a raven jumped from his chest.

"You're not experienced," said Genesmere. "I'm not dead yet. But I'm obliged to you for being so enterprising. You've cleared my head. Quit that talk, Russ Genesmere." He went to the mule that had given out during the night. "Poor Jeff! We must lighten your pack. Now if that hunchback had died here, the birds would have done his business for him without help from any of your cats. Am I saying that, now, or only thinking it? I know I'm alone. I've travelled that way in this world. Why?" He turned his face, expecting some one to answer, and the answer came in a fierce voice: "Because you're a man, and can stand this world off by yourself. You look to no one." He suddenly took out the handkerchief and tore the photograph to scraps. "That's lightened my pack all it needs. Now for these boys, or they'll never make camp." He took what the mules carried, his merchandise, and hid it carefully between stones—for they

had come near the mountain country—and looking at the plain he was leaving, he saw a river. "Ha, ha!" he said, slyly; "you're not there, though. And I'll prove it to you." He chose another direction, and saw another flowing river. "I was expecting you," he stated, quietly. "Don't bother me. I'm thirsty."

But presently as he journeyed he saw lying to his right a wide fertile place with fruit trees and water everywhere. "Peaches too!" he sang out, and sprang off to run, but checked himself in five steps. "I don't seem able to stop your foolish talking," he said, "but you shall not chase around like that. You'll stay with me. I tell you that's a sham. Look at it." Obedient, he looked hard at it, and the cactus and rocks thrust through the watery image of the lake like two photographs on the same plate. He shouted with strangling triumph, and continued shouting until brier-roses along a brook and a farm-house unrolled to his left, and he ran half-way there, calling his mother's name. "Why, you fool, she's dead!" He looked slowly at his cut hands, for he had fallen among stones. "Dead, back in Kentucky, ever so long ago," he murmured, softly. "Didn't stay to see you get wicked." Then he grew stern again. "You've showed yourself up, and you can't tell land from water. You're going to let the boys take you straight. I don't trust you."

He started the mules, and caught hold of his horse's tail, and they set out in single file, held steady by their instinct, stumbling ahead for the water they knew among the mountains. Mules led, and the shouting man brought up the rear, clutching the white tail like a rudder, his feet sliding along through the stones. The country grew higher and rougher, and the peaks blazed in the hot sky; slate and sand and cactus below, gaping cracks and funnelled erosions above, rocks like monuments slanting up to the top pinnacles; supreme Arizona, stark and dead in space, like an extinct planet, flooded blind with eternal brightness. The perpetual dominating peaks caught Genesmere's attention. "Toll on!" he cried to them. "Toll on, you tall mountains. What do you care? Summer and winter, night and day, I've known you, and I've heard you all along. A man can't look but he sees you walling God's country from him, ringing away with your knell."

He must have been lying down during some time, for now he saw the full moon again, and his animals near him, and a fire blazing that himself had evidently built. The coffee-pot sat on it, red-hot and split open. He felt almost no suffering at all, but stronger than ever in his life and he heard something somewhere screaming "water, water, water," fast and unceasing, like an alarm-clock. A rattling of stones made him turn, and there stood a few staring cattle. Instantly he sprang to his feet, and the screaming stopped. "Round 'em up, Russ Genesmere. It's getting late," he yelled, and ran among the cattle, whirling his rope. They dodged weakly this way and that, and next he was on the white horse urging him after the cows, who ran in a circle. One struck the end of a log that stuck out from the fire, splintering the flames and embers, and Genesmere followed

on the tottering horse through the sparks, swinging his rope and yelling in the full moon. "Round 'em up! round 'em up! Don't you want to make camp? All the rest of the herd's bedded down along with the ravens."

The white horse fell and threw him by the edge of a round hole, but he did not know it till he opened his eyes and it was light again, and the mountains still tolling. Then like a crash of cymbals the Tinaja beat into his recognition. He knew the slate rock; he saw the broken natural stairs. He plunged down them, arms forward like a diver's, and ground his forehead against the bottom. It was dry. His bloodshot eyes rolled once up round the sheer walls. Yes, it was the Tinaja, and his hands began to tear at the gravel. He flung himself to fresh places, fiercely grubbing with his heels, biting into the sand with his teeth; while above him in the cañon his placid animals lay round the real Tinaja Bonita, having slaked their thirst last night, in time, some thirty yards from where he now lay bleeding and fighting the dust in the dry twin hole.

He heard voices, and put his hands up to something round his head. He was now lying out in the light, with a cold bandage round his forehead, and a moist rag on his lips.

"Water!" He could just make the whisper.

But Lolita made a sign of silence.

"Water!" he gasped.

She shook her head, smiling, and moistened the rag. That must be all just now.

His eye sought and travelled, and stopped short, dilating; and Lolita screamed at his leap for the living well.

"Not yet! Not yet!" she said in terror, grappling with him. "Help! Luis!"

So this was their plot, the demon told him—to keep him from water! In a frenzy of strength he seized Lolita. "Proved! Proved!" he shouted, and stuck his knife into her. She fell at once to the earth and lay calm, eyes wide open, breathing in the bright sun. He rushed to the water and plunged, swallowing and rolling.

Luis ran up from the cows he was gathering, and when he saw what was done, sank by Lolita to support her. She pointed to the pool.

"He is killing himself!" she managed to say, and her head went lower.

"And I'll help you die, caberon! I'll tear your tongue. I'll—"

But Lolita, hearing Luis's terrible words, had raised a forbidding hand. She signed to leave her and bring Genesmere to her.

The distracted Luis went down the stone stairs to kill the American in spite of her, but the man's appearance stopped him. You could not raise a hand against one come to this. The water-drinking was done, and Genesmere lay fainting, head and helpless arms on the lowest stone, body in the water. The Black Cross stood dry above. Luis heard Lolita's voice, and dragged Genesmere to the top as quickly as he could. She, seeing her lover, cried his name once

and died; and Luis cast himself on the earth.

"Fool! fool!" he repeated, catching at the ground, where he lay for some while until a hand touched him. It was Genesmere.

"I'm seeing things pretty near straight now," the man said. "Come close. I can't talk well. Was—was that talk of yours, and singing—was that bluff?"

"God forgive me!" said poor Luis.

"You mean forgive me," said Genesmere. He lay looking at Lolita. "Close her eyes," he said. And Luis did so. Genesmere was plucking at his clothes, and the Mexican helped him draw out a handkerchief, which the lover unfolded like a treasure. "She used to look like this", he began. He felt and stopped. "Why, it's gone!" he said. He lay evidently seeking to remember where the picture had gone, and his eyes went to the hills whence no help came. Presently Luis heard him speaking, and leaning to hear, made out that he was murmuring his own name, Russ, in the way Lolita had been used to say it. The boy sat speechless, and no thought stirred in his despair as he watched. The American moved over, and put his arms round Lolita, Luis knowing that he must not offer to help him do this. He remained so long that the boy, who would never be a boy again, bent over to see. But it was only another fainting fit. Luis waited; now and then the animals moved among the rocks. The sun crossed the sky, bringing the many-colored evening, and Arizona was no longer terrible, but once more infinitely sad. Luis started, for the American was looking at him and beckoning.

"She's not here," Genesmere said, distinctly.

Luis could not follow.

"Not here, I tell you." The lover touched his sweetheart. "This is not her. My punishment is nothing," he went on, his face growing beautiful. "See there!"

Luis looked where he pointed.

"Don't you see her? Don't you see her fixing that camp for me? We're going to camp together now."

But these were visions alien to Luis, and he stared helpless, anxious to do anything that the man might desire. Genesmere's face darkened wistfully.

"Am I not making camp?" he said.

Luis nodded to please him, without at all comprehending.

"You don't see her." Reason was warring with the departing spirit until the end. "Well, maybe you're right. I never was sure. But I'm mortal tired of travelling alone. I hope—"

That was the end, and Russ Genesmere lay still beside his sweetheart. It was a black evening at the cabin, and a black day when Luis and old Ramon raised and fenced the wooden head-stone, with its two forlorn names.

Chapter 4

Mud and Immortality

R emington's caricature of a monocled Wister in the December letter was an engaging bit of whimsey, much like the profiles and three-quarter views of other friends with which the artist graced countless calling cards, envelopes, napkins, guest books, and tablecloths throughout his professional life. By itself the sketch merited only momentary interest, but as an emblem of what had happened between Remington and Wister since the 1893 meeting at Geyser Basin, it was indeed suggestive. However Remington intended the line he drew between his signature and Wister's monocle, it conveniently exemplified a linkage between the two men. Yet it also presented a puzzle: did the signature grow out of the profile, or the profile out of the signature? Did the sketch represent the creation of Remington by Wister or the creation of Wister by Remington?

There is, of course, no way of telling—but the question is no less a question because it lacks an answer. Indeed, a curious facet of the Wister-Remington relationship was that whereas each man repeatedly and enthusiastically praised the other's work, neither ever acknowledged the other's very considerable influence on himself. One case in point was Wister's failure to see that Remington not only "ordered" but actually wrote much of "The Evolution"; another, Remington's similar failure to recognize Wister's unintentional but nonetheless significant part in producing "The Bronco Buster," Remington's first bronze. Wister, appending "The Evolution" to his preface for a new edition of *Red Men and White* in 1928, praised Remington's pictures but neglected to mention the pages of "notes" Remington sent for the essay or the alternate bully-

155

ing and pleading from the artist which doubtless had much to do with getting the essay written and into print. Remington, asked in 1895 how he happened to begin sculpting, after ten years of illustrating and painting, replied merely that "the possibilities of clay" appeared to him all at once "as a genuine revelation."[1]

What Remington may have meant by such a reply was that a question about the origins of his interest in sculpting did not deserve serious consideration. Yet there was every reason to take the question seriously, for it dealt not just with the beginning of important changes in Remington's career, but with equally important developments in Wister's. Moreover, Remington's "revelation" not only created shock waves which had their effect on Wister's writing about the West, but also came as a direct result of the artist's involvement with Wister in the first place. Early in October 1894, Remington returned from bear hunting in New Mexico to find Wister's story "The Second Missouri Compromise" waiting for him at New Rochelle. On October 20, Wister himself arrived for a conference. Before the end of the month, Remington wrote to Wister that he had completed a "side view" of the story's hero, Specimen Jones—almost certainly the same one that appeared with the "Compromise" when it was printed in March of the next year. Sometime between his October 20 meeting with Wister and his completion of the side view of Specimen Jones, Remington experienced the revelation that turned him into a sculptor.

The weather at New Rochelle that fall was cold and disagreeable. As Remington wrestled with "The Second Missouri Compromise" after Wister's visit, mixed snow and rain made it impossible for him to take his daily outings. When Augustus Thomas, Remington's playwright-journalist neighbor, came to call one stormy afternoon, he found Remington restless and distracted. The artist paced up and down with his charcoal pencil before an easel that held blank paper. His problem was to show Specimen Jones breaking in on poker-playing legislators at the Idaho territorial capitol. Yet the picture he began to draw while he talked intermittently with Thomas was not the "side view" he later turned in. While Thomas watched, Remington quickly placed the figures and sketched their outlines: Jones, with his back toward the viewer, in the foreground, and beyond that the poker players at their table. Clearly, this was an unsatisfactory arrangement, for not only was the corporal's back less interesting than the rest of him, but it also obstructed one's

view of the legislators. With only a moment's hesitation, **Remington** erased the outline in the foreground, and redrew Jones—in profile this time—at the picture's left. Thomas was astonished. "Fred," he told his friend, "you're not a draftsman; you're a sculptor." Remington only laughed, but Thomas refused to let the matter drop. Indicating the newly drawn side view of Specimen Jones, he explained: "You saw all round that fellow, and could have put him anywhere you wanted him." Such ability, he told Remington, was known as "the sculptor's degree of vision."[2] Remington had it. The only thing that remained was for him to use it.

The more Remington thought about Augustus Thomas's statement, the more it burned into his brain. Very shortly after his experience with the "side view" of Specimen Jones, he consulted with the well-known sculptor, Frederic Ruckstull. "Ruck," he asked, "do you think I could model? Thomas has suggested that I could." Ruckstull was even more certain than Thomas of Remington's success. When Remington asked him why, he replied, "Because you *see*, in your mind, so very clearly anything that you want to draw." Surely, he argued, Remington could "draw just as clearly in wax as . . . on paper." Ruckstull grew impatient when Remington raised the question of technique. "Technique be hanged," he said, and departed for New York City, where he bought Remington a modeling stand and some tools.[3] By January 1, 1895, while Wister began trying to organize "The Evolution," Remington was launched on his new career.

Yet sculpting was hard work, and despite his bursts of enthusiasm, Remington became so discouraged with his own efforts that on several occasions, before finishing his model, he came close to smashing it in exasperation. To add to his troubles, the cold weather continued, Wister dragged his feet on "The Evolution," and the Chicago Pullman strikes of the summer before appeared to be repeated closer to home as trolley-car riots at New York City. During the week of January 20, Remington became ill. When the National Guard was called to Brooklyn later in the same week, he decided to leave cold weather, riots, and even his model behind and go to Florida as soon as he was well enough to travel. Days before departing, he wrote to Wister, who had recently hatched the love plot between the Virginian and Molly Wood in a story later entitled "Where Fancy Was Bred," flinging a mock threat concerning "The Evolution" behind him:

Either leave the country—Manuscript or Die—

*I feel that I may—I have grip—and there is a riot in Brooklyn and
I am tired out—and two servants are sick and the old lady has to work
and is out of temper and I am going to Florida for a month the very
minute I can get the Doc. to say I can.*

Come—go 'long.—aligators—tarpon.—

I have got a receipt for being great*—everyone might not be able to
use this receipt but I can. D—— your "glide along" songs—they die in
the ear—your Virginian will be eaten up by time—all paper is pulp now.
My oils will all get old wasting—that is, they will look like sale molases
in time—my water colors will fade—but I am to endure in bronze—
even rust does not touch.—I am modeling—I find I do well—I am doing
a cow boy on a bucking broncho and I am going to rattle down through
all the ages, unless some anarchist invades the old mansion and knocks
it off the shelf. How does that strike your fancy Charles—*

*I have simply been fooling my time away—I can't tell a red blanket
from a grey overcoat for color but when you get right down to facts—
and thats what you have got to sure establish when you monkey with the
plastic clay, I am there—there in double leaded type—*

*Well—come on, lets go to Florida—you don't have to think there.
We will fish.*

<div align="center">

Yours
</div>

<div align="right">*Frederic R*</div>

Like the later caricature of Wister's profile attached to the artist's signa-
ture, the closing sketch in this letter showed Remington and Wister
literally and metaphorically in the same boat.

Even though Remington still liked to think of himself and Wister as
partners, his discovery of "plastic clay" constituted not only a "receipt
for being *great*," but also a "receipt" for producing salable art that stood
by itself without any printed text to accompany it. Only two months
before, he pled with Wister to "write me an essay . . . get a lot of ponies
'just a smokin' in it." Now, he could assert that "all paper is pulp." In
the spring, shortly before Wister departed for his extended western tour,
Remington told him that "my model is said by competent judges to be
immortal." When Wister returned late in August, the model was ready
to be cast in bronze. Therefore, Wister found his relationship with Rem-
ington suddenly and significantly changed. Whereas there had been weeks

Either leave the country — Manuscript or Die —

I feel that I may — I have grip — and there
is a riot in Brooklyn and I am tired out —
and two servants are sick and the old lady
has to work and is out of temper and I
am going to Florida for a month the very
minute I can get the Doc. to say I can.
 Come — go 'long. — aligators —
Tarpon. —
 I have got a receipt for being
great — everyone might not be able to use the
receipt but I can. D — your "glide along
songs" — they die in the ear — your Virginian
will be eaten up by time — all paper is pulp now.

my oils will all get old mastery - that is, they will
look like oale molasses in time - my water colors
will fade - but I am to endure in bronze -
even rust does not touch. - I am modeling -
I find I do well - I am doing a cow boy
on a bucking broncho and I am going to rattle
down through all the ages, unless some anarchist
invades the old mansion and knock I off the shelf.

How does that o'like your fancy Charles –

I have simply been fooling my time away – I can't tell a red blanket from a grey overcoat for color but when you get right down to facts – and that's what you have got to sure establish when you monkey with the plastic clay. I am there – there in double leaded type –

Well – come on, lets go to Florida – you don't have to think there. We will fish.

Yours Jordan R

in 1894 and early 1895 when Remington's rapid-fire notes arrived almost daily, impatiently urging Wister on with some project, part of August, all of September, and most of October passed without a single line from New Rochelle. Not even Wister's rhapsodic letter concerning "The Evolution" brought an answer. The explanation finally came in the morning mail of October 19, which brought the *Harper's Weekly* carrying a full-page treatment of "The Bronco Buster," copyrighted a little less than three weeks before, on Remington's thirty-fourth birthday and the eleventh anniversary of his marriage to Eva Caten. There was a large photograph of the statuette, accompanied by an enthusiastic notice from art critic Arthur Hoeber.

Remington had told Wister repeatedly of his bronze and even sent him an early sketch of it the previous January. The photograph in *Harper's Weekly* contained nothing Wister wasn't already aware of, for it showed just what Remington said it did in his application for a copyright: "Equestrian statue of cowboy mounted upon and breaking in wild horse standing on hind feet. Cowboy holding onto horse's mane with left hand while right hand is extended upwards."[4] But when Wister read Arthur Hoeber's review, he felt a thrill of not wholly agreeable surprise, for Hoeber, duly noting the technical difficulty of the "Buster," also brought into the open those qualities which made Remington's vision of the West different from Wister's. What Hoeber liked best about the "Buster" was precisely what Remington had to fight to get Wister to include in "The Evolution."

Hoeber began by recalling Remington's first appearance in national magazines "some ten years ago" with the "unconventional if somewhat crude drawings" printed in *Outing* and *The Century*. Even then, Hoeber remembered, "a future was prophesied for Frederic Remington," because his illustrations showed "cavalrymen mounted on beasts that were really in action . . . soldiers that were actually fighting." Very shortly, Remington fulfilled his promise, sounding a "new note" with the honesty of his work. For the first time, Hoeber observed, "we saw the cowboy as he really was, divested of the nonsense of romance." Even in the 1880s Remington saw the West "with eyes wide open . . . perceptions keen." Now, however, the "Bronco Buster" showed that the range and energy of Remington's talents were even greater than his admirers had dared hope:

Breaking away from the narrow limits and restraints of pen and ink on flat

"The Bronco-Buster." This photograph appeared with Arthur Hoeber's October 1895 review of Remington's bronze.

surface, Remington has stampeded, as it were, to the greater possibilities of plastic form in clay, and in a single experiment has demonstrated his abilities to adequately convey his ideas in a new and more effective medium of expression. . . . The serious fight between man and horse is given with a realism and intensity that come only from profound knowledge. . . . Every detail has

been carried out. . . . In short, well as he has succeeded in other directions, it is quite evident that Mr. Remington has struck his gait, and that . . . other roads are open to him. . . . Does any one regret the change?⁵

The closing question was clearly rhetorical, but when Wister read it at Philadelphia on October 19, it carried additional force as well.

Less than a month remained before the publication of *Red Men and White*, an event which for Wister signaled a beginning rather than a termination. Only two days before, on October 17, Ripley Hitchcock of Appleton's had told Wister at New York that "The Evolution" constituted "the statement in twelve pages"⁶ of a book-length western history, but Wister already had enough plans for fiction about the West to keep him busy for some time and was even then planning a second volume of western stories. As he read Hoeber's review of the "Bronco Buster" and remembered Hitchcock's praise of "The Evolution," he must also have recalled the light that had broken over him two years before when he had realized on the train between Harrisburg and Philadelphia that "Baalam and Pedro" owed its success to Remington's picture of a horse trade. In any case, he recognized the value of Remington's illustrations. Therefore, he had ample reason to "regret the change" begun with the "Bronco Buster." The note he wrote to Remington that afternoon showed how much he wanted to keep Remington as a partner:

Why in h—— Oh Bear don't you write to me. Where are you. How are you. Who are you. The notice of Bronze Broncho Billy Buster by Bear came this AM *and precipitated this—And . . . if you don't send me Pony Tracks with my name written inside, I'll buy it myself and send you Red Men & White with your name written inside. Then you'll feel 'shamed— Kindest regards to the Madam. Yours*
OCTOBER 19, 1895 *O.W.*

Whether consciously or not, Wister's note represented a definite departure from his usual letter-writing style. The bluff hyperbole it attempted seemed an obvious imitation of Remington.

Remington's reply, written five days later, was ambivalent. The artist still valued Wister's friendship and was illustrating Wister's Christmas story, entitled "A Journey in Search of Christmas," to appear in the December 14 *Harper's Weekly*—but the old note of cajolery was gone:

My dear "Dan"—

As that seems to be the only way I can identify you with your friends Well *Dan*—*I want Redmen & White with you in it, with no d—— commonplace sentiment like* yours truly *top of your name and as for "Pony Tracks" the next time I am [at Lippincott's] in Franklin Square I will inscribe my theory of nerve-cells & ship to you.*

I have only one idea now—*I only have an idea every seven years & never more than one at a time but its* mud—*all other forms of art are trivialities*—*mud*—*or its sequence "bronze" is a thing to think of when you are doing it*—*and afterwards too. It dont decay. The moth dont break through & steal*—*the rust & the idiot can not harm it for it is there to say by God one day I was not painted in another tone from this*—*one day anyone could read me. Now I am* black letter—*I do not speak through a season on the stage*—*I am d—— near eternal if people want to know about the past and above all I am so simple that wise-men & fools of all ages can "get there" and know* whether or not.

Hope to see you—*Just got the Xmas Story*—*am doing it.*

Yours

OCTOBER 24, 1895 *Frederic R——*

For the first time since the Geyser Basin meeting of 1893, Remington made no reference to dragging Wister into "the immortal band." For the first time in his life, he truly felt he was there himself. To see clearly that he got there, not only by abandoning "the narrow limits and restraints of pen and ink on flat surface" but by "breaking away" from what Arthur Hoeber called "the nonsense of romance," it was necessary only to compare the "Bronco Buster" with "The Last Cavalier."

Wister did just that when he got Remington's letter next day. The buster's mount stood on two legs while the other two slashed empty air, and the buster himself, his right foot free of the stirrup, his right arm flung straight out, strained every muscle to retain his precarious seat. The past represented in the background of "The Last Cavalier" was simply absent—for the "Buster" had no background. Whatever chronological region he came from, he represented only action, occupied only a timeless present. The statue was "d—— near eternal," not because it was cast of bronze, but because it caught completely an action which could never be completed. It showed that Remington had finally dis-

covered a way to dissolve the skyline altogether.

With Remington's latest letter still before him, Wister thumbed through his other letters from the artist until he came to the one of seven months earlier which enthusiastically asserted that "Wister is *doing it. . . . We* have reached the *ideal* stage." Then he sat down to write his friend a curious confession:

Dear Mud: You are right. Only once in a while you'll still wash your hands to take hold of mine I hope. It would be an awful blow to one of this team if bronze was to be all, hereafter. I am going to own the Broncho Buster. The name is as splendid as the rest. I am glad you're doing the Christmas story—if you'll put in that suggestion of the eternal that you had all through the Evolution. If you haven't already got your notions, bear Santa Claus in the window in mind. I read an old note from you this morning in which you spoke of our "forgetting the things we know" —and striking the ideal. It is something worthwhile, if true. Worth all the Kodaks in Narragansett. I liked "Three old Friends" in The Maltese Cat. If the sinews and nerves don't go back on me, there shall be five good stories presently, and all moving away from the Kodak. Tomorrow, Saturday, I shall see the Broncho Buster at 430 West 16th Street. I am dining an engaged man in the evening. My best regards to Mrs. Remington; & the Gods prosper you.

<div align="right">

Always yours
Owen Wister.
</div>

OCTOBER 26, 1895

Here was no attempt to mimic Remington's joviality, no effort to suggest that "there ought to be music" for Remington's work. Even the colon that followed the salutation suggested a chilling of the Wister-Remington relationship, and the "Always yours" with which the letter closed sounded almost like goodbye.

Yet Wister did assert his hope that Remington would still have time for illustrations, even praising the relatively commonplace "Three Old Friends," which represented a trio of polo players for Rudyard Kipling's fanciful story "The Maltese Cat," in the July 1895 *Cosmopolitan*. Moreover, he spoke of "five good stories" he hoped to write "moving away from the Kodak" in accordance with Remington's precept of forgetting "the *things* we *know*." The most important thing about Wister's letter

was that it indicated Wister's recognition of an important fact: both he and Remington were entering new phases of their careers and personal lives. Wister's engagement to Mary Channing Wister, a cousin, thus became part of the same maturing process reflected by Remington's new interest in bronze and his own renewed determination to pursue "the ideal." A question doubtless much in Wister's mind as he wrote was what effect the maturing process would have on his professional and personal relationship with Remington. Part of the answer came the following week, when Remington wrote with an offer both conciliatory and derisive:

My dear Wister

Bully for you going up against my bronze—As for the Last of the Cavaliers—it is yours but you must pay for the frame. I am going to have a sale in November and it was going in so thats why the frame is ordered. I will scratch it in my catalogue and have it shipped as soon as I can.

Will that be cheap enough—

Yours faithfully

LATE OCTOBER 1895 *Frederic Remington*

Wister's promise to "own the 'Broncho Buster' " brought Remington's gift of "The Last Cavalier." The statue, which excited Remington, vaguely threatened Wister—but the painting, which Wister loved, failed to command Remington's highest regard. Remington's gift therefore implied an ambivalent attitude. Indulging Wister's impulse to "withdraw and mourn" for the past of "The Last Cavalier," Remington also recognized his own preference for the violent engagement captured in his bronze.

Wister did not comment on the ambivalence of Remington's gift but did send his thanks, asking when the sale would take place and renewing his request for *Pony Tracks*. By the time Remington replied late in October, his feelings for Wister were warming again.

Dear Nerve Cell—

"I open" as the theatrical folks say on Nov. 14. American Art Association—6-E. 23rd and sell everything but "the old lady" on the night of Nov 19—I am going to send you a bunch of my cards and ask you to mail them to Phila. folks where they may do me some good.

I will tell Wilmert & Son to ship you the picture and bill. My framing bill is bigger than the Taj Mahal and I am shy on it—but you would have to frame it anyway and it will be done "right" now. Did you see the original? It may not be ready in a week.

I am d—— near crazy between illustrating talky-talky stories where everything is too d—— easy to see in your minds eye and too d—— intangible to get on a canvass—(that's you and I except Mr. Whitney's musk ox so far as he is concerned but I'm d—— if you can imagine how little I know about musk-ox when you get down to brass tacks)

I'll never think about Pony Tracks but I'm trying to beat the band.

That sale—the bronze—magazines Horse Show pictures—a patent I am trying to engineer—a story (good one) which I can't *write about canoeing (by the way I'm going to do that all over again with you to make copy) and several other things make life perfectly Chineese cookie to me*

<div align="right">

yours

</div>

LATE OCTOBER 1895 *F.R.*

Busier than ever before, Remington still found time to illustrate Wister's stories. The two pictures he made for "A Journey in Search of Christmas," however, confirmed his assertion that his life had become "perfectly Chineese cookie," for they contained no suggestion of "the eternal." Well executed—even arresting, because of the contrast between rustic and urban which constituted their focus—they were still more or less conventional treatments. They asked no question, stated no violent conflict. Remington's discovery of bronze clearly diminished his interest in commercial illustrating.

When *Red Men and White* came out in November 1895, Wister was already hard at work on stories for his next western volume, *Lin McLean*. Latest in the series was "A Journey in Search of Christmas," which would appear in the December 14 *Harper's Weekly*. The first had been "How Lin McLean Went East," printed in 1892. In December 1893, *Harper's Monthly* had carried another story about Lin, "The Winning of the Biscuit Shooter," and "Lin McLean's Honey-Moon" had followed a year later in the same journal. Between December 1895 and December 1897, when *Lin McLean* was published as a book, two more of the stories that went into it were printed. *Lin*, therefore, represented an effort that spanned five years and reflected in its various episodes forces influential in shaping both Remington and Wister. Although the book was published

at a time when relations between Remington and Wister had grown definitely cool, it was ironically the closest to Remington's temperament of all the books Wister wrote.

"How Lin McLean Went East," the first episode of *Lin* to be written, was a good example of the early Wister. The persistent theme of the Prodigal Son, the august presence of the Bishop of Wyoming, the miraculous curative powers of the western landscape, all indicated that this story sprang directly from Wister's first western experience. As Wister came into contact with Remington, however, the episodes of *Lin* lost their speculative cast and became more lively. "The Winning of the Biscuit Shooter," which related how Katy Lusk, a railroad hash-house waitress from Sidney, Nebraska, took advantage of Lin's innocence, was permeated by elements of the grotesque and ironic, empty of the large historical concerns and biblical analogies that informed "How Lin Mc-Lean Went East." Indeed, it was totally different from anything Wister had written before. Likewise, "Lin McLean's Honey-Moon" and "A Journey in Search of Christmas" also showed Remington's influence, but the closest Wister ever came to capturing in prose the seriocomic quality that characterized Remington's best work was the episode of *Lin* first called "The Burial of the Biscuit Shooter" and later retitled "Destiny at Drybone." This was without question best of the "five good stories" Wister promised Remington "moving away from the Kodak."

Not published until December 1897, "Destiny" originated on Wister's western trip of 1895, when he collected stories concerning Fort Fetterman, an abandoned military base near Douglas, Wyoming. By the beginning of November Wister had completed a preliminary manuscript. He could not have avoided knowing that the story contained elements which Remington would find attractive. Therefore, the fact that he sent it to New Rochelle in rough draft form for Remington's approval, also asking for more information about the New York sale, indicated a solicitude for the artist hitherto absent. Yet Remington dismissed Wister's story in one sentence, going on to mention the art show and the coming November elections:

Dear Wister—The burial of the B.S is good
You may know all about my sale, Kind sir—the first thing that it opens
on the 14 ant the whole "bilin" is sold to the most enthusiastic bidder on
the night of the 19th and that's the end of it because "I run a square

game" and what in hell kind of a game do you think a fellow can play
and have "the gang wid him."
 Hope you will land your two friends down there on the Buster.
 Hope Tammaney gets done today but I aint cock-sure about it.
 Hope we can go southwest together in February—I want to paint.
EARLY NOVEMBER 1895

Remington's triple "hope" served only to emphasize the problematical
tone of his whole utterance. Only a year before he had admitted himself
"by nature a sceptic," but had promised Wister immortality for "La
Tinaja." Now he withheld judgment.

 Tammany Hall made a clean sweep of New York City, capturing the
Justice of City Court posts, winning nine of twelve state senate seats, and
gaining twenty-six of the thirty-five seats contested in the state assembly.
Reporting the victory on November 3, the *Times* gloomily attributed it
to Tammany's capture of four-fifths of the German immigrant vote—
something Wister later made much of in stories like "The Game and the
Nation" and political essays like "The Keystone Crime." There was better
news when Remington's show opened the following week on Twenty-
third Street. In both upper and lower halls of the American Art Gallery,
more than a hundred Remington works were displayed, including line
drawings, pencil sketches, charcoals, oils, and of course the "Bronco
Buster." Reviewers generally agreed that Remington was "always interest-
ing," but almost invariably gave special attention to his single bronze.
"The statuette," observed one account, presented Remington "in a new
and unexpected light, opening up possibilities and a field wherein he will
be quite alone."[7] The judgment was prophetic in more ways than one.

 Wister dutifully journeyed from Philadelphia to New York on Novem-
ber 19 to be present at Remington's sale, which was somewhat more
than moderately successful. Theodore Roosevelt, who also attended,
wrote Remington the next day with praise almost as good as money:

I have never so wished to be a millionaire or indeed any other person
than a literary man with a large family of small children and taste for
practical politics and bear hunting, as when you have pictures to sell.
It seems to me that you in your line, and Wister in his, are doing the
best work in America today.[8]

Perhaps without knowing it, Roosevelt echoed the feeling of Arthur Hoeber and other critics who sensed that Remington was "alone." Wherever one looked, there were signs of recognition that Remington was doing something new—and when *Red Men and White* was printed, there were signs of a similar recognition that Wister had entered a "no man's land." The surprising thing was that no one, with the possible exception of Wister himself, recognized in 1895 that the two men were alone in a no man's land together.

After his sale Remington went to Virginia for a week's hunting. He returned in fine spirits, wearing his new success at sculpting more gracefully than before, and eager to take Wister west in February. When the December *Bookman* with its enthusiastic review of *Red Men and White* arrived at Philadelphia, followed closely by Remington's note with its caricature of Wister wearing a monacle, there was every indication that Wister and Remington were ready to come truly together at last. A February trip to the Rio Grande looked like the beginning of a new cooperation which could lead beyond "The Evolution," "away from the Kodak," and into "the eternal." But there was a fatal interruption. On November 29, days after Remington's return from Virginia, Wister became ill and was confined to his bed for nearly a month. Remington's December note found him in the depths of depression, for he thought he recognized a recurrence of the same nervous disorder that had sent him west in 1885. His friend and physician, Dr. S. Weir Mitchell, advised another trip, this time to Europe.

Accordingly, Remington went southwest by himself in February, and Wister, well enough to travel by spring, departed for France and England. When Wister returned to Philadelphia in July, feeling much better, he decided to extend his vacation by taking a trip to Wyoming. Remington, meanwhile, spent the summer painting in Montana. Back at Philadelphia again in October, Wister rapidly wrote "Separ's Vigilante," another story for *Lin McLean*. When he finished, he sent it off for Remington to read at New Rochelle, only to find when Remington replied that the artist was too busy with other things to be very interested:

My dear Wister

Have concluded to build a butlers pantry and a studio (Czar size) on my house—we will be torn for a month and then will ask you to come over—throw your eye on the march of improvement and say this is a

great thing for American art. The fireplace is going to be like this. —Old Norman farm house—Big—big

<div align="center">

Yours

Frederic Remington

</div>

New Rochelle. N.Y.

<div align="center">

"Separs V. good"—

</div>

SOMETIME IN JUNE OR JULY, 1896

"Separ's Vigilante" was badly marred by the same sentimental tone that made parts of "Destiny at Drybone" uncomfortable. Had Wister gone west with Remington in February 1896, he might never have written it. Had Remington taken time in October to criticize the story, he could easily have told Wister what was wrong with it. But Wister, since the death of his father in March, was deeply occupied with trying to put his family's complicated financial affairs in order and prepare for his new responsibilities as a married man. Remington, while he worked on drawings for his first book of pictures, looked anxiously toward the Caribbean, where a revolution was heating up in Cuba.

That winter Wister hunted mountain sheep in Wyoming, writing to Remington when he returned of his success. On February 10, 1897, Remington replied with congratulations and an invitation to visit:

Dear W.—We expect to be at home next month and glad to see you— I have even forgotten how you look

Luck to get sheep this day and age—

<div align="center">

Yours

</div>

FEBRUARY 10, 1897 *Frederic Remington*

Once he started in earnest revising stories for *Lin McLean*, however, Wister found that the job demanded all his time and energy. On April 21 he managed to finish rewriting "How Lin McLean Went East." Next he turned to the long neglected "Burial of the Biscuit Shooter."

Wister worked rapidly and under the strain of numerous pressures. Unfortunately, it showed in the story he wrote. The manuscript Wister sent to Remington for approval in November 1895 came from a tale told Wister the previous summer in Wyoming by Amos Barber, the state's former governor. The title Wister initially assigned it properly designated its focus as the grotesque funeral scene of Katy Lusk—which occupied

My dear Wister

Have concluded to build a butlers pantry and a studio (Czar size) on my house — we will be Town for a month and then will ask you to come over — throw your eye on the march of improvement and say this is a great thing for American art. The fire place

is going [sketch] Is to be like

this, [sketch] — old german

farm house —

Big – big –

Yours
Frederic Remington

New Rochelle. N.Y.
"Separs V. good" —

**Frederic Remington standing before the fireplace he had
built in his studio at New Rochelle in 1896.**

Owen Wister on a "cayuse," probably in Wyoming.

section III of "Destiny at Drybone" when it appeared in December 1897. It showed Wister disillusioned with his old dream of a western golden age and determined to deal with the West's grotesque actuality—Wister at his best. Katy Lusk transcended Wister's other heroines by becoming, as a cowboy put it, "one of us." Her hard, coarse face and disagreeable manners only made her frankly sexual interest in Lin and her experienced knowledge of men in general more believable. She was no schoolmarm from the East, "lady" from the South, or potential mother of a new western race. Because Wister didn't have to be careful of Katy's reputation, he could be honest about her person. Likewise, he could strip away his romantic notions of Drybone, leaving the ghost town "a postage stamp . . . pasted in the middle of Wyoming's big map, a paradise for the

Four-Ace Johnstons" whose "chief historian" was a repeatedly rifled graveyard. The uncompleted story demonstrated Wister's willingness in 1895 to follow Remington's advice, forgetting "the *things* we *know*" and embarking in a new direction. Yet as he revised the story in 1897, Wister found himself unable to sustain the honesty of its perceptions.

As he worked, Wister became increasingly convinced that he must designate Katy Lusk as a type analogous to "little black Hank" of "Hank's Woman": an undesirable whose main function was to be disposed of interestingly. Conversely, Lin himself would have to abandon his charming brashness for respectability. Wister made a serious error by thus returning to a position he no longer fully accepted, but he stuck to his decision, requesting Remington to draw a picture of Lin that emphasized the cowboy's resemblance to Specimen Jones, that other "real" American from "The Second Missouri Compromise." Near the end of May, Remington, fresh from a rural vacation, replied that he would try his best:

My dear Wister—

I have your documents and note carefully. I will do L.MacL——
justice or bust. It is not always possible to live up to the strange ideals
of such a fanciful cuss "as you be."

When will Harper give me the order?

Can you come over here & spend next Sunday with us?

We are just home from a week in the Adirondacks—feel better—

Mrs. R says tell Wister be sure come—

<div align="right">

Yours faithfully

</div>

LATE MAY 1897 *Frederic Remington*

Work made it impossible for Wister to accept Remington's invitation. With the deadline for publication of *Lin McLean* rapidly approaching, it was imperative to finish the final episode. Through June and part of July he wrestled with it, getting Katy Lusk buried and Lin reunited with cheerful but wooden Jessamine Buckner, the eastern girl first introduced in "Separ's Vigilante." According to his shift in the story's emphasis away from Katy Lusk, Wister changed its name from "The Burial of the Biscuit Shooter" to the alliterative but somewhat turgid "Destiny at Drybone."

"Destiny" opened and closed very badly indeed, for everything Jessamine Buckner touched turned immediately stiff. When Jessamine talked to Billy Lusk in the story's opening scene, all sense of Separ's dingy railroad station on the wind-swept prairie was lost. When she appeared again at the end to embrace Lin and call him "dear, dear neighbor," she not only effectively emasculated the cowboy but robbed his previous experience at Drybone of all meaning. Yet in between, Wister managed some moments of real brilliance, working with character and setting in a more complex fashion than ever before. He suggested the relationship between Katy and Lin with admirable restraint and sensitivity—the very antithesis of the syrupy directness which characterized his handling of the cowboy's attraction for Jessamine Buckner. In the superbly executed sequence at Lin's cabin on Box Elder Creek, Wister demonstrated genuine dramatic skill by having Katy relate her meeting with Miss Buckner and showing the narrative's result on Lin. Likewise, Lin's nightmare journey across the prairie's "cheating sameness" to Drybone, with its graveyard on one side and "hog ranch," or bordello, on the other, gave Wister a chance to show how well he could catch the spirit of a symbolic landscape.

Clearly, "Destiny at Drybone" was a culmination of Wister's persistent desire to regard the West as a stage rather than a place, for each of the story's significant events, from the tense encounter of Lin and Katy at Box Elder to the colorful funeral procession at Drybone's graveyard, was lavishly and meticulously staged. Yet the drama's central actor, Lin himself, remained strangely indistinct by contrast with the deftly outlined figures of Katy and her husband or Chalkeye, Jerky Bill, and the other cowboys. The reason was that despite his stated resolve to move away from "the things we know," Wister found it impossible to renounce his earliest faith in the West's capability to produce "real Americans." Therefore, he created two Lins in "Destiny": a "real" one—made of foggy, sentimental stuff—to marry Jessamine Buckner, and another one—fickle, adolescent, sexually attractive, with a mean streak and a killer instinct—to cohabit with Katy Lusk. The former Lin had little but a certain questionable innocence to recommend him. The latter was no "real" American, but he moved with real verve, spoke with a real edge and generated real excitement.

In section I of "Destiny," Wister drew the sentimental Lin—a man who pined away a hard day's ride from Separ and his sweetheart. Sig-

nificantly, this Lin acquired plausibility only by being absent. In section II, however, the other Lin appeared, shooting the heads from chickens, threatening and taunting Katy's spineless husband, boasting about his amorous encounters, cursing, and even striking Katy herself with his closed fist. He was killer as well as lover, *isolato* rather than "neighbor." Wister's task was to deal somehow with the chasm which separated this Lin from the Lin of section I. In section III he tried to bring the two Lins together, but failed. At the cabin on Box Elder, Lin refused to admit that he ever loved Katy Lusk. Immediately afterward, Katy committed suicide by swallowing laudanum at Drybone. Wister's inference was clearly that Lin's refusal led to Katy's death—despite the fact that Katy herself called Lin an "innocent." Yet Wister also seemed to see Katy's suicide as the means through which to give Lin not only respectability but maturity. As Katy lay expiring on a bed, he had Lin remark in relief that "I think I'm a man now."

On the bed the mass, with its pink ribbons, breathed and breathed. . . . So did the heart of darkness wear itself away, and through the stone-cold air the dawn began to filter and expand.

The trouble was that Katy's death signaled not so much the beginning of Lin's maturity as the end of his youth.

When Katy's "heart of darkness" beat its last, Lin sank immediately into premature dotage. Looking down at Katy's "stolid, bold features" into which "death had called up the faint-colored ghost of youth," the cowboy "remembered all his Bear Creek days," remarking, "hindsight is a turrible clear way o' seein' things." Yet Lin's "Bear Creek days" were what gave joy to Wister's book. By having Lin himself repudiate them, Wister admitted a defeat in his struggle with the West, for while Wister recognized the cowboy's attractiveness, he seemed incapable of coming to terms with the cowboy except by transforming him into something else.

The strength of "Destiny" was that it intermittently represented Lin for what he was—an anachronism. Its weakness derived from Wister's failure to exploit Lin's complexity. The violent, gentle innocent who loved and hated Katy Lusk at Bear Creek was far more interesting than the "neighbor" who mistakenly thought Jessamine Buckner "a real girl"; but Wister, who still seemed unable to move beyond his vision of a golden age as *form* even though that vision had faded as *history*, disposal

of Lin the killer and *isolato* in the same way as he disposed of Katy Lusk, his logical mate—by allowing Jessamine Buckner to touch him. With Katy and the old Lin gone, only a family man was left, and the only thing the family man could do was "live happily ever after."

Wister was dissatisfied with "Destiny at Drybone" when he sent it to Alden in July, but he was relieved to be finished with it, for it meant that *Lin McLean* was finished, and with it a whole phase of Wister's career. With the historical vision that dictated the form of his writing about the West dissolving, Wister began to see some sense in E. S. Martin's advice to "swap skies" and desert the West as subject. His struggle with Lin McLean, ending as it did with that hero's disheartening termination, seemed for the moment to mark the end of his own western interest. Indeed, he even wondered whether the whole of the United States contained enough to write about, remarking to his mother that "excepting corners, our [American] atmosphere is chilly and unsympathetic" to literature.[9] While Remington tried at New Rochelle to make Lin look like Specimen Jones, Wister planned a holiday in New England instead of going west.

Remington found it difficult to live up to Wister's "strange ideals" concerning Lin because the Lin that Wister insisted on was one Remington understandably found implausible. When he finished the picture in July, therefore, and sent it to Alden, he wrote to Wister that it showed Lin "just as he ought to be . . . better than Specimen [Jones]." Then Remington departed for a month's fishing on Cranberry Lake, near the Canadian border.

When Wister stopped at Alden's New York office on his way to Maine, however, he saw Remington's picture of Lin and was displeased with it. When Remington heard of this, he wrote from Cranberry Lake, promising to try again and urging Wister to hurry with his preface for Remington's picture book, *Drawings*, to be published by R. H. Russell in December.

My dear Wister—

As you will see we are here—and probably wont come out (if it ever stops raining) until 15 Aug.

Write me what (address New R——) want done with McLean—I will redraw—

Write me short preface such as will stun the public by its brevity & by

lm MacLean
after photograph

**Remington's sketch of Lin McLean, drawn "from a photograph"
in 1900. Probably much like the artist's earliest drawings of
Lin in 1897, this one emphasizes the hero's juvenile qualities.**

*its Homeric style. Get off the Earth—see visions—go back—launch into
the future—& just send to R. H. Russell, 33 Rose St. N.Y., and ask him
for set of proofs—he knows & will send them—*

for these many thanks

going west I suppose

*Sorry not to have been able to see you at New Rochelle—but later we
will manage—When will you be back?*

Yours

JULY 1897 *Frederic Remington*

As we shall see, Wister's preface for *Drawings* was not brief, but it was
visionary and "Homeric" in ways that made it not entirely appropriate
for Remington's book. Likewise, Remington's work on Lin McLean was
troublesome because the Lin that Remington wanted to draw was the

one who killed Katy Lusk rather than the one who became Jessamine Buckner's "neighbor."

Remington's initial picture of Lin—the one Wister disapproved of at New York—was lost or destroyed, but it may have looked something like the sketch Remington playfully sent Wister three years later in 1900. Drawn from a photograph, the latter work represented Lin as an awkward youth with big ears and a long neck. But Remington also managed to suggest determination in the set of this Lin's jaw and a certain enigmatic cruelty in the curious configuration of his eyebrows. This was the Lin that Wister had Governor Barker call a "six foot infant"—the Lin who shot the heads off chickens at Box Elder Creek and made use of the hog ranch across the Platte from Drybone. What Remington did to make him acceptable to Wister was mature him. In the picture that appeared with "Destiny" in the December *Harper's*, the same long neck and big ears were present—but Remington had added a moustache, filled out the cheeks and covered the prominent Adam's apple with a bandana.

The picture *Harper's* used in December was one of a pair Remington sent them in August. One, said the artist, was "lady like," the other "sardonic"—both "cheerful looking S.O.B.[s]." Fortunately, Alden chose to print the "sardonic" Lin, but even so, Remington was dissatisfied. He had managed to keep Lin from looking neighborly—but only by practicing a kind of subterfuge. Consequently, he told Wister he didn't think the illustration would "set any houses on fire." Although he didn't say so directly, he was also unhappy with the whole of *Lin McLean* and the alliance with Wister which produced it.

When Wister's book was published in October, bearing Remington's picture of its hero on the cover, critics were enthusiastic, and even Henry James noted that *Lin* made an interesting use of native American materials. Yet Remington began to feel bored. The highest praise he could give Wister was the comment that " 'Destiny' was a great story—Everyone says so and everyone knows everything." Although "Destiny at Drybone" contained enough deftly shaded dramatic scenes to give it a very considerable interest, it was by no standard the "great story" Remington sarcastically observed "everyone" said it was. Even Wister recognized that the tale's ending made a concession to sentimentality, and Remington found the dominance of Jessamine Buckner positively disgusting.

The partnership that had seemed so strong and so sure to succeed in 1895 now seemed weak and sour.

LIN McLEAN

Destiny At Drybone
by Owen Wister
I.

CHILDREN have many special endowments, and of these the chiefest is to ask questions that their elders must skirmish to evade. Married people and aunts and uncles commonly discover this, but mere instinct does not guide one to it. A maiden of twenty-three will not necessarily divine it. Now except in one unhappy hour of stress and surprise, Miss Jessamine Buckner had been more than equal to life thus far. But never yet had she been shut up a whole day in one room with a boy of nine. Had this experience been hers, perhaps she would not have written Mr. McLean the friendly and singular letter in which she hoped he was well, and said that she was very well, and how was dear little Billy? She was glad Mr. McLean had staid away. That was just like his honorable nature, and what she expected of him. And she was perfectly happy at Separ, and "yours sincerely and always, 'Neighbor.' " Postscript. Talking of Billy Lusk—if Lin was busy with gathering the cattle, why not send Billy down to stop quietly with her? She would make him a bed in the ticket-office, and there she would be to see after him all the time. She knew Lin did not like his adopted child to be too much in cow-camp with the men. She would adopt him, too, for just as long as convenient to Lin—until the school opened on Bear Creek, if Lin so wished. Jessamine wrote a quantity concerning how much better care any woman can take of a boy of Billy's age than any man knows. The stage-coach brought the answer to this remarkably soon—young Billy with a trunk and a letter of twelve pages in pencil and ink—the only writing of this length ever done by Mr. McLean.

"I can write a lot quicker than Lin," said Billy upon arriving. "He was fussing at that away late by the fire in camp, an' waked me up crawling in our bed. An' then he had to finish it next night when we went over to the cabin for my clothes."

"You don't say!" said Jessamine. And Billy suffered her to kiss him again.

When not otherwise occupied, Jessamine took the letter out of its locked box, and read it, or looked at it. Thus the first days had gone finely at Separ, the weather being beautiful and Billy much out-of-doors. But sometimes the weather changes in Wyoming; and now it was that Miss Jessamine learned the talents of childhood.

Soon after breakfast this stormy morning Billy observed the twelve pages being taken out of their box, and spoke from his sudden brain. "Honey Wiggin says Lin's losing his grip about girls," he remarked. "He says you couldn't 'a' downed him onced. You'd 'a' had to marry him. Honey says Lin 'ain't worked it like he done in old times."

"Now I shouldn't wonder if he was right," said Jessamine, buoyantly. "And that being the case, I'm going to set to work at your things till it clears, and then we'll go for our ride."

"Yes," said Billy. "When does a man get too old to marry?"

"I'm only a girl, and I don't know."

"Yes. Honey said he wouldn't 'a' thought Lin was that old. But I guess he must be thirty."

"Old!" exclaimed Jessamine. And she looked at a photograph upon her table.

"But Lin 'ain't been married very much," pursued Billy. "Mother's the only one they speak of. You don't have to stay married always, do you?"

"It's better to," said Jessamine.

"Ah, I don't think so," said Billy, with disparagement. "You ought to see mother and father. I wish you would leave Lin marry you, though," said the boy, coming to her with an impulse of affection. "Why won't you if he don't mind?"

She continued to parry him; but this was not a very smooth start for eight in the morning. Moments of lull there were, when the telegraph called her to the front room, and Billy's young mind shifted to inquiries about the cipher alphabet. And she gained at least an hour teaching him to read various words by the sound. At dinner, too, he was refreshingly silent. But such silences are unsafe, and the weather was still bad. Four o'clock found them much where they had been at eight.

"Please tell me why you won't leave Lin marry you." He was at the window, kicking the wall.

"That's nine times since dinner," she replied, with tireless good-humor. "Now is you ask me twelve—"

"You'll tell?" said the boy, swiftly.

She broke into a laugh. "No. I'll go riding and you'll stay at home. When I was little and would ask things beyond me, they only gave me three times."

"I've got two more, anyway. Ha-ha!"

"Better save 'em up, though."

"What did they do to you? Ah, I don't want to go a-riding. It's nasty all over." He stared out at the day against which Separ's doors had been tight closed since morning. Eight hours of furious wind had raised the dust like a sea. "I wish the old train would come," observed Billy, continuing to kick the wall. "I wish I was going somewheres." Smoky, level, and hot, the south wind leapt into Separ across five hundred unbroken miles. The plain was blanketed in a

tawny eclipse. Each minute the near buildings became invisible in a turbulent herd of clouds. Above this travelling blur of the soil the top of the water-tank alone rose bulging into the clear sun. The sand spirals would lick like flames along the bulk of the lofty tub, and soar skyward. It was not shipping season. The freight-cars stood idle in a long line. No cattle huddled in the corrals. No strangers moved in town. No cow-ponies dozed in front of the saloon. Their riders were distant in ranch and camp. Human noise was extinct in Separ. Beneath the thunder of the sultry blasts the place lay dead in its flapping shroud of dust.

"Why won't you tell me?" droned Billy. For some time he had been returning, like a mosquito brushed away.

"That's ten times," said Jessamine, promptly.

"Oh, goodness! Pretty soon I'll not be glad I came. I'm about twiced as less glad now."

"Well," said Jessamine, "there's a man coming to-day to mend the government telegraph line between Drybone and McKinney. Maybe he would take you back as far as Box Elder, if you want to go very much. Shall I ask him?"

Billy was disappointed at this cordial seconding of his mood. He did not make a direct rejoinder. "I guess I'll go outside now," said he, with a threat in his tone.

She continued mending his stockings. Finished ones lay rolled at one side of her chair, and upon the other were more waiting her attention.

"And I'm going to turn back handsprings on top of all the freight-cars," he stated, more loudly.

She indulged again in merriment, laughing sweetly at him, and without restraint.

"And I'm sick of what you all keep a-saying to me!" he shouted. "Just as if I was a baby."

"Why, Billy, who ever said you were a baby?"

"All of you do. Honey, and Lin, and you now, and everybody. What makes you say 'that's nine times, Billy, oh, Billy, that's ten times,' if you don't mean I'm a baby? And you laugh me off, just like they do, and just like I was a regular baby. You won't tell me—"

"Billy, listen. Did nobody ever ask you something you did not want to tell them?"

"That's not a bit the same, because—because—because I treat 'em square, and because it's not their business. But every time I ask anybody 'most anything, they say I'm not old enough to understand; and I'll be ten soon. And it is my business when it's about the kind of a mother I'm a-going to have. Suppose I quit acting square, an' told 'em, when they bothered me, they weren't young enough to understand! Wish I had. Guess I will, too, and watch 'em step around." For a moment his mind dwelt upon this, and he whistled a revengeful strain.

"Goodness, Billy!" said Jessamine, at the sight of the next stocking. "The whole heel is scorched off."

He eyed the ruin with indifference. "Ah, that was last month, when I and Lin shot the bear in the swamp-willows. He made me dry off my legs. Chuck it away."

"And spoil the pair? No, indeed!"

"Mother always chucked 'em, an' father'd buy new ones, till I skipped from home. Lin kind o' mends 'em."

"Does he?" said Jessamine, softly. And she looked at the photograph.

"Yes. What made you write him for to let me come and bring my stockin's and things?"

"Don't you see, Billy, there is so little work at this station that I'd be looking out of the window all day just the pitiful way you do?"

"Oh!" Billy pondered. "And so I said to Lin," he continued, "why didn't he send down his own clothes, too, an' let you fix 'em all? And Honey Wiggin laughed right in his coffee-cup so it all sploshed out. And the cook he asked me if mother used to mend Lin's clothes. But I guess she chucked 'em, like she always did father's and mine. I was with father, you know, when mother was married to Lin that time." He paused again, while his thoughts and fears struggled. "But Lin says I needn't ever go back," he went on, reasoning and confiding to her. "Lin don't like mother any more, I guess." His pondering grew still deeper, and he looked at Jessamine for some while. Then his face wakened with a new theory. "Don't Lin like you any more?" he inquired.

"Oh," cried Jessamine, crimsoning, "yes! Why, he sent you to me!"

"Well, he got hot in camp when I said it sending his clothes to you. He quit supper pretty soon, and went away off a-walking. And that's another time they said I was too young. But Lin don't come to see you any more."

"Why, I hope he loves me," murmured Jessamine. "Always."

"Well, I hope so too," said Billy, earnestly. "For I like you. When I seen him show you our cabin on Box Elder, and the room he had fixed for you, I was glad you were coming to be my mother. Mother used to be awful. I wouldn't 'a' minded her licking me if she'd done other things. Ah, pshaw! I wasn't going to stand that." Billy now came close to Jessamine. "I do wish you would come and live with me and Lin," said he. "Lin's awful nice."

"Don't I know it?" said Jessamine, tenderly.

" 'Cause I heard you say you were going to marry him," went on Billy. "And I seen him kiss you and you let him that time we went away when you found out about mother. And you're not mad, and he's not, and nothing happens at all, all the same! Won't you tell me, please?"

Jessamine's eyes were glistening, and she took him in her lap. She was not going to tell him that he was too young this time. But whatever things she had shaped to say to the boy were never said.

Through the noise of the gale came the steadier sound of the train, and the girl rose quickly to preside over her ticket-office and duties behind the railing

in the front room of the station. The boy ran to the window to watch the great event of Separ's day. The locomotive loomed out from the yellow clots of drift, paused at the water-tank, and then with steam and humming came slowly on by the platform. Slowly its long dust-choked train emerged trundling behind it, and ponderously halted. There was no one to go. No one came to buy a ticket of Jessamine. The conductor looked in on business, but she had no telegraphic orders for him. The express agent jumped off and looked in for pleasure. He received his daily smile and nod of friendly discouragement. Then the light bundle of mail was flung inside the door. Separ had no mail to go out. As she was picking up the letters, young Billy passed her like a shadow, and fled out. Two passengers had descended from the train, a man and a large woman. His clothes were loose and careless upon him. He held valises, and stood uncertainly looking about him in the storm. Her firm heavy body was closely dressed. In her hat was a large handsome feather. Along between the several cars brakemen leaned out, watched her, and grinned to each other. But her big, hard-shining blue eyes were fixed curiously upon the station where Jessamine was.

"It's all night we may be here, is it?" she said to the man, harshly.

"How am I to help that?" he retorted.

"I'll help it. If this hotel's the sty it used to be, I'll walk to Tommy's. I've not saw him since I left Bear Creek."

She stalked into the hotel, while the man went slowly to the station. He entered, and found Jessamine behind her railing, sorting the slim mail.

"Good-evening," he said. "Excuse me. There was to be a wagon sent here."

"For the telegraph-mender? Yes, sir. It came Tuesday. You're to find the pole-wagon at Drybone."

This news was good, and all that he wished to know. He could drive out and escape a night at the Hotel Brunswick. But he lingered, because Jessamine spoke so pleasantly to him. He had heard of her also.

"Governor Barker has not been around here?" he said.

"Not yet, sir. We understand he is expected through on a hunting-trip."

"I suppose there is room for two and a trunk in that wagon?"

"I reckon so, sir." Jessamine glanced at the man, and he took himself out. Most men took themselves out if Jessamine so willed; and it was mostly achieved thus, in amity.

On the platform the man found his wife again.

"Then I needn't to walk to Tommy's," she said. "And we'll eat as we travel. But you'll wait till I'm through with her." She made a gesture toward the station.

"Why—why—what do you want with her? Don't you know who she is?"

"It was me told you who she was, James Lusk. You'll wait till I've been and asked her after Lin McLean's health, and till I've saw how the likes of her talks to the likes of me."

He made a feeble protest that this would do no one any good.

"Sew yourself up, James Lusk. If it has been your idea I come with yus clear from Laramie to watch yus plant telegraph poles in the sage-brush, why you're off. I 'ain't heard much o' Lin since the day he learned it was you and not him that was my husband. And I've come back in this country to have a look at my old friends—and" (she laughed loudly and nodded at the station) "my old friends' new friends!"

Thus ordered, the husband wandered away to find his wagon and the horse. Jessamine, in the office, had finished her station duties and returned to her needle. She sat contemplating the scorched sock of Billy's, and heard a heavy step at the threshold. She turned, and there was the large woman with the feather quietly surveying her. The words which the stranger spoke then were usual enough for a beginning. But there was something of threat in the strong animal countenance, something of laughter ready to break out. Much beauty of its kind had evidently been in the face, and now, as substitute for what was gone, was the brag look of assertion that it was still all there. Many stranded travellers knocked at Jessamine's door, and now, as always, she offered the hospitalities of her neat abode, the only room in Separ fit for a woman. As she spoke, and the guest surveyed and listened, the door blew shut with a crash.

Outside in a shed, Billy had placed the wagon between himself and his father.

"How you have grown!" the man was saying; and he smiled. "Come, shake hands. I did not think to see you here."

"Dare you to touch me!" Billy screamed. "No, I'll never come with you. Lin says I needn't to."

The man passed his hand across his forehead, and leaned against the wheel. "Lord! Lord!" he muttered.

His son warily slid out of the shed and left him leaning there.

II.

Lin McLean, bachelor, sat out in front of his cabin, looking at a small bright pistol that lay in his hand. He held it tenderly, cherishing it, and did not cease slowly to polish it. Revery filled his eyes, and in his whole face was sadness unmasked, because only the animals were there to perceive his true feelings. Sunlight and waving shadows moved together upon the green of his pasture, cattle and horses loitered in the opens by the stream. Down Box Elder's course, its valley and golden-chimneyed bluffs widened away into the level and the blue of the greater valley. Upstream, the branches and shining quiet leaves entered the mountains where the rock chimneys narrowed to a gateway, a citadel of shafts and turrets, crimson and gold above the filmy emerald of the trees. Through there the road went up from the cottonwoods into the cool quaking-asps and pines, and so across the range and away to Separ. Along the ridge-pole of the new stable, two hundred yards downstream, sat McLean's turkeys, and cocks

and hens walked in front of him here by his cabin and fenced garden. Slow smoke rose from the cabin's chimney into the air, in which were no sounds but the running water and the afternoon chirp of birds. Amid this framework of a home the cow-puncher sat, lonely, inattentive, polishing the treasured weapon as if it were not already long clean. His target stood some twenty steps in front of him—a small cottonwood-tree, its trunk chipped and honeycombed with bullets which he had fired into it each day for memory's sake. Presently he lifted the pistol and looked at its name—the word "Neighbor" engraved upon it.

"I wonder," said he aloud, "if she keeps the rust off mine?" Then he lifted it slowly to his lips and kissed the word "Neighbor."

The clank of wheels sounded on the road, and he put the pistol quickly down. Dreaminess vanished from his face. He looked around alertly, but no one had seen him. The clanking was still among the trees a little distance up Box Elder. It approached deliberately, while he watched for the vehicle to emerge upon the open where his cabin stood; and then they came, a man and a woman. At sight of her Mr. McLean half rose, but sat down again. Neither of them had noticed him, sitting as they were in silence and the drowsiness of a long drive. The man was weak-faced, with good looks sallowed by dissipation, and a vanquished glance of the eye. As the woman had stood on the platform at Separ, so she sat now, upright, bold, and massive. The brag of past beauty was a habit settled upon her stolid features. Both sat inattentive to each other and to everything around them. The wheels turned slowly and with a dry dead noise, the reins bellied loosely to the shafts, the horse's head hung low. So they drew close. Then the man saw McLean, and color came into his face and went away.

"Good-evening," said he, clearing his throat. "We heard you was in cow-camp."

The cow-puncher noted how he tried to smile, and a freakish change crossed his own countenance. He nodded slightly, and stretched his legs out as he sat.

"You look natural," said the woman, familiarly.

"Seem to be fixed nice here," continued the man. "Hadn't heard of it. Well, we'll be going along. Glad to have seen you."

"Your wheel wants greasing," said McLean, briefly, his eye upon the man.

"Can't stop. I expect she'll last to Drybone. Good-evening."

"Stay to supper," said McLean, always seated on his chair.

"Can't stop, thank you. I expect we can last to Drybone." He twitched the reins.

McLean levelled a pistol at a chicken, and knocked off its head. "Better stay to supper," he suggested, very distinctly.

"It's business, I tell you. I've got to catch Governor Barker before he—"

The pistol cracked and a second chicken shuffled in the dust. "Better stay to supper," drawled McLean.

The man looked up at his wife.

"So yus need me!" she broke out. " 'Ain't heart enough in yer played-out body to stand up to a man. We'll eat here. Get down."

The husband stepped to the ground. "I didn't suppose you'd want—"

"Ho! want? What's Lin, or you, or anything to me? Help me out."

Both men came forward. She descended, leaning heavily upon each, her blue staring eyes fixed upon the cow-puncher.

"No, yus ain't changed," she said. "Same in your looks and same in your actions. Was you expecting you could scare me, you Lin McLean?"

"I just wanted chickens for supper," said he.

Mrs. Lusk gave a hard high laugh. "I'll eat 'em. It's not I that cares. As for—" She stopped. Her eye had fallen upon the pistol and the name "Neighbor."

"As for you," she continued to Mr. Lusk, "don't you be standing dumb same as the horse."

"Better take him to the stable, Lusk," said McLean.

He picked the chickens up, showed the woman to the best chair in his room, and went into his kitchen to cook supper for three. He gave his guests no further attention, nor did either of them come in where he was, nor did the husband rejoin the wife. He walked slowly up and down in the air, and she sat by herself in the room. Lin's steps as he made ready round the stove and table, and Lusk's slow tread out in the setting sunlight, were the only sounds about the cabin. When the host looked into the door of the next room to announce that his meal was served, the woman sat in her chair no longer, but stood with her back to him by a shelf. She gave a slight start at his summons, and replaced something. He saw that she had been examining "Neighbor," and his face hardened suddenly to fierceness as he looked at her; but he repeated quietly that she had better come in. Thus did the three sit down to their meal. Occasionally a word about handing some dish fell from one or other of them, but nothing more, until Lusk took out his watch and mentioned the hour.

"Yu've not ate especially hearty," said Lin, resting his arms upon the table.

"I'm going," asserted Lusk. "Governor Barker may start out. I've got my interests to look after."

"Why, sure," said Lin. "I can't hope you'll waste all your time on just me."

Lusk rose and looked at his wife. "It'll be ten now before we get to Drybone," said he. And he went down to the stable.

The woman sat still, pressing the crumbs of her bread. "I know you seen me," she said, without looking at him.

"Saw you when?"

"I knowed it. And I seen how you looked at me." She sat twisting and pressing the crumb. Sometimes it was round, sometimes it was a cube, now and then she flattened it to a disc. Mr. McLean seemed to have nothing that he wished to reply.

"If you claim that pistol is yourn," she said next, "I'll tell you I know better.

If you ask me whose should it be if not yourn, I would not have to guess the name. She has talked to me, and me to her.''

She was still looking away from him at the bread-crumb, or she could have seen that McLean's hand was trembling as he watched her, leaning on his arms.

"Oh yes, she was willing to talk to me!" The woman uttered another sudden laugh. "I knowed about her—all. Things get heard of in this world. Did not all about you and me come to her knowledge in its own good time, and it done and gone how many years? My! my! my!" Her voice grew slow and absent. She stopped for a moment, and then more rapidly resumed: "It had travelled around about you and her like it always will travel. It was known how you had asked her, and how she had told you she would have you, and then told you she would not when she learned about you and me. Folks that knowed yus and folks that never seen yus in their lives had to have their word about her facing you down you had another wife, though she knowed the truth about me being married to Lusk and him livin' the day you married me, and ten and twenty marriages could not have tied you and me up, no matter how honest you swore to no hind'rance. Folks said it was plain she did not want yus. It give me a queer feelin' to see that girl. It give me a wish to tell her to her face that she did not love yus and did not know love. Wait, wait, Lin! Yu' never hit me yet."

"No," said the cow-puncher. "Nor now. I'm not Lusk."

"Yu' looked so—so bad, Lin. I never seen yu' look so bad in old days. Wait, now, and I must tell it. I wished to laugh in her face and say, 'What do you know about love?' So I walked in. Lin, she does love yus!"

"Yes," breathed McLean.

"She was sittin' back in her room at Separ. Not the ticket-office, but—"

"I know," the cow-puncher said. His eyes were burning.

"It's snug, the way she has it. 'Good-afternoon,' I says. 'Is this Miss Jessamine Buckner?' "

At his sweetheart's name the glow in Lin's eyes seemed to quiver to a flash.

"And she spoke pleasant to me—pleasant and gay like. But a woman can tell sorrow in a woman's eyes. And she asked me would I rest in her room there, and what was my name. 'They tell me you claim to know it better than I do,' I says. 'They tell me you say it is Mrs. McLean.' She put her hand on her breast, and she keeps lookin' at me without never speaking. 'Maybe I am not so welcome now,' I says. 'One minute,' says she. 'Let me get used to it.' And she sat down.

"Lin, she is a square-lookin' girl. I'll say that for her.

"I never thought to sit down onced myself; I don't know why, but I kep' a-standing, and I took in that room of hers. She had flowers and things around there, and I seen your picture standing on the table, and I seen your six-shooter right by it—and, oh, Lin, hadn't I knowed your face before ever she did, and

that gun you used to let me shoot on Bear Creek? It took me that sudden! Why, it rushed over me so I spoke right out different from what I'd meant and what I had ready fixed up to say.

" 'Why did you do it?' I says to her, while she was a-sitting. 'How could you act so, and you a woman?' She just sat, and her sad eyes made me madder at the idea of her. 'You have had real sorrow,' says I, 'if they report correct. You have knowed your share of death, and misery, and hard work, and all. Great God! ain't there things enough that come to yus uncalled-for and natural, but you must run around huntin' up more that was leavin' yus alone and givin' yus a chance? I knowed him onced. I knowed your Lin McLean. And when that was over, I knowed for the first time how men can be different.' I'm started, Lin, I'm started. Leave me go on, and when I'm through I'll quit. 'Some of 'em, anyway,' I says to her, 'has hearts and self-respect, and ain't hogs clean through.'

" 'I know,' she says, thoughtful like.

"And at her whispering that way I gets madder.

" 'You know!' I says then. 'What is it that you know? Do you know that you have hurt a good man's heart? For onced I hurt it myself, though different. And hurts in them kind of hearts stays. Some hearts is that luscious and pasty you can stab 'em and it closes up so yu'd never suspicion the place; but Lin McLean! Nor yet don't yus believe his is the kind that breaks—if any kind does that. You may sit till the gray hairs, and you may wall up your womanhood, but if a man has got manhood like him, he will never sit till the gray hairs. Grief over losin' the best will not stop him from searchin' for a second best after a while. He wants a home, and he has got a right to one,' says I to Miss Jessamine. 'You have not walled up Lin McLean,' I says her. Wait, Lin, wait. Yus needn't to tell me that's a lie. I know a man thinks he's walled up for a while.''

"She could have told you it was a lie,'' said the cow-puncher.

"She did not. 'Let him get a home,' says she. 'I want him to be happy.' 'That flash in your eyes talks different,' says I. 'Sure enough yus wants him to be happy. Sure enough. But not happy along with Miss Second Best.'

"Lin, she looked at me that piercin'!

"And I goes on, for I was wound away up. 'And he will be happy, too,' I says. 'Miss Second Best will have a talk with him about your picture and little "Neighbor," which he'll not send back to yus, because the hurt in his heart is there. And he will keep 'em out of sight somewheres after his talk with Miss Second Best.' Lin, Lin, I laughed at them words of mine, but I was that wound up I was strange to myself. And she watchin' me that way! And I says to her: 'Miss Second Best will not be the crazy thing to think I am any wife of his standing in her way. He will tell her about me. He will tell how onced he thought he was solid married to me till Lusk came back; and she will drop me out of sight along with the rest that went nameless. They was not oncomprehensible to you, was they? You had learned something by livin',

guess! And Lin—your Lin, not mine, nor never mine in heart for a day so deep as he's yourn right now—he has been gay—gay as any I've knowed. Why, look at that face of his! Could a boy with a face like that help bein' gay? But that don't touch what's the true Lin deep down. Nor will his deep-down love for you hinder him like it will hinder you. Don't you know men and us is different when it comes to passion? We're all one thing then; but they ain't simple. They keep along with lots of other things. I can't make yus know, and I guess it takes a woman like I have been to learn their nature. But you did know he loved you, and you sent him away, and you'll be homeless in yer house when he has done the right thing by himself and found another girl.'

"Lin, all the while I was talkin' all I knowed to her without knowin' what I'd be sayin' next, for it come that unexpected, she was lookin' at me with them steady eyes. And all she says when I quit was, 'If I saw him I would tell him to find a home.' "

"Didn't she tell yu' she'd made me promise to keep away from seeing her?" asked the cow-puncher.

Mrs. Lusk laughed. "Oh, you innocent!" said she.

"She said if I came she would leave Separ," muttered McLean, brooding.

Again the large woman laughed out, but more harshly.

"I have kept my promise," Lin continued.

"Keep it some more. Sit here rotting in your chair till she goes away. Maybe she's gone."

"What's that?" said Lin. But still she only laughed harshly. "I could be there by to-morrow night," he murmured. Then his face softened. "She would never do such a thing!" he said to himself.

He had forgotten the woman at the table. While she had told him matters that concerned him he had listened eagerly. Now she was of no more interest than she had been before her story was begun. She looked at his eyes as he sat thinking and dwelling upon his sweetheart. She looked at him, and a longing welled up into her face. A certain youth and heavy beauty relighted the features.

"You are the same, same Lin everyways," she said. "A woman is too many for you still, Lin!" she whispered.

At her summons he looked up from his revery.

"Lin, I would not have treated you so."

The caress that filled her voice was plain. His look met hers as he sat quite still, his arms on the table. Then he took his turn at laughing.

"You!" he said. "At least I've had plenty of education in you."

"Lin, Lin, don't talk that brutal to me to-day. If yus knowed how near I come shooting myself with 'Neighbor.' That would have been funny! I knowed yus wanted to tear that pistol out of my hand because it was hern. But yus never did such things to me, fer there's a gentleman in you somewheres, Lin. And yus didn't never hit me, not even when you come to know me well. And when

I seen you so unexpected again to-night and you just the same old Lin, scaring Lusk with shooting them chickens, so comic and splendid, I could 'a' just killed Lusk sittin' in the wagon. Say, Lin, what made yus do that, anyway?"

"I can't hardly say," said the cow-puncher. "Only noticing him so turruble anxious not to stop—well, a man acts without thinking."

"You always did, Lin. You was always a comical genius. Lin, them were good times."

"Which times?"

"You know. You can't tell me you have forgot."

"I have not forgot much. What's the sense in this?"

"Yus never loved me!" she exclaimed.

"Shucks!"

"Lin, Lin, is it all over? You know yus loved me on Bear Creek. Say you did. Only say it was once that way." And as he sat, she came and put her arms round his neck. For a moment he did not move, letting himself be held; and then she kissed him. The plates crashed as he beat and struck her down upon the table. He was on his feet, cursing himself. As he went out of the door, she lay where she had fallen beneath his fist, looking after him and smiling.

McLean walked down Box Elder Creek through the trees towards the stable, where Lusk had gone to put the horse in the wagon. Once he leaned his hand against a big cottonwood, and stood still with half-closed eyes. Then he continued on his way. "Lusk!" he called presently, and in a few steps more, "Lusk!" Then, as he came slowly out of the trees to meet the husband, he began, with quiet evenness, "Your wife wants to know—" But he stopped. No husband was there. Wagon and horse were not there. The door was shut. The bewildered cow-puncher looked up the stream where the road went, and he looked down. Out of the sky where daylight and stars were faintly shining together sounded the long cries of the night-hawks as they sped and swooped to their hunting in the dusk. From among the trees by the stream floated a cooler air, and distant and close by sounded the splashing water. About the meadow where Lin stood, his horses fed, quietly crunching. He went to the door, looked in, and shut it again. He walked to his shed and stood contemplating his own wagon alone there. Then he lifted away a piece of trailing vine from the gate of the corral, while the turkeys moved their heads and watched him from the roof. A rope was hanging from the corral, and seeing it, he dropped the vine. He opened the corral gate, and walked quickly back into the middle of the field, where the horses saw him and his rope, and scattered. But he ran and herded them, whirling the rope, and so drove them into the corral, and flung his noose over two. He dragged two saddles—men's saddles—from the stable, and next he was again at his cabin door with the horses saddled. She was sitting quite still by the table where she had sat during the meal, nor did she speak or move when she saw him look in at the door.

"Lusk has gone," said he. "I don't know what he expected you would do. Or I would do. But we will catch him before he gets to Drybone."

She looked at him with her dumb stare. "Gone?" she said.

"Get up and ride," said McLean. "You are going to Drybone."

"Drybone," she echoed. Her voice was toneless and dull.

He made no more explanations to her, but went quickly about the cabin. Soon he had set it in order, the dishes on their shelves, the table clean, the fire in the stove arranged; and all these movements she followed with a sort of blank mechanical patience. He made a small bundle for his own journey, tied it behind his saddle, brought her horse beside a stump. When at his sharp order she came out, he locked his cabin and hung the key by a window, where travellers could find it and be at home.

She stood looking where her husband had slunk off. Then she laughed. "It's about his size," she murmured.

Her old lover helped her in silence to mount into the man's saddle—this they had often done together in former years—and so they took their way down the silent road. They had not many miles to go, and after the first two lay behind them, when the horses were limbered and had been put to a canter, they made time quickly. They had soon passed out of the trees and pastures of Box Elder and among the vast low stretches of the greater valley. Not even by day was the river's course often discernible through the ridges and cheating sameness of this wilderness; and beneath this half-darkness of stars and a quarter-moon the sage spread shapeless to the looming mountains, or to nothing.

"I will ask you one thing," said Lin, after ten miles.

The woman made no sign of attention as she rode beside him.

"Did I understand that she—Miss Buckner, I mean—mentioned she might be going away from Separ?"

"How do I know what you understood?"

"I thought you said—"

"Don't you bother me, Lin McLean." Her laugh rang out, loud and forlorn— one brief burst that startled the horses and that must have sounded far across the sage-brush. "You men are rich," she said.

They rode on, side by side, and saying nothing after that. The Drybone road was a broad trail, a worn strip of bareness going onward over the endless shelvings of the plain, visible even in this light; and presently, moving upon its grayness on a hill in front of them, they made out the wagon. They hastened and overtook it.

"Put your carbine down," said McLean to Lusk. "It's not robbers. It's your wife I'm bringing you." He spoke very quietly.

The husband addressed no word to the cow-puncher. "Get in, then," he said to his wife.

"Town's not far now," said Lin. "Maybe you would prefer riding the balance of the way?"

"I'd—" But the note of pity that she felt in McLean's question overcame her, and her utterance choked. She nodded her head, and the three continued slowly climbing the hill together.

From the narrows of the steep, sandy, weather-beaten banks that the road slanted upward through for a while, they came out again upon the immensity of the tableland. Here, abruptly, like an ambush, was the whole unsuspected river close below to their right, as if it had emerged from the earth. With a circling sweep from somewhere out in the gloom it cut in close to the lofty mesa beneath tall clean-graded descents of sand, smooth as a railroad embankment. As they paused on the level to breathe their horses, the wet gulp of its eddies rose to them through the stillness. Upstream they could make out the light of the Drybone bridge, but not the bridge itself; and two lights on the further bank showed where stood the hog-ranch opposite Drybone. They went on over the table-land, and reached the next herald of the town, Drybone's chief historian, the graveyard. Beneath its slanting head-boards and wind-shifted sand lay many more people than lived in Drybone. They passed by the fence of this shelterless acre on the hill and shoutings and high music began to reach them. At the foot of the hill they saw the sparse lights and shapes of the town where ended the gray stripe of road. The many sounds, feet, voices, and music, grew clearer, unravelling from their muffled confusion, and the fiddling became a tune that could be known.

"There's a dance to-night," said the wife to the husband. "Hurry."

He drove as he had been driving. Perhaps he had not heard her.

"I'm telling you to hurry," she repeated. "My new dress is in that wagon. There'll be folks to welcome me here that's older friends than you."

She put her horse to a gallop down the broad road toward the music and the older friends. The husband spoke to his horse, cleared his throat and spoke louder, cleared his throat again, and this time his sullen voice carried, and the animal started. So Lusk went ahead of Lin McLean, following his wife with the new dress at as good a pace as he might. If he did not want her company, perhaps to be alone with the cow-puncher was still less to his mind.

"It ain't only her he's stopped caring for," mused Lin, as he rode slowly along. "He don't care for himself any more."

III.

To-day, Drybone has altogether returned to the dust. Even in that day its hour could have been heard beginning to sound, but its inhabitants were rather deaf. Gamblers, saloon-keepers, murderers, outlaws, male and female, all were so busy with their cards, their lovers, and their bottles as to make the place seem

young and vigorous; but it was second childhood which had set in.

Drybone had known a wholesome adventurous youth, where manly lives and deaths were plenty. It had been an army post. It had seen horse and foot, and heard the trumpet. Brave wives had kept house for their captains upon its bluffs. Winter and summer they had made the best of it. When the War Department ordered the captains to catch Indians, the wives bade them God-speed. When the Interior Department ordered the captains to let the Indians go again, still they made the best of it. You must not waste Indians. Indians were a source of revenue to so many people in Washington and elsewhere. But the process of catching Indians armed with weapons sold them by friends of the Interior Department, was not entirely harmless. Therefore there came to be graves in the Drybone graveyard. The pale weather-washed head-boards told all about it: "Sacred to the memory of Private So-and-So, killed on the Dry Cheyenne, May 6, 1875." Or it would be, "Mrs. So-and-So, found scalped on Sage Creek." But even the financiers at Washington could not wholly preserve the Indian in Drybone's neighborhood. As the cattle by ten thousands came treading with the next step of civilization into this huge domain, the soldiers were taken away. Some of them went west to fight more Indians in Idaho, Oregon, or Arizona. The battles of the others being done, they went east in better coffins to sleep where their mothers or their comrades wanted them. Though wind and rain wrought changes upon the hill, the ready-made graves and boxes which these soldiers left behind proved heirlooms as serviceable in their way as were the tenements that the living had bequeathed to Drybone. Into these empty barracks came to dwell and to do business every joy that made the cow-puncher's holiday, and every hunted person who was baffling the sheriff. For the sheriff must stop outside the line of Drybone, as shall presently be made clear. The captain's quarters were a saloon now; professional cards were going in the adjutant's office night and day; and the commissary building made a good dance-hall and hotel. Instead of guard-mounting, you would see a horse-race on the parade-ground, and there was no provost-sergeant to gather up the broken bottles and old boots. Heaps of these choked the rusty fountain. In the tufts of yellow ragged grass that dotted the place plentifully were lodged many aces and queens and ten-spots, which the Drybone wind had blown wide from the doors out of which they had been thrown when a new pack was called for inside. Among the grass tufts would lie visitors who had applied for beds too late at the dance-hall, frankly sleeping their whiskey off in the morning air.

Above on the hill, the graveyard quietly chronicled this new epoch of Drybone. So-and-So was seldom killed very far out of town, and of course scalping had disappeared. "Sacred to the memory of Four-Ace Johnston, accidently shot, Sep. 4, 1885." Perhaps one is still there unaltered: "Sacred to the memory of Mrs. Ryan's babe. Aged two months." This unique corpse had succeeded in dying with its boots off.

But a succession of graves was not always needed to read the changing tale of the place, and how people died there; one grave would often be enough. The soldiers, of course, had kept treeless Drybone supplied with wood. But in these latter days wood was very scarce. None grew nearer than twenty or thirty miles—none, that is, to make boards of a sufficient width for epitaphs. And twenty miles was naturally far to go to hew a board for a man of whom you knew perhaps nothing but what he said his name was, and to whom you owed nothing, perhaps, but a trifling poker debt. Hence it came to pass that head-boards grew into a sort of directory. They were light to lift from one place to another. A single coat of white paint would wipe out the first tenant's name sufficiently to paint over it the next comer's. By this thrifty habit the original boards belonging to the soldiers could go round, keeping pace with the new civilian population; and though at first sight you might be puzzled by the layers of names still visible beneath the white paint, you could be sure that the clearest and blackest was the one to which the present tenant had answered.

So there on the hill lay the graveyard, steadily writing Drybone's history; and making that history lay the town at the bottom—one thin line of houses framing three sides of the old parade-ground. In these slowly rotting shells people rioted, believing the golden age was here, the age when everybody should have money and nobody should be arrested. For Drybone soil, you see, was still government soil, not yet handed over to Wyoming; and only government could arrest there, and only for government crimes. But government had gone, and seldom worried Drybone. The spot was a postage-stamp of sanctuary pasted in the middle of Wyoming's big map, a paradise for the Four-Ace Johnstons. Only, you must not steal a horse. That was really wicked, and brought you instantly to the notice of Drybone's one official—the coroner. For they did keep a coroner—Judge Slaghammer. He was perfectly illegal, and lived next door in Albany County. But that county paid him fees and mileage to keep tally of Drybone's casualties. His wife owned the dance-hall, and between their industries they made out a living. And all the citizens made out a living. The happy cow-punchers on ranches far and near still earned and instantly spent the high wages still paid them. With their bodies full of youth and their pockets full of gold, they rode into town by twenties, by fifties, and out again next morning, penniless always and happy. And then the Four-Ace Johnstons would sit card-playing with each other till the innocents should come to town again.

To-night the innocents had certainly come to town, and Drybone was furnishing to them all its joys. Their many horses stood tied at every post and corner—patient, experienced cow-ponies, well knowing it was an all-night affair. The talk and laughter of the riders was in the saloons; they leaned joking over the bars, they sat behind their cards at the tables, they strolled to the post-trader's to buy presents for their easy sweethearts, their boots were keeping audible time with the fiddle at Mrs. Slaghammer's. From the multitude and vigor of the sounds there, the

dance was being done regularly. "Regularly" meant that upon the conclusion of each set the gentleman led his lady to the bar and invited her to choose; and it was also regular that the lady should choose. Beer and whiskey were the alternatives.

Lin McLean's horse took him across the square without guiding from the cow-puncher, who sat absently with his hands folded upon the horn of his saddle. This horse, too, was patient and experienced, and could not know what remote thoughts filled his master's mind. He looked around to see why his master did not get off lightly, as he had done during so many gallant years, and hasten in to the conviviality. But the lonely cow-puncher sat mechanically identifying the horses of acquaintances.

"Toothpick Kid is here," said he, "and Limber Jim, and the Doughie. You'd think he'd stay away after the trouble he— I expect that pinto is Jerky Bill's."

"Go home!" said a hearty voice.

McLean eagerly turned. For the moment his face lighted from its sombreness. "I'd forgot you'd be here," said he. And he sprang to the ground. "It's fine to see you."

"Go home!" repeated the Governor of Wyoming, shaking his ancient friend's hand. "You in Drybone to-night, and claim you're reformed? Fie!"

"Yu' seem to be on hand yourself," said the cow-puncher, bracing to be jocular, if he could.

"Me! I've gone fishing. Don't you read the papers? If we poor Governors can't lock up the State House and take a whirl now and then—"

"Doc," interrupted Lin, "it's plumb fine to see yu'!" Again he shook hands.

"Why, yes! we've met here before, you and I." His Excellency the Hon. Amory W. Barker, M. D., stood laughing, familiar and genial, his sound white teeth shining. But behind his round spectacles he scrutinized McLean. For in this second hand-shaking was a fervor that seemed a grasp, a reaching out, for comfort. Barker had passed through Separ. Though an older acquaintance than Billy, he had asked Jessamine fewer and different questions. But he knew what he knew. "Well, Drybone's the same old Drybone," said he. "Sweet-scented hole of iniquity! Let's see how you walk nowadays."

Lin took a few steps.

"Pooh! I said you'd never get over it." And his Excellency beamed with professional pride. In his doctor days Barker had set the boy McLean's leg; and before it was properly knit the boy had escaped from the hospital to revel loose in Drybone on such another night as this. Soon he had been carried back, with the fracture split open again.

"It shows, does it?" said Lin. "Well, it don't usually. Not except when I'm—when I'm—"

"Down?" suggested his Excellency.

"Yes, Doc. Down," the cow-puncher confessed.

Barker looked into his friend's clear hazel eyes. Beneath their dauntless sparkle was something that touched the Governor's good heart. "I've got some whiskey along on the trip—Eastern whiskey," said he. "Come over to my room awhile."

"I used to sleep all night onced," said McLean, as they went. "Then I come to know different. But I'd never have believed just mere thoughts could make yu'—make yu' feel like the steam was only half on.—I eat, yu' know!" he stated suddenly. "And I expect one or two in camp lately have not found my muscle lacking. Feel me, Doc."

Barker dutifully obeyed, and praised the excellent sinews.

Across from the dance-hall the whining of the fiddle came, high and gay; feet blurred the talk of voices, and voices rose above the trampling of feet. Here and there some lurking form stumbled through the dark among the rubbish; and, clearest sound of all, the light crack of billiard-balls reached dry and far into the night. Barker contemplated the stars and calm splendid dimness of the plain. " 'Though every prospect pleases, and only man is vile,' " he quoted. "But don't tell the Republican party I said so."

"It's awful true, though, Doc. I'm vile myself. Yu' don't know. Why, *I* didn't know!"

And then they sat down to confidences and whiskey; for so long as the world goes round a man must talk to a man sometimes, and both must drink over it. The cow-puncher unburdened himself to the Governor; and the Governor filled up his friend's glass with the Eastern whiskey, and nodded his spectacles, and listened, and advised, and said he should have done the same, and like the good Governor that he was, never remembered he was Governor at all with political friends here who had begged a word or two. He became just Dr. Barker again, the young hospital surgeon (the hospital that now stood a ruin), and Lin was again his patient—Lin, the sunburnt free lance of nineteen, reckless, engaging, disobedient, his leg broken and his heart light, with no Jessamine or conscience to rob his salt of its savor. While he now told his troubles, the quadrilles fiddled away careless as ever, and the crack of the billiard-balls sounded as of old.

"Nobody has told you about this, I expect," said the lover. He brought forth the little pistol, "Neighbor." He did not hand it across to Barker, but walked over to Barker's chair, and stood holding it for the doctor to see. When Barker reached for it to see better, since it was half hidden in the cow-puncher's big hand, Lin yielded it to him, but still stood and soon drew it back. "I take it around," he said, "and when one of those stories comes along, like there's plenty of, that she wants to get rid of me, I just kind o' take a look at 'Neighbor' when I'm off where it's handy, and it busts the story right out of my mind. I have to tell you what a fool I am."

"The whiskey's your side," said Barker. "Go on."

"But, Doc, my courage has quit me. They see what I'm thinking about just

like I was a tenderfoot trying his first bluff. I can't stick it out no more, and I'm going to see her, come what will. I've got to. I'm going to ride right up to her window and shoot off 'Neighbor,' and if she don't come out I'll know—"

A knocking came at the Governor's room, and Judge Slaghammer entered. "Not been to our dance, Governor?" said he.

The Governor thought that perhaps he was tired, that perhaps this evening he must forego the pleasure.

"It may be wiser. In your position it may be advisable," said the coroner. "They're getting on rollers over there. We do not like trouble in Drybone, but trouble comes to us—as everywhere."

"Shooting," suggested his Excellency, recalling his hospital practice.

"Well, Governor, you know how it is. Our boys are as big-hearted as any in this big-hearted Western country. You know, Governor. Those generous, warm-blooded spirits are ever ready for anything."

"Especially after Mrs. Slaghammer's whiskey," remarked the Governor.

The coroner shot a shrewd eye at Wyoming's chief executive. It was not politically harmonious to be reminded that but for his wife's liquor a number of fine young men, with nothing save youth untrained and health the matter with them, would to-day be riding their horses instead of sleeping on the hill. But the coroner wanted support in the next campaign. "Boys will be boys," said he. "They 'ain't pulled any guns to-night. But I come away, though. Some of 'em's making up pretty free to Mrs. Lusk. It ain't suitable for me to see too much. Lusk says he's after you," he mentioned incidentally to Lin. "He's fillin' up, and says he's after you." McLean nodded placidly, and with scant politeness. He wished this visitor would go. But Judge Slaghammer had noticed the whiskey. He filled himself a glass. "Governor, it has my compliments," said he. "Ambrosier. Honey-doo."

"Mrs. Slaghammer seems to have a large gathering," said Barker.

"Good boys, good boys!" The judge blew importantly, and waved his arm. "Bull-whackers, cow-punchers, mule-skinners, tin horns. All spending generous. Governor, once more! Ambrosier. Honey-doo." He settled himself deep in a chair, and closed his eyes.

McLean rose abruptly. "Good-night," said he. "I'm going to Separ."

"Separ!" exclaimed Slaghammer, rousing slightly. "Oh, stay with us, stay with us." He closed his eyes again, but sustained his smile of office.

"You know how well I wish you," said Barker to Lin. "I'll just see you start."

Forthwith the friends left the coroner quiet beside his glass, and walked toward the horses through Drybone's gaping quadrangle. The dead ruins loomed among the lights of the card-halls, and always the keen jockey cadences of the fiddle sang across the night. But a calling and confusion were set up, and the tune broke off.

"Just like old times!" said his Excellency. "Where's the dump pile?" It was

where it should be, close by, and the two stepped behind it to be screened from wandering bullets. "A man don't forget his habits," declared the Governor. "Makes me feel young again."

"Makes me feel old," said McLean. "Hark!"

"Sounds like my name," said Barker. They listened. "Oh yes. Of course. That's it. They're shouting for the doctor. But we'll just spare them a minute or so to finish their excitement."

"I didn't hear any shooting," said McLean. "It's something, though."

As they waited, no shots came; but still the fiddle was silent, and the murmur of many voices grew in the dance-hall, while single voices wandered outside, calling the doctor's name.

"I'm the Governor on a fishing-trip," said he. "But it's to be done, I suppose."

They left their dump hill and proceeded over to the dance. The musician sat high and solitary upon two starch-boxes, fiddle on knee, staring and waiting. Half the floor was bare; on the other half the revellers were densely clotted. At the crowd's outer rim the young horsemen, flushed and swaying, retained their gaudy dance partners strongly by the waist, to be ready when the music should resume. "What is it?" they asked. "Who is it?" And they looked in across heads and shoulders, inattentive to the caresses which the partners gave them.

Mrs. Lusk was who it was, and she had taken poison here in their midst, after many dances and drinks.

"Here's Doc!" cried an older one.

"Here's Doc!" chorussed the young blood that had come into this country since his day. And the throng caught up the words. "Here's Doc! here's Doc!"

In a moment McLean and Barker were sundered from each other in this flood. Barker, sucked in toward the centre, but often eddied back by those who meant to help him, heard the mixed explanations pass his ear unfinished—versions, contradictions, a score of facts. It had been wolf-poison. It had been rat-poison. It had been something in a bottle. There was little steering in this clamorous sea; but Barker reached his patient, where she sat in her new dress, hailing him with wild inebriate gayety.

"I must get her to her room, friends," said he.

"He must get her to her room," went the word. "Leave Doc get her to her room." And they tangled in their eagerness around him and his patient.

"Give us 'Buffalo Girls!'" shouted Mrs. Lusk. "'Buffalo Girls,' you fiddler!"

"We'll come back," said Barker to her.

" 'Buffalo Girls,' I tell yus. Ho! there's no sense in looking at that bottle, Doc. Take yer dance while there's time!" She was holding the chair.

"Help him!" said the crowd. "Help Doc."

They took her from her chair, and she fought, a big pink mass of ribbons, fluttering and wrenching itself among them.

"She has six ounces of laudanum in her," Barker told them, at the top of

his voice. "It won't wait all night."

"I'm a whirlwind!" said Mrs. Lusk. "That's my game! And you done your share," she cried to the fiddler. "Here's my regards, old man! 'Buffalo Girls' once more!"

She flung out her hand, and from it fell notes and coins, rolling and ringing around the starch-boxes. Some dragged her on, while some fiercely forbade the musician to touch the money, because it was hers, and she would want it when she came to. Thus they gathered it up for her. But now she had sunk down, asking in a new voice where was Lin McLean. And when one grinning intimate reminded her that Lusk had gone to shoot him, she laughed out richly, and the crowd joined in her mirth. But even in the midst of the joke she asked again in the same voice where was Lin McLean. He came beside her among more jokes. He had kept himself near, and now at sight of him she reached out and held him. "Tell them to leave me go to sleep, Lin," said she.

Barker saw a chance. "Persuade her to come along," said he to McLean. "Minutes are counting now."

"Oh, I'll come," she said, with a laugh, overhearing him, and holding still to Lin.

The rest of the old friends nudged each other. "Back seats for us," they said. "But we've had our turn in front ones." Then, thinking they would be useful in encouraging her to walk, they clustered again, rendering Barker and McLean once more wellnigh helpless. Clumsily the escort made its slow way across the quadrangle, cautioning itself about stones and holes. Thus, presently, she was brought into the room. The escort set her down, crowding the little place as thick as it would hold; the rest gathered thick at the door, and all of them had no thought of departing. The notion to stay was plain on their faces.

Barker surveyed them. "Give the doctor a show now, boys," said he. "You've done it all so far. Don't crowd my elbows. I'll want you," he whispered to McLean.

At the argument of fair play, obedience swept over them like a veering of wind. "Don't crowd his elbows," they began to say at once, and told each other to come away. "We'll sure give the Doc room. You don't want to be shovin' your auger in, Chalkeye. You want to get yourself pretty near absent." The room thinned of them forthwith. "Fix her up good, Doc," they said, over their shoulders. They shuffled across the threshold and porch with roundabout schemes to tread quietly. When one or other stumbled on the steps and fell, he was jerked to his feet. "You want to tame yourself," was the word. Then suddenly Chalkeye and Toothpick Kid came precipitately back. "Her cash," they said. And leaving the notes and coins, they hastened to catch their comrades on the way back to the dance.

"I want you," repeated Barker to McLean.

"Him!" cried Mrs. Lusk, flashing alert again. "Jessamine wants him about

now, I guess. Don't keep him from his girl!" And she laughed her hard, rich laugh, looking from one to the other. "Not the two of yus can't save me," she stated, defiantly. But even in these last words a sort of thickness sounded.

"Walk her up and down," said Barker. "Keep her moving. I'll look what I can find. Keep her moving brisk." At once he was out of the door; and before his running steps had died away, the fiddle had taken up its tune across the quadrangle.

"'Buffalo Girls!'" exclaimed the woman. "Old times! Old times!"

"Come," said McLean. "Walk." And he took her.

Her head was full of the music. Forgetting all but that, she went with him easily, and the two made their first turns around the room. Whenever he brought her near the entrance, she leaned away from him toward the open door, where the old fiddle tune was coming in from the dark. But presently she noticed that she was being led, and her face turned sullen.

"Walk," said McLean.

"Do you think so?" said she, laughing. But she found that she must go with him. Thus they took a few more turns.

"You're hurting me," she said next. Then a look of drowsy cunning filled her eyes, and she fixed them upon McLean's dogged face. "He's gone, Lin," she murmured, raising her hand where Barker had disappeared.

She knew McLean had heard her, and she held back on the quickened pace that he had set.

"Leave me down. You hurt," she pleaded, hanging on him.

The cow-puncher put forth more strength.

"Just the floor," she pleaded again. "Just one minute on the floor. He'll think you could not keep me lifted."

Still McLean made no answer, but steadily led her round and round, as he had undertaken.

"He's playing out!" she exclaimed. "You'll be played out soon!" She laughed herself half awake. The man drew a breath, and she laughed more to feel his hand and arm strain to surmount her increasing resistance. "Jessamine!" she whispered to him. "Jessamine! Doc'll never suspicion you, Lin."

"Talk sense," said he.

"It's sense I'm talking. Leave me go to sleep. Ah, ah, I'm going! I'll go; you can't—"

"Walk! walk!" he repeated. He looked at the door. An ache was numbing his arms.

"Oh, yes, walk! What can you and all your muscle— Ah, walk me to glory then, craziness! I'm going; I'll go. I'm quitting this outfit for keeps. Lin, you're awful handsome to-night! I'll bet—I'll bet she has never seen you look so. Let me—let me watch yus. Anyway, she knows I came first!"

He grasped her savagely. "First! You and twenty of yu' don't— God! what

do I talk to her for?''

"Because—because—I'm going; I'll go. He slung me off—but he had to sling—You can't—stop—''

Her head was rolling, while the lips smiled. Her words came through deeper and deeper veils, fearless, defiant, a challenge inarticulate, a continuous mutter. Again he looked at the door as he struggled to move with her dragging weight. The drops rolled on his forehead and neck, his shirt was wet, his hands slipped upon her ribbons. Suddenly the drugged body folded and sank with him, pulling him to his knees. While he took breath so, the mutter went on, and through the door came the jigging fiddle. A fire of desperation lighted his eyes. "'Buffalo Girls!'" he shouted hoarsely in her ear, and got once more on his feet with her. Still shouting at her to wake, he struck a tottering sort of step, and so, with the bending load in his grip, strove feebly to dance the laudanum away.

Feet stumbled across the porch, and Lusk was in the room. "So I've got you!" he said. He had no weapon, but made a dive under the bed and came up with a carbine. The two men locked, wrenching impotently, and fell together. The carbine's loud shot rang in the room, but did no harm; and McLean lay sick and panting upon Lusk as Barker rushed in.

"Thank God!" said he, and flung Lusk's pistol down. The man, deranged and encouraged by drink, had come across the doctor, delayed him, threatened him with his pistol, and when he had torn it away, had left him suddenly and vanished. But Barker had feared, and come after him here. He glanced at the woman slumbering motionless beside the two men. The husband's brief courage had gone, and he lay beneath McLean, who himself could not rise. Barker pulled them apart.

"Lin, boy, you're not hurt?" he asked, affectionately, and lifted the cow-puncher. McLean sat passive, with dazed eyes, letting himself be supported.

"You're not hurt?" repeated Barker.

"No," answered the cow-puncher, slowly. "I guess not." He looked about the room and at the door. "I got interrupted," he said.

"You'll be all right soon," said Barker.

"Nobody cares for me!" cried Lusk, suddenly, and took to querulous weeping.

"Get up," ordered Barker, sternly.

"Don't accuse me, Governor," screamed Lusk. "I'm innocent." And he rose.

Barker looked at the woman and then at the husband. "I'll not say there was much chance for her," he said. "But any she had is gone through you. She'll die."

"Nobody cares for me!" repeated the man. "He has learned my boy to scorn me." He ran out aimlessly, and away into the night, leaving peace in the room.

"Stay sitting," said Barker to McLean, and went to Mrs. Lusk.

But the cow-puncher, seeing him begin to lift her toward the bed without

help, tried to rise. His strength was not sufficiently come back, and he sank as he had been. "I guess I don't amount to much," said he. "I feel like I was nothing."

"Well, I'm something," said Barker, coming back to his friend, out of breath. "And I know what she weighs." He stared admiringly through his spectacles at the seated man.

The cow-puncher's eyes slowly travelled over his body, and then sought Barker's face. "Doc," said he, "ain't I young to have my nerve quit me this way?"

His Excellency broke into his broad smile.

"I know I've racketed some, but ain't it rather early?" pursued McLean, wistfully.

"You six-foot infant!" said Barker. "Look at your hand."

Lin stared at it—the fingers quivering and bloody, and the skin grooved raw between them. That was the buckle of her belt, which in the struggle had worked round and been held by him unknowingly. Both his wrists and his shirt were ribbed with the pink of her sashes. He looked over at the bed where lay the woman heavily breathing. It was a something, a sound, not like the breath of life; and Barker saw the cow-puncher shudder.

"She is strong," he said. "Her system will fight to the end. Two hours yet, maybe. Queer world!" he moralized. "People half killing themselves to keep one in it who wanted to go—and one that nobody wanted to stay!"

McLean did not hear. He was musing, his eyes fixed absently in front of him. "I would not want," he said, "I'd not wish for even my enemy to have a thing like what I've had to do to-night."

Barker touched him on the arm. "If there had been another man I could trust—"

"Trust!" broke in the cow-puncher. "Why, Doc, it is the best turn yu' ever done me. I know I am a man now—if my nerve ain't gone."

"I've known you were a man since I knew you!" said the hearty Governor. And he helped the still unsteady six-foot to a chair. "As for your nerve, I'll bring you some whiskey now. And after"—he glanced at the bed—"and to-morrow you'll go try if Miss Jessamine won't put the nerve—"

"Yes, Doc, I'll go there, I know. But don't yu'—don't let's while she's— I'm goin' to be glad about this, Doc, after a while, but—"

At the sight of a new-comer in the door he stopped in what his soul was stammering to say. "What do you want, Judge?" he inquired, coldly.

"I understand," began Slaghammer to Barker—"I am informed—"

"Speak quieter, Judge," said the cow-puncher.

"I understand," repeated Slaghammer, more official than ever, "that there was a case for the coroner."

"You'll be notified," put in McLean again. "Meanwhile you'll talk quiet in this room."

Slaghammer turned, and saw the breathing mass on the bed.

"You are a little early, Judge," said Barker, "but—"

"But your ten dollars are safe," said McLean.

The coroner shot one of his shrewd glances at the cow-puncher, and sat down with an amiable countenance. His fee was, indeed, ten dollars; and he was desirous of a second term.

"Under the apprehension that it had already occurred—the misapprehension—I took steps to impanel a jury," said he, addressing both Barker and McLean. "They are—ah—waiting outside. Responsible men, Governor, and have sat before. Drybone has few responsible men to-night, but I procured these at a little game where they were—ah—losing. You may go back, gentlemen," said he, going to the door. "I will summon you in proper time." He looked in the room again. "Is the husband not intending—"

"That's enough, Judge," said McLean. "There's too many here without adding him."

"Judge," spoke a voice at the door, "ain't she ready yet?"

"She is still passing away," observed Slaghammer, piously.

"Because I was thinking," said the man—"I was just— You see us jury is dry and dead broke. Doggonedest cards I've held this year, and—Judge, would there be anything out of the way in me touching my fee in advance, if it's a sure thing?"

"I see none, my friend," said Slaghammer, benevolently, "since it must be." He shook his head and nodded it by turns. Then, with full-blown importance, he sat again, and wrote a paper, his coroner's certificate. Next door in Albany County these vouchers brought their face value of five dollars to the holder; but on Drybone's neutral soil the saloons would always pay four for them, and it was rare that any juryman could withstand the temptation of four immediate dollars. This one gratefully received his paper, and, cherishing it like a bird in the hand, he with his colleagues bore it where they might wait for duty and slake their thirst.

In the silent room sat Lin McLean, his body coming to life more readily than his shaken spirit. Barker, seeing that the cow-puncher meant to watch until the end, brought the whiskey to him. Slaghammer drew documents from his pocket to fill the time, but was soon in slumber over them. In all precincts of the quadrangle Drybone was keeping it up late. The fiddle, the occasional shouts, and the crack of the billiard-balls travelled clear and far through the vast darkness outside. Presently steps unsteadily drew near, and round the corner of the door a voice, plaintive and diffident, said, "Judge, ain't she 'most pretty near ready?"

"Wake up, Judge!" said Barker. "Your jury has gone dry again."

The man appeared round the door—a handsome, dishevelled fellow—with hat in hand, balancing himself with respectful anxiety. There was a second voucher made out, and the messenger strayed back happy to his friends. Barker and McLean sat wakeful, and Slaghammer fell at once to napping. From time to

time he was roused by new messengers, each arriving more unsteady than the last, until every juryman had got his fee and no more messengers came. The coroner slept undisturbed in his chair. McLean and Barker sat. On the bed the mass, with its pink ribbons, breathed and breathed, while moths flew round the lamp, tapping and falling with light sounds. So did the heart of the darkness wear itself away, and through the stone-cold air the dawn began to filter and expand.

Barker rose, bent over the bed, and then stood. Seeing him, McLean stood also.

"Judge," said Barker, quietly, "you may call them now." And with careful steps the Judge got himself out of the room to summon his jury.

For a short while the cow-puncher stood looking down upon the woman. She lay lumped in her gaudiness, the ribbons stained by the laudanum; but into the stolid, bold features death had called up the faint-colored ghost of youth, and McLean remembered all his Bear Creek days. "Hindsight is a turrable clear way o' seein' things," said he. "I think I'll take a walk."

"Go," said Barker. "The jury only need me, and I'll join you."

But the jury needed no witness. Their long waiting and the advance pay had been too much for these responsible men. Like brothers they had shared each others' vouchers until responsibility had melted from their brains and the whiskey was finished. Then, no longer entertained, and growing weary of Drybone, they had remembered nothing but their distant beds. Each had mounted his pony, holding trustingly to the saddle, and thus, unguided, the experienced ponies had taken them right. Across the wide sage-brush and up and down the river they were now asleep or riding, dispersed irrevocably. But the coroner was here. He duly received Barker's testimony, brought his verdict in, and signed it, and even while he was issuing to himself his own proper voucher for ten dollars came Chalkeye and Toothpick Kid on their ponies, galloping, eager in their hopes and good wishes for Mrs. Lusk. Life ran strong in them both. The night had gone well with them. Here was the new day going to be fine. It must be well with everybody.

"You don't say!" they exclaimed, taken aback. "Too bad."

They sat still in their saddles, and upon their reckless, kindly faces thought paused for a moment. "Her gone!" they murmured. "Hard to get used to the idea. What's anybody doing about the coffin?"

"Mr. Lusk," answered Slaghammer, "doubtless—"

"Lusk! He'll not know anything this forenoon. He's out there in the grass. She didn't think nothing of him. Tell Bill—not Dollar Bill, Jerky Bill, yu' know; he's over the bridge—to fix up a hearse, and we'll be back." The two drove their spurs in with vigorous heels, and instantly were gone rushing up the road to the graveyard.

The fiddle had lately ceased, and no dancers staid any longer in the hall.

Eastward the rose and gold began to flow down upon the plain over the tops of the distant hills. Of the revellers, many had never gone to bed, and many now were already risen from their excesses to revive in the cool glory of the morning. Some were drinking to stay their hunger until breakfast; some splashed and sported in the river, calling and joking; and across the river some were holding horse-races upon the level beyond the hog-ranch. Drybone air rang with them. Their lusty, wandering shouts broke out in gusts of hilarity. Their pistols, aimed at cans or prairie-dogs or anything, cracked as they galloped at large. Their speeding, clear-cut forms would shine upon the bluffs, and descending, merge in the dust their horses had raised. Yet all this was nothing in the vastness of the growing day. Beyond their voices the rim of the sun moved above the violet hills, and Drybone, amid the quiet, long, new fields of radiance, stood august and strange.

Down along the tall, bare slant from the graveyard the two horsemen were riding back. They could be seen across the river, and the horse-racers grew curious. As more and more watched, the crowd began to speak. It was a calf the two were bringing. It was too small for a calf. It was dead. It was a coyote they had roped. See it swing! See it fall on the road!

"It's a coffin, boys!" said one, shrewd at guessing.

At that the event of last night drifted across their memories, and they wheeled and spurred their ponies. Their crowding hoofs on the bridge brought the swimmers from the water below, and dressing, they climbed quickly to the plain and followed the gathering. By the door already were Jerky Bill and Limber Jim and the Doughie, and always more dashing up with their ponies, halting with a sharp scatter of gravel to hear and comment. Barker was gone, but the important coroner told his news. And it amazed each comer, and set him speaking and remembering past things with the others.

"Dead!" each one began.

"Her, does he say?"

"Why, pshaw!"

"Why, Frenchy said Doc had her cured!"

"Jack Saunders claimed she had rode to Box Elder with Lin McLean."

"Dead? Why, pshaw!"

"Seems Doc couldn't swim her out."

"Couldn't swim her out?"

"That's it. Doc couldn't swim her out."

"Well—there's one less of us."

"Sure! She was one of the boys."

"She grub-staked me when I went broke in '84.

"She gave me fifty dollars onced at Lander, to buy a saddle."

"I run agin her when she was a biscuit-shooter."

"Sidney, Nebraska. I run agin her there, too."

"I knowed her at Laramie."

"Where's Lin? He knowed her all the way from Bear Creek to Cheyenne." They laughed loudly at this.

"That's a lonesome coffin," said the Doughie. "That the best you could do?"

"You'd say so!" said Toothpick Kid.

"Choices are getting scarce up there," said Chalkeye. "We looked the lot over."

They were arriving from their search among the old dug-up graves on the hill. Now they descended from their ponies, with the box roped and rattling between them. "Where's your hearse, Jerky?" asked Chalkeye.

"Have her round in a minute," said the cowboy, and galloped away with three or four others to help.

"Turruble lonesome coffin, all the same," repeated the Doughie. And they surveyed the box that had once held some soldier.

"She did like fixin's," said Limber Jim.

"Fixin's!" said Toothpick Kid. "That's easy."

While some six of them with Chalkeye bore the light, half-rotted coffin into the room, many followed Toothpick Kid to the post-trader's store. Breaking in here, they found men sleeping on the counters. These had been able to find no other beds in Drybone, and lay as they had stretched themselves on entering. They sprawled in heavy slumber, some with not even their hats taken off, and some with their boots against the rough hair of the next one. They were quickly pushed together, few waking, and so there was space for spreading cloth and chintz. Stuffs were unrolled and flung aside, till many folds and colors draped the motionless sleepers, and at length a choice was made. Unmeasured yards of this drab chintz were ripped off, money treble its worth was thumped upon the counter, and they returned, bearing it like a streamer to the coffin. While the noise of their hammers filled the room, the hearse came tottering to the door, pulled and pushed by twenty men. It was an ambulance left behind by the soldiers, and of the old-fashioned shape, concave in body, its top blown away in winds of long ago; and as they revolved, its wheels dished in and out, like hoops about to fall. While some made a harness from ropes, and throwing the saddles off two ponies backed them to the vehicle, the body was put in the coffin, now covered by the chintz. But the laudanum upon the front of her dress revolted those who remembered their holidays with her, and turning the woman upon her face, they looked their last upon her flashing colored ribbons, and nailed the lid down. So they carried her out, but the concave body of the hearse was too short for the coffin; the end reached out, and it might have fallen. But Limber Jim, taking the reins, sat upon the other end, waiting and smoking. For all Drybone was making ready to follow in some way. They had sought the husband, the chief mourner. He, however, still lay in the grass of the quadrangle, and despising him as she had done, they left him to wake when

he should choose. Those men who could sit in their saddles rode escort, the old friends nearest, and four held the heads of the frightened cow-ponies who were to draw the hearse. They had never known harness before, and they plunged with the men who held them. Behind the hearse the women followed in a large ranch-wagon, this moment arrived in town. Two mares drew this, and their foals gambolled around them. The great flat-topped dray for hauling poles came last, with its four government mules. The cowboys had caught sight of it and captured it. Rushing to the post-trader's, they carried the sleeping men from the counter and laid them on the dray. Then, searching Drybone outside and in for any more incapable of following, they brought them, and the dray was piled.

Limber Jim called for another drink, and, with his cigar between his teeth, cracked his long bull-whacker whip. The ponies, terrified, sprang away, scattering the men that held them, and the swaying hearse leaped past the husband, over the stones and the many playing-cards in the grass. Masterfully steered, it came safe to an open level, while the throng cheered the unmoved driver on his coffin, his cigar between his teeth.

"Stay with it, Jim!" they shouted. "You're a king!"

A steep ditch lay across the flat where he was veering, abrupt and nearly hidden; but his eye caught the danger in time, and swinging from it leftward so that two wheels of the leaning coach were in the air, he faced the open again, safe, as the rescue swooped down upon him. The horsemen came at the ditch, a body of daring, a sultry blast of youth. Wheeling at the brink, they turned, whirling their long ropes. The skilful nooses flew, and the ponies, caught by the neck and foot, were dragged back to the quadrangle and held in line. So the pageant started; the wild ponies quivering but subdued by the tightened ropes, and the coffin steady in the ambulance beneath the driver. The escort, in their fringed leather and broad hats, moved slowly beside and behind it, many of them swaying, their faces full of health, and the sun, and the strong drink. The women followed, whispering a little; and behind them the slow dray jolted, with its heap of men waking from the depths of their whiskey, and asking what this was. So they went up the hill. When the riders reached the tilted gate of the graveyard, they sprang off and scattered among the hillocks, stumbling and eager. They nodded to Barker and McLean, quietly waiting there, and began choosing among the open, weather-drifted graves from which the soldiers had been taken. Their figures went up and down the uneven ridges, calling and comparing.

"Here," said the Doughie, "here's a good hole."

"Here's a deep one," said another.

"We've struck a well here," said some more. "Put her in here."

The sand hills became clamorous with voices until they arrived at a choice, when some one with a spade quickly squared the rain-washed opening. With

lariats looping the coffin round they brought it, and were about to lower it, when Chalkeye, too near the edge, fell in, and one end of the box rested upon him. He could not rise by himself, and they pulled the ropes helplessly above.

McLean spoke to Barker. "I'd like to stop this," said he, "but a man might as well—"

"Might as well stop a cloud-burst," said Barker.

"Yes, Doc. But it feels—it feels like I was looking at ten dozen Lin McLeans." And seeing them still helpless with Chalkeye, he joined them and lifted the cowboy out.

"I think," said Slaghammer, stepping forward, "this should proceed no further without some— Perhaps some friend would recite 'Now I lay me'?"

"They don't use that on funerals," said the Doughie.

"Will some gentleman give the Lord's Prayer?" inquired the coroner.

Foreheads were knotted; trial mutterings ran among them; but some one remembered a prayer-book in one of the rooms in Drybone, and the notion was hailed. Four mounted, and raced to bring it. They went down the hill in a flowing knot, shirts ballooning and elbows flapping, and so returned. But the book was beyond them. "Take it you; you take it," each one said. False beginnings were made, big thumbs pushed the leaves back and forth, until impatience conquered them. They left the book and lowered the coffin, helped again by McLean. The weight sank slowly, decently, steadily, down between the banks. The sound that it struck the bottom with was a slight sound, the grating of the load upon the solid sand; and a little sand strewed from the edge and fell on the box at the same moment. The rattle came up from below, compact and brief, a single jar, quietly smiting through the crowd, smiting it to silence. One removed his hat, and then another, and then all. They stood eying each his neighbor, and shifting their eyes, looked away at the great valley. They they filled in the grave, brought a head-board from a grave near by, and wrote the name and date upon it by scratching with a stone.

"She was sure one of us," said Chalkeye. "Let's give her the Lament."

And they followed his lead:

> "Once in the saddle I used to go dashing,
> Once in the saddle I used to go gay;
> First took to drinking, and then to card-playing;
> Got shot in the body, and now here I lay.
>
> "Beat the drum slowly,
> Play the fife lowly,
> Sound the dead march as you bear me along.
> Take me to Boot Hill, and throw the sod over me—
> I'm but a poor cowboy, I know I done wrong."

When the song was ended, they left the graveyard quietly, and went down

the hill. The morning was grown warm. Their work waited them across many sunny miles of range and plain. Soon their voices and themselves had emptied away into the splendid vastness and silence, and they were gone—ready with all their might to live or to die, to be animals or heroes, as the hours might bring them opportunity. In Drybone's deserted quadrangle the sun shone down upon Lusk still sleeping, and the wind shook the aces and kings in the grass.

IV.

Over at Separ, Jessamine Buckner had no more stockings of Billy's to mend, and much time for thinking and a change of mind. The day after that strange visit when she had been told that she had hurt a good man's heart without reason, she took up her work; and while her hands despatched it her thoughts already accused her. Could she have seen that visitor now, she would have thanked her. She looked at the photograph on her table. "Why did he go away so quickly?" she sighed. But when young Billy returned to his questions she was buoyant again, and more than a match for him. He reached the forbidden twelfth time of asking why Lin McLean did not come back and marry her. Nor did she punish him as she had threatened. She looked at him confidentially, and he drew near, full of hope.

"Billy, I'll tell you just why it is," said she. "Lin thinks I'm not a real girl."

"A—ah," drawled Billy, backing from her with suspicion.

"Indeed that's what it is, Billy. If he knew I was a real girl—"

"A—ah," went the boy, entirely angry. "Anybody can tell you're a girl." And he marched out, mystified, and nursing a sense of wrong. Nor did his dignity allow him to reopen the subject.

To-day, two miles out in the sage-brush by himself, he was shooting jack-rabbits, but began suddenly to run in toward Separ. A horseman had passed him, and he had loudly called; but the rider rode on, intent upon the little distant station. Man and horse were soon far ahead of the boy, and the man came into town galloping.

No need to fire the little pistol by her window, as he had once thought to do! She was outside before he could leap to the ground. And as he held her, she could only laugh, and cry, and say "Forgive me! Oh, why have you been so long?" She took him back to the room where his picture was, and made him sit, and sat herself close. "What is it?" she asked him. For through the love she read something else in his serious face. So then he told her how nothing was wrong; and as she listened to all that he had to tell, she too grew serious, and held very close to him. "Dear, dear neighbor!" she said.

As they sat so, happy with deepening happiness, but not gay yet, young Billy burst open the door. "There!" he cried. "I knowed Lin knowed you were a girl!"

Chapter 5

Wild Oats in Cuba, a Honeymoon in Washington State

As a child Remington had listened avidly while his father told stories of the Civil War. While he attended Highland Military Academy, he relished pictures of "Indians, cowboys, villains or toughs," writing to a friend that his favorite subject was "soldiers."[1] The first picture published with his signature bore the caption: "Apache War—Indian Scouts on Geronimo's Trail." By the end of 1897 it was abundantly clear that whereas Wister worked hard to make his stories end in peaceful reconciliation, Remington loved a scrap for its own sake. Fights furnished the major subject of his work, whether he painted, drew, sculpted, or wrote. Thus, there was nothing surprising in his scorn for Lin McLean's "little pistol" or his dismay at Jessamine Buckner's eclipse of Lin as "six foot infant." Small wonder that Remington felt his partnership with Wister going stale in 1897, for his boredom was merely a recurrence of the same chronic condition that first sent him west from Canton in 1881. And even smaller wonder that he responded so enthusiastically to the explosion which in 1898 plummeted the *Maine* to the bottom of Havana harbor.

When the *Maine* blew up, Remington was thirty-seven years old. Born too late for the Civil War, he had missed participating in the last campaign of the American Indian Wars by a matter of days, and as we have seen, he was quickly disillusioned by the mechanized, automatic military operations he had witnessed at Aldershot in 1892. Remington wanted to take part in fighting that would "make men glad and death easy."[2] The "splendid little war" in Cuba seemed his last chance, and to it he brought an artist's laboriously cultivated skill coupled with a boy's longing for

adventure. He told Wister in 1897, "We are getting old, and one cannot *get* old without having seen a war." This sense of personal urgency showed more clearly than anything else how different from each other Remington and Wister were.

Wister saw the Spanish-American War as fulfillment of a national "destiny," but Remington regarded it as opportunity for personal fulfillment—the chance to express a part of himself which he felt time would inevitably diminish. By coming just when it did, the war allowed Remington a last fling at boyish carelessness, a gesture of defiance he had to make before exchanging excitement about the future for interest in the past. Nowhere in the pictures he made of battle, the accounts he gave in news stories, or even letters he wrote about the war was there any attempt at analysis, any indication that Remington desired to *interpret* the events that formed his subject. On the contrary, there appeared everywhere the explicit absence of interpretation that comes with strict adherence to the form of. an experience itself. Remington's spare, vivid treatment stripped battlefield events of everything but action, as when he described the battle at the San Juan River for *Harper's Weekly*:

A man came, stooping over, with his arms drawn up and hands flapping downward at the wrists. That is the way with all people when they are shot through the body, because they want to hold the torso steady, because if they don't it hurts.[3]

Yet Remington's eye was anything but cameralike, and he made no attempt to leave himself out of the events he recounted. For *Harper's Weekly* he wrote, "I want to hear a 'shave tail' bawl; I want to get some dust in my throat; kick dewy grass; to see a sentry in the moonlight; and to talk the language of my tribe."[4] Colorful impressions and a good deal of personal enthusiasm invariably marked Remington's record of the war. The record was so straightforwardly stated and so thoroughly concrete, however, that it also conveyed a startling sense of objectivity. Its basis was sensation rather than speculation, hunger rather than history. Remington caught every detail and recorded it with relish.

Wister, on the other hand, made love, not war, in 1898. On the day Congress officially opened hostilities with Spain, he married a cousin and longtime sweetheart, Mary Channing Wister, at Philadelphia. Whereas Remington's descriptions resembled in their vivid objectivity those of a younger contemporary, Stephen Crane—for whom Remington did some

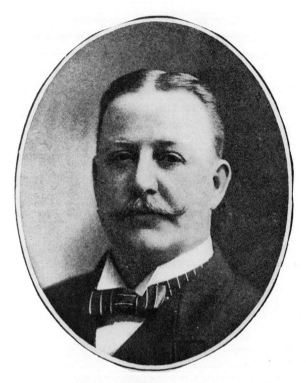

Portrait of Frederic Remington, probably about 1908.

illustrating and who also reported the fight at San Juan Hill—Wister
romantically insisted that the war had to *mean* something. Whenever he
wrote about it, he described it as a great, collective action that had its
part in the grand drama of history. For Remington's objective impres-
sionism, Wister substituted a highly subjective moral distinction between
Europe and America, which he still held in 1930 when he wrote his
biography of Theodore Roosevelt:

That brief war opened a new chapter for us. The whirl of history put us
among the world's great nations, which other great nations had never till then
held us to be. We remain even today more ready to proclaim the glory of
this than to accept its responsibilities.
　After disgusting Europe by our victory, we displeased her still more by our
generosity. We did not annex Cuba. We liberated her, cleaned the yellow
fever out of her, and came away with the understanding that she must get on
properly by herself. This, with one or two other conspicuous acts of like

nature, has made Europe peculiarly sensitive to our shortcomings; and today, since the future seems to be ours and the past hers, she is more sensitive than ever.[5]

Basically, Wister agreed with his friend John Hay that the Cuban conflict, "begun with the highest motives" and "carried on with magnificent intelligence and spirit," seemed "favored by that fortune which loves the brave." Yet Wister fused Hay's nationalism with his own idealism by insisting that the brave were also the good.

The Spanish war touched the lives of Remington and Wister in several ways. First, with the help of Remington's famous painting of the Rough Riders charging San Juan Hill—something the Rough Riders never did—it put their mutual friend Theodore Roosevelt into the governor's mansion at Albany and eventually into the White House. Second, it gave Remington not only a chance to see the fighting he anticipated for so long, but also a severe case of tropical fever, from which he was long in recovering. Third, the war deprived Owen and Molly Wister of the honeymoon they had planned in the Wind River Mountains, since their army friends there were transferred to Cuba. And finally, because Wister and Remington responded to the war so differently, it further cooled their already diminishing friendship.

Remington first mentioned war to Wister in November 1895, correctly surmising that its arrival would accelerate the process which was dissolving the frontier that he and Wister exploited in their work. "I think I smell war in the air," he wrote. "When that comes the wild west will have passed into history and history is only valuable after the lapse of 100 years. And by that time you and I will be dead." This, however, was before Remington began to regard the war as both a lark and a business opportunity. By closing with a curious sketch, simultaneously humorous and romantic, which showed a cowboy riding into the sunset, he demonstrated at once that the chivalric notions of "The Evolution" were still in his mind and that he still resisted them: the rider moving into the picture instead of across it, the caricature of a buffalo skull instead of the phantom heroes, the substitution of an old horse's bony rump for the lean cow pony suggested that Remington felt a war with Spain could ironically bring about fulfillment of the fantasy stated in "The Last Cavalier."

Yet American newspapers were beginning to discover the hard cash

After my sale I am going to Virginia for a weeks shooting — quail.

They are writing editorials out west about the Buster.

I think I smell war in the air. When that comes the Wild West men have passed into History and History is only valuable after the lapse of 100 years! and by that time you and I will be dead.

Kipling "Only Indias" is oplendid —

Finis. —

value of heating up the little revolution underway at Havana. As they vied with each other for more lurid descriptions of Spanish atrocities, American public opinion responded by becoming increasingly hawkish. Although President Grover Cleveland insisted that the United States remain officially neutral, a Cuban "junta" sold bonds and distributed propaganda in New York City, and "filibustering" expeditions found shelter in scores of American ports. Remington, full of his new success as sculptor, spent the winter at New Rochelle working and nervously watching the news. Wister, basking appreciatively in the warmth of good reviews for *Red Men and White,* planned a trip to Europe.

Early in the spring of 1896, Remington made his usual western sojourn, this time to the Southwest. When he got back in March, he wrote to Wister with the germ of a new idea:

Dear Wister—

Just back from Texas & Mexico. Got an article—good illustrations but I tumble down on the text—it's a narrative of the Texas Rangers— I call it "How the law got into the chaparral."—May have to ask you to bisect, cross-cut—spay alter, eliminate, quarter & have dreams over it and sign it with the immortal sig of he who wrote "Where Fancy was bred"—had a good time—painted—shot—loafed—quit drinking on Feb. 1 for ever and got some ideas—

I think we are going to have that war—then we are as yesterday.—? But we may not get lost in the shuffle after all—We are pretty quick in the woods ourselves—

Want you over here—Come a week from this Saturday—stay over Sunday. Got big ideas—heap talk. New mud. "How the broncho buster got busted"—its going to beat the "Buster" or be a companion piece.

yours

MARCH 1896 *Frederic R.*

No longer was Remington's attitude toward the coming war fatalistic. His recognition that he and Wister were "quick in the woods" represented the beginning of his belief that they might be able to use the Cuban revolution much as they had already begun to use the American West. The same shift in attitude was reflected by Remington's essay on "How the Law Got into the Chaparral," printed by *Harper's Magazine* in December. It concerned Remington's Texas interview with Colonel "Rip" Ford,

who became a Texas Ranger in the 1830s. Over good cigars at the San
Antonio Club, Ford recalled his adventures for Remington and a friend:

> Through the veil of tobacco smoke the ancient warrior spoke his sentences
> slowly, at intervals, as his mind gradually separated and arranged the details
> of countless fights. His head bowed in thought; anon it rose sharply at recollec-
> tions, and as he breathed, the shouts and lamentations of crushed men—the
> yells and shots—the thunder of horses' hoofs—the full fury of the desert
> combats came to the pricking ears of the Deacon and me.

Remington found the San Antonio interview exciting and illuminating,
for while it offered no assurance that Remington, Wister, and their West
would not soon be "history," it emphatically denied Remington's dis-
heartening theory that "history is valuable only after a lapse of 100 years."
The artist clearly saw in Colonel Ford's historical account an immediate
and direct relevance to the national and international events which filled
his own imagination in 1896:

> We saw through the smoke the brave young faces of the hosts which poured
> into Texas to war with the enemies of their race. They were clad in loose
> hunting frocks, leather leggings, and broad black hats; had powder horns and
> shot pouches hung about them; were armed with bowie knives, Mississippi
> rifles, and horse pistols; rode Spanish ponies, and were impelled by Destiny
> to conquer, like their remote ancestors, "the godless hosts of Pagan" who
> came swimming "o'er the Northern Sea."

No wonder Remington asked for Wister's help in writing the essay! It
was built upon the same assumptions that informed "The Evolution,"
contained echoes of the same romantic strains that Wister loved in "The
Last Cavalier." Remington, however, who felt uneasy with such notions,
rested his essay mostly on a literal transcription of Colonel Ford's talk.
He knew that "the outlines of the thing are strong . . . because . . . fights
were what the old colonel had dealt in during his active life, much as
other men do in stocks and bonds or wheat and corn." Nonetheless, he
felt that the account would "fare better at the hands of one used to phras-
ing and capable also of more points of view than the colonel was used to
taking."

If Wister had agreed to romanticize Colonel Ford's account, "How
the Law Got into the Chaparral" might have turned out quite differently.
As it was, however, the old man's stories of how Texas Rangers carried

out the conquest of Texas in the first half of the nineteenth century dove-
tailed neatly with Remingon's own feelings about Cuba in 1896. Talking
with Colonel Ford and writing an essay about him set Remington think-
ing. Even the new "mud," called "The Wounded Bunkie" when it was
cast two years later, expressed the growing sense of conflict that filled his
imagination. In his mind's eye he began to see a new avatar of the
"puncher" materializing, and when the group of former and would-be
cowboys who called themselves the Rough Riders bivouacked at Tampa,
it seemed a dream come true.

Meanwhile, Wister wrote from Philadelphia that the European trip he
planned made it impossible for him to help revise Remington's essay,
and shortly before Wister sailed for Cherbourg in April, Remington
replied in a letter that added another dimension to his developing image
of the latest cavalier:

*Dear Wister—Well, I'de like to see you before you go to Europe and get
acquainted with the new man—*

*I think it is a good scheme for you to go over to Europe. It will take
you out of yourself and if you dissipate recklessly you may find the old
Wister will come back in the flesh. I expect you will see a big war with
Spain over here and will want to come back—and see some more friends
die.* Cuba Libre. *It does seem tough that so many Americans have had to
be and have still got to be killed to free a lot of d—— niggers who are
better off under the yoke. There is something fatefull in our destiny that
way. This time, however, we will kill a few Spaniards instead of Anglo
Saxons, which will be proper and nice. Still, Wister, you can count the
fellows on your fingers and toes who will go under in disease—friends of
yours.*

<div align="right">

Your[s]

Frederic R——
</div>

The connection between the war to "liberate" Cuba and the emanci-
pation of Negro slaves in America was, of course, one that propagandists
for the war made much of, and stories about the "racial" differences
between Spaniards and Americans were also popular. The biases Reming-
ton expressed in his letter were both dreary and ordinary. What dis-
tinguished the letter, however, was the razor edge of its irony. It made
fun of Wister's latest success, Cuba, Spain, the United States, history, and

Dear Wister — Well, I de like to see you before you go to Europe and get acquainted with the new man —

 I think it is a good scheme for you to go over to Europe it will take you out of yourself and if you dissipate recklessly you may find the old wister will come back in the flesh. I expect you will see a big war with Spain over here and will want to come back — and see some more friends die. Cuba libre

It does seem tough that so many Americans have had to be and have still got to be killed to free a lot of d— niggers who are better off under the yoke. There is something fateful in our destiny that way. This time however we will kill a few Spaniards instead of Anglo Saxons which will be proper and nice, still Wister you can count the fellows on your fingers and toes who will go under in any case — friends of yours.

 Yours
 Frederic R—

Going to war — The Vomito. —

finally itself. The fact that the caricatures which ended it were funny in no way masked or diminished the aggression they expressed. The first soldier's feminine physique and pompous strut, the abject curve of the second's spine, his wide, staring eye and reptilian profile were all repulsive. Yet they represented features of an activity Remington knew he was eager for and assumed that Wister was also. The essence of their parodic force was that through them, Remington ridiculed himself. When applied to history the same ability Augustus Thomas called "the sculptor's degree of vision"—a knack for seeing all sides of something at once —inevitably resulted in a vision that mocked itself. Often bitter, sometimes nihilistic, this vision was Remington's response as an intelligent man to the jingoism he had not only to observe but actually to participate in if he was to have his war.

Fortunately, Remington had another project to keep him occupied while he waited for his war to come. By the time Wister returned from his European tour in June, Remington had sent in the pictures for his book, *Drawings*. At Remington's request Wister wrote a preface, which showed on one hand how much he liked the work and on the other how strangely blind he was to one of its most important features. He called the West a "lotus mystery" and said that Remington "expressed" it:

I have stood before many paintings of the West. Paintings of mountains, paintings of buffalo, paintings of Indians—the whole mystic and heroic pageant of our American soil; the only greatly romantic thing our generation has known, the last greatly romantic thing our Continent holds; indeed the poetic episode most deeply native that we possess. Long before my eyes looked upon its beautiful domain, I studied the paintings; but when Remington came with only a pencil, I forgot the rest! And now I have seen for myself, and know how he has caught alive not only the roped calf, or the troop cook sucking his comfortable corn-cob, the day-by-day facts of the wilderness, but the eternal note also, the pity and the awe of that epic life. He has made them visible by his art, and set them down as a national treasure. Look at the Pony War Dance. That wild fury of religion, that splendor of savagery clashes down to us from the Stone Age. If you will open the Old Testament where Joshua delayed the course of the sun, or they blew down a city wall with a trumpet, you will come upon the same spirit. Look at the Medicine-men and the lightning. Again man's untamed original soul communes with a God of vengeance and terror. Is it not like Elijah and the fire stroke from heaven upon the altar? Then turn to the Sheep-herder's breakfast. Unless you have known that solitude, no words of mine can tell you how Remington has been a poet here. With some lines and smears on paper he has expressed that lotus mystery of the wilderness. He has taken a ragged

vagrant with a frying pan and connected him with the eternal. The dog, the pack-saddle, the ass, the dim sheep in the plain, those tender outlines of bluffs and ridges—it is Homer or the Old Testament again; time and the present world have no part here!

Much of what Wister said was correct. Many of the pieces in *Drawings* were indeed brilliantly conceived and superbly executed. The epic affinities were without doubt powerfully present. The solitude, the silence, the distance—Remington caught them all, just as Wister said he had. But there was something else in the pictures too, something Wister either missed or preferred to ignore: they fairly bristled with the same aggression, more fully and attractively expressed, that characterized "Going to War" and "The Vomito." Of the sixty-five works in *Drawings,* only five of those representing more than one human figure failed to involve a violent conflict. Whereas the West Remington captured in *Drawings* may, as Wister later put it, have been "a vanished world" in 1896, the spirit he put into it was both current and widespread. The daily newspapers, even such staid journals as the *Washington Post,* expressed it in plain terms and without apology:

A new consciousness seems to have come upon us—the consciousness of strength—and with it a new appetite, the yearning to show our strength. . . . Ambition, interest, land hunger, pride, the mere joy of fighting, whatever it may be, we are animated by a new sensation. We are face to face with a strange destiny. The taste of Empire is in the mouth of the people even as the taste of blood in the jungle. It means an Imperial policy, the Republic, renascent, taking her place with the armed nations.[6]

The Stone Age, Joshua, Elijah, Homer, and the Old Testament were all in *Drawings,* but the book's guiding impulse was the "joy of fighting"— which, translated into the political dimension, meant "an Imperial policy." Wister moved closer to this realization, but still missed it, at the end of his preface:

Perhaps you do not value all this as I do. Perhaps the seamy side shuts you from the rest, and you shrink from the brutality of man and the suffering of beasts. I have heard people speak thus sometimes, and give thanks for their books, and their bathrooms, for the opera, and for Europe where they can travel in a landscape seasoned by history. Well, Europe is richer, much richer, than any desert, and it is toward its use and comprehension on the whole, that our struggling faces are set. Our fond, quack-ridden Republic looks, after all, toward the old world for its teaching. But we have a landscape

seasoned by mystery, where chiefs and heroes move, fit subjects for the poet. If you do not see this, perhaps you are too near. Let me ask you to think of the bloody slaughters in Homer, and of all the great art you know from him to the present day; has not the terrible its share of notice? Doubtless you would have stopped Homer's reciting to you how bodies were hacked to pieces beneath the walls of Troy, and how swinish were sometimes the companions of Ulysses. But how you read it all with pleasure. Do you believe Art would have amounted to much if it had excluded pain and ugliness and narrowed its gaze upon the beautiful alone?

At any rate I am glad that we have Remington, one of the kind that makes us aware of things we could not have seen for ourselves. We have been scarce enough in native material for Art to let go what the soil provides us. We have often failed to value what the intelligent foreigner seizes upon at once. And I think as the Frontier recedes into tradition, fewer of us will shrink from its details. If Remington did nothing further, already has he achieved: he has made a page of American history his own.

What Wister neglected to add was that the "page of American history" Remington attacked with his charcoal pencil was still being written. Remington felt more and more certain that the same impulse which swept the star of empire westward would send American battleships steaming east to Daiquiri Bay.

Remington never put it in quite those words, but he was quick to recognize that both the historical westward movement and the coming eastward expansion were associated with conquest and surrounded by a certain glamor. Exotic settings, colorful participants, and most of all, action on a large and violent scale made them attractive to him personally and available to him artistically. The strongest indication of how closely Remington linked the western life depicted in *Drawings* with the conflict in the Caribbean was the fact that he never questioned the supposition that he—both as man and artist—could use them in precisely the same way. Immediately after finishing his portfolio for *Drawings,* he wrote to Wister early in the summer of 1896, enclosing a sketch of himself as an infantry officer:

My dear Wister—

Got my work done on book—it's "away from the Kodak"—and when I get fixed want to load you up with ball cartridge and fire you off.

Am going Montana for two months—to sweat & stink and thirst & slave & paint—particularly paint. If we don't go to war with the Dagoes or the Yaps—Wouldn't that be just our ticket for soup though—Let's

form a partnership on the scrap. *Only if it promised hot enough I will start in as a Capt. of Infantry.*

<div align="center">

Yours truly,

Frederic Remington

Capt.—1st N.Y. Vols.

</div>

JUNE 1896 <div align="right">*U.S.A.*</div>

This was the first explicit mention of a scheme Remington pursued with increasing vigor until war was declared a year and a half later.

Whereas Remington itched for war because he saw in it the same variety of excitement once present in the now conquered province of the West, Wister still found in the West an insularity which made it possible for him to ignore the international maneuvering that led to war with Spain. After returning from Europe in June, Wister spent a brief time with friends and family in Philadelphia. Then he was off for the West on July 18. Two days later, while his Pullman was towed up the Platte River Valley toward Cheyenne, he wrote that "such a teeming and industrious place can never go finally wrong no matter what they do in Washington." However casually noted, this was a reaffirmation of the attitude Wister stated many times before—the same attitude that blinded him to any sense of "time and the present" in Remington's *Drawings*: the land had an existence of its own, apart from men or politics. Remington painted the action of its conquest—that process through which it acquired a political identification—but Wister indulged a preference for those qualities of the land that he thought of as somehow eternal. Remington's greatest talent was his ability to capture an instant of time, but Wister insisted on timelessness. Remingon, who told Julian Ralph that he wanted as an epitaph, "he knew the horse," was an artist of action, whereas Wister, who wanted to "know" the land itself, became increasingly a landscape artist. At the end of July, insulated by the wilderness from what President Cleveland called the "epidemic of insanity" that was sweeping the nation, Wister sat on the bank of Wind River and wrote enthusiastically to his mother of an "extraordinary country that no one has described":

Red mounds . . . are turned to rich rose by the green of the cottonwood trees which green is by the rose reciprocally glistened to transparent emerald; and all between the folds of level & slant go from green through

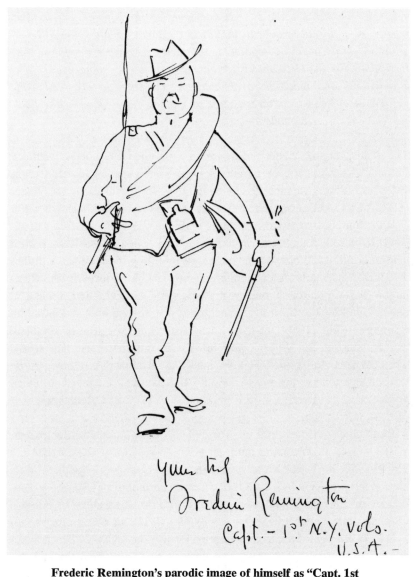

yum tnf
Fredui Remington
Capt. - 1st N.Y. Vols.
U.S.A. -

Frederic Remington's parodic image of himself as "Capt. 1st N.Y. Vols. U.S.A.," drawn in a letter to Wister.

buff and saffron to brown and grey, the whole thing graded and mingled so subtly & softly as to seem made of some rare wonderful plush. Crude is the very last word for it. When you take sage-brush, which of itself is

between lavender and the olive leaf, and find it looks white, green, blue, purple, & violet, according to the angle of slant and the value of background against which it happens to be thrown, you are moving among intricacies for which painting would have to devise some wholly new conventions and methods to be able to state them at all. And while written down, these mixtures sound so violent, their blend in the landscape is inexpressibly delicate and evasive.

The landscape of Wister's description contained no horses, soldiers, Indians, sheepherders, or mountain lions—not even an insect. It consisted exclusively of unitary and motionless form, sufficient for Wister in and of itself because it embodied not the instant Remington sought to capture but the perpetual emptiness within which the succession of instants occurred. Remington repeatedly demonstrated his restlessness with landscapes like the one Wister described by filling them with multitudes of figures, avalanches of action, frequently a fight. Furthermore, Remington never painted a prairie that looked like "rare and wonderful plush." Had he known of it, the metaphor would have offended him. Not Remington, but Henry James, whom Wister had just seen in England, was responsible for Wister's new interest in the visual. He was ready, wrote Wister, to "follow Henry James's advice, and put much more landscape into my narrative." Despite the painter's language in which Wister tried to describe it, this was not a step toward Remington, but one away from him.

Remingon returned to New Rochelle from Montana in September. Wister stayed in Wyoming until early October; shortly after arriving at Philadelphia he wrote three stories in quick succession. "Separ's Vigilante," later collected in *Lin McLean,* and "Grandmother Stark," a component of *The Virginian,* were printed without illustrations. "Sharon's Choice," later collected in *The Jimmyjohn Boss and Other Stories,* appeared in *Harper's Magazine* with four illustrations by A. B. Frost. Remington's proposed partnership was not working out. Remington, however, was having his fling at the Cuban revolt without Wister. Beginning in January 1897, the *New York Journal* carried a series of pictures by Remington on a wide variety of subjects connected with the conflict. Many were accompanied by vivid accounts from the pen of Richard Harding Davis. One, prominently occupying a half page in the February 12 edition, even depicted a nude woman routed from her cabin while

Spanish troops searched an American steamer. In light of Remington's well-known aversion to drawing women—even fully clothed—this picture demonstrated how much the artist was willing to endure to participate in the "scrap" he saw coming.

Working with Davis for the *Journal* was better than missing the war altogether, but it failed to satisfy Remington because the Hearst newspaper refused to give him the free hand he wanted. He was required to draw scenes—like the nude woman on the steamer—which he not only hadn't witnessed but wasn't interested in. On at least one occasion, his drawings were altered before they appeared in print. It was work to make a man hate himself, and Remington ruminated on a scheme more to his liking. About his skill as an illustrator he had no doubts, but he felt, as he put it in his earlier letter to Wister, that he might "tumble down on the text." He wanted independence from Hearst, freedom to tell the truth as he saw it, and a writer whom he respected to work with. Most of all, he wanted to stop drawing from photographs and imagination on command and go to Cuba. Gradually the plan evolved. In the fall, he dictated it to Eva, who wrote it out in her large, honest hand and sent it off to Philadelphia:

My dear Mr. Wister:

I am at the desk and Frederic desires me to say that he has the greatest scheme for you and himself in conjunction [with] war ever on top of the sea or over the land or under the sky. There is going to be a war (in Frederic's mind) *and then will be to us an enormous interim in which we will grow pale and poor. Meanwhile it is possible for just such a pair of old nerve-cells such as you and I, to make an offensive alliance against publishers. I have often thought of this thing in connection with various other geniuses—Richard Harding [Davis] for instance or Poultney [Bigelow] without instance. You can readily see that they will not pause but all such people intend to turn this trick. We will have to fight such people or combinations of such people. And all I want to do is to combine with you—if you are game for it. It seems natural and right that you and I are in a position to "do" the whole d—— "bilin". Now this war is reasonably sure as near as man can figure within another year, if not a year, I'm yourn—Meanwhile all men in our business must keep their combinations. Publishers anticipate these events and why should not we. We are getting old and one cannot get old without having seen a war. We would*

go at it as gentlemen since no newspaper man will see a Modern war. We will want to go at it with no purpose except that which we might undertake afterwards. Of course this precludes the newspaper possibilities and confines us to magazines, or some other "funny" combinations which we must consider. I want to talk to you about this and I want you to think of it and I do not want you to think it is not great.

We will be in town at the time of the picture sale and hope to see you if you are in the city then and later over here. Frederic's anticipation of war soon *does not frighten me in the least as he has anticipated it for eleven years and now it is all very funny to me. With so many kind regards—*

<div align="right">

Most sincerely,

Eva A. Remington

</div>

NOVEMBER 1897

There was no need for quotation marks. Eva's conventional prose fell away from her husband's rhetoric like snow from a hot chimney. If Remington's plan contained a trace of desperation, it may have been because measures to end the Cuban revolt were making war with Spain seem less certain than Remington wanted it to be. In September, President McKinley had offered American assistance in bringing Spain and the insurgents together at the conference table, and although this overture was rejected, the new government at Madrid in a dramatic gesture gave all Cubans the rights of other Spanish citizens. Even more significantly, it instituted a program designed to bring about home rule for the island. When McKinley delivered his annual message to Congress in December, he argued against U.S. intervention in the Caribbean, saying that Spain should "be given a reasonable chance to realize her expectations and to prove the asserted efficacy of the new order of things to which she stands irrevocably committed." There were indications that Eva Remington might be correct in refusing to take seriously her husband's plans for war. Yet McKinley's conciliatory stance was against the interests of many Americans who, like Remington, wanted a fight. At about this time William Randolph Hearst is supposed to have wired Remington with the message: "You supply the pictures, and I'll supply the war." Whether or not Hearst actually sent the wire, he did do everything he could to keep the peace from coming—and Remington helped him.

In January 1898, Owen and Molly Wister planned their wedding for

spring. On February 9, Hearst's *New York Journal* printed in its entirety a private letter from the Spanish minister Enrique de Lome, stolen from a Havana post office. "McKinley's message," wrote de Lome, "I regard as bad. Besides the ingrained and inevitable bluntness . . . it once more shows what McKinley is, weak and a bidder for the admiration of the crowd, besides being a would be politician who tries to leave a door open behind himself while keeping on good terms with the jingoes of his party."[7] The stolen letter, relatively unimportant in itself, assumed a new significance when printed under two-inch headlines, becoming an "incident" that angered the government at Madrid, outraged many Americans, and rapidly reheated relations between Spain and the United States. War suddenly seemed closer than ever. Less than a week later headlines screamed that the *Maine* and 260 American corpses rested at the bottom of Havana harbor. Mr. Hearst was delivering his war. Remington was going to see action in Cuba.

The *Maine* blew up on February 15. On February 22 the President appeared at the University of Pennsylvania to deliver what Wister called "a sermon wise, reserved and sincere" on the subject of "national honor and national benevolence."[8] As Wister's designation for it indicated, the "sermon" said little but seemed to make Wister hopeful that peace could be preserved. Wister, however, tended to think wishfully about peace, much as Remington thought wishfully about war. On March 3 Congress quickly passed a large defense appropriation, and Wister told his mother a week later that "the Congress voted McKinley 50 millions on Thursday unanimously for purposes of 'peace' and the imminence of war seems decreased for some strange magnetic reason which I think everyone feels." Like Remington, Wister read the news, but without Remington's sense of irony. His observations on it, therefore, sounded queer and flat. "If there is war," he wrote, "Spain will probably bring it on to save its position with its own self. Then it can lose Cuba and keep honor gracefully. The American people have been very quiet, so has Congress and the Senate. That quiet represents our greatest quality." Had they come from Remington, the last two sentences would have carried the same sting as Mark Twain's remark that Congress constituted America's "criminal class," yet there was no mistaking Wister's seriousness. His stated belief that Americans were "quiet" showed merely that he wasn't listening— probably because he didn't want to hear what was being said. The press clamored for revenge, Congress passed inflammatory resolutions. *Har-*

per's Weekly reported from Key West that "rumors and denials fly thick and fast through this excited town. Conspiracy and intrigue are in the air, and the place is filled with correspondents, each wrapping his movements in mystery, and locking his 'news'—being the last wild rumor—securely in his own mind."[9] Theodore Roosevelt wrote that "the blood of the murdered men of the *Maine* calls not for indemnity but for the full measure of atonement, which can only come by driving the Spaniard from the New World." The year 1898 was not a quiet year. Furthermore, contrary to Wister's impression, Spain was willing to concede almost anything to avoid armed conflict with the United States, but McKinley, pressed from many sides, surrendered to what he felt was consensus and sent his war message to the Congress on April 11. The joint House-Senate resolution of April 20 declared war at Washington while wedding bells rang for the Wisters at Philadelphia.

Almost immediately after receiving news of the *Maine* disaster, Remington departed for Key West with Richard Harding Davis, under contract with both *Harper's Weekly* and the *New York Journal*. Positive that the war was coming immediately, he and Davis planned to smuggle themselves secretly into Cuba before American troops landed, thus getting the opportunity to observe an aspect of the fighting not available to most American correspondents. Three times they tried to get to Cuba by small boat, and three times they failed, the third time narrowly missing being drowned. When war was officially declared and the battleship *Iowa* steamed out of Tampa harbor, however, Remington was aboard. For seven interminable days, the ship sailed up and down ten miles out from Havana. Remington hated "this epitome of modern science, with its gay white officers, who talk of London, Paris, China, and Africa in one breath." He hated the engineers and firemen who ran the ship, "sweating and greasy and streaked with black—grave, serious persons of super-human intelligence—men who have succumbed to modern science." But most of all he hated the boredom, "the appalling sameness of this pacing up and down before Havana."[10] Therefore, he "deserted" and went home for a short rest before the invasion. From New Rochelle he wrote to Wister, who was spending the first part of his honeymoon in Charleston, South Carolina:

My dear Wister:—

Am just back from the South for a few days to "get cool"—I go

Thursday.

If I don't become a bucket of water before that time, I hope to see the landing in Cuba but if any yellow fever microbes come my way—I am going to duck. They are not in my contract.

I understand you are married—Mrs. R. got your cards but was sick at the time—she had what I call the "battle-ship attack" for I was at the time sailing around with Mr. Fighting Bob Evans—and meeting with no more harm than too much eating and drinking will bring where you don't have exercise enough.

Well ol man—I congratulate you—I didn't think you would be caught but these chaps who seem to have escaped out into the brush get rounded up just the same as tame stock—mostly.

Give my regards to Mrs. and tell her I think she got a pretty good fellow but she wants to keep a rope on you—you have been broncho *so long—it's different with kids.*

Put this in her kind of English. We hope to see you over some time—after we lick the Dagoes—Say old man there is bound to be a lovely scrap around Havana—a big murdering—sure—

<div align="right">

Yours faithfully,

</div>

JUNE 1898 <div align="right">*Frederic Remington*</div>

While Molly and Owen Wister found South Carolina "simply delicious," Remington, true to his word, returned to Tampa and began turning out martial illustrations with amazing rapidity. His pictures covered every aspect of the military operation, from portraits of its general officers to, of course, its horses. Yet he never forgot about the main event, the "big murdering." The moment he waited years for arrived when General Shafter's headquarters ship, the *Seguranca,* slipped into Daiquiri Bay on June 20, six days after leaving Tampa. Remington sat on the quarterdeck, sipping iced drinks with Richard Harding Davis and Caspar Whitney, and waited for the show to start. Flags waved, bugles sounded, whistles blew. Once again the young Anglo-Saxons, "impelled by Destiny to conquer," were about to act the drama that won the West.

For thousands of Americans the landing at Daiquiri Bay was a triumph. Poets wrote odes about it. Politicians made hay from it. Soldiers spun it into tales for a whole generation of saucer-eyed children. But for Frederic Remington, it was a disappointing spectacle. The cavalry had no horses. The heat was ennervating. Because of shortages, many of

the troops wore heavy, blue woolens, instead of the light khakies they should have had. The rifle fire was muted and unexciting. The dead and dying were not picturesque. It all ended in a muddy swamp, drinking dirty water. With stroke after stroke of ironic genius, Remington told the whole story in his unpretentiously entitled essay, "With the Fifth Corps," a small and unrecognized masterpiece, recalling Mark Twain's "Private History of a Campaign That Failed" and Stephen Crane's "Red Badge of Courage"—by all odds among the very finest literary achievements to come from the Spanish War.

After Remington was "finished" by yellow fever and evacuated, the battle for Santiago was quickly won. As American troops neared the town from the inland side on July 3, American warships destroyed the Spanish fleet outside the harbor. Two days before, Wister and his bride had boarded the train at Charleston for the first leg of their trip to Washington state. At the end of July, McKinley dictated terms of peace to Spain. On August 2, Wister wrote to his mother of ascending the Columbia River in a boat:

Our train was due at Wenatchee at 8:44 P.M.—but reached there at 10:44. I was troubled at this somewhat, because if the boat up the Columbia was to start at dawn the next morning as I had an idea it did, there seemed little time to arrange for our trunks being got on board— ourselves rested and breakfasted. But my anxiety was needless. The boat went at 3 A.M.! On stepping down from the car, and while feeling highly lost (more lost than I have ever felt in the west before) a man came up asking if we were passengers for the boat, and I found the thing was to go on board at once. He was very civil—had a cart & two horses—put the trunks in—we got in and at once were driving across the wide world in total darkness. In about 10 minutes we came to a bank, very steep, & stopped. Down below was a dimly seen boat and no way to get there but by sliding. So I took Molly's arm & we slid down. . . . It was the awfullest boat you ever saw but it had staterooms and I left Molly in one of these while I went back to help slide our trunks down the bank. . . . I could not without writing a piled up crescendo chapter of 10 or 20 pages give you any idea of this journey of 70 miles up the overwhelming river. We were perfectly comfortable, sitting in the shade on the deck. . . . And when the scenery was not engrossing us, I read Trollope aloud. But the river is the most dreadful thing I have ever seen. I thought it dreadful

in 1892 when I only crossed it on a ferry; but after this journey it is
something to have nightmares about for 20 years. . . . It lies in a rut,
away below the world, and you look up at steep hills sometimes 2,000
feet above you each side—they are unearthly hills, unearthly in color &
shape, & in formidable dimensions. They make a vast endless winding
cleft of prison, and down through this cleft the water rushed like a mill
race with unending swirl. . . . About the scenery, which is magnificent
& would be beautiful if it were not so terrible, Molly said exactly the
same thing. She said it made her think of certain scenery in classic myths.
And I said Cyclops' dens, & she said exactly. Also, it made you feel as
if it were the Ural Mountains, or the upper Ganges, or . . . Thibet.

It was still the landscape rather than its contents that fascinated Wister,
and he still sought to describe its "eternal" quality by analogy with legen-
dary symbols of eternity. The method was "arty" but not artful, the exact
opposite of Remington's. Remington summed up the difference neatly in
his "Fifth Corps" article. "My art," he wrote, "requires me to go down
the road where the human beings are . . . in the landscape which to me
is overshadowed by their presence."

Yet if Remington's method was more exciting than Wister's, it was
also more dangerous. And whereas Wister's ascent of the Columbia with
Molly could be described through the carefully literary fantasy of reading
Trollope in Cyclop's den, Remington, as he himself admitted, was care-
less indeed at Cuba. While the Wisters toured Washington state, Reming-
ton limped home to recover from the "yellow fever microbes" not in his
contract, and Theodore Roosevelt stepped ashore at New York with his
Rough Riders to the accompaniment of "ten thousand cheers." Far away,
the Stars and Stripes fluttered in the breeze above Manila, and the
"Imperial policy" Remington sensed in *Drawings* began to bear fruit.

Remington's disappointment with the Cuban campaign did not change
the fact that his initial interest in it proceeded directly from a love for
physical action. His means of coming to terms with the war was much
like Roosevelt's; to find it, live it, finish it. The spendthrift compulsion
that dragged him to Cuba was fully satisfied only when he himself was
fully spent. Yet the Wisters' Washington honeymoon—in one sense an
explicit disengagement from the dangerous possibility Remington went
to the Caribbean to find—was, not surprisingly, informed by a steady
and powerful urge to absorb and store experience. While Remington

spent himself in Cuba, the newlyweds conquered their Pacific wilderness by savoring it. On August 12, the same day Spain and the United States signed a peace protocol officially ending the war less than three months after it began, Molly Wister mailed a letter telling her mother-in-law, whom she still addressed as "Cousin Sarah," how she and Owen lived in a one-room cabin and made their own terms with the wilderness:

Civilization looks delightful from here though I am absorbed in what I see & enjoy every moment (except when the mosquitoes are beyond endurance). I believe I have never liked anything as much as this new experience—certainly have never found anything as strange. I was not prepared for it in the least. I had not heard a word about the Columbia River from Dan, or anyone else. And even Dan, who had seen it before, did not take his new impressions very quietly. . . . As we reached Winthrop at night I could see nothing but the outlines of the mountains, splendid & beautiful. The next morning I hurried to the door & looked out upon miles & miles of what seemed like the most unlovely wilderness, almost desolation. Miles & miles of parched brown earth & scorched grass in rolling hills that meet the mountains with dark, weary looking pine trees scattered here & there. Everything seemed stern & unforgiving. You can hardly imagine what the impression of nature with its beauty & tenderness left out is like. For several days I saw very little else: Then the sense of freedom, & repose & endless space came, & now have given me new eyes. The hills, which I really hated at first, seemed to have turned a soft & lovely gold—& though I still think the country more beautiful in every way by night, I cannot see it enough by day. I should be happy here for a long time.

A contentious critic might argue that Molly Wister found the western landscape "more beautiful in every way by night" precisely because she was temperamentally incapable of seeing it "enough by day," but capacity for romantic imagination rather than deficiency of vision was responsible for the way Molly and Owen saw the West. Theodore Roosevelt demonstrated how such an imagination worked when he described how the Rough Riders enjoyed their final holiday at Long Island before disbanding. "Galloping over the open, rolling country, through the cool fall evenings," he wrote, "made us feel as though we were out on the great Western plains." For him, as for the Wisters, the West could be trans-

planted anywhere, because it was not a place, but a state of mind.

An interesting corollary to this view was that if "the great Western plains" could be hauled to Montauk beach, so could the cowpuncher. The latter movement, however, was not so easy as the former. Again, Roosevelt demonstrated why. When the Rough Riders gathered for the last time in September, they presented Roosevelt with a bronze copy of Remington's "Bronco Buster," a cowboy portable indeed—primarily because he and his horse were miniatures—but there was nothing small about the use Roosevelt made of the "Buster." The statue, he told his men, represented "the foundation" of their regiment. Therefore, it showed that "Uncle Sam has a nobler reserve of fighting men to call upon, if the necessity arises, than any other country in the world." His argument contained little logic but much force, for while it deprived the "Buster" of his identity as a distinct historical phenomenon, it simultaneously fulfilled Remington's earlier vision of him as a warrior.

Remington would have wholeheartedly agreed with Roosevelt in 1897, but the Cuban campaign had changed him. While the end of the war marked the beginning of Roosevelt's successful political career, it also began something Remington was sorry to see—not quite the "enormous interim" in which to "grow pale and poor" he had predicted the year before, but the time when he began to look back instead of forward.

In September, Roosevelt wrote to Remington with thanks for the "Bronco Buster." Early in October, the Wisters ended their Washington idyll and returned to Philadelphia, where they bought a house on Pine Street and settled down to married life. Remington continued to write about the war and draw pictures of it. *Scribner's Magazine* printed his "Charge of the Rough Riders at San Juan Hill" in April 1899, but his "sculptor's degree of vision" no longer allowed him to participate in the imperial expansion the picture represented. He became increasingly convinced of his mistake in thinking that the impulse which won the West was identical with that which guided the Cuban campaign. Roosevelt was wrong in stating that the "Bronco Buster" formed "the foundation" of the Rough Riders. For Remington, the "Buster" came to represent his youth and the youth of his country. The war had shown him that both were over. Without wanting to, he changed from special correspondent to historian. In September he wrote to Wister, admitting, " '*that was my War*'—that old cleaning up of the West—that is the war I am going to put in the rest of my time at."

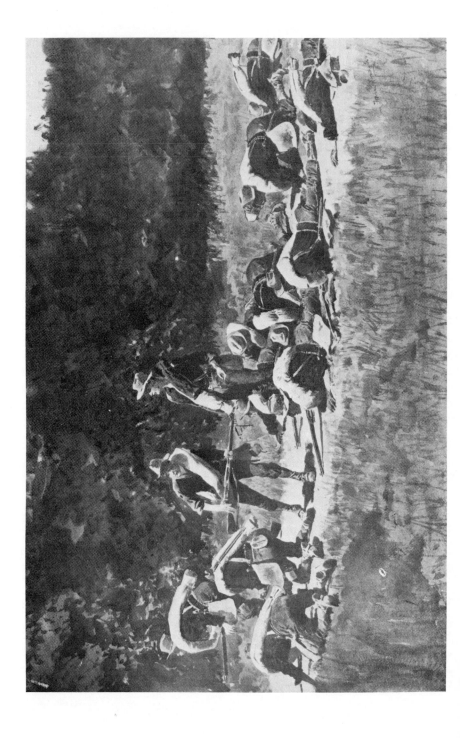

With The Fifth Corps.
by Frederic Remington.

I APPROACH this subject of the Santiago campaign with awe, since the ablest correspondents in the country were all there, and they wore out lead-pencils most industriously. I know I cannot add to the facts, but I remember my own emotions, which were numerous, interesting, and, on the whole, not pleasant. I am as yet unable to decide whether sleeping in a mud-puddle, 1the confinement of a troop-ship, or being shot at is the worst. They are all irritating, and when done on an empty stomach, with the object of improving one's mind, they are extravagantly expensive. However, they satisfied a life of longing to see men do the greatest thing which men are called on to do.

The creation of things by men in time of peace is of every consequence, but it does not bring forth the tumultuous energy which accompanies the destruction of things by men in war. He who has not seen war only half comprehends the possibilities of his race. Having thought of this thing before, I got a correspondent's pass, and ensconced myself with General Shafter's army at Tampa.

When Hobson put the cork in Cervera's bottle, it became necessary to send the troops at once, and then came the first shock of the war to me. It was in the form of an order to dismount two squadrons of each regiment of cavalry and send them on foot. This misuse of cavalry was compelled by the national necessities, for there was not at that time sufficient volunteer infantry equipped and in readiness for the field. It is without doubt that our ten regiments of cavalry are the most perfect things of all Uncle Sam's public institutions. More good honest work has gone into them, more enthusiasm, more intelligence, and they have shown more results, not excepting the new navy or the postal system.

The fires of hatred burned within me. I was nearly overcome by a desire to "go off the reservation." I wanted to damn some official, or all officialism, or so much thereof as might be necessary. I knew that the cavalry officers were to a man disgusted, and thought they had been misused and abused. They recognized it as a blow at their arm, a jealous, wicked, and ignorant stab. Besides, the interest of my own art required a cavalry charge.

General Miles appeared at Tampa about that time, and I edged around toward him, and threw out my "point." It is necessary to attack General Miles with great care and understanding, if one expects any success. "General, I wonder

239

who is responsible for this order dismounting the cavalry?" I ventured.

I think the "old man" could almost see me coming, for he looked up from the reading of a note, and in a quiet manner, which is habitual with him, said, "Why, don't they want to go?" and he had me flat on the ground.

"Oh yes, of course! They are crazy to go! They would go if they had to walk on their hands!" I said, and departed. A soldier who did not want to go to Cuba would be like a fire which would not burn—useless entirely. So no one got cursed for that business; but it is a pity that our nation finds it necessary to send cavalry to war on foot. It would be no worse if some day it should conclude to mount "bluejackets" for cavalry purposes, though doubtless the "bluejackets" would "sit tight." But where is the use of specialization? One might as well ask the nurse-girl to curry the family horse.

So the transports gathered to Port Tampa, and the troops got on board, and the correspondents sallied down to their quarters, and then came a wait. A Spanish war-ship had loomed across the night of some watch-on-deck down off the Cuban coast. Telegrams flew from Washington to "stop where you are." The mules and the correspondents were unloaded, and the whole enterprise waited.

Here I might mention a series of events which were amusing. The exigencies of the service left many young officers behind, and these all wanted, very naturally, to go to Cuba and get properly shot, as all good soldiers should. They used their influence with the general officers in command; they begged, they implored, and they explained deviously and ingeniously why the expedition needed their particular services to insure success. The old generals, who appreciated the proper spirit which underlay this enthusiasm, smiled grimly as they turned "the young scamps" down. I used to laugh to myself when I overheard these interviews, for one could think of nothing so much as the schoolboy days, when he used to beg off going to school for all sorts of reasons but the real one, which was a ball-game or a little shooting-trip.

Presently the officials got the Spanish war-ship off their nerves, and the transports sailed. Now it is so arranged in the world that I hate a ship in a compound, triple-expansion, forced-draught way. Barring thhe disgrace, give me "ten days on the island." Do anything to me, but do not have me entered on the list of a ship. It does not matter if I am to be the lordly proprietor of the finest yacht afloat, make me a feather in a sick chicken's tail on shore, and I will thank you. So it came about that I did an unusual amount of real suffering in consequence of living on the *Segurança* during the long voyage to Cuba. I used to sit out on the after-deck and wonder why, at my time of life, I could not so arrange my affairs that I could keep off ships. I used to consider seriously if it would not be a good thing to jump overboard and let the leopard-sharks eat me, and have done with a miserable existence which I did not seem to be able to control.

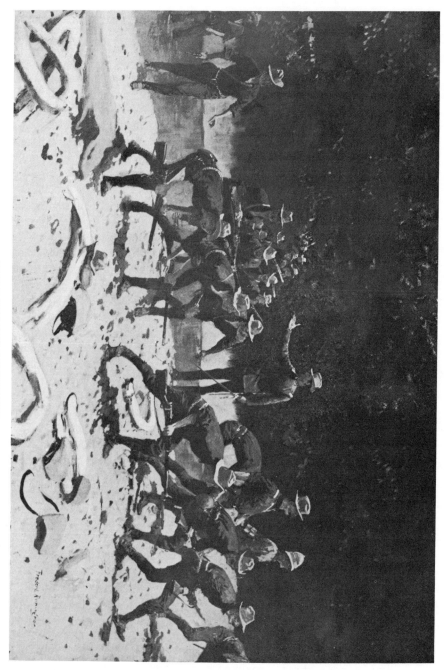

AT THE BLOODY FORD OF THE SAN JUAN

When the first landing was made, General Shafter kept all the correspondents and the foreign military attachés in his closed fist, and we all hated him mightily. We shall probably forgive him, but it will take some time. He did allow us to go ashore and see the famous interview which he and Admiral Sampson held with Garcia, and for the first time to behold the long lines of ragged Cuban patriots, and I was convinced that it was no mean or common impulse which kept up the determination of these ragged, hungry souls.

Then on the morning of the landing at Daiquiri the soldiers put on their blanket rolls, the navy boats and launches lay by the transports, and the light ships of Sampson's fleet ran slowly into the little bay and "turned everything loose" on the quiet, palm-thatched village. A few fires were burning in the town, but otherwise it was quiet. After severely pounding the coast, the launches towed in the long lines of boats deep laden with soldiery, and the correspondents and foreigners saw them go into the overhanging smoke. We held our breath. We expected a most desperate fight for the landing. After a time the smoke rolled away, and our people were on the beach, and not long after some men climbed the steep hill on which stood a block-house, and we saw presently the stars and stripes break from the flag-staff. "They are Chinamen!" said a distinguished foreign soldier; and he went to the other side of the boat, and sat heavily down to his reading of our artillery drill regulations.

We watched the horses and mules being thrown overboard, we saw the last soldiers going ashore, and we bothered General Shafter's aid, the gallant Miley, until he put us all on shore in order to abate the awful nuisance of our presence.

No one had any transportation in the campaign, not even colonels of regiments, except their good strong backs. It was for every man to personally carry all his own hotel accommodations; so we correspondents laid out our possessions on the deck, and for the third time sorted out what little we could take. I weighed a silver pocket-flask for some time, undecided as to the possibility of carriage. It is now in the woods of Cuba, or in the ragged pack of some Cuban soldier. We had finally three days of crackers, coffee, and pork in our haversacks, our canteens, rubber ponchos, cameras, and six-shooter—or practically what a soldier has.

I moved out with the Sixth Cavalry a mile or so, and as it was late afternoon, we were ordered to bivouac. I sat on a hill, and down in the road below saw the long lines of troops pressing up the valley toward Siboney. When our troops got on the sand beach, each old soldier adjusted his roll, shouldered his rifle, and started for Santiago, apparently by individual intuition.

The troops started, and kept marching just as fast as they could. They ran the Spaniards out of Siboney, and the cavalry brigade regularly marched down their retreating columns at Las Guasimas, fought them up a defile, outflanked, and sent them flying into Santiago. I think our army would never have stopped until it cracked into the doomed city in column formation, if Shafter had not

discovered this unlooked-for enterprise, and sent his personal aide on a fast horse with positive orders to halt until the "cracker-line" could be fixed up behind them.

In the morning I sat on the hill, and still along the road swung the hard-marching columns. The scales dropped from my eyes. I could feel the impulse, and still the Sixth was held by orders. I put on my "little hotel equipment," oade my friends good-by, and "hit the road." The sides of it were blue with cast-off uniforms. Coats and overcoats were strewn about, while the gray blankets lay in the camps just where the soldiers had gotten up from them after the night's rest. This I knew would happen. Men will not carry what they can get along without, unless they are made to; and it is a bad thing to "make" American soldiers, because they know what is good for them better than anyone who sits in a roller-chair. In the tropics mid-day marching under heavy kits kills more men than damp sleeping at night. I used to think the biggest thing in Shafter's army was my pack.

It was all so strange, this lonely tropic forest, and so hot. I fell in with a little bunch of headquarters cavalry orderlies, some with headquarters horses, and one with a mule dragging two wheels, which I cannot call a cart, on which General Young's stuff was tied. We met Cubans loitering along, their ponies loaded with abandoned soldier-clothes. Staff-officers on horseback came back and said that there had been a fight on beyond, and that Colonel Wood was killed and young Fish shot dead—that the Rough Riders were all done to pieces. There would be more fighting, and we pushed forward, sweating under the stifling heat of the jungle-choked road. We stopped and cracked cocoanuts to drink the milk. Once, in a sort of savanna, my companions halted and threw cartridges into their carbines. I saw two or three Spanish soldiers on ahead in some hills and brush. We pressed on; but as the Spanish soldiers did not seem to be concerned as to our presence, I allowed they were probably Cubans who had taken clothes from dead Spanish soldiers, and so it turned out. The Cubans seem to know each other by scent, but it bothered the Northern men to make a distinction between Spanish and Cuban, even when shown Spanish prisoners in order that they might recognize their enemy by sight. If a simple Cuban who stole Spanish soldier clothes could only know how nervous it made the trigger fingers of our regulars, he would have died of fright. He created the same feeling that a bear would, and the impulse to "pull up and let go" was so instinctive and sudden with our men that I marvel more mistakes were not made.

At night I lay up beside the road outside of Siboney, and cooked my supper by a soldier fire, and lay down under a mango-tree on my rubber, with my haversack for a pillow. I could hear the shuffling of the marching troops, and see by the light of the fire near the road the white blanket rolls glint past its flame—tired, sweaty men, mysterious and silent too, but for the clank of tin cups and the monotonous shuffle of feet.

In the early morning the field near me was covered with the cook-fires of infantry, which had come in during the night. Presently a battery came dragging up, and was greeted with wild cheers from the infantry, who crowded up to the road. It was a great tribute to the guns; for here in the face of war the various arms realized their interdependence. It is a solace for cavalry to know that there is some good steady infantry in their rear, and it is a vast comfort for infantry to feel that their front and flanks are covered, and both of them like to have the shrapnel travelling their way when they "go in."

At Siboney I saw the first wounded Rough Riders, and heard how they had behaved. From this time people began to know who this army doctor was, this Colonel Wood. Soldiers and residents in the Southwest had known him ten years back. They knew Leonard Wood was a soldier, skin, bones, and brain, who travelled under the disguise of a doctor, and now they know more than this.

Then I met a fellow-correspondent, Mr. John Fox, and we communed deeply. We had not seen this fight of the cavalry brigade, and this was because we were not at the front. We would not let it happen again. We slung our packs and most industriously plodded up the Via del Rey until we got to within hailing distance of the picket posts, and he said: "Now, Frederic, we will stay here. They will pull off no more fights of which we are not a party of the first part." And stay we did. If General Lawton moved ahead, we went up and cultivated Lawton; but if General Chaffee got ahead, we were his friends, and gathered at his mess fire. To be popular with us it was necessary for a general to have command of the advance.

But what satisfying soldiers Lawton and Chaffee are! Both seasoned, professional military types. Lawton, big and long, forceful, and with iron determination. Chaffee, who never dismounts but for a little sleep during the darkest hours of the night, and whose head might have been presented to him by one of William's Norman barons. Such a head! We used to sit around and study that head. It does not belong to the period; it is remote, when the race was young and strong; and it has "warrior" sculptured in every line. It may seem trivial to you, but I must have people "look their part." That so many do not in this age is probably because men are so complicated; but "war is a primitive art," and that is the one objection I had to von Moltke, with his simple student face. He might have been anything. Chaffee is a soldier.

The troops came pouring up the road, reeking under their packs, dusty, and with their eyes on the ground. Their faces were deeply lined, their beards stubby, but their minds were set on "the front"—"on Santiago." There was a suggestion of remorseless striving in their dogged stepping along, and it came to me that to turn them around would require some enterprise. I thought at the time that the Spanish commander would do well to assume the offensive, and marching down our flank, pierce the centre of the straggling column; but I have since

changed my mind, because of the superior fighting ability which our men showed. It must be carefully remembered that, with the exception of three regiments of Shafter's army, and even these were "picked volunteers," the whole command was our regular army—trained men, physically superior to any in the world, as any one will know who understands the requirements of our enlistment as against that of conscript troops; and they were expecting attack, and praying devoutly for it. Besides, at Las Guasimas we got the *moral* on the Spanish.

Then came the "cracker problem." The gallant Cabanais pushed his mules day and night. I thought they would go to pieces under the strain, and I think every "packer" who worked on the Santiago line will never forget it. Too much credit cannot be given them. The command was sent into the field without its proper ratio of pack-mules, and I hope the blame of that will come home to some one some day. That was the *direct* and *only* cause of all the privation and delay which became so notable in Shafter's operations. I cannot imagine a man who would recommend wagons for a tropical country during the rainy season. Such a one should not be censured or reprimanded; he should be spanked with a slipper.

So while the engineers built bridges, and the troops made roads behind them, and until we got *"three days' crackers ahead"* for the whole command, things stopped. The men were on half-rations, were out of tobacco, and it rained, rained, rained. We were very miserable.

Mr. John Fox and I had no cover to keep the rain out, and our determination to stay up in front hindered us from making friends with any one who had. Even the private soldiers had their dog-tents, but we had nothing except our two rubber ponchos. At evening, after we had "bummed" some crackers and coffee from some good-natured officer, we repaired to our neck of woods, and stood gazing at our mushy beds. It was good, soft, soggy mud, and on it, or rather in it, we laid one poncho, and over that we spread the other.

"Say, Frederic, that means my death; I am subject to malaria."

"Exactly so, John. This cold of mine will end in congestion of the lungs, or possibly bronchial consumption. Can you suggest any remedy?"

"The fare to New York," said John, as we turned into our wallow.

At last I had the good fortune to buy a horse from an invalided officer. It seemed great fortune, but it had its drawback. I was ostracized by my fellow-correspondents.

All this time the reconnoissance of the works of Santiago and the outlying post of Caney was in progress. It was rumored that the forward movement would come, and being awakened by the bustle, I got up in the dark, and went gliding around until I managed to steal a good feed of oats for my horse. This is an important truth as showing the demoralization of war. In the pale light I saw a staff-officer who was going to Caney, and I followed him. We overtook others, and finally came to a hill overlooking the ground which had been fought over

so hard during the day. Capron's battery was laying its guns, and back of the battery were staff-officers and correspondents eagerly scanning the country with field-glasses. In rear of these stood the hardy First Infantry, picturesquely eager and dirty, while behind the hill were the battery horses, out of harm's way.

The battery opened and knocked holes in the stone fort, but the fire did not appear to depress the rifle-pits. Infantry in the jungle below us fired, and were briskly answered from the trenches.

I had lost my canteen and wanted a drink of water, so I slowly rode back to a creek. I was thinking, when along came another correspondent. We discussed things, and thought Caney would easily fall before Lawton's advance, but we had noticed a big movement of our troops toward Santiago, and we decided that we would return to the main road and see which promised best. Sure enough, the road was jammed with troops, and up the hill of El Poso went the horses of Grimes's battery under whip and spur. Around El Poso ranch stood Cubans, and along the road the Rough Riders—Roosevelt's now, for Wood was a brigadier.

The battery took position, and behind it gathered the foreigners, naval and military, with staff-officers and correspondents. It was a picture such as may be seen at a manœuvre. Grimes fired a few shells toward Santiago, and directly came a shrill screaming shrapnel from the Spanish lines. It burst over the Rough Riders, and the manœuvre picture on the hill underwent a lively change. It was thoroughly evident that the Spaniards had the range of everything in the country. They had studied it out. For myself, I fled, dragging my horse up the hill, out of range of Grimes's inviting guns. Some as gallant soldiers and some as daring correspondents as it is my pleasure to know did their legs proud there. The tall form of Major John Jacob Astor moved in my front in jack-rabbit bounds. Prussian, English, and Japanese correspondents, artists, all the news, and much high-class art and literature, were flushed, and went straddling up the hill before the first barrel of the Dons. Directly came the warning scream of No. 2, and we dropped and hugged the ground like star-fish. Bang! right over us it exploded. I was dividing a small hollow with a distinguished colonel of the staff.

"Is this thing allowed, Colonel?"

"Oh, yes, indeed!" he said. "I don't think we could stop those shrapnel."

And the next shell went into the battery, killing and doing damage. Following shell were going into the helpless troops down in the road, and Grimes withdrew his battery for this cause. He had been premature. All this time no one's glass could locate the fire of the Spanish guns, and we could see Capron's smoke miles away on our right. Smoky powder belongs with arbalists and stone axes and United States ordnance officers, which things all belong in museums with other dusty rust.

Then I got far up on the hill, walking over the prostrate bodies of my old friends the Tenth Cavalry, who were hugging the hot ground to get away from the hotter shrapnel. There I met a clubmate from New York, and sundry good

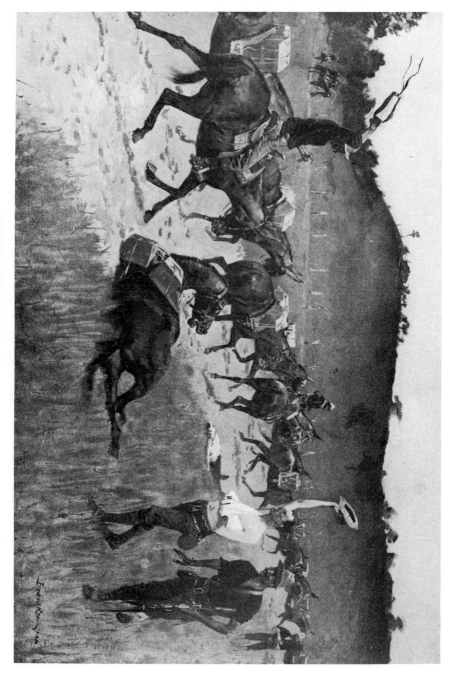

IN THE REAR OF THE BATTLE—WOUNDED ON THE SAN JUAN ROAD

foreigners, notably the Prussian (Von Goetzen), and that lovely "old British salt" Paget, and the Japanese major, whose name I could never remember. We sat there. I listened to much expert artillery talk, though the talk was not quite so impressive as the practice of that art.

But the heat—let no man ever attempt that after Kipling's "and the heat would make your blooming eyebrows crawl."

This hill was the point of vantage; it overlooked the flat jungle, San Juan hills, Santiago, and Caney, the whole vast country to the mountains which walled in the whole scene. I heard the experts talk, and I love military science, but I slowly thought to myself this is not my art—neither the science of troop movement nor the whole landscape. My art requires me to go down in the road where the human beings are who do these things which science dictates, in the landscape which to me is overshadowed by their presence. I rode slowly, on account of the awful sun. Troops were standing everywhere, lying all about, moving regularly up the jungle road toward Santiago, and I wound my way along with them, saying, "Gangway, please."

War is productive of so many results, things happen so awfully fast, men do such strange things, pictures make themselves at every turn, the emotions are so tremendously strained, that what knowledge I had fled away from my brain, and I was in a trance; and you know, cheerful reader; I am not going to describe a battle to you.

War, storms at sea, mountains, deserts, pests, and public calamities leave me without words. I simply said "Gangway" as I wormed my way up the fateful road to Santiago. Fellows I knew out West and up North and down South passed their word to me, and I felt that I was not alone. A shrapnel came shrieking down the road, and I got a drink of water from Colonel Garlington, and a cracker. The soldiers were lying alongside and the staff-officers were dismounted, also stopping quietly in the shade of the nearest bush. The column of troops was working its way into the battle-line.

"I must be going," I said, and I mounted my good old mare—the colonel's horse. It was a tender, hand-raised trotting-horse, which came from Colorado, and was perfectly mannered. We were in love.

The long columns of men on the road had never seen this condition before. It was their first baby. Oh, a few of the old soldiers had, but it was so long ago that this must have come to them almost as a new sensation. Battles are like other things in nature—no two the same.

I could hear noises such as you can make if you strike quickly with a small walking-stick at a very few green leaves. Some of them were very near and others more faint. They were the Mausers, and out in front through the jungle I could hear what sounded like a Fourth of July morning, when the boys are setting off their crackers. It struck me as new, strange, almost uncanny, because I wanted the roar of battle, which same I never did find. These long-range,

smokeless bolts are so far-reaching, and there is so little fuss, that a soldier is for hours under fire getting into the battle proper, and he has time to think. That is hard when you consider the seriousness of what he is thinking about. The modern soldier must have moral quality; the guerilla is out of date. This new man may go through a war, be in a dozen battles, and survive a dozen wounds without seeing an enemy. This would be unusual, but easily might happen. All our soldiers of San Juan were for the most part of a day under fire, subject to wounds and death, before they had even a chance to know where the enemy was whom they were opposing. To all appearance they were apathetic, standing or marching through the heat of the jungle. They flattened themselves before the warning scream of the shrapnel, but that is the proper thing to do. Some good-natured fellow led the regimental mascot, which was a fice, or a fox-terrier. Really, the dog of war is a fox-terrier. Stanley took one through Africa. He is in all English regiments, and he is gradually getting into ours. His flag is short, but it sticks up straight on all occasions, and he is a vagabond. Local ties must set lightly on soldiers and fox-terriers.

Then came the light as I passed out of the jungle and forded San Juan River. The clicking in the leaves continued and the fire-crackers rattled out in front. "Get down, old man; you'll catch one!" said an old alkali friend, and I got down, sitting there with the officers of the cavalry brigade. But promptly some surgeons came along, saying that it was the only safe place, and they began to dig the sand to level it. We, in consequence, moved out into the crackle, and I tied my horse with some others.

"Too bad, old fellow," I thought; "I should have left you behind. Modern rifle fire is rough on horses. They can't lie down. But, you dear thing, you will have to take your chances." And then I looked at the preparation for the field hospital. It was altogether too suggestive. A man came, stooping over, with his arms drawn up, and hands flapping downward at the wrists. That is the way with all people when they are shot through the body, because they want to hold the torso steady, because if they don't it hurts. Then the oncoming troops poured through the hole in the jungle which led to the San Juan River, which was our line of battle, as I supposed. I knew nothing of the plan of battle, and I have an odd conceit that no one else did, but most all the line-officers were schooled men, and they were able to put two and two together mighty fast, and in most instances faster than headquarters. When educated soldiers are thrown into a battle without understanding, they understand themselves.

As the troops came pouring across the ford they stooped as low as they anatomically could, and their faces were wild with excitement. The older officers stood up as straight as on parade. They may have done it through pride, or they may have known that it is better to be "drilled clean" than to have a long ranging wound. It was probably both ideas which stiffened them up so.

Then came the curious old tube drawn by a big mule, and Borrowe with

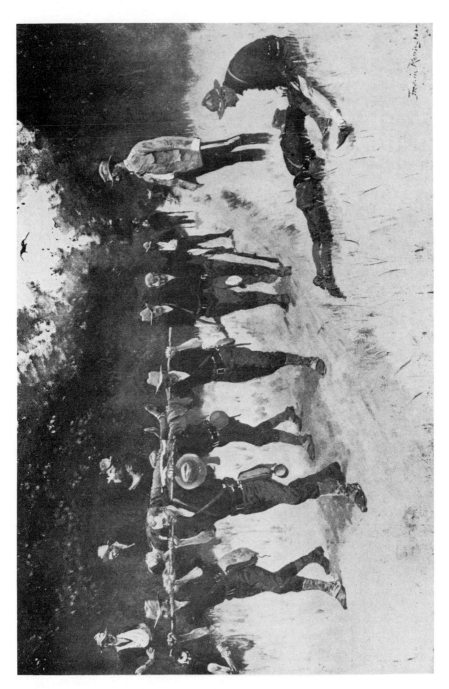

"THE WOUNDED, GOING TO THE REAR, CHEERED THE AMMUNITION"

his squad of the Rough Riders. It was the dynamite-gun. The mule was unhooked and turned loose. The gun was trundled up the road and laid for a shot, but the cartridge stuck, and for a moment the cheerful grin left the red face of Borrowe. Only for a moment; for back he came, and he and his men scraped and whittled away at the thing until they got it fixed. The poor old mule lay down with a grunt and slowly died. The fire was now incessant. The bullets came like the rain. The horses lay down one after another as the Mausers found their billets. I tried to take mine to a place of safety, but a sharp-shooter potted at me, and I gave it up. There was no place of safety. For a long time our people did not understand these sharp-shooters in their rear, and I heard many men murmur that their own comrades were shooting from behind. It was very de-moralizing to us, and on the Spaniards' part a very desperate enterprise to lie deliberately back of our line; but of course, with bullets coming in to the front by the bucketful, no one could stop for the few tailing shots. The Spaniards were hidden in the mango-trees, and had smokeless powder.

Now men came walking or were carried into the temporary hospital in a string. One beautiful boy was brought in by two tough, stringy, hairy old soldiers, his head hanging down behind. His shirt was off, and a big red spot shone brilliantly against his marblelike skin. They laid him tenderly down and the surgeon stooped over him. His breath came in gasps. The doctor laid his arms across his breast, and shaking his head, turned to a man who held a wounded foot up to him, dumbly imploring aid, as a dog might. It made my nerves jump, looking at that grewsome hospital, sand-covered, with bleeding men, and yet it seemed to have fascinated me; but I gathered myself and stole away. I went down the creek, keeping under the bank, and then out into the "scrub," hunting for our line; but I could not find our line. The bullets cut and clicked around, and a sharpshooter nearly did for me. The thought came to me, what if I am hit out here in the bush while all alone? I shall never be found. I would go back to the road, where I should be discovered in such case; and I ran quickly across a space that my sharp-shooting Spanish friend did not see me. After that I stuck to the road. As I passed along it through an open space I saw a half-dozen soldiers sitting under a tree. "Look out—sharp-shooters!" they sang out. "Wheet!" came a Mauser, and it was right next to my ear, and two more. I dropped in the tall guinea-grass, and crawled to the soldiers, and they studied the mango-trees; but we could see nothing. I think that episode cost me my sketch-book. I believe I lost it during the crawl, and our friend the Spaniard shot so well I wouldn't trust him again.

From the vantage of a little bank under a big tree I had my first glimpse of San Juan hill, and the bullets whistled about. One would "tumble" on a tree or ricochet from the earth, and then they shrieked. Our men out in front were firing, but I could not see them. I had no idea that our people were to assault that hill—I thought at the time such an attempt would be unsuccessful.

I could see with my powerful glass the white lines of the Spanish intrenchments. I did not understand how our men could stay out there under that gruelling, and got back into the safety of a low bank.

A soldier said, while his stricken companions were grunting around him, "Boys, I have got to go one way or the other, pretty damn quick." Directly I heard our line yelling, and even then did not suppose it was an assault.

Then the Mausers came in a continuous whistle. I crawled along to a new place and finally got sight of the fort, and just then I could distinguish our blue soldiers on the hill-top, and I also noticed that the Mauser bullets rained no more. Then I started after. The country was alive with wounded men—some to die in the dreary jungle, some to get their happy home-draft, but all to be miserable. Only a handful of men got to the top, where they broke out a flag and cheered. "Cheer" is the word for that sound. You have got to hear it once where it means so much, and ever after you will grin when Americans make that noise.

San Juan was taken by infantry and dismounted cavalry of the United States regular army without the aid of artillery. It was the most glorious feat of arms I ever heard of, considering every condition. It was done without grub, without reserves of either ammunition or men, under tropical conditions. It was a storm of intrenched heights, held by veteran troops armed with modern guns, supported by artillery, and no other troops on the earth would have even thought they could take San Juan heights, let alone doing it.

I followed on and up the hill. Our men sat about in little bunches in the pea-green guinea-grass, exhausted. A young officer of the Twenty-fourth, who was very much excited, threw his arms about me, and pointing to twenty-five big negro infantrymen sitting near, said, "That's all—that is all that is left of the Twenty-fourth Infantry," and the tears ran off his mustache.

Farther on another officer sat with his arms around his knees. I knew him for one of these analytical chaps—a bit of a philosopher—too highly organized—so as to be morose. "I don't know whether I am brave or not. Now there is S——; he don't mind this sort of thing. I think—"

"Oh, blow your philosophy!" I interrupted. "If you were not brave, you would not be here."

The Spanish trenches were full of dead men in the most curious attitudes, while about on the ground lay others, mostly on their backs, and nearly all shot in the head. Their set teeth shone through their parted lips, and they were horrible. The life never runs so high in a man as it does when he is charging on the field of battle; death never seems so still and positive.

Troops were moving over to the right, where there was firing. A battery came up and went into position, but was driven back by rifle fire. Our batteries with their smoky powder could not keep guns manned in the face of the Mausers. Then, with gestures much the same as a woman makes when she is herding

chickens, the officers pushed the men over the hill. They went crawling. The Spanish were trying to retake the hill. We were short of ammunition. I threw off my hat and crawled forward to have a look through my glass at the beyond. I could hardly see our troops crouching in the grass beside me, though many officers stood up. The air was absolutely crowded with Spanish bullets. There was a continuous whistle. The shrapnel came screaming over. A ball struck in front of me, and filled my hair and face with sand, some of which I did not get out for days. It jolted my glass and my nerves, and I beat a masterly retreat, crawling rapidly backwards, for a reason which I will let you guess. The small-arms rattled; now and then a wounded man came back and started for the rear, some of them shot in the face, bleeding hideously.

"How goes it?" I asked one.

"Ammunition! ammunition!" said the man, forgetful of his wound.

I helped a man to the field hospital, and got my horse. The lucky mare was untouched. She was one of three animals not hit out of a dozen tied or left at the hospital. One of these was an enormous mule, loaded down with what was probably officers' blanket rolls, which stood sidewise quietly as only a mule can all day, and the last I saw of him he was alive. Two fine officers' chargers lay at his feet, one dead and the other unable to rise, and suffering pathetically. The mule was in such an exposed position that I did not care to unpack him, and Captain Miley would not let any one shoot a horse, for fear of the demoralizing effect of fire in the rear.

A trumpeter brought in a fine officer's horse, which staggered around in a circle. I saw an English sabre on the saddle, and recognized it as Lieutenant Short's, and indeed I knew the horse too. He was the fine thoroughbred which that officer rode in Madison Square military tournament last winter, when drilling the Sixth Cavalry. The trumpeter got the saddle off, and the poor brute staggered around with a bewildered look in his eager eyes, shot in the stifle-joint, I thought; and then he sat down in the creek as a dog would on a hot day. The suffering of animals on a battle-field is most impressive to one who cares for them.

I again started out to the hill, along with a pack-train loaded with ammunition. A mule went down, and bullets and shell were coming over the hill aplenty. The wounded going to the rear cheered the ammunition, and when it was unpacked at the front, the soldiers seized it like gold. They lifted a box in the air and dropped it on one corner, which smashed it open.

"Now we can hold San Juan hill against them garlics—hey, son!" yelled a happy cavalryman to a doughboy.

"You bet—until we starve to death."

"Starve nothin'—we'll eat them gun-teams."

Well, well, I said, I have no receipt for licking the kind of troops these boys represent. And yet some of the generals wanted to retreat.

Having had nothing to eat this day, I thought to go back to headquarters

camp and rustle something. Besides, I was sick. But beyond the hill, down the road, it was very dangerous, while on the hill we were safe. "Wait for a lull; one will come soon," advised an old soldier. It is a curious thing that battle firing comes like a big wind, and has its lulls. Now it was getting dark, and during a lull I went back. I gave a wounded man a ride to the field hospital, but I found I was too weak myself to walk far. I had been ill during the whole campaign, and latterly had fever, which, taken together with the heat, sleeping in the mud, marching, and insufficient food, had done for me.

The sight of that road as I wound my way down it was something I cannot describe. The rear of a battle. All the broken spirits, bloody bodies, hopeless, helpless suffering which drags its weary length to the rear, are so much more appalling than anything else in the world that words won't mean anything to one who has not seen it. Men half naked, men sitting down on the road-side utterly spent, men hopping on one foot with a rifle for a crutch, men out of their minds from sunstroke, men dead, and men dying. Officers came by white as this paper, carried on rude litters made by their devoted soldiers, or borne on their backs. I got some food about ten o'clock and lay down. I was in the rear at headquarters, and there were no bullets and shells cracking about my ears, but I found my nerves very unsettled. During the day I had discovered no particular nervousness in myself, quite contrary to my expectations, since I am a nervous man, but there in the comparative quiet of the woods the reaction came. Other fellows felt the same, and we compared notes. Art and literature under Mauser fire is a jerky business; it cannot be properly systematized. I declared that I would in the future paint "set pieces for dining-rooms." Dining-rooms are so much more amusing than camps. The novelist allowed that he would be forced to go home and complete "The Romance of a Quart Bottle." The explorer declared that his treatise on the "Flora of Bar Harbor" was promised to his publishers.

Soldiers always joke after a battle. They have to loosen the strings, or they will snap. There was a dropping fire in the front, and we understood our fellows were intrenching. Though I had gotten up that morning at half past three, it was nearly that time again before I went to sleep. The fever and the strong soldier-coffee banished sleep; then, again, I could not get the white bodies which lay in the moonlight, with the dark spots on them, out of my mind. Most of the dead on modern battle-fields are half naked, because of the "first-aid bandage." They take their shirts off, or their pantaloons, put on the dressing, and die that way.

It is well to bear in mind the difference in the point of view of an artist or a correspondent, and a soldier. One has his duties, his responsibilities, or his gun, and he is on the firing line under great excitement, with his reputation at stake. The other stalks through the middle distance, seeing the fight and its immediate results, the wounded; lying down by a dead body, mayhap, when

the bullets come quickly; he will share no glory; he has only the responsibility of seeing clearly what he must tell; and he must keep his nerve. I think the soldier sleeps better nights.

The next day I started again for the front, dismounted, but I only got to El Poso Hill. I lay down under a bank by the creek. I had the fever. I only got up to drink deeply of the dirty water. The heat was intense. The re-enforcing troops marched slowly up the road. The shells came railroading down through the jungle, but these troops went on, calm, steady, like true Americans. I made my way back to our camp, and lay there until nightfall, making up my mind and unmaking it as to my physical condition, until I concluded that I had "finished."

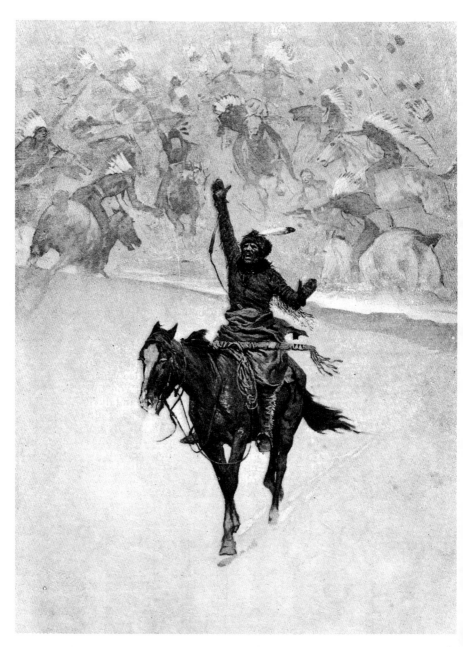

"Un I Was Yell Terrible," from "How Order No. 6 Went Through." As an Indian Scout for the Cavalry, Sundown becomes delirious from cold and hunger.

Chapter 6

Interregnum

A t their first meeting in 1893, Wister and Remington were both men of strong convictions, which sometimes seemed to co-incide. Although neither was sure what the West meant, each felt certain that its meaning could be found out. Yet riots, strikes, and Populism eroded Wister's faith in the West's transforming possibilities until little was left but sentiment. War in Cuba destroyed at a single stroke Remington's emerging vision of the western conquest as a model for empire building. As the century drew to a close, Remington and Wister still shared an interest in the West, but in the seven years since their meeting, they had lost their old sense of the region's importance. There-fore, the question that now occupied them differed somewhat from the one they addressed in such works as "The Evolution of the Cow-puncher." No longer did it seem so urgent to explain the West's meaning as it did to affirm its former existence as frontier. The consequences were complex but easily stated: failing to find "real Americans" in the West, Wister began searching for them in the East, continuing to write about the West but regarding it for the most part as past history rather than future possibility; increasingly aware that the frontier had slipped away, Remington intensified his efforts to recapture it, experimenting with new techniques in pictures, bronzes, and writing. In 1898 both Remington and Wister were standing on the threshold of greater achievement, but the partnership begun at Geyser Basin had suffered.

Wister returned from his Washington honeymoon refreshed and happy. He found a new Philadelphia, more exciting and agreeable than the old one had ever been, for marriage and success as a writer had

changed his perspective. Remington, however, grew unpleasantly aware as never before that a bustling suburban town had grown up around his big house at New Rochelle, blocking his view of Long Island Sound, disturbing the quiet, and cluttering the landscape with streets and buildings. To escape, he bought an island in Chippewa Bay on the St. Lawrence River, three miles from the Canadian border. "Ingleneuk," as Remington christened his retreat, contained five acres of woods and grass and, fronting its own small bay, a comfortable house with a private pier. From 1898 until his death in 1909, Remington ruled his tiny kingdom for part of nearly every summer. He built a studio, remodeled the house, and laid out large tennis courts. The island gave him a good place to work, rest, and entertain his friends. Yet there was something incongruous about the man who hunted bear in New Mexico and loved the atavistic wherever he encountered it settling down on five acres of beech and pine trees at Chippewa Bay. The nearby small towns, the visitors, and the other "summer people" whose houses dotted the surrounding woods, made Ingleneuk a poor substitute for the West. Remington recognized from the beginning that resting himself at the island meant something far different from spending himself in the wilderness. "[I] just live to come up here," he said of Ingleneuk, significantly adding, "[you] can't beat it anywhere—'cept out on the plains."[1]

Although Remington preferred the "vacant land" he had gone west from Canton to discover nearly two decades before, he saw that his New York retreat was expedient. "That old cleaning up of the West" to which he had decided to devote himself seemed definitely over, and the rewards to be gained from yearly western trips diminished steadily. Now nearly forty years old, Remington weighed well over three hundred pounds and found western travel increasingly difficult. His Cuban experience showed him both that he must now settle for less of the strenuous life and that the winning of the West had little in common with modern wars of conquest. Yet even while withdrawal to Chippewa Bay expressed Remington's recognition of painful realities, it also contained a complicated affirmation—for by increasingly separating himself from the *new* West, Remington insulated his earlier perceptions of the *old* West, arming himself with a new sense of the old West as "ideal."

Accordingly, Remington's work began to exhibit new subtlety and refinement. The harsh outlines used to delineate figures and topography in *Drawings* gave way to bright colors that flowed into one another against

purple distances and delicately mottled skies. Bronze horses acquired sheen and grace not present in the "Bronco Buster" and defied gravity by galloping forever in midair, all four feet free of earth. Simple patterns of journalistic prose were replaced by difficult techniques of fiction. All three areas of Remington's professional endeavor reflected an awareness, not clearly present before. The technique missed by editors when Remington had tried to sell his sketches nearly two decades earlier in New York was finally showing. Remington defined his awareness in 1903, when he told Edwin Wildman that "art is a process of elimination."[2] His imaginative use of color, polished bronze, and complex narrative was most successful when least substantial. "What you want to do," he argued, "is just create the thought—materialize the spirit of the thing . . . then your audience discovers the thing you held back, and that's skill." Having set out in 1881 to conquer the West, he now saw that his prediction of 1895 had come true: the old West was history. Yet even in the face of historical fact, Remington refused to adopt the role of historian. Instead, he turned prestidigitator, conjuring with spirits which denied history by dissolving.

Wister responded to the same conditions in a very different manner. The first writing he did after returning from his honeymoon involved an effort to reach back to the old West of his youth, for it derived from his third journey west, made in 1888. Yet it contained nothing of the elegiac quality Wister earlier associated with "the eternal," suggested no meaning beyond itself. Instead, it dealt in straightforward expository prose with an odd incident of weather. Entitled "Where Lightning Struck," the essay concerned an unsuccessful hunt for mountain sheep in the Washakie Needles, north of Wind River.[3] After being drenched with rain, pelted with hail, and frightened by lightning in a sudden thunderstorm, Wister and his companions were alarmed by loud buzzing noises in their ears and stinging sensations down their spines. When they removed their hats, the buzzing and stinging suddenly ceased. The explanation they finally hit upon was that static electricity generated by the thunderstorm had charged their hats like leyden jars, sending a current of electrical energy through their bodies to the ground. Wister finished "Where Lightning Struck" on January 20, 1899. Nine years later the essay was printed in *Science* under the title, "An Electric Storm on the Washakie Needles."[4] Wister used its central incident in a highly imaginative story called "Timberline," also first printed in 1908.[5] For the present, however, the essay

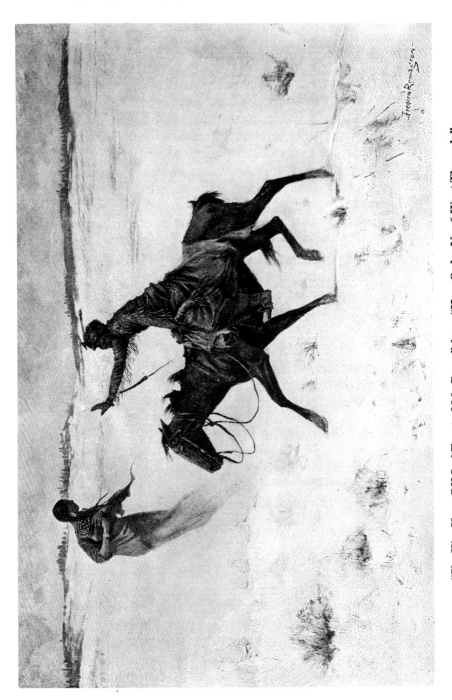

"She Was Keep Off Jus' Front of My Pony," from "How Order No. 6 Went Through."
Sundown is guided by a vision of a woman in his attempt to deliver a military order.

reflected a significant shift in Wister's use of western materials.

Wister's earliest writings about the West—works like "How Lin McLean Went East" and "The Evolution of the Cow-puncher"—depicted the same region of outlandish appearance and violent weather which appeared in the "Lightning" essay, yet they also reflected his persistent effort to link the West with pervasive tendencies of American life. With "Destiny at Drybone," he ended his pursuit of the imperial theme, for he no longer believed in the West as a key to American history. Clearly, Wister still loved the past he found expressed in "The Last Cavalier," but when he attempted to capture it, he found himself floundering among fragments that wouldn't fit together.

"Where Lighning Struck" reflected the same attention to accurate detail, the same desire to fully encompass an event, even the same fascination with the West present in works like "Hank's Woman"—but it missed entirely the sense of excitement Wister's early stories generated. As a writer of fiction, Wister still loved the spectacular and colorful. As historian he felt compelled to deal with the drab and homely. A collision between potentially fanciful material and analytic method was therefore what destroyed "Where Lightning Struck." Wister put his finger on the difficulty four years later in 1902, when he described his famous novel, *The Virginian,* as "the portrait of a man . . . with the picture, the whole, large picture, of the era and manners in which he existed, for a background."[6] Nothing could be further from Remington's effort to capture "the spirit of a thing" by practicing "a process of elimination." Wister, who wanted to explain the thing itself, felt that leaving things out constituted error rather than skill: "I take side after side of manners of life, omitting none, and when I'm through you have the whole, with the man standing out in the middle." Romantic though Wister was, his method remained that of a historian. Elaboration was its characteristic device, completeness its usual object.

The same month that Wister wrote "Where Lightning Struck" saw publication of *Sundown Leflare,* a collection of Remington's short stories which neither sold well nor attracted much critical attention but did show how Remington applied to his prose the same techniques he was beginning to use with oil and bronze, thus avoiding the trap Wister fell into with "Destiny at Drybone" and the paralysis that afflicted "Where Lightning Struck." Wister wrote romantic fiction which he insisted on regarding as historical. Therefore, he found himself continuously occupied

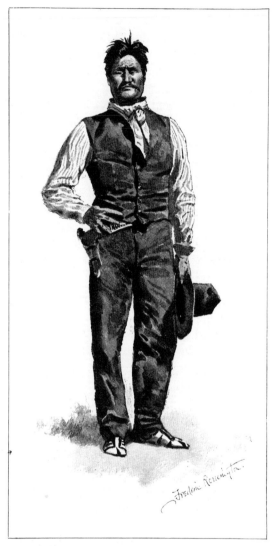

"Sundown Leflare, Washed and Dressed Up."

with historical concerns. Even the title of *Red Men and White,* his first book, expressed a preoccupation with categories of race, time, and location. Yet Remington longed to make *all* categories vanish, straining toward impossible bronzes in which form and substance gave way entirely to movement. Likewise, he tried in *Sundown Leflare* to dissolve

both romantic past and unromantic future, leaving only "the spirit of a thing"—which had no location in time at all. To this end, he made Sundown Leflare himself, hero and primary narrator of the book, "cross bred, red *and* white"[7] [italics mine]. The stories Sundown told denied the retrospective view of history in order to affirm an instant of perception.

Whereas Wister's romantic vision proceeded directly from an elegiac attitude toward the past, Remington seemed to argue that even if the past existed it could not be reached. His main activity in the Sundown stories was a process of shifting his narrative from the level of history to the level of myth. Sundown thus became the *permanent* prodigal, alien and *isolato*. Therefore, Sundown himself was never explained or defined, and he never matured. His future, if he had one, was always a matter of filmiest speculation. Only his own colorful, incoherent yarns suggested that he remembered a previous time. Clearly, Remington's intention was to show that Sundown, like the "Bronco Buster," existed at one moment only: the present.

Yet, Remington created Sundown as a man of middle years who told stories about the days when he was young. By doing so, he appeared to subject Sundown to the same maturing process that turned Lin McLean into a "neighbor." He could annihilate time in pictures and bronzes by ignoring it—but the feat was harder to accomplish in stories, because prose, in order to make sense, had to occupy and deal directly with chronological progressions. Unable to solve his problem with narrative alone, Remington combined his narrative with pictures. "The Great Medicine Horse," first of the Sundown tales, described Sundown merely as "crossbred"; but the next tale, "How Order No. 6 Went Through," showed the scout in three drawings. The first two were highly imaginative renderings of Sundown as a young man. The third revealed "Sundown Leflare Washed and Dressed Up"—not the youthful Indian scout of the past, but the yarn spinner of the present, a sturdy, handsome figure with unruly hair, wearing Indian moccasins and an ill-fitting suit of white man's clothing. The progression thus represented was a normal time sequence, and Remington extended by opening his third story, "Sundown Leflare's Money," with a verbal description of the Sundown who wore European clothes:

Sitting together comfortably on the front porch of the house of the man who

ran the flouring-mill at the agency, Sun-Down and I felt clean, and we both had on fresh clothes. He had purchased at the trader's a cotton shirt with green stripes, which would hold the entire attention of any onlooker.

"The Great Medicine Horse" dealt with a middle-aged Sundown, "Order No. 6" with a younger one—and "Sundown Leflare's Money" illuminated an intermediate stage of Sundown's life, a comic venture into the quasi-commercial world of horse trading and stud poker. Accordingly, its two pictures showed a Sundown more mature and more like a white man than before, but still wearing a fringed buckskin tunic rather than the cotton shirt with green stripes. In the first, Sundown peered suspiciously at a card sharp; in the second, he chased a railroad train on horseback. Both represented him in close contact with the European civilization which produced his striped shirt. The picture of Sundown Leflare washed and dressed up was central to the first three stories in Remington's book, for it provided an anchor in the present from which to make excursions into the past.

Because the first three tales comprised a chronicle of how Sundown acquired his striped shirt and European haircut, Remington's picture of the scout "dressed up" also represented their culmination. The process was as thoroughly "historical" as the one Wister traced in *Lin McLean.* Yet Remington used his next tale to dissolve the historical framework established in the first three, "eliminating" the Europeanized half-breed and setting another figure in his place.

"Sundown Leflare's Warm Spot" began the substitution by introducing a new subject: the "romance"—in both possible senses—of the hero. Such romance was certainly suggested in Remington's drawing of "Sundown Leflare Washed and Dressed Up," but Remington now supplied a verbal picture to complicate his earlier drawing:

[Sundown] is a strange man, with his curious English and his weird past. He is a tall person of great physical power, and must in his youth have been a handsome vagabond. Born and raised with the buffalo Indians, still there was white man enough about him for a point of view which I could understand. His great head, almost Roman, was not Indian, for it was too fine; nor was it French; it answered to none of those requirements. His character was so fine a balance between the two, when one considerd his environment, that I never was at a loss to place his inflections. And yet he was an exotic, and could never bore a man who had read a little history.[8]

The description clearly corresponded to Remington's drawing of Sun-

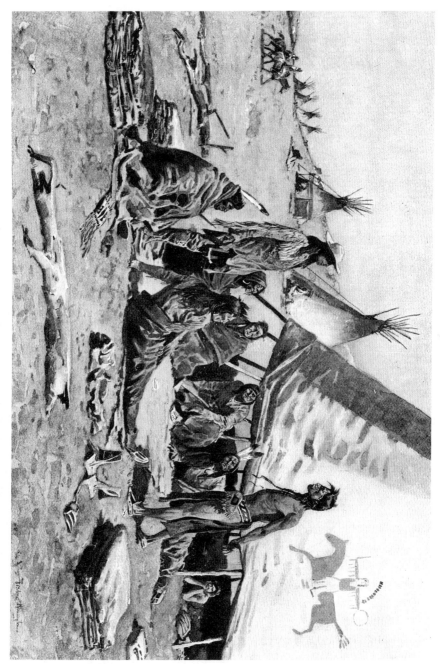

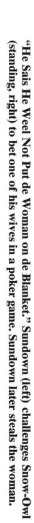

"He Sais He Weel Not Put de Woman on de Blanket." Sundown (left) challenges Snow-Owl (standing, right) to bet one of his wives in a poker game. Sundown later steals the woman.

down but was not its equivalent. The drawing stood by itself as a complete representation; yet in the description, "weird past," an appearance of uncertain origin, and "curious English" combined to make Sundown "an exotic" interesting to Remington's narrator because he had "read a little history." By describing Sundown, the narrator blurred the sharp outlines of Remington's picture. Since the scout's speech and physiognomy appeared to the narrator as puzzles rather than solutions, his "weird past" became a matter not of fact but of imaginative speculation.

Remington's narrator had much in common with Wister, who habitually thought of experience as a series of events that *meant* something because they might be expected to fall into patterns which one could use to answer questions. He therefore lived in a continuous state of unfulfilled expectation. The beginning of "Sundown Leflare's Warm Spot" found him riding beside Sundown, waiting for "something to happen." Hoping to discover whether Sundown had "ever had a romance," he turned and asked where Sundown was "living now." Sundown, who had *not* "read . . . history," refused to regard himself as historical: "Leevin' here," he answered, "I leev on dees pony, er een de blanket on the white pack-horse."[9] Remington's point could not be more plainly stated. Sundown "lived" wherever he happened to be. Whatever "weird past" belonged to him, he made his own by never allowing it to be separated from the present. Yet the narrator, determined to establish a continuity between the Sundown who rode beside him and one who had "a romance," was not easily put off. Pursuing his questions, he discovered that Sundown had fathered numerous children by no fewer than six women. Under the narrator's guidance, the scout finally produced a "story": one of his women had belonged to the Sioux chief White Owl. Sundown felt attracted to her and tried to buy her. Failing in this, he attempted to win her by cheating at cards. White Owl still refused to give the woman up, so Sundown was forced to steal her, killing White Owl in a subsequent duel which had obvious parallels with medieval jousting matches. This, thought the narrator, was "romance" indeed. The dusty half-breed riding beside him came from another, more heroic time. The empty landscape he rode through rang with Arthurian echoes. Had it occurred to him, he might have noted that the hills which rolled away on either side of him looked like "grass-grown books." But Remington brought the whole, elaborate structure that the narrator's imagination had produced down in an instant by having Sundown end his narrative with an offhanded

"He Was Laugh at Me from between de Wheel," from "Sundown Leflare's Money." Sundown (mounted) pursues a card sharp (under boxcar, center) who has cheated him.

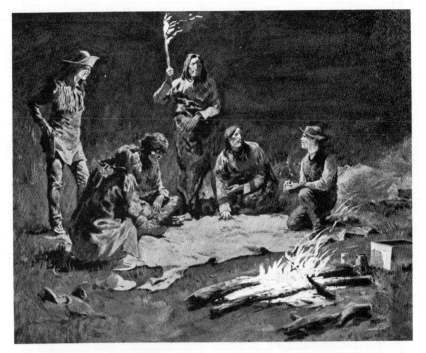

"I Was Geet Up un Was Look at de Leetle Man." Sundown (left) watches the card sharp (kneeling, right).

remark about what happened to the woman won from White Owl: "Oh, de squaw—well, I sol' her for one hundred dollar to a white man on de Yellowstone . . . t'ree year aftair."[10]

The narrator's imaginary pattern thus collapsed, leaving only something that looked like a paradox, and Sundown remained unsolved by history. To deal with him at all, the narrator had to retreat again into speculation:

This rough plains wanderer is an old man now, and he may have forgotten his tender feelings of long ago. He had never examined himself for anything but wounds of the flesh, and nature had laid rough roads in his path, but still he sold the squaw for whom he had been willing to give his life.[11]

The speculation solved nothing, for the narrator wanted not a phenomenon but continuity, not experience but history. "How," he asked himself, "can I reconcile this romance to its positively fatal termination?" When

it came, the answer was as cryptic and demanding as the skyline Rem-
ington put into his picture of "The Horse Trade" in 1893, but because
it constituted what Remington "held back" in ".Sundown Leflare's Warm
Spot," it also designated the story's theme. Only after the day's ride was
over and the narrator prepared for sleep did Remington allow Sundown
to reveal with his usual nonchalance that the latest of his children was
still an infant. Asked about the mother, he replied with the story's kernel
of meaning:

Oh, her mudder—well, she was no Enjun. Don' know where she ees now.
When de lettle baby was born, her mudder was run off on de dem railroad.[12]

It was precisely the same configuration that occurred at the beginning of
the story when Sundown replied to the question about his residence by
saying "leevin' here." Clearly, it meant that for all the colorful stories
Sundown could tell, and despite the fact that the narrator could talk
about his "weird past," Sundown *had* no past—only a present. Even the
narrator showed that he began to understand by observing after Sun-
down's latest revelation that "my romance had arrived."

Remington's narrator insisted that Sundown was "an old man now,"
yet understood "now" only as part of an imaginary pattern. His percep-
tion, as Remington repeatedly showed, was not reliable, for whenever
the narrator attempted to visualize a Sundown other than the one who
wore a cotton shirt, vest, and necktie, he found himself speculating about
origins and motivations, trapped by his own sense of history. Reming-
ton's illustrations for "Sundown Leflare's Warm Spot," however, corre-
sponded to Sundown's own description of himself as "all same Enjun—
fringe, bead, long hair—but I was wear de hat."[13] Furthermore, the half-
wild young man they pictured was identical in every respect to the hero
of Remington's only novel, *John Ermine of the Yellowstone*, written four
years later in 1902. The Wister-like narrator searched Sundown's "weird
past" for romance while waiting expectantly for "something to happen"
in the future. Therefore, he regarded Sundown as "an old man." Yet
Remington's use of Sundown was to make him never older, always
younger. The young man in the buckskin tunic did not *mature into* but
was *generated by* the stocky figure in the cotton shirt. Remington thus
added new dimension to Sundown's mutability: by being both red *and*
white, Sundown became neither red *nor* white. By being both Sundown
Leflare *and* John Ermine, he became neither Sundown Leflare *nor* John

Ermine. As he concurrently lost his historical identity and dissolved into imagination, he demonstrated the process through which Remington endeavored to forget "the *things* we *know*" in pursuit of "the ideal."

Arresting as the *Sundown* stories were in some parts, Remington lacked as writer the skill he surely had as sculptor. Even when he managed in such potentially attractive stories as "Sundown Leflare's Warm Spot" to convey a sense of his complex intention, he fell somewhat short of executing it. He rendered Sundown himself brilliantly but seemed incapable of fully exploiting the complex relationship between Sundown and the eastern narrator. The flaw was finally fatal, for it weakened Remington's irony and turned the *Sundown* stories into brightly colored vignettes.

While Remington struggled early in 1899 to achieve mastery of techniques to express his increasingly complex vision of the West, Wister engaged in what can only be called a retrenchment. After finishing "Where Lightning Struck" in January, he set to work on two pieces that showed how thoroughly he had revised his earlier view of the West's centrality to American history. One was a story called "Padre Ignazio," the other a long poem entitled "My Country: 1899." "Padre Ignazio" forsook the Great Plains and Rocky Mountains of the 1870s and '80s—the days of the Indian campaigns and cattle booms which occupied Wister's previous work—for California in 1855. Even more importantly, it forsook the national themes of those earlier works to focus on the inner struggle of an elderly Spanish missionary. "My Country: 1899" kept the national theme but turned decisively away from the West. Together, the two works marked the beginning of a new direction in Wister's career. The young man who went to Wyoming in 1885 to discover himself was now married and nearing middle age, a man of affairs. The West which fifteen years before had promised him everything now began to look shabby and unpleasant. Wister's new perspective caused him to see it not as the center of history but as an intermittently instructive episode in the larger drama of national life.

"Padre Ignazio," finished early in April, contained two major characters. One was a cultured European priest who had come to the coastal mission of Santa Ysabel del Mar early in the nineteenth century to escape complications of life in society; the other, a young American adventurer from New Orleans, who had come to California in search of gold. For the padre, who looked out from his mission at "flowers and sunny ridges . . . at the huge, blue triangle of sea" and murmured that "Paradise . . .

need not hold more beauty and peace,"[14] the California coast represented a latter-day Garden of Eden. But Wister introduced Gaston Villiere to Santa Ysabel as "Temptation," having him call the Padre's paradise "a beautiful Garden of Ignorance." The story finally resolved itself into a discourse on the spiritual function of the wilderness: was the "vacant land" truly a "Paradise" as the padre had convinced himself, or was it, as Gaston Villiere argued, a delusion?

Wister's answer was equivocal, for the California coast of "Padre Ignazio" functioned as metaphor for the unspoiled West of Wister's youth, and Wister peopled it with characters who represented the two sides of his own divided attitude. The wilderness was Padre Ignazio's chance to do good, Gaston Villiere's chance for adventure—yet Wister was careful to show that both men were firmly rooted in European traditions. He joined Spanish priest and American vagabond with the same finely spun but powerful link that had earlier enabled him to connect the Big Horn Mountains with Bayreuth—music. The culture-starved padre substituted scores from European operas for sacred music in his mission worship. Gaston Villiere came to Santa Ysabel armed with melodies from the most recent operatic achievement, *Il Trovatore*. By being the language of civilization and therefore the language through which Padre Ignazio and Gaston Villiere communicated most effectively, music also linked them with what Villiere called "all cultivated men and women away from whose quickening society the brightest of us grow numb."[15] An interesting corollary was that in Wister's story, the padre's surreptitiously acquired operas rather than the armor of his faith operated as the primary means through which civilization engaged the wilderness. Santa Ysabel was Paradise, but Paradise touched by art. Conversely, it had its own effect on those it touched. The padre grew in it to a new understanding of himself. Gaston Villiere, having left to "join the other serpents at San Francisco," shortly returned as a corpse to be buried in the mission cemetery while the choir chanted passages from *Il Trovatore*. The point was that Wister regarded the wilderness in "Padre Ignazio" as both paradise *and* delusion, because it participated in a historical process which appeared to be definable.

In "Padre Ignazio," the engagement between Europe and America produced a happy combination of cultivation with rusticity. The padre manufactured lotions and perfumes from wild herbs; shaggy vaqueros whistled snatches from *William Tell* and *Semiramide* as they herded

cattle in the hills. At the beginning, both Villiere and the padre were redeemed by the land, having come to it as escape from sorrows which afflicted them at home; at the end, they redeemed the land by sanctifying it with death. The whole corresponded to what Wister painted as a scheme in which sacrifice became atonement.

Neither redemption nor atonement appeared in Remington's vision of the West. When death came, it saved no one, culminated nothing. Even before the Spanish American War, Remington regarded the conflict central to western experience as *event* rather than *process.* "Massai's Crooked Trail," first printed in 1898, was typical, for the "bronco Chiracahua" whose story it told murdered, raped, abducted—and was never caught or tamed.[16] When Theodore Roosevelt, then assistant secretary of the navy, read the piece, he wrote enthusiastically to Remington, designating the wide difference between tales like "Padre Ignazio" on one hand and "Massai" and the *Sundown* stories on the other:

Are you aware, O Sea-going plainsman, that aside from what you do with the pencil, you come closer to the real thing with the pen than any other man in the western business? And I include Hough, Grinnell and Wister. Your articles have been a growing surprise. I don't know how you do it, any more than I know how Kipling does it; but somehow you get close not only to the plainsman and soldier, but to the half breed and Indian, in the same way Kipling does to the British Tommy and the Gloucester codfisher. Literally innumerable short stories and sketches of cowboys, Indians and soldiers have been, and will be written. Even if very good they will die like mushrooms, unless they are the very best; but the very best will live and will make the cantos in the last Epic of the Western Wilderness, before it ceased being a wilderness. Now, I think you are writing this "very best."

In particular it seems to me that in Massai you have struck a note of grim power as good as anything you have done. The whole account of that bronco Indian, atavistic down to his fire stick; a revival, in his stealthy, inconceivably lonely and bloodthirsty life, of a past so remote that the human being as we know him was but partially differentiated from the brute, seems to me to deserve characterization by that excellent but much abused adjective, weird. Without stopping your work with the pencil, I do hope you will devote more and more time to the pen.[17]

Remington responded by producing more stories, or "articles" as Roose-

velt chose to call them, in the same vein. "The Essentials at Fort Adobe," a narrative of military operations in Arizona, appeared in April, followed in quick succession by four of the *Sundown* tales.

None of Wister's Indians had the vividness of Massai, none of his frontiersmen the immediacy of Sundown Leflare. With "Padre Ignazio," he abandoned forever any attempt to capture the atavistic and devoted himself to examining refinements of the process through which historical institutions functioned—both in the West and elsewhere. This was the impulse that governed "My Country: 1899," the long ode Wister began early in the year and delivered as Phi Beta Kappa poem at Harvard in June.

"My Country" conveniently exemplified the turn of Wister's thought. Written as a dialogue between "Uncle Sam," who represented the state, and "Columbia" who represented the national conscience, it comprised a somewhat pompous debate about national priorities and goals. Wister began it with a picture of Uncle Sam "balconied in ease" at Washington and lulled to sleep by "golden draughts" from his "cup of Well-to-do." But just as Wister used Gaston Villiere to disrupt Padre Ignazio's Paradise, he introduced Columbia to waken Uncle Sam and remind him of the "gnawing, scheming, screeching vermin band" of criminals and dishonest politicians who threatened to destroy the republic. When Uncle Sam proudly mentioned his recent conquest of Cuba and the Philippines, Columbia replied with derision:

> Your war! Could you have spied it in the flood
> From Sumter that to Appomattox raged?
> Where Gettysburg counts but one wave of blood,
> How large should Santiago's drop be gauged?[18]

Yet the war was finally recognized as useful, for it secured the republic's "moated hemisphere" from European influence. After sixty-seven stanzas of wrangling, the domestic quarrel ended on a note of amity as Uncle Sam addressed Columbia:

> O my dear better Angel and my star,
> My earthy sight needs yours, your heavenly, mine!
> I am your flesh, and you my spirit are;
> I were too gross alone, you, too divine!

Parted, I'd fall in dust, and you would shine
In voiceless ether. Therefore we unite
To walk on earth together, that we walk aright.
Me shall you pilot to the eternal goal,
 I'll steer you safe through every needy day;
So shall the years extreme unharming roll
 To right or left; we'll find the middle way,
 Stumble and rise, till marvelling Nations say:
Behold the twain that make their Country's health,
The necessary two that poise her Commonwealth![19]

Explicit concern with national politics, pointed argument for governmental reform, and a distinctly academic ring all marked "My Country" as a radical departure from the kind of writing Wister began to attempt in the early nineties. And the poem mentioned the West only as America's "Asia fronting beach."

When Wister delivered "My Country" in June, Remington, having spent April and May at Ingleneuk, had departed for his last extended visit to the Rockies. Shortly before leaving, he received "Padre Ignazio" from *Harper's Weekly* with instructions for pictures. Wister described the piece as "quite a long short story . . . a peg or two higher" in "execution" than anything he had written before, and the *Weekly* wanted to use it in their special Christmas number with colored illustrations.[20] Yet even Wister recognized that "the thing tells itself almost entirely in dialogue," and should thus have anticipated Remington's response. Two years had passed since Remington wrangled with Wister about the appearance of Lin McLean. Since then, Wister had written little—and nothing that required Remington's services. Now Remington read "Padre Ignazio" with dismay and puzzlement. He could find nothing in the story to draw pictures of. Therefore, he sent it back. It was the first time he turned down the opportunity to illustrate Wister's work. Without illustrations, "Padre Ignazio" was unsuitable for the Christmas number of *Harper's Weekly*, going to the *Monthly* instead, where it was printed the following April. Though disappointed by Remington's refusal to illustrate the story, Wistery told his mother, "I understand, [for] all the action is in men's minds and not their bodies."[21]

Perhaps because Remington could express his vision of the West's romance in bronze and on canvas as well as in prose, he managed to

keep a sense of its survival in the present. His journey to Montana in the summer of 1899 produced no pictures of raw, new copper-mining towns or jerry-built railway depots, but several studies of landscapes, animals, and men which suggested the atavistic vigor of "Massai's Crooked Trail." Yet Wister, whose chronicle of the West was confined to continuous prose narratives, was compelled not only by habit of mind but by the very form he used to express a sense of continuity.

While Remington painted in Montana, Wister took his wife, who was expecting a baby in the fall, to Saunderstown, Rhode Island, where he worked on his next book, called *The Jimmyjohn Boss and Other Stories* when it appeared in 1900. Historical continuity rather than atavistic survival comprised the book's focus, for Wister included early tales like "Hank's Woman" and "A Kinsman of Red Cloud," some essentially non-western pieces like "Padre Ignazio," and three new stories of the *modern* West. These last showed Wister's earlier quest for large mythic patterns supplanted by a journalistic fascination for the bizarre. "The Jimmyjohn Boss" related the adventures of a youthful ranch foreman sent to preside over Christmas dinner at a line camp demolished by drunken and potentially murderous cowboys. "Sharon's Choice" told the story of how ignorant but kind-hearted residents of a dusty New Mexico village "elected" a crippled orphan winner of their annual elocution contest. "Twenty Minutes for Refreshments," the most attractive of the three, also concerned a contest at Sharon—this time a competition to pick the area's most beautiful child.

Wister began "Twenty Minutes" on August 2. Mrs. Porcher Brewton, its heroine, was a thoroughly middle-class club woman with aristocratic pretensions who gave the story some of its best humorous moments. Sharon itself Wister described as utterly bleak, a "flat litter . . . sheds, stores, and dwellings, a shapeless congregation on the desert."[22] The story's action concerned how proud parents with names like Shot Gun Smith quarrel over the relative merits of babies christened Bosco, Cuba, Cusseta, Aqua Marine, and so forth, finally realizing that they have all been duped by the perpetrator of the contest, a traveling representative for a baby food product called Mrs. Eden's Manna in the Wilderness. "Twenty Minutes" showed that Wister was finally developing a sense of humor, that he had a good eye for colorful minutiae, and that his old vision of the West as the key to history was vanished entirely. Even though the story made an almost slavish use of material gathered four

years before, Wister produced it in 1899 out of a sense of excitement and discovery, for it represented a new development in his attempt to come to terms with the new West. Gone were the cowpunchers, the spectacular landscapes, biblical analogies, and operatic themes. The scenes and characters that remained were grotesque. The drama they acted was a farce.

Success in a story like "Twenty Minutes" indicated that the passing of the old West did not necessarily mean the *end* of Wister's career—but such success also augured a *different* career for Wister. While Remington, refusing to be historian, became impressionist and romantic instead, Wister, whose historical habits of mind demanded that he deal somehow with the present, emerged as a local colorist. Whereas Wister entered a "no man's land" with the imperial romances of *Red Men and White*, he now found himself in a realm well peopled with writers like William Deforest, Booth Tarkington, Kate Chopin, Mary Noallis Murfree, and—foremost of them all—his old friend and mentor, William Dean Howells. The imperial romances had to be set in the West, because the West constituted both their theme and their subject—but local color, as other local colorists had amply demonstrated, was peripatetic. It derived its charm from a combination of "color," or regional eccentricity, with location. In theory at least, one region could provide it as well as another. Accordingly, Wister began thinking about the color to be found in other parts of America even while he worked on Westerns for *The Jimmyjohn Boss*. The pleasant Rhode Island coast where he was summering charmed him, and he made notes for a "Saunderstown story" about crab fishermen. Reading Frank Norris's new novel, *McTeague*— set in the West, yet anything but a Western—gave him a new respect for literary naturalism. A renewal of his old interest in the Civil War started him in extensive reading on the subject and made him wonder whether he should try his hand at writing actual biography and history rather than continuing to grope for a viable combination of historical materials with fictional forms. Clearly, Wister was searching during the summer and fall of 1899 for ways to come to terms professionally with changes in his own life and attitudes. The best fiction he produced during that time, a short story called "The Game and the Nation," reflected both his attraction to local color and biography and his determination to address issues of historical importance.

Shortly after finishing it, Wister described "The Game and the Nation"

as "a thing that goes like an express train . . . national high comedy—of the people."²³ There were no dates in the story, and only a few place names designated its location as correspondent to the actual railroad route through Nebraska, Wyoming, and Montana, yet it did achieve a synthesis of complex historical ideas. Having shown in stories like "Sharon's Choice" and "Twenty Minutes for Refreshments" that the West did not seem likely to produce a superior American civilization, Wister now considered the possibility that it might at least contain superior *individuals*. His opening sentences plainly stated the thesis he intended the story to prove:

All America is divided into classes—the Quality and the Equality. The latter will always recognize the former when mistaken for it. Both will be with us until our women bear nothing but kings.²⁴

Both Quality and Equality were here represented by characters Wister later used in his famous novel, *The Virginian*. The lesser character was an ambitious cowboy named Trampas, his master none other than the Virginian himself.

Wister had used the Virginian in three previous stories—as a practical joker in "Em'ly" (1893) and "Where Fancy Was Bred" (1896), and as a cowboy who couldn't abide cruelty to horses in "Balaam and Pedro" (1894)—but never had he attached such symbolic meaning to the hero's actions or set them in a context so thoroughly metaphorical. The hero's charming exterior masked a ruthless determination, and his superiority consisted in a talent for seeming weakest when he was really strongest. Appropriately, his favorite pastime was stud poker, a game from which he also derived a personal philosophy—understanding, as Wister had him put it at one point, that "cyards are only one o' the manifestations of poker in this hyeh world . . . most any old thing will do . . . to play poker with."²⁵ In "The Game and the Nation" the Virginian's men, his job, and his honor were the stakes.

Wister used a small group of easterners and cowboys stranded together beside a railroad track in Montana to demonstrate the Virginian's skill. Initially, the group was divided, but the warring factions finally boarded the same train, bound for the same destination. That which brought them together, the Virginian's famous tall tale of frog ranching in California, acquired larger meaning as Wister shaped it into an emblem for American

"Quality." Not only did the easterners who listened recognize the yarn as what they "came West for," but the tale bound them together in a way which asserted both their personal diversity and their common nationality. The "crowd" that gathered to hear the Virginian "edged close, drawn by a common tie"—despite the fact that some of its members wore "yellow sleeping-car slippers," others cowboy boots with "Mexican spurs."[26] Wister even called the moment when the recently mutinous cowboys found themselves won over by the Virginian's art "the most beautiful—the most American . . . of all." By calling the moment "American," he appeared to suggest that Americans at their best possessed an ability to make the right choice between gentlemen like his hero and shrewd schemers like Trampas.

"The Game and the Nation" treated an idea about American history by using stud poker and the Virginian's tall tale as metaphors. Therefore, it proved excellent preparation for Wister's next project, a short biography of General Grant, for the short story comprised a *synthesis*, and the Grant biography was, as Wister later stated, a "short book . . . derived from long ones"[27]—an attempt to catch the spirit, not only of Grant, but of the nation by examining episodes which became metaphorical because of the representative quality clearly attached to them. When William James read the Grant book a year later, he remarked that the "little tome" gave him "a new idea of the way in which it is possible to write history."[28] Yet the book made an even larger impression on Wister himself, demonstrating to him that what he earlier called "material hunting" did not necessarily require long, dusty journeys with unpleasant people in hot Pullman cars. It could be accomplished in the comfort of one's home by reading.

Wister's realization had little in common with Remington's tacit recognition of the circumstances that sent him to Ingleneuk, for it constituted a retreat from the West accomplished in order to engage history, while Remington's retreat to Chippewa Bay was an escape from history to capture the romance of the West. Wister therefore found himself poised between two roles. His writing of the past five years established him as an authority on the American West, but following the impulse which initially led him to an interest in the West—a desire to define and explain the national life—now appeared to mean something quite different than it had in 1885. Into this delicately balanced situation, Remington, fresh from the wide open spaces, rushed with his letter of September 1:

My dear Wister:—

Just back from 2 months in Montana and Wyoming—trying to paint at the impossible—had a good time—as Miss Columbia said to Uncle Sam "That was my War"—that old cleaning up of the West—that is the war I am going to put in the rest of my time at.

I am doing a big picture for Paris now—derived from Reno's repulse —where they all crossed the ford in a huddle—its kind of unpatriotic but art is impersonal I am told.

I am meanwhile tuseling with your d—— subjectives in "The Game and the Nation." You get harder all the while for the plastic man.

What do you think of my little stories—they must feel amateurish to you but they are not subjective and they give me a chance to use "my right" as they say in the arena.

How do you get on with your wife—who is boss? or haven't you had time to settle that yet. I believe that sometimes takes several campaigns. Annexation is attended with difficulties.

I am going to Saratoga Monday. Do you take the National Institute seriously?

That was a great poem *of yours but if I ever get a chance at you I will cure that Boston fever—I thought you argued too well for Columbia— d—— her in that case—*

Yours faithfully

SEPTEMBER 1, 1899 *Frederic Remington*

Remington's painting "for Paris," intended for the Paris Exposition in 1900, depicted Sioux warriors turning Colonel Reno's troops back from Little Big Horn Creek in 1876, the immediate prelude to General George Custer's famous defeat. For whatever reason, it was never exhibited. His "stories" were the tales of Sundown Leflare, Massai, and the others appearing in *Harper's Magazine*.

Yet the most arresting feature of Remington's September 1 letter was the attitude it expressed toward "The Game and the Nation," for the "d—— subjectives" which annoyed the artist reflected a growing difference between Wister's way of seeing the West and his own. Wister, with his earlier notion of the West's transforming possibilities gone, was free to regard the region merely as setting. Conversely, Remington began, in oils like "Reno's Repulse" and "Caught in the Circle," to experiment with techniques for *integrating* setting with action. For his stories and

bronzes, this meant using action to powerfully suggest a sense of the landscape left unrepresented. In his painting it initiated the period marked by works like "Ceremony of the Scalps," where background and foreground were fully merged in a single, flat whirl of movement. In short, Remington's work tied the artist more firmly than ever to the West, while Wister's seemed certain to abandon the West as theme, even if it kept a western setting.

Wister's earlier compulsion to write about the West because it gave free rein to his imagination had gradually given way to concern for a proper background and particularity of time. Having used the material of the West to compose a historical metaphor in "The Game and the Nation" and the material of books to synthesize a metaphorical history in his study of General Grant, Wister now toyed with the idea of combining the latter process with the former—putting a fictional narrative derived from books into an appropriate "historical" setting. This was a logical extension of his use of a first-person, greenhorn narrator to lend verisimilitude to tales like "The Game and the Nation"—a technique Remington also took advantage of in the Sundown stories. Yet whereas the narrator, obviously a creature of the author, conveyed only the authority of the author himself, the fictional *literary* source functioned as illusion of a more reliable authority—one over which the author supposedly had no control.

As early as 1897, Remington had experimented with the technique in a sketch called "Joshua Goodenough's Old Letter," purportedly the 1798 communication from a former British colonist in America to his son. The "letter" was complete with quasi-archaic language and ellipses to indicate blurred or illegible handwriting. Supposedly, Remington's only contribution was a brief headnote:

The following letter has come into my possession, which I publish because it is history, and descends to the list of those humble beings who builded so well for us the institutions which we now enjoy in this country. It is yellow with age, and much frayed out at the foldings, being in those spots no longer discernible.[29]

Remington's intent was to enhance a fictional tale by attributing to it the sanction of "history." He used the same technique a year later in "The Spirit of Mahongui," which purported to be "an extract from the memoirs of le Chevalier Bailloquet, a Frenchman living in Canada, where he was

engaged in the Indian Fur Trade, about the middle of the seventeenth century." It needed no translation, said Remington, "since the author lived his latter life in England, having left Canada as the result of troubles with the authorities,"[30] but so determined was Remington to represent the quaintness of the seventeenth-century Frenchman's adopted English that the account was practically unreadable. Remington's experiments with the technique he utilized in "Joshua Goodenough's Old Letter" and "The Spirit of Mahongui" may well have come from reading Mark Twain's *Personal Recollections of Joan of Arc*, serialized in *Harper's Monthly* during 1895 as the translation of a statement made in 1431 by "the Sieur Louis de Conte," an "unimpeachable" source. Indeed, Remington's tales, flawed as they were, still communicated delight in passing a fictional past peopled with fictional characters off as historical actuality. By adopting the role of historian, Remington mocked history. That which he "held back," giving the reader a chance to "discover" it for himself, was simply the assumption that if fiction could be history, then history must be fiction.

The attractiveness fictional history held for Wister derived from a different source and carried a different meaning. When Wister wrote about the present, as he did in "Twenty Minutes for Refreshment," he could afford to be humorous—but whenever he turned toward the sacred past, reverence overtook him. While he still worked on his Grant biography—a task that required him to look back to the Civil War, which first had attracted his interest at St. Paul's School—he rediscovered another of his early interests: Nathaniel Hawthorne's *Scarlet Letter*, an account Hawthorne claimed to have found written on "yellow parchment" in the unused second story of a U.S. customhouse at Salem, Massachusetts, along with a "rag of scarlet cloth" cut in the shape of a capital "A." "By an accurate measurement," Hawthorne solemnly averred, "each limb [of the letter] proved to be precisely three inches and a quarter in length." Hawthorne seemed a perfect model for Wister in 1899, for while the future history of the West was not working out as Wister planned it, past history like that Wister dealt with in the Grant book and found charmingly fictionized in *The Scarlet Letter* remained secure. He thus decided to embark on a project he later characterized as "Hawthorne *up to date* . . . no imitation of him, but what he might do now if he were alive."[31]

Wister set his projected novel in a forgotten corner of New England

countryside "at the end of an unimportant branch of a Massachusetts railroad," and planned it as a tale of witchcraft and hypnotism put into perspective by modern psychological theory. With a theme suggested by Hawthorne and a setting attractive both for its nearness and its associations with his boyhood ramblings, Wister needed only something to bring his story "up to date." This was furnished by another source with close personal associations—Dr. S. Weir Mitchell. Two years after sending Wister to Wyoming in 1885, Mitchell had read a paper to the Philadelphia College of Physicians concerning the case of "Mary Reynolds," another instance of hysterical neurosis in which the patient suffered from hallucinations comparable to those through which Hawthorne's Young Goodman Brown lost his faith, psychosomatic symptoms analogous to the scarlet *A* which appeared on Dimmesdale's breast in *The Scarlet Letter*. In short, Mitchell's paper gave Wister a source for his story that was both "up to date" and "historical." In a document intended as a preface to his work, he noted of Mitchell's paper that "sleeping in the books of a learned body bound to science lies a true story that is as strange as the imaginary story I shall tell you in this book."[32] By deciding to write a "psychological" novel set in a region he knew as a young man and derived jointly from the author who most interested him as a student and the physician largely responsible for making him a writer, Wister finally recognized that the historical dynamic he sought to express as chronology in 1885 was a quality of imagination rather than of time.

Enthusiasm for his project quickly captured Wister, and that winter he wrote to Remington, breaking a long silence with news of his work. Remington, however, replied with hurt and puzzlement:

My dear Wister:

So glad to hear from you again—Yes—you are "a pig." please be more human in the future.

But I say—it will be forgiven if you go into poetry & "sich" but why go East? Why do that pie and pine tree mourning necessary to do New England unless you are going to do the "Smedley" part—creased "pants" and bric a brack.

You were the only "good thing" that ever came my way. Whatever are left will die of running after Phillipos under hot suns.

Come back—do the 4 volume novel about a South Western Natty

Bumpo—Believe me, I know. I was born in October and that "sign" gives "savvy."

Mrs. R. has been sick for a week—all right now. Want you to come up—when you get ready. Mrs. R. says bring the "Kid." We will put a pipe line on your cow.

Where are you going to settle.

<div align="right">

Yours

Frederic R.

</div>

DECEMBER 1899

Wister's poem "My Country: 1899" was one thing, a novel about New England quite another. The verse discourse on politics concerned subjects closely linked with the attraction that held Wister and Remington to the West and each other from the very beginning of their association. The projected novel marked a departure not only from the West itself, but from the alliance formed in 1893 to use it.

Remington was now less tolerant of Wister's scheme than he would have been a year or two earlier, and Wister was less tolerant of Remington's criticism, for several small irritations eroded each man's confidence in the other. By the end of the year Wister completed his Grant book, but Remington was not yet finished illustrating "The Game and the Nation." As *Done in the Open*, Remington's still untitled picture book, began to take shape, Remington grew impatient to have the introduction and poems Wister earlier promised. As "The Game and the Nation" remained unillustrated, Wister grew anxious about Remington's ability to draw pictures that would coincide with his own idea of the story. Meanwhile, F. L. H. Noble started a new magazine, appropriately entitled the *New Magazine*, at New York and invited Wister to write stories for it. On February 7, Noble wrote to Wister urging him to "remember we are going to try and make a specialty of having this new magazine as *American* as possible on account of its being by *American* authors on *American* subjects."[33] He also wanted Wister to write a longer work which would appeal to the temper of the times as he understood them. A month later, Noble developed the idea further, suggesting that he no longer thought of Wister as a chronicler of the West at all:

The public now want the American historical novel, and there is no helter skelter taste about it. So far the American historical novel has been simply an adaptation of the Stanley Weyman story, changing the names and the scene, the plot, dialogue and people remain the same. Now we want to write

an American historical novel that will be American and different. You agree with me on this subject, and you have all the ability and material to do it. And it is wrong both to us and to yourself to refuse the opportunity. . . . You can always do the sort of work that you are engaged in at present, I mean the cowboy and that sort of thing, but the time for this sort of story is limited as you can readily recognize. You ought not to let it go by, really you ought not to.[34]

Noble gave E. S. Martin's comment of five years before a new urgency, for Wister was no longer a young man with plenty of time to wonder about the future. Forty years old and standing at the threshold of a new century, he understood that the future of 1885 was the present of 1900; the past of the old West, a creature of his own imagination. Noble's plea for currency corresponded to Wister's own fear of being left behind.

Wister wrote to Remington that spring, urging promptness with pictures for "The Game and the Nation" and indulging his usual tendency to regard himself as a romantic, even tragic figure. He felt he must be getting old. His own work about the West, he thought, was largely finished. Remington's short stories had amply demonstrated that *Sundown Leflare* and *Crooked Trails* might be the beginning of a larger and more comprehensive picture of the region than Wister could hope to produce. As for himself, he planned to turn to other things. Remington's reply expressed both resignation and dismay:

My dear Wister:

Well-well-hell—what did I write—I didn't mean to say anything which should sound heavy. Let us believe we are both heavy livered in Spring Time.

You must give me lots of time to illustrate your great story properly.

I may write a short character story much like Sun Down Leflare. I dont intend to "do the West" and I couldn't if I would. I am only a character man. What we do along such lines can have no comparison. I'm a snare-drum and you are an organ.

Can't come over now—I am going to my island on 1st of June—and have work to finish—and am tired out—worn to a frazzle.

Don't forget the poems. Where do you summer—

<div align="right">

Yours

Frederic Rem.

</div>

MARCH 1900

Remington finished with "The Game and the Nation" in time for it to be published in the May number of *Harper's Monthly*. The first three of his four drawings were undistinguished except for the accuracy with which the initial one rendered Wister's greenhorn narrator in the likeness of Wister himself. In the last illustration, however, Remington added a touch of his own to Wister's tale, thereby demonstrating that he was more than just a "character man." Wister's description of the heterogeneous group that gathered at trackside to hear the Virginian tell his yarn of frog ranching included easterners, westerners, and Mexicans—"yellow sleeping-car slippers planted miscellaneous and motionless near a pair of Mexican spurs"—but Remington's picture added two pairs of beaded moccasins occupied by figures to match. One wore a bright bonnet of feathers and fringed buckskin leggings to distinguish him from the white men. The other, whose features shown in profile resembled those of the Caucasians in the picture, sported cloth trousers and a wide-brimmed hat, worn flat on the top of his head. Beneath his blanket, he might have worn a cloth shirt, for he was clearly a "breed" like Sundown Leflare.

When "Padre Ignazio" appeared in April, it received some notice, but mostly unfavorable. Reviewers recognized the tale as the first extensive work of Wister's to be printed for some time. Yet they disliked it because it represented so wide a departure from Wister's earlier stories. The *New York Tribune*'s account was typical:

Mr. Owen Wister is not one of the writers who can be accused of overproduction and it may even be that he would profit by more industrious practice. His admirers long entertained great hopes of this young writer whose powers in vivid, flowing and humorous narrative were so considerable. It cannot be said that these hopes have yet been justified. His story in the current *Harper's*, while graceful, refined and touching, is of no remarkable merit. It is conventional and takes no special distinction from its early California atmosphere. The author has shown himself capable of better things.[35]

As Wister read the review, two realizations must have struck him with considerable force. First, the designation of "young writer" no longer quite fit him at forty. Second, the attempts he was making to break out of the "no man's land" he entered with *Red Men and White* were being met with much less enthusiasm in 1900 than had Remington's attempt to "break away from the limitations of pen and ink on flat paper" in 1895.

The book about psychological witchcraft in New England thus began to lose some of its attractiveness, and Wister dropped it for the moment

until he could finish stories to make up his next book, *The Virginian.* Noble continued to badger him on behalf of the *New Magazine,* urging him to write a series of stories about American sports, to be illustrated by A. B. Frost, but Wister remained firm in his refusal. For the summer he planned a trip across the continent and a leisurely exploration of California's San Joaquin Valley. Toward the end of April, Remington, who had broken his leg earlier in the spring, wrote from New Rochelle with surprising news—the Grant book pleased him:

My dear Ownie

Read the Grant book and think you did very well with such a dry subject. You certainly made me read it and I'm d—— if I would if it didn't catch on.

I have the splints off my tootsie but the thing is pulpy yet. I hobble around on crutches and I never could find any inanimate object in my best days—now judge of the account of my contributions to a "swear box" which the old lady has organized on me. I say d—— the cavaliers— d—— all saddles and horse painters and—Well D—— that's my sad fade-away now, But "When the devil was sick" I suppose.

Would like to have you drop in on me—for a night. Its a poor compliment—glad to see anything half human in my durance. Show you a mud of a indian & a pony which is burning the air—I think & hope he won't fall off as I did—he has a very teetery seat and I am nervous about even mud riders.

I have a photo of your "What I think McL looks like" but haven't moral energy enough to send it to you—still I won't plead Statute of limitations if you come around.

Hope to go to my island on 1st of June but am wobbly and my work is behind. Have a painting to do besides my illustrations.

Am never going to write any more—I have spread myself out too thin —I am going to begin to do the armadillo act or the greek wheel—kind of get together.

Whitney tells me you are "doing me." Its a low down job—let me see a proof please—I may want a mandamus.

LATE APRIL 1900 *Frederic Remington*

It was the first time in five years that this kind of praise had come from New Rochelle. Following as it did so closely behind the unfavorable

notices of "Padre Ignazio" made it for all its abrasiveness doubly welcome.

Wister decided to accept the invitation. Remington's mud, entitled "The Cheyenne" when it was cast in bronze and copyrighted seven months later, and the fact that Wister was writing the introductory note for Remington's small portfolio of pastels, *A Bunch of Buckskins*, and thinking about verses for the larger *Done in the Open* gave the two men immediate mutual interests to discuss. *The Jimmyjohn Boss* was scheduled to be printed in June and the Grant book in August. After "The Game and the Nation" appeared in the May *Harper's*, Wister felt relieved of pressures that had borne down on him through the winter. Remington, when he heard that Wister was coming to New Rochelle, replied with warmth that recalled the palmy days of the early nineties when two young men set out to "do" the West and join "the immortal band" together:

Dear Wister—
So you are coming on Sunday the 13th—*yes?*
Well come on!
I am as you know working on a big picture book—of the West and I want you to write a preface. I want a lala too no d—— newspaper puff saying how much I weigh etc. etc. but telling the d—— public that this is the real old thing—step up and buy a copy—last chance—ain't going to be any more West etc.
How's that hit you? Will you?

<div align="right">

Yours

</div>

EARLY MAY 1900 *Frederic Remington*

Wister made the journey to New Rochelle as planned. And although he and Remington would never again be as close as they were in 1895, the visit marked an end to the near separation almost two years long. The two old friends sat again as they had seven years before at Geyser Basin, planning eagerly projects which would never quite come to fruition in the ways they hoped—Remington's illustrations for *The Virginian* and Wister's verses for *Done in the Open*.

Chapter 7

Last Chance

Neither Remington nor Wister knew it, but their May 13 meeting at New Rochelle was prelude to the final period in their uneven relationship. With the passing of the old West, the failure of Wister's historical vision, Remington's disappointment with Manifest Destiny—and each man's intermittent mistrust of the other—the brief warming that occurred during 1901 and 1902 was Indian summer only, a thaw that signaled frost. There was no open quarrel or formal break, but Wister's large success with *The Virginian* in 1902 and Remington's profitable alliance with *Collier's*, begun the following year, put each man into a sphere of his own. The partnership begun in a September snowstorm and carried spasmodically forward over ten eventful years dissolved at last when it encountered prosperity.

Yet even as it dissolved, the partnership marked Remington and Wister in important ways. Wister's *Virginian* owed more to Remington than Wister ever acknowledged. Remington's work—both with forms and with words—became distinctly literary, mirroring not only the subjects of Wister's fiction, but many of its techniques as well. Therefore, what appeared on its surface as a process of drifting apart was really the last in a series of curious intersections begun at Geyser Basin in 1893.

Following the New Rochelle meeting, Wister spent three months with his family in Rhode Island, while Remington retreated to Ingleneuk. *The Jimmyjohn Boss* was printed as planned in June but sold poorly and attracted little critical notice—a condition Wister blamed on the house of Harper, which suffered financial troubles and tried to economize by cutting its advertising budget. Later, Wister noted of the publishers,

"I suppose the fact is they took me for granted and never thought much about it."[1] He felt vindicated when magazines like *Lippincott's*, *Cosmopolitan*, and the *Saturday Evening Post* jumped at the chance to print his stories and George Brett of the Macmillan Company expressed interest in the as yet unfinished *Virginian*. The *Post* enthusiastically received his next story, "Superstition Trail," and even agreed to let Remington illustrate it, contributing to the sense of newness Wister carried with him when he departed for California in August to hunt material. Wister had seen Remington, affirming their partnership, acquired a new publisher, and begun to work in earnest on a new book. As he traveled down the California coast from San Francisco, his journal filled with gratifying rapidity, and he planned "a short story of the same highly colored kind as 'La Tinaja Bonita' . . . all southern and prismatic."[2] When he returned to Philadelphia late in September, a note from Remington awaited him:

O— W—
Philadelphia outfit spoke of two pictures—halfs I suppose—Jump them for 1 Virginian—full—and arrange so that you can use it.—
SEPTEMBER 1901 *Frederic R.*

Brief though it was, the note reflected confidence rather than doubt, pleasure rather than dismay. Remington's eagerness to draw the Virginian contrasted sharply with his reluctant praise of the Grant book and his refusal to draw Padre Ignazio. The reason was not that Remington needed work, because he now struggled against a flood of orders larger than he could comfortably handle. Nor was it because he liked "Superstition Trail," for the *Post* had not yet sent him the story. Indeed, since Remington had for more than a year experienced only disappointments with Wister's work, he might have rejected "Superstition Trail" out of hand without even seeing it—had it not been for the Virginian himself, a figure he recognized and loved because he had helped create him.

Six years earlier, in 1894, Remington had told Wister that many cowboys were former southerners, come West after the Civil War, something Wister already clearly knew, for the Virginian had made his debut eleven months before that when the November 1893 number of *Harper's Monthly* carried "Em'ly," Wister's third western tale and the first to

Frederic Remington on horseback, sometime between 1903 and 1905.

name his famous hero. Yet this Virginian had little in common with the shrewd poker player of "The Game and the Nation." He was merely a "special cowboy" assigned by Judge Henny—later to become Judge Henry—to take care of the greenhorn narrator. One unsigned illustration pictured him clad in rumpled clothes, puffing a corncob pipe, and lounging on a crate—for all the world like a backwoods farmer. In short, he was a clown, whose only connection with the "slim young giant, more beautiful than pictures,"[3] who emerged as Wister's apotheosis of the cowpuncher, seemed to be the coincidence of a name. When "Balaam and Pedro" appeared the next year, however, the Virginian had traded his baggy clothes for snugly fitting chaps and shirt gray with the dust of travel. He wore a "broad, soft hat" jauntily "pushed back," sported a

"loose-knotted, dull scarlet handkerchief" at his throat, and hooked "one casual thumb . . . in the cartridge belt that slanted across his hips." His transformation was complete, and there seemed little doubt as to its cause: between writing "Em'ly" in 1892 and finishing "Balaam and Pedro" in 1893, Wister met Frederic Remington at Geyser Basin.

The first illustration Remington did for Wister after the Geyser Basin meeting—his picture of the horse trade in Balaam's pasture—was also his first picture of the Virginian. Even though two more episodes concerning Wister's hero—"Where Fancy Was Bred" and "Grandmother Stark"—were published during the next three years, neither was illustrated. Remington made his second picture of the southerner for "The Game and the Nation" (1900); his third and last, for "Superstition Trail" (1902). Meanwhile, Remington created a Virginian of his own. Perhaps he was dismayed to see the horse trader of "Balaam" turn into the practical joker of "Where Fancy Was Bred." At any rate, having told Wister in 1894 that many westerners came up from Kentucky or Ten-

Frederic Remington sketching in Wyoming, about 1905.

Unsigned illustration, clearly not by Remington, for "Em'ly" (1893), first episode of *The Virginian* **to see print. The Virginian is the seated figure at right.**

nessee, he proceeded next year to write the story of "a Southern gentleman, or rather a boy . . . refugeed out of Fredericksburg with his family, before the federal advance," who later found his way to the great plains as an Indian fighter.[4] When the tale appeared in the August 1897 number of *Harper's Monthly*, it was called "A Sergeant of Orphan Troop." Its hero, repeatedly designated as "the Virginian," also had another name—Carter Johnson—and was described as a man upon whom "Nature . . . had lavished . . . her very last charm." His function in the story was to assume command of the Third U.S. Cavalry's "orphan troop"—so called because it lacked a permanent commanding officer—during a desperate winter battle with northern Cheyennes. Four pictures, one of them in color, showed him performing heroic deeds. And his physiognomy was precisely the same in every respect as that of the "puncher . . . turned horse and cattle thief" about whom Remington wrote to Wister in 1894. By 1900, Remington *knew* the Virginian and, because he knew him so well, wanted to draw him. Whether the southerner appeared as soldier or cowboy, bearded or clean shaven, made little difference. He was always a

natural aristocrat who lived by bravery and skillful bluffing, a joyfully independent spirit who played life and lived cards. Remington expected no surprises in "Superstition Trail" because he understood its hero as a man who never lost control. Therefore, he was shocked when the *Post* sent him the first installment of Wister's story early in September: the episode's last paragraph revealed the Virginian near collapse, sobbing tears of confusion, "utterly overcome."

Remington's surprise was not altogether unpleasant, for although Wister's tale seemed even more "subjective" than his earlier work, something in it rang true. Its hero was the same hardy southerner who appeared in "The Game and the Nation"—still deceptively amiable, still dangerous, still addicted to poker—but divided, like Genesmere of "La Tinaja," against himself. Thus, the bluff he carried out with relative ease in his tall tale of frog ranching here seemed more difficult, since it involved not only the contest with a clever adversary, but a struggle to keep his own moral balance. Remington had to admit that even a man upon whom "Nature . . . had lavished . . . her very last charm" could not keep a poker face after being forced to hang his best friend for rustling. "Superstition Trail" had the same somber sense of moral urgency which caused Remington to call "La Tinaja" "enormous":

My dear W——
"Superstition Trail" is artistically the best thing you have done. I am going to do the interior of the stable Part I. I haven't part II yet.

As to Harpers—they are hard up and employ cheap men. Also . . . new men. New & cheap lets you out along with all other old men. They dropped me out of the window over a year ago but I find a way to get printed.

I think the pastels [for A Bunch of Buckskins] will be all right.—did they send you the portfolio? when the shoppies put them in their windows passing fire engines will stop & hook onto the adjoining hydrant.
Y——

SEPTEMBER 1900 *Fred R.*

Clearly, the Virginian's arrival at New Rochelle was welcome, for it represented the renewed hope Remington and Wister shared in 1900 for

Opening illustration from "A Sergeant of Orphan Troop." Carter Johnson (left center) stands with members of the Third U.S. Cavalry, surveying the carnage after an Indian battle.

their continuing partnership. The southerner's figure in "The Horse Trade" marked the spot where Remington and Wister first came together seven years before. His continued presence in "Superstition Trail" suggested that point still two years in the future when his apotheosis would be achieved.

Meanwhile when November elections swept Theodore Roosevelt from the governor's chair at Albany to the vice-president's office at Washington, both Remington and Wister were pleased. For his own part, Roosevelt still found time to praise the work of his old friends, as when he called Wister's Grant book "the very best short biography which has ever been written of any prominent American."[5] By spring, Wister had begun welding the Virginian's adventures together into a single, continuous narrative. Remington retreated as usual to his island in May. Wister took his family to Rhode Island and continued to wrestle with the second part of "Superstition Trail," negotiating alternately with Harper's and with George Brett of the Macmillan Company concerning publication of *The Virginian.* Finished with *A Bunch of Buckskins,* Remington now worked on *Done in the Open,* taking time out to do numerous illustrations for *Collier's,* like the one that appeared on the magazine's cover that fall, accompanied by a romantic quatrain dashed off by Wister. Although both Remington and Wister continued to mourn their own lost youth and to grumble about the trend of national life—as when Wister wrote an article about Theodore Roosevelt which, he said, was founded on the joint propositions that "Americans like a gentleman when they see one and . . . that in a republic such as ours, at present, the scum rises to the surface"[6]—they themselves enjoyed greater success than ever before. The sinister event which ended that almost ideal summer thus seemed almost unreal: while Remington prepared to leave his island and the Wisters counted the days until Molly would give birth to twins, an assassin killed President McKinley at Buffalo.

The murder's most immediate consequence was to put Theodore Roosevelt into the White House. Wister had been close to Roosevelt for years, and even Remington, though he cared little for politics, preferred Roosevelt, whom he knew and admired, to McKinley, whom he had always disliked. When Remington heard of the birth of Wisters' twins, which occurred on September 21, just one week after the assassination, he characteristically mixed business, friendship, and politics, melting them into each other with undiminshed enthusiasm:

My dear Wister—

Congratulations on babies—you are quite a daddy by now.

Will remember the Virginian.

Am simply going to do a pastel of old time buckskin with no background for Wilderness Hunter. I can see no other way and [Caspar] Whitney wants something which will hold the crowd. We illustrators are getting to be advertising adjuncts nowadays.

I dont know what Russell has decided.

No paper in here

<div align="right">*Frederic Remington*</div>

"What's the matter with Roosevelt—" Nothing!

OCTOBER 1901

R. H. Russell was Remington's publisher. His decision no doubt concerned selecting drawings to be included in *A Bunch of Buckskins,* a matter which caused him some consternation and which Wister was anxious about, since he needed to know what works to mention in his preface. But Wister's concern about Russell's choice was surely less than Remington's dismay at becoming an "advertising adjunct." The pastel that accompanied Wister's essay on "The Wilderness Hunter" when it appeared in the December *Outing* was just what Remington said it was—a conventionally romantic figure in fringed clothing. Both picture and essay—a similarly conventional treatment of frontier history, written with a fashionable conservationist tendency—reflected one disheartening fact: success made Remington and Wister susceptible to being used by publishers in something like the same way they themselves used the West. Whether the two men liked it or not, they had become salable commodities.

A good example of how the selling worked was the jointly produced cover for *Collier's Weekly* of September 14. Late in July, *Collier's* decided to use Remington's picture. On August 29, Albert Lee, the editor, sent Wister a telegram asking for the verses:

Can you mail us tomorrow quatrain to go with Spirited Drawing by Remington Mounted Cowboy about to throw lariat, wire answer.

Wister had never seen the picture, but overnight he wrote the quatrain— and when verse and picture appeared together, Remington, who until .

**"The Two Men Climbed Slowly." Otto Bordeson (standing) watches
while Johnson scales a cliff to engage the enemy. Between them
lies the corpse of a Cheyenne warrior.**

then knew nothing of Wister's part in the project, called the verse "a
corcarina." A few days later he took time to clarify the intent of his
designation:

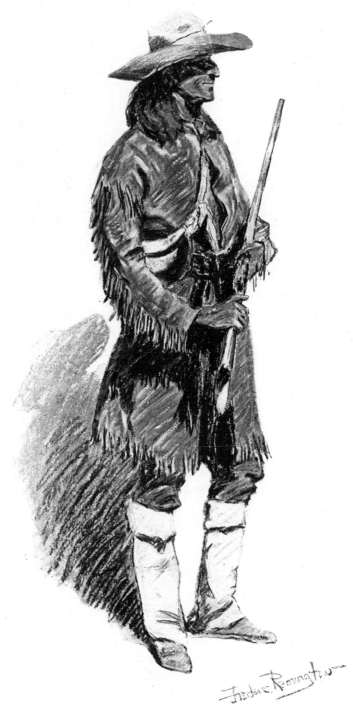

"The Wilderness Hunter."

My dear Wister:
Hope you are going to be able to do the little poems for my next
Russell book. The thing you did for the cow-boy was a great help to the
picture. Sort of puts the d—— public under the skin.
"How be ye these days any how?" I don't expect to meet you again
in this incarnation but I sort of remember how you looked back in the
spring of '50.
OCTOBER 18, 1901 *Frederic Remington*

Remington, of course, had never been coy about money, lacking al-
together Wister's earlier fears about the effects of being "too much before
the public." He frankly loved being printed and getting paid for it—but
his public had never been so important for him as it appeared to be now.
Wister's sentimental quatrain neither explained nor enhanced Reming-
ton's picture—but it did *advertise* it by joining it with a popular senti-
ment—the same service performed for "The Wilderness Hunter" by
Remington's pastel. Feeling that publishers thought of him as an "adver-
tising adjunct," Remington, perhaps without realizing it, began some-
times to think of Wister as one.
 The feat was not difficult, for Wister seemed trapped in the same
hectic commercial round which chafed Remington. He too began to
develop the habit of aiming each of his productions at some particular
public. Of course, for anyone who made his living by publishing in popu-
lar journals, this made good sense; in Wister's case, however, it reinforced
an already noticeable tendency to patronize. When Wister tried to cap-
ture the truth about something—as he had in his western tales of 1894
and 1895—he often managed to forget both his own identity and the
reader's long enough to tell a story. Until after the Spanish-American
War, Wister's fiction, frequently concerned with political issues, was only
rarely partisan—often touching the distinctions between races and social
classes, but by no means exclusively dependent for readers upon the
white, Protestant, Republican upper class to which Wister himself be-
longed. Indeed, so long as Wister kept even a vestige of his faith in a
potentially unified American civilization, condescending attitudes stayed
out of his writing, for Wister regarded himself and his audience as
linked by a common "Americanism."
 Yet as faith in the large notion of "real Americans" was replaced by

a less generous faith in "quality," Wister found the number of readers with whom he wished to identify himself shrinking, while the size of his reading public grew. He aimed his *Outing* essay on Theodore Roosevelt at "a large audience of out-of-doors, plain, uneducated, shrewd-minded men of sport"[7] whom he hoped to influence but with whom he neither had nor wanted to have anything fundamentally in common. The work's first sentence thus contained the most transparent possible appeal to just the group Wister described: "It so happens," wrote Wister, "that Mr. Roosevelt was busy fighting the first time that I ever laid eyes on him." The occasion was a college wrestling match, and from there Wister's essay moved through various other battles to conclude of Roosevelt that "he takes no mean advantage of an adversary; he stops when 'time' is called; he fights 'on the square'; he is what the West calls a 'white man.' "

However accurate statements like these might have been, they struck a false note, for they were admittedly distortions—rhetorical tricks of omission intended to capture the approval of a specific group. The same sort of distortion marked Wister's introduction for *A Bunch of Buckskins,* finished and sent in to R. H. Russell by the end of September. Remington wanted something that would make "passing fire engines . . . stop and hook on to the adjoining hydrant." Wister provided something quite different—an elaborately polite discourse wholly out of keeping with the unpretentious pastels that made the book. After calling the pictures— eight studies of motionless mounted figures notable among Remington's works for their comparative serenity—"splashes of barbaric spendor," Wister addressed the reader directly:

> You must kindly abet my efforts to introduce you to the "Bunch of Buck-skins" by feigning that you need an introduction. We must not confess to each other the patent truth that whatever Mr. Remington may choose to do requires no introduction from me, or from anybody else.[8]

Obviously, this was a smoke screen. Even Wister probably suspected his inability to write the kind of introduction Remington's pictures required.

In a letter of October 4, Remington, even while praising Wister's essay, plainly stated the reason for Wister's problem. It had nothing to do with the superficial confusion about names he noted at the letter's beginning, and everything to do with the profound erosion he hinted at in its closing.

My dear Wister—

Russell in re-reading your introduction to pastels thinks you talk of (Old Ramon) when you speak of Half Breed.

Old Ramon was a Mexican, which is equivalent to a half breed—was an indian trader from Taos—before the northern indian wars and then scouted for Miles & was quite celebrated. He was an old typical Rocky Mountain man. The half breed is the one with the white blanket coat. While we are not going to name them, yet you may want to look again.

As for the article—it is immense, but when I read it Extract of Vermillion would make a blue mark on my face. I have to put on my smoked glasses.

Am going to show some paintings in New York this December and hope you can run over and see them. They are a step ahead so far as paint goes.

Am on your second "Sup Trail"—going to do where the Vir—— looks back at you when the man comes out of the sky.

<div align="center">

Y——

Frederic R.
</div>

October 4 & I am 40 years old to day. Its a down hill pull from here.

OCTOBER 4, 1901

Forty, of course, was far from old, and Remington had no way of knowing that only seven years remained until his death. Both he and Wister, who was only one year older, kept vigorous and busy. For both, however, reaching forty meant something special. It was a point beyond which they could no longer be called young—and youth was what each had lived by. When each first went west, his own youth coincided with what Wister later called "the era of . . . jubilant adolescence"[9] that produced the cowboy. Now, at the beginning of a new century, that era was unmistakably over. Remington kept his equilibrium through energy and self-ridicule. Wister, who had never been able to take himself lightly, began to feel displaced.

This made the winter of 1901 a difficult time. Fifteen years before, Wister had regarded the West as America's future. Now, as he slaved to put *The Virginian* together, he could not avoid knowing that the West designated the region not only of the nation's past, but of his own. His

task thus acquired a special urgency, for *The Virginian* was Wister's last novel about the West and his last real cowboy story. In a sense, it was his final word on the whole tangle of circumstances and personalities that linked him with Remington and involved both men in a common pursuit. In November Wister formally broke with the house of Harper, days afterward signing a contract for *The Virginian* with the Macmillan Company. That same month, the second and last installment of "Superstition Trail" was printed in the *Saturday Evening Post,* accompanied by the last picture Remington ever drew for a Wister story—an undistinguished but curiously appropriate work dominated by the receding rumps of four horses.

Wister sensed the finality of *The Virginian,* but neither he nor Remington knew that the picture in "Superstition Trail" closed the book that had begun nearly a decade before with "The Horse Trade." Preparations for his December sale and chores connected with the still unnamed *Done in the Open* occupied Remington at New Rochelle. At Charleston, South Carolina, where he and his family spent that winter, Wister toiled at his book, declining Remington's invitation to meet in New York. The sale went off successfully, and Eva Remington wrote Wister after Christmas that "Santa Claus put a Steinway piano in my stocking this year"—news which gave Wister little joy, for his book seemed mired in endless difficulties. In February Wister told his mother that the work was "like going up a mountain." Whenever he thought he had reached "the last rise," he discovered yet another rise ahead.[10] By March 5, however, he was working on "the last, long chapter." A week later he finished and sent the manuscript to George Brett at New York. He had reached the top of his "mountain," created a cavalier who was truly "last." As Remington noted, the rest was "a down hill pull."

The Virginian was printed late in May, and by the end of June Wister knew he had written a runaway best seller. For Wister himself, the book meant instant and almost universal success. For Remington, it meant a reexamination of his earlier statement that "I will never write any more stories," motivating him to write *John Ermine of the Yellowstone* the same summer. There were certainly reasons for the continued partnership of Remington and Wister, and there were even reasons for thinking that *The Virginian,* although not itself illustrated by Remington, could point the direction toward books which Remington and Wister might produce together. The trouble was that publication of *The Virginian* co-

incided with a series of events which showed Remington at his most fuddled and Wister at his stiffest. The result was an irritant neither man could ignore and a demonstration appalling in its suddenness of how illusory their union had been even when it seemed most firm.

On May 19, while Wister waited apprehensively for *The Virginian* to be printed, he received, with R. H. Russell's apologies, the large portfolio of sixty-eight pictures for Remington's next book, still untitled. Russell wanted a verse for each picture, an introduction, and finally, a title. Tired, worried about his own book, and upset about the abruptness of Russell's requests, Wister wrote to Remington, suggesting a conference at New York, where he was going that week in connection with the printing of his book. Since he planned to leave Philadelphia the following day, May 20, Wister told Remington to contact him at the Players' Club, a place they both knew and frequented. When he left Philadelphia, Wister took with him the portfolio sent by Russell, confident that he and Remington could come to terms with it during the following days.

Remington, however, misunderstood. When he received Wister's letter, he dashed off a note of one sentence suggesting noon lunch at the Players' on Thursday, May 29—sending the note to Wister at Philadelphia. Receiving no reply by the beginning of the next week, he telegraphed—again to Philadelphia—without avail. Meanwhile, Wister waited impatiently for Remington to contact him in New York, but Remington, anxious to get away from New Rochelle and finally convinced that Wister had given up the idea of a conference, departed for his island on Friday, May 30. When Remington failed to appear at the Players', Wister at last stormed into Russell's Twenty-ninth Street office to ask what had happened. Russell's assistant, F. J. Singleton, had no answer, being ignorant both of Wister's desire to meet with Remington and Remington's present whereabouts. Wister left the office confused and angry. After completing his business with George Brett, he departed for home.

Singleton subsequently succeeded in contacting Remington at Ingleneuk, and when Wister arrived at Philadelphia on June 7, he found a pile of mail that explained the whole series of misunderstandings but resolved nothing. First, there was Remington's note concerning the never-accomplished meeting at the Players' Club; next, the telegram asking for Wister's confirmation of that same meeting. Third, there was a letter from Ingleneuk, written after Singleton's communication with Remington, showing how oblivious Remington still was of Wister's anxiety:

304 MY DEAR WISTER

My dear Wister—

Telegraphed you at Philadelphia but got no reply—left N.Y. Friday night—a week gone and have been setting. The Missis arrived to day with the trifles like paper and ink. My "injun" and I have been "burning bacon and coolin' coffee" for a week. On the batch. As for the poetry—I cant say anything more than that I would like you to do it but I wouldn't stop important work to do pen edgings for you and dont expect you will for me. . . .

I have worked very hard this year and now that the relaxation has come I despise labor—which is supposed to be so holy and which is in proper doses.

Are you pennsy fellows going to make us burn the trees on our lawns for fuel this winter? Be gad—the proposition looks gloomy from this rock. It may be a good year to go South. Well—let me hear from you. The Kid says "Virginian" out—will order a copy.

<div align="right">

Yours

Frederic R.

</div>

MAY 1902

The impending strikes in Pennsylvania coal mines seemed to Remington more important than Wister's quarrel with Russell's publishing house, the desire for rest at Ingleneuk more urgent than acquiring Wister's help with the picture book. And the final slight—more infuriating for its non-chalance—was Remington's offhanded mention of the newly printed *Virginian.*

Remington's three communications alone were enough to anger Wister after his hectic New York trip, but another letter also awaited him—one which turned Remington's forgetfulness into a threat. Even before he opened the letter, Wister must have been prepared for something un-pleasant by the R. H. Russell imprint that appeared on the envelope. What he found inside confirmed his worst suspicions: it was a reprimand —injudiciously worded to say the least—from Russell's assistant, F. J. Singleton. Recalling the New York meeting of the week before, Singleton reminded Wister of "the necessity of getting [Remington's] book under way at the earliest possible moment," adding that "under the circum-stances every day's delay after the 15th of this month will mean a con-siderable loss to Mr. Remington and myself."[11] He closed with what Wister regarded as insufferable impertinence: "I will await with interest the receipt of a few lines from you by return mail."

Return mail carried Wister's icy reply, heavy with irony, hard with indignation. With Singleton's request before him, Wister sat down at his desk, dashed his own letter off in longhand, and mailed it immediately:

Dear Sir: Mr. Remington departed without further answer to my letter than a telegram to dine with him, addressed here when I had asked him to communicate with me at the Players' Club. I found the telegram 5 days after it had been sent. I must ask you to excuse my not telling you this at once, last Monday.

But if Mr. Russell or Mr. Remington are to lose by every day's delay after the 15 of this month, that is certainly not my affair. Last September Mr. Russell asked me to do this work. He showed me the portfolio then, saying it was not quite complete, but would be sent me soon. It now comes, eight months afterwards, with no word during the interim, but with a request now that I hurry. I am sorry to say that I am not free. I shall be busy for five or six weeks more. Then I shall be more than glad to do the portfolio. Let me return it at once, or let me keep it and make the best speed I can when I am free, but I can not consider that the delay is any responsibility of mine.

<div align="right">

Yours truly
Owen Wister.

</div>

JUNE 8, 1902

Wister's letter was clearly angry. Moreover, it was the letter of a busy man assured in his own success and of his own importance. What it showed most unmistakably was that Wister no longer thought of himself as a petitioner for entrance into "the immortal band."

Nor did Remington any longer try to drag him there. Remington's retreat to Ingleneuk in the spring of 1902 was accomplished not to paint, or even—although the artist admitted to having had a year of "very hard" work—to rest. It was made with the explicit purpose of writing a novel. For the first time in his life, Remington was attempting a task clearly derivative from his contact with Wister. Therefore, his response to Wister's annoyance constituted a stated attitude quite different from anything which had entered the Remington-Wister relationship before. Hearing from Singleton of the angry interview in New York, Remington wrote from Ingleneuk with a statement as close to apology as he was constitutionally capable of making:

My dear Wister—Oh gee—oh gee—here is a how do do—Now I don't know anything about it one way or the other—so fire away.—dont hit me?
AUGUST 1902 *Frederic R.*

When Wister delayed work on "The Evolution" in 1894 and 1895, Remington masked his annoyance with banter—as he now made some attempt to do in connection with the Russell book—and Wister responded in kind. Yet those earlier disagreements were parts of good-natured encounters which promised more encounters to come. Invariably, they ended in the warmth of mutual admiration. Now, however, the evolution of *Wister's* cowpuncher was complete. And the finality of *The Virginian* made it possible for Wister to regard his partnership with Remington as part of the same past that *The Virginian* chronicled. Remington felt the finality, too, for as we shall see, *John Ermine of the Yellowstone,* the novel he was beginning even while he made his apology to Wister, constituted the final word on his own radical type of the western man—a synthesis of Massai, Carter Johnson, and Sundown Leflare. For both Remington and Wister, therefore, *Done in the Open* suddenly became a vaguely disagreeable anticlimax, and Wister's disenchantment with it reflected not only a feeling that Russell had been inept at putting the book together, but also a far deeper conviction that he and Remington no longer had anything valuable to give each other. The warmth of their earlier debates had fused two visions at crucial points. "The Evolution," "La Tinaja," and the best in *Lin McLean* and *Sundown Leflare* showed what happened when two ways of seeing the West melted together into what momentarily appeared to be a single complex myth—but the chill which congealed their present quarrel augured, not collision and communication, but disengagement and silence.

By August more than fifty thousand copies of *The Virginian* had been printed, and an unsigned review in the *Atlantic Monthly* correctly noted that its hero constituted the "final apotheosis of the cowboy: a type which the author laments in his preface as already obsolete."[12] That same month *Current Literature* carried a full-page picture of Wister on its frontispiece. These and other similar events showed that by defining the man he made hero of his book, Wister also radically redefined himself. No one any longer referred to him as a "young writer" or implied that his talents were yet to be proven. On the contrary, publishers and public alike regarded him as a man of versatility, experience, and skill, waiting

eagerly for his next utterance.

In December, Richard Watson Gilder invited Wister to go to Central America for the *Century Magazine.* In January, he dined at the White House with Cabot Lodge, Finley Peter Dunne (creator of "Mr. Dooley"), and, of course, the president. When it became known that he was author of *The Virginian,* several ladies at the following diplomatic reception "screamed." Happily, Wister noted, "none fainted."[13] The most gratifying result of *The Virginian*'s success was that it raised Wister's other works—even those not yet completed—into prominence. An unsigned essay in the *Atlantic* commented of Wister that "the same grasp and vision which have given his stories their unusual historic and human value made his short Life of Grant a masterpiece." It went on to note that Wister was rumored to be planning biographies of Franklin and Oliver Wendell Holmes, and concluded that "the completion of Mr. Wister's portrait gallery is worth waiting for."[14]

To put it briefly, Wister's spectacular success had an immediate and important effect on his attitude toward Remington, Remington's attitude toward him, and the publishing industry's attitude toward Remington and Wister as a team. When *Red Men and White* appeared in 1898, Nancy Huston Banks wrote in *The Bookman,* as other reviewers did elsewhere, that Remington deserved part of the credit for that book's sensitivity to the "feeling of the great plains," and Remington quickly confirmed his own awareness of the part he played in producing the book by commenting on the photograph of Wister beside the "govt. hoss" which accompanied Miss Banks' review—ending his letter with a sketch of Wister linked to his own signature. In August 1902, however, *The Bookman* again printed the same picture of Wister and the cavalry mount, and again mentioned Wister and Remington together—but with a subtle difference. The essay's first two sentences told the whole story: "In *The Bookman* map of four years ago the names of Mr. Owen Wister and Mr. Frederic Remington stretched across New Mexico and Arizona. But with his recently published *The Virginian,* Mr. Wister has driven into the soil of Wyoming a stake which seems likely to remain for a long time to come."[15] *Red Men and White,* an uneven but "promising" book, established tentative quitclaim on the Southwest for Remington and Wister together. *The Virginian,* an "apotheosis," made Wister sole literary proprietor of Wyoming "for some time to come," perhaps forever.

When he saw the 1902 *Bookman* review of *The Virginian* at Ingleneuk,

Remington surely recognized the accompanying photograph as the same one that had inspired him to satiric fun in 1898. "You and the govt. hoss," he wrote to Wister on that previous occasion. "—his head is bigger than yours, and that's a good sign." Yet now Remington wrote nothing at all, for no one who knew Wister could avoid also knowing that the author's opinion of himself had changed—and small wonder. Writing from a desk cluttered with enthusiastic reviews of his new book clipped not only from American journals and newspapers—both large and small —but from such august oracles as the *London Times,* Wister exclaimed to his mother that "with the press and letters from friends and letters from strangers, and leading the list of best sellers in New York and Boston, there is only one critic left I care for, and his word I shall not hear— time–"[16] Among the people he did hear from were publishers—who offered him ten cents per word for whatever fiction, nonfiction or poetry he cared to produce. By the end of August, one hundred thousand copies of *The Virginian* had been printed, and its sales showed no signs of diminishing. The size of Wister's ego was no longer a laughing matter.

Of course, Wister had every reason to be proud of his accomplishment. Had his book been merely a popular success, he might have felt that it missed the mark of literary excellence, a quality he had consistently aimed at from the beginning of his writing career, but had always somehow missed. Even Henry James acclaimed *The Virginian,* cheering "Bravo, bravo," and telling Wister that what he liked best about the book was "exactly the fact of the *subject* itself, so clearly & finely felt by you . . . & so firmly carried out as the exhibition, to the last intimacy, of the man's character."[17] Of the hero, James enthusiastically observed that "you have made him *live* with a high, but lucid complexity, from head to foot & from beginning to end; you have not only intensely seen and conceived him, but you have reached with him an admirable objectivity." This was high praise indeed, made higher by the dizzy elevation from which it came. How different it was from Remington's comment on "La Tinaja" that "others may monkey—but you arrive with a terrible crash every pop!"

Thus it was not surprising that as Wister's confidence in his own ability grew, his estimation of Remington's diminished. In his 1897 preface to *Drawings,* Wister called Remington "a poet" who "came only with a pencil," saw "a ragged vagrant with a frying pan," and connected him "with the eternal," making "a page of American history his own." Now,

only four years later, while he half-heartedly composed verses for Remington's Russell book, he wrote to his mother that "I am doing some doggerel for an album of Remington's pictures. . . . He is the most uneven artist I know, which you find out very much when you come to extract verse from each drawing. Some are full of meaning and some empty as old cartridges."[18] The metaphor was apt, doubtless revealing more than Wister intended, for it recalled the spent shell casings that littered the single, shabby street of *Lin McLean*'s Drybone, hollow reminders of reckless celebrations. Whether Wister knew it or not, his latest comment on Remington's work had something in it of Lin's remark that "hind sight is a turruble clear way o' seein' things."

By August 20 Wister had completed his verses and introduction for Remington's book and sent them off to New York. Russell thanked him, noting that both prose and poetry would "add greatly to the general effect" of the planned publication and repeating his earlier plea for Wister to suggest an appropriate title. Meanwhile, Wister wrote several essays on various subjects and one short story, a comic treatment of military life entitled "In the Back" when *Collier's Weekly* printed it the following year. At Wister's request, *Collier's* sent the piece to Remington for illustrations. Remington sent the story back to *Collier's,* and dashed off a letter to Wister explaining why:

Have just been through your short story for Colliers about the Secty. of War and it nearly killed me before my time. "The deeply religious whiskers" & he had some marsh land which he intended to sell the Govt. for a Navy yard and "Sistah Stone" and the Captain's moustaish—Say Bill you are all right

I sent it back because it dont need illustrations—its all there—I wouldn't care to interfere.

<div align="center">Y——</div>

LATE AUGUST 1902 *Frederic R.*

Like Wister's assertion in *A Bunch of Buckskins* that "whatever Mr. Remington may choose to do requires no introduction from me, or from anybody else," Remington's explanation was politely evasive. "In the Back," a simple tale, set on a western military post and dealing with picturesque characters, would have been measurably sharpened by pictures from Remington. It was not "all there" as Remington claimed.

Wister may even have written "In the Back" with Remington specifically in mind. He doubtless knew that Remington could improve the story and would, under ordinary circumstances, have been glad to accept it as an assignment. Having done Remington a favor by writing verses and an introduction for the Russell book, he now wondered at Remington's apparent reluctance to reciprocate in even so small a way as dashing off pictures of subjects he liked for a story clearly within the bounds of his expertise. Thus, he wrote Remington immediately, asking him to reconsider. Remington, however, still refused. And his next letter from Ingleneuk stated the *real* reason:

My dear Wist—
Cawnt do it yu no—I am as busy as a cat havin a fit.
Long story is my Trouble—but I mean to see you later.—I am going to have a show in Dec—have to get a "lost wax" order off in ten days—do a little illustration and then I am going to see you—I have got an idea which I think will interest you—it concerns a statement which must be made which will stop dead the fools who are trying to confuse the public, by their ignorance, into thinking that they too understand. I have collected material but haven't the right kind of mind to discharge it. It must be, I think, an Essay. That's however—

<div align="center">

Y——

</div>

Frederic R.

The "essay" Remington spoke of was never written, but the "long story," Remington's equivalent of *The Virginian,* was.

Remington called his long story *John Ermine of the Yellowstone.* When the book appeared late in 1902, it raised a double question: first, who— or *what*—was Frederic Remington; second, what relationship did *John Ermine* and its hero bear to *The Virginian,* published just five months before? On the surface these looked like separate considerations, but a December 13 review in the *New York Times* implicitly recognized that they were in fact two halves of the same intriguing puzzle. "Ordinary human beings," began the reviewer, were always surprised "when a man who has long done one thing superlatively well suddenly demonstrates that he has decided talents in another direction." Utilizing the conventional rhetoric of journalistic praise, he admitted that "it certainly does not seem quite fair that one who draws and paints remarkably good pic-

tures . . . should also be able to write a remarkably good story."[19] The point, of course, was that the reviewer thought *John Ermine* "remarkably good" and Remington remarkably versatile. Precisely the same kind of observation had been made over and over again seven years before when Remington surprised the public by showing that he was a sculptor as well as painter and illustrator. The *Times* reviewer summed it up in 1902 by noting that "it has always been and always will be true that 'to him that hath shall be given.' " The most important factor in defining Remington's professional identity was a large creative energy capable of expressing itself in diverse ways.

The other side of the problem was more difficult. Remington and Wister had long been associated both with each other and with the West. Both had attempted to understand the westerner. Both had now written novels—published by the same company and within five months of each other—clearly aimed at defining that westerner and his context in some final way. One book surely resembled the other, but at no point did the two books come truly together. As the *Times* reviewer of *John Ermine* put it, Remington's novel "makes one think of *The Virginian,* and yet it is *The Virginian* with a thousand differences." The statement suffered from hyperbole, but contained a grain of truth. *John Ermine* made one think of *The Virginian* because it was clearly derivative from *The Virginian,* Remington having decided to write it immediately after Wister completed his own novel—and the relationship was complicated by the fact that *The Virginian,* composed of stories written while Remington and Wister worked closely together, was also clearly derivative from *John Ermine.* The "thousand differences" resolved themselves into two fundamental facts: John Ermine and the Virginian, both "historical" characters, resembled each other physically but not temperamentally. The worlds in which they lived looked the same but operated under different laws.

In John Ermine—a white man raised in an Absaroke lodge and then thrust into a comparatively complex life among white men and women on a frontier military base—Remington combined the savagery of Massai, the "weird past" of Sundown Leflare, and the natural gentility of Carter Johnson. By doing so, he created a protagonist whose heroic dimension was at least potentially far greater than that of the farm boy-turned cowboy-turned family man who was hero of *The Virginian.*

Early in the novel, Remington had a frontiersman describe Ermine

as "all the same Injun"[20]—the same words he earlier gave Sundown Leflare to describe himself. Later, however, Remington commented that even a glance showed Ermine "was evolved from a race which . . . got its yellow hair, fair skin, and blue eyes amid the fjords, forests, rocks, and ice floes of the north of Europe."[21] Ermine's Indian family "persuaded themselves" that their adopted offspring "was born white, but . . . had a Crow heart"—and Remington wrote merely that this showed the Indians "did not understand the laws of heredity."[22] The truth, of course, was that neither John Ermine's white skin nor his Indian upbringing defined him. Characteristically, Remington put the perception which most thoroughly informed his hero into the mouth of the hero himself. Asked where his family lived, Ermine gave the answer that should surprise no one who knew Remington's fondness for Lin McLean: "I have no relatives anywhere on the earth."[23]

Wister showed how important a family was for the hero by ending his book with a brief account of his happy married life. Even more significant than the fact that Wister last referred to the hero as a father was his repeated insistence that the Virginian's family extended far beyond the circle of cousins, aunts, brothers, and sisters commonly thought of as "relatives." The hero's firmest genetic ties were with "Quality" of whatever nationality or location. Himself a southerner, the Virginian was proud of the part his ancestors played in the Civil War. The same standard of pride—transferred to himself—sent him west. As we have seen, however, Wister could not forget that the Civil War was a war between brothers— which meant that the best men on both sides were related to each other in more intimate ways than they might be to their conceivably degenerate offspring—men like the "brothers" Wister's hero left behind him in Virginia.

Therefore, Wister had to send the Virginian east from Wyoming to discover in New England what Lin McLean couldn't find at Boston. After his marriage to Molly Stark Wood, the Virginian was taken to Dunbarton, New Hampshire, to meet Molly's great aunt in a room which prominently displayed a "family portrait" of General Stark, now one of the Virginian's relatives "in law," who distinguished himself as a Union soldier in the War Between the States. Parallels between General Stark and the Virginian became explicit as Molly's aunt looked at the portrait and remembered that "New Hampshire was full of fine young men in those days," adding that "nowadays most of them have gone away to seek their

fortunes in the West."²⁴ The Virginian resembled not only General Stark but men who left family portraits of people like General Stark behind them. Between his life and the General's there was a certain continuity, and what kind of continuity it was became clear when the aunt asked her next question. Referring to the young New Hampshire men who went west in search of fortunes, she asked the Virginian, "Do they find them I wonder?" There was no hesitation in the Virginian's reply: "Yes, ma'am. All the good ones do." The resemblance between the Virginian and General Stark was a *family* resemblance. Both men belonged to a continuing brotherhood of "all the good ones."

One of the two major differences between John Ermine and the Virginian was that Wister's hero claimed all "Quality" as relatives, whereas Remington's had "no relations anywhere on the earth." The second major difference was that as a family man, the Virginian lived and prospered while John Ermine, as orphan and *isolato,* spent himself and was destroyed.

Throughout both *Crooked Trails* and the *Sundown* stories, Remington repeatedly emphasized the inability of American Indians to come to terms with European institutions—most especially the institution of marriage. In those earlier books men like Massai and Sundown Leflare bought, stole, won, abducted, or otherwise acquired the women they wanted. They were able to succeed because they were either red or half red and thus contacted European civilization only at its periphery. Yet John Ermine had qualities which carried him beyond the edges of the isolated settlements raided by Massai or the trackside saloons and gambling dens where Sundown Leflare mingled with white prostitutes and card sharps. When he came to Fort Ellis, he proved himself as soldier, poker player, and gentleman, gambling, hunting and joking with the officers on an equal footing. Finally, he penetrated the vital center of the fort's small social order, a mirror of the larger social order which it represented. Remington took him past genial companionship with officers at war and in the hunt—past even the conviviality of their poker tables—to the sanctuary of the post commandant's parlor, where he had John Ermine propose marriage to Katherine Searles, the commandant's daughter.

Had Wister written *John Ermine,* the proposal would doubtless have been accepted, for Ermine possessed both a white skin—which made him socially acceptable—and all the attributes of "Quality"—which would, for Wister, have joined him in brotherhood with "all the good ones."

For Remington, however, giving Ermine a white skin was not so much a way of making the hero socially acceptable as of getting him into the commandant's parlor; his courage, intelligence, and determination not so much ways of linking him with other superior individuals as of making him capable of recognizing and dealing with his own isolation. To put it simply, John Ermine was a natural man but not a family man. Therefore, his encounter with European civilization became just what Remington said it was: war. His proposal to Katherine Searles was a campaign in "that old cleaning up of the West."

Wedding Molly Wood to the Virginian was a way for Wister to accomplish truce between North and South, East and West, old and new. Katherine Searles' refusal of John Ermine was Remington's way of showing that no truce was possible between East and West, past and present, natural and civilized. The path Remington laid out for John Ermine made this unmistakably clear: leaving the commandant's parlor, Ermine recognized that "I am all alone."[25] When Katherine's father and other officers of the post tried to point out to him the impropriety of his proposal, he shot one of them in the arm, fled, and resolved to come back and kill the soldier to whom Katherine was about to be betrothed. When he came back, he was killed. Unlike the Virginian, he could never grow older. Like Sundown Leflare, he passed from history into myth.

Both the Virginian and John Ermine were historical in the sense that they both represented types their creators understood as central to the history of the West. Yet the historical West of *John Ermine* came to an end with the hero's death, while the equally historical West of *The Virginian* could be expected to continue producing "Quality" even after the Cattle Kingdom was over. *The Virginian* depicted a region governed by the laws of change, a place where the arrival of railroads, wire fences, and irrigation, and the necessarily subsequent departure of cattle kings, range wars, and cowpunchers were expected—even predictable events much like the changing of the seasons. Thus, the Virginian could marry Molly Wood, put on Eastern clothes and become a coal magnate without turning a hair. As he himself put it, "most any old thing will do . . . to play poker with." In *John Ermine,* however, the Virginian's maxim applied only superficially. Ermine's skill at poker could not save him from disaster, for the central fact of Remington's book was not the continuity of change—which a good poker player like the Virginian always counted on to transform whatever it was he "played" with into something he could

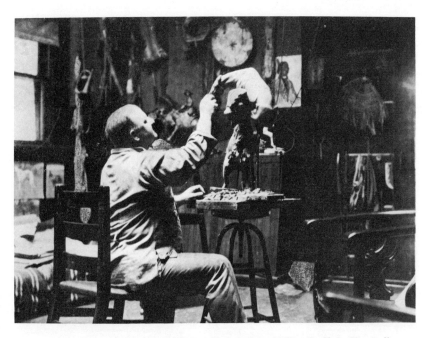

**Frederic Remington at work on clay model of "The Buffalo Horse,"
one of his most spectacular feats of sculpting, 1907.**

use to win—but the irresistible urge toward identity which impelled Ermine to propose marriage, attempt murder, and be destroyed.

Although he never read *John Ermine*, Henry James deftly touched the fundamental difference between that novel and *The Virginian* in a 1902 letter to Wister. James liked the *subject* of Wister's book but objected to its *form*—most especially to the form of its happy ending. In place of the "mere *prosaic* justice, & rather grim at that" which Wister gave his hero with "achieved parentage, prosperity, maturity" and union with "the little Vermont person" Molly, James wanted "all sorts of poetic justice."[26] Finding the Virginian himself attractive, James still felt Wister missed the most important point that could be made about him: that beneath the bluff of the poker player there lurked not only purpose but a principle. "I thirst for his blood," wrote James. "I should have made him perish in his flower and in some splendid and somber way." The advice James gave to Wister, Remington took without needing to have it offered.

Remington and Wister had finally expressed their respective visions

An elderly Owen Wister.

of the vanished West in such widely different ways that their partnership seemed clearly over. Yet each man's involvement in his own work made is difficult for him to see how far he had drifted from the other.

In September, shortly after Remington finished his novel, Wister wrote with news that poetry for the Russell book was finished, also complaining about the shabbiness with which he felt he had been treated by Russell and Singleton, and Remington sympathetically replied that "the whole poetry scheme was rough, but I'm glad it has been patched up." In reference to Russell and Singleton, he added that "such gall is not easily understood." Again apologizing for his inability to illustrate "In the Back," he continued:

I simply couldn't stop to do your story now and so told Edwards—and I dont suppose they want to hold it to suit my convenience. I have done no painting since late last winter and have three pictures which must be finished since I want to get away later, so I have had to suspend illustrations for a while.

The summer it took to write *John Ermine* had put Remington behind with his other work. This work now captured his time and interest. For that reason, Remington missed the point of both Wister's book and his own, and the permanent separation both books signaled appeared to him only as temporary drift. Similarly, Wister failed to understand the tangle of attitudes and standards which caused his recent evaluation of Remington as "the most uneven artist" he knew. In response to Russell's earlier request, he came up with a title for Remington's book of pictures, and Remington, impressed with the financial success of *The Virginian,* even while seemingly blind to the book's vision of the West, scrawled his thanks on a postcard of September 8:

> *"Done in the Open" is good—My what a killing you have made—*
> *Y——*

SEPTEMBER 8, 1902 *Frederic Remington.*

As Remington noted, *Done in the Open* was a suitable title. Ironist though he was, however, Remington still failed to see that he himself had made "a killing" by ending *John Ermine* in the way he did—and that that killing, set against the survival of the Virginian as a family man, shadowed forth the already accomplished end of his partnership with Wister.

Wister missed the irony too, not only because he was no ironist but also because he had not seen *John Ermine*—which was not yet published. Shortly after receiving Remington's postcard, he finished the introduction for *Done in the Open* and sent it off to Russell. The essay contained no explicit mention of Remington's uneveness, but despite the fact that Wister called Remington a "national treasure," the sense of a continuing relationship which informed his preface to *Drawings* was gone. In its place was the hint of something that could only be called moribund. At one point Wister noted that "as the historian Green wrote what he called a history of the English people, so Remington is drawing his contemporary history of the most picturesque of the American people." At another, he commented that Remington "has pictured the red man." These and other similar observations which comprised the essay all recognized Remington as historian—which Wister had repeatedly done before. Yet they were all of a piece in another, more important way: they utilized a particular variety of laudatory rhetoric. And what that particular variety

was came clear in Wister's last sentence:

If it should ever occur to the minds of the not always discerning academic institutions that Remington should be crowned at their hands, I should like to hear him receive his degree in these words: "Frederic Remington, Draughts-man, Historian, Poet."[27]

The rhetoric of Wister's essay was funereal. Its last sentence might have served as an epitaph.

Wister, of course, probably didn't think of his Introduction for *Done in the Open* as an obituary, and Remington surely did not. When he received a freshly printed copy of his book late in November, he wrote to Wister, showing that he was still alive. Yet the letter was still clearly terminal. Beneath its thanks for Wister's preface, its humorous reference to the strikes again plaguing Pennsylvania coal mines, even in its ridicule of the movement then afoot at New York to start a writers' union, there floated a recognition that something was over:

My dear W—— Copy of my book just at hand and I have read Intro & poems—the poems are great and I feel like this—sort of unusually puffed up—There were passages in that Intro. which sent my natural color up several octaves. A little Greek fire is good for the business. Had a copy of "Coming through the Rye" bronze in Tiffanys but it sold— have made another which I hope to have there in less than a month and you surely must see it.

My little old story comes out soon but that wont interest you. However if you read it tell me what's what and spare not.

I havent seen you since you were a young man—I'm bald headed and one legged and the curves are more easily followed than ever. We are burning the Steinway this week—the old Virginia sideboard goes next week—suppose you are burning copies of the Virginian.

Did you see in the N.Y. Herald that we have all got to join the union. Amalgimated Ass. of Quillers and Daubers No. 2 affiliated with the Pants Makers and Liberty Dawners. Say wouldn't that warm your ears?

<div align="right">

yours

</div>

LATE NOVEMBER 1902 *Frederic R.*

In a sense, the letter summed everything up. Two young men met and were now no longer young. They had both been captured by the West

301 WEBSTER AVENUE,
NEW ROCHELLE, N.Y.

Napoleon W — Copy of my book
just at hand and I have read
Intro + poems — the poems are great
and I feel like this — out of
unusually puffed up —

There were passages in that Intro.
which sent my natural color up
several octaves. A little Greek
fire or jucel for the business.

I had a copy of "Coming through the Rye" bronze in Tiffanys but it sold — have made another which I hope to have there in less than a month, and you surely must see it.

My little old thing comes out soon but that wont interest you. However if you read it tell me what's what and spare not.

I havn't seen you since you were a young man — I'm bald headed and one legged and the curves are never easily followed than ever. We are burning the Steinway this week — the old virginia side-board goes next

WREK — suffices you an honestly offers of the Ungarian.

Did you see in N.Y. Herald that we have all got

to join the union. Quadriplegta Case, of Quartes and

Daubros No. 2. afflicts with the Paulo Mothers

are Liberty Dawners. Say wouldn't that warm you

Ears?

yours

Frederic R.

and had used their captivity to express themselves about politics, history, art, and perception itself. Both had finally written books which showed how big the region of their common captivity was and how far it had allowed the captives to wander from each other. "Coming Through the Rye," Remington's bronze, expressed the region's wistful gaiety. "At the Sign of the Last Chance," a story Wister wrote twenty-three years afterward, suggested its sadness. Historically, the West that captured Remington and Wister was over. Yet even after Remington and Wister parted, bronzes like "Coming Through the Rye" made Remington's perception of it "damn near eternal"—and Wister, despite Remington's facetious suggestion, would never like Faustus burn his books. So Remington's letter, with its comic self-portrait, was neither renunciation of the West nor escape from it. But it was a good exit.

Epilogue

Seven years later, on the day after Christmas, 1909, Remington died, and the funeral quality of Wister's preface for *Done in the Open* was finally put to appropriate use about a week afterward when *Collier's Weekly* printed the essay's last four paragraphs. Under the new title of "An Appreciation," the paragraphs made one of several obituaries of the late artist carried by the January 8, 1910, number of the journal. "An Appreciation" was all Wister added to the flood of essays concerning Remington which appeared shortly after the artist's death. On the face of it, this seemed curious, for however uneven Wister's relationship with Remington had been, it had also been rich in experience and learning. However far apart the two men strayed in some ways, they had been close indeed in others. As Eva Remington had told Wister in 1894, "You are one of the few men whom [Frederic] loves & he cannot see too much of you,"—and shortly afterward Wister reciprocated the warmth thus expressed when Remington elatedly discovered sculpting: "It would be an awful blow to one of this team if bronze was to be all, hereafter," Wister wrote, adding his hope that "once in a while you'll still wash your hands to take hold of mine." Warmth there had certainly been—and with it friendship, fruitful collaboration, and creation. When Remington died in 1909, therefore, why was Wister's "appreciation" confined to four paragraphs written seven years before?

The reasons were multiple. First, Wister himself had been bedridden for several weeks the previous August with a mysterious fever—and in December, shortly before Remington died, he had suffered an alarming relapse. Second, he had not seen or been associated with Remington for years. Most importantly, however, Wister knew that what he said in *Done in the Open* was all he had to say about Remington. By January 1910, he began to see, albeit imperfectly, what his relationship with Remington had been about. His realization occurred in two distinct stages. The first started in 1902, when *John Ermine* set Remington free from writing and *The Virginian* set Wister free from his initial vision of the West. The second happened suddenly one day during the summer that followed

Remington's death.

After the 1902 publication of *Done in the Open,* Remington and Wister went their separate ways. Almost immediately Wister began planning the novel of manners that was called *Lady Baltimore* when it appeared in 1906. Set in Charleston, South Carolina—called "Kings Port" in the book—it was a quasi-Jamesian treatment of polite life among "genteel" folk like those whom both the Virginian and Lin McLean had left behind them. Wister also continued to produce stories about the West, but the region pictured in them was the *new* West—a region only remotely related to Judge Henry's Sunk Creek ranch and peopled with an odd assortment of quacks and murderers among whom "good ones" appeared but rarely. Moreover, he "swapped skies" often, writing political, biographical, and occasional essays as well as stories concerning various aspects of life in America's increasingly urban East. Just as the Virginian felt that "most any old thing" would do to play poker with, Wister, his fortune made and his reputation established, believed he could now afford to take E. S. Martin's advice of ten years earlier.

Remington, on the other hand, applied to himself—and in his own hyperbolic fashion—John Ermine's remark that "I have no relations anywhere on earth," making Ermine's vanished world his own with a completeness he had seemed incapable of before. Early in 1903, he entered into an agreement with *Collier's* which not only paid him handsomely but allowed him freedom to treat the *old* West as he felt it should be treated. The result was a series of remarkable oils which showed that Remington, having built his reputation as realist, had at last "arrived" as impressionist. Green horses, white skies, pale yellow Indians, red bison, violet beards abounded in them. Works like "Downing the Nigh Leader," printed by *Collier's* in 1907, and "Bringing Home the New Cook," which *Collier's* carried later that same year, defied Wister's designation of Remington as "Draughtsman, Historian, Poet." Historical and poetic they surely were—but they also expressed something else. The speed and energy Remington caught in the Arizona sketches of the 1880s still informd these later paintings, still dominated utterly the landscape which formed their perfunctory background. The difference was an elegiac quality—something Remington began to become aware of when he retreated to Ingleneuk. And the key to expressing the elegiac quality was color.

Remington's pastel of "A Breed," from *A Bunch of Buckskins*, was by

no means photographic, but to see how far the artist moved "away from the Kodak" during the years between 1902 and his death, it was necessary only to contrast "A Breed" with "Ceremony of the Scalps," printed by *Collier's* in 1908. The former work was drawn "from life"—clearly a direct product of the western wandering Remington began in 1880. Yet the latter, while certainly "lively," represented not life but imagination. As one looked at the picture, skyline, background, foreground, and figures were "eliminated." All that remained was a sense of survival in the present of the picture itself of what Roosevelt called "inconceivably lonely and blood-thirsty life." Before the Spanish-American War, Remington had lamented that "the wild west will [pass] into history"—and as *prediction* his lament expressed historical truth, for even in 1895, the wild West was on the verge of being historically over. Yet as *perception,* Remington's lament was wholly inadequate, for the very passing it mourned caused Remington's advance beyond the "things we know" and made his final phase his finest. The West's passage "into history" made possible for Remington its transformation into art.

The same passage caused Wister to turn away from the old West. Shortly before *Collier's* printed "Ceremony" in June 1908, Remington began contemplating another trip to Arizona, hopefully to be taken that fall after he had finished work on his latest commission, a life-sized equestrian statue for Philadelphia's Fairmont Park. Remembering *Done in the Open* and thinking back to the former occasions when he and Wister planned western trips but never made them together, he decided to give the combination one more opportunity to work:

My dear Wister—
Lunched to day with Mr. Worth the mining engineer and we are proposing to go into his deserts in October and he has hopes you might go and I think it would be a good scheme—we wuld have a good time and might uncover some new color.
I am doing a big cow-boy for Fairmont Park and I thought I would scratch on the base
"He rides the Earth with hoofs of might"
did you do that or was it Georg Wharton Edwards?—
Yours
JUNE 1908 Frederic Remington

Of course, nothing in Remington's letter indicated that he thought there was any real chance of Wister's accepting the invitation—and indeed there was none.

When he got Remington's letter, Wister didn't even bother to look back at *Done in the Open,* where the line Remington mentioned accompanied a picture of "The Cow Puncher"—not, incidentally, one of Remington's best:

> He rides the earth with hoofs of might,
> His is the song the eagle sings;
> Strong as the eagle's, his delight,
> For like his rope, his heart hath wings.

Instead, Wister remembered another, earlier version of the same verse:

My dear Remington: If you mean this—

> *No more he rides, yon waif of might,*
> *His was the song the eagle sings.*
> *Strong as the eagle's his delight,*
> *For like his rope, his heart had wings—*

I wrote it to accompany a cover-illustration you have in Collier's Sept. 14, 1900.

I am glad we are going to have a cowboy from you in Fairmont Park & should be proud if any verse of mine went underneath.

There's no chance for me to go with Worth. I wish I could merely for the pleasure. I am sure some new color is there, but I rather think it is pictorial & yours, & not narrative & mine. It is likely to furnish more *specimens of the same kind of thing one has met. But I am sure the figures & the landscape are well worth seeking.*

<div style="text-align: right">

Yours Faithfully

</div>

JUNE 1908 *Owen Wister*

Four things about Wister's letter were notable. First was its formal politeness—which marked it as a more or less obligatory communication with a former associate. Second was the fact that Wister wrote "there's no chance for me to go with *Worth,*" omitting Remington altogether—

which made the politeness positively chilly. Third was the distinction between "pictorial" and "narrative" color—suggesting how thoroughly Wister now accepted the role of "local colorist." And finally—most importantly—was Wister's failure to distinguish between the verse he wrote for the "*Collier's* puncher" in 1901 and the one he wrote for *Done in the Open* a year later. The verse for *Done in the Open* concerned a *mythical* figure who—in defiance of history—"*rides.*" The *Collier's* verse was obituary for a "waif" who rides "no more." Wister's letter of 1908 thus explained part of the reason Wister contributed only "An Appreciation" when Remington died: printing the last four paragraphs of Wister's 1902 *Done in the Open* essay as an obituary for Remington in 1910 was appropriate precisely because the essay as it appeared in 1902 constituted an obituary on the passing of whatever life it was that held Wister and Remington together with each other and the West.

As Wister convalesced at Philadelphia in January 1910 and read his "Appreciation" of Remington in *Collier's,* the essay's full significance failed to reach him, for his own illness was oppressive. Yet Remington's death may have had something to do with the plan that began to hatch in Wister's mind very soon. By February Wister felt considerably better. In May his old friend Henry James, also recovering from a recent illness, came down from Massachusetts for a visit, and Wister told him that he intended during the summer to make a journey to Wyoming, his first in eleven years. In 1885, the same journey had refreshed him by giving him a new awareness of himself. Now, as he suffered from depression which seemed analogous to that he had felt at Boston twenty-five years before, he hoped the "curative regions" might once more perform their magic. Wister described his plans to James with enthusiasm, and James, after returning to Massachusetts, wrote of the "vivid assurance" Wister had given him "of all that you have to get better and better, to get beautifully well for." In 1908 Remington's invitation for a western trip brought Wister's observation that such a journey was "likely to furnish *more* specimens of the same kind of thing one has met"; in 1910 such a prospect seemed inviting. Yet what fifty-year-old Wister found in Wyoming that summer surprised him by duplicating the 1885 experience at Major Wolcott's ranch in an unexpected fashion.

The prairie Wister rode across in 1910 was the same one that had thrilled him in 1885, and the same indigo mountains punctured the horizon. Even the train he rode on was "like the trains of other days." Towed

by an "ancient locomotive with a big wide smokestack," it was "half freight, no Pullman, ancient coaches." Even down to "the regular original pattern of newsboy with bad novels, bad candy, bad bananas," it fit the paradigm of Wister's recollections. Yet the train also resembled the "Last Cavalier" on Remington's canvas—or better yet, the purple stagecoach from "Downing the Night Leader"—for solid though it was, it traveled across a landscape of dreams. As Wister sat on it, tired but eager, he smelled "the first whiff of the sage brush" and felt the thrill of a renewal like that of twenty years before, when he had woken up to the fact that the air at Major Wolcott's ranch was . . "like no other air." Curiously, though, he noted this time as he had not before that "the past became visible." Looking out the smudged window, he saw "scores and hundreds [of antelope] only a little way off; a sort of cinnamon and amber color . . . transparent and phantom like, with pale legs." While he watched, they ran, becoming "receding dots of motion," and disappeared. Then Wister realized that "no antelope were there." For the first time, he understood what had pulled him and Remington together at Geyser Basin in 1893 and pushed them apart again nine years afterward: "What you seek," he told himself, "what your eyes have been straining to see, is yourself at twenty, your youth before you ever thought that it . . . would pass." When Remington boasted of being "d—— near eternal" and promised to "lug" Wister "into the immortal band," Wister had usually been inclined to regard it as flattery or exaggeration. Now he recognized with astonishment that behind Remington's hyperbole there lurked a personal truth: "I am a ghost," he admitted.[1]

The West was youth, and youth—his own at any rate—was gone. This was the second stage of Wister's realization about his partnership with Remington. And the way in which Wister perceived it, seeing himself as "a ghost," made the realization instructive. Remington had never admitted to the West as past or himself as "ghostly," always insisting on his work as a means to eliminate time from "the spirit of a thing." Conversely, Wister's ghostly antelope, along with the rest of his youthful western experience, was "gone forevermore," sweeping Wister himself along whether he wanted to go or not. In both cases, there was a "process of elimination" at work, and in both cases corporeal actuality became something else. Yet the elimination Wister sensed confirmed a final termination, and that which Remington caught expressed a continuous beginning; Wister's "ghost" receded into the past, Remington's "spirit"

rushed out of it.

Therefore, Remington and Wister represented two fundamentally different responses to the American West. Remington's West was informed by the artist's powerful vision of it as a place where things happened. Wister's resembled a vivid scenario for his own rapidly developing sense of history. Although Wister's impulses were romantic and Remington's antiromantic, Remington continued until the end of his life to pursue "that old cleaning up of the West" which he was born too late to witness at first hand, while Wister, cerebral and sentimental, nonetheless described the dusty region of company towns, Populists, prudery, and small-time criminals to which the prairies had largely given way by the turn of the century. Wister's primary trouble was an intense and unconscious subjectivity which marred his fiction by depriving it of original form and his nonfiction by making it sometimes grandiose; Remington's was an abrasive and isolating irony which made it difficult for him to profit by contact with other men and their work. Caught between the lost nineties and the roaring twenties, between the roles of historian and fictionist, Wister spent much of his life trying to decide what niche he belonged in—and consequently he developed a sensitivity about himself which was not always entirely wholesome. Likewise, the same sandpaper wit that made it possible for Remington to have a "sculptor's degree of vision" became not only a shield against pomposity but also a wall between the artist and potentially valuable experience.

An air of incompleteness hung about each man's career. The modest and homely folk who passed for heroes in Wister's works, the wistful blending of verisimilitude with lyric form in Remington's were tokens of promise finally beyond achievement, subjects never quite subdued to art. The reason may well have been that the two men could never get truly together. Although much has been made of the loneliness of American culture, many of its greatest creative achievements have sprung from fruitful alliances—Melville and Hawthorne, Howells and Mark Twain, Emerson and Thoreau, Henry James and a whole circle that included such diverse personalities as Stephen Crane and Edith Wharton. Neither Remington nor Wister had the advantage of such an alliance—and this indicated something not only about Remington and Wister, but also about the West: if the two men were perverse and difficult, so was the region they met in.

When men and region came together in 1893, it looked as though the

event might begin a conquest. Wister's earnestness balanced Remington's skepticism. Remington's humor balanced Wister's gravity. The West itself expressed a complex challenge too exciting to be ignored. And both men asked the right question—the same one Thoreau had written down two generations earlier at Walden Pond: "What does the West stand for?" Yet Remington and Wister came to Geyser Basin not for conquest, but to be captured, and the chronicle they produced remained fragmentary. Neither each man separately nor both together were quite sufficient to generate the "epic" Wister dreamed of. Yet the alliance itself was surely not a failure, for even its predictable end shadowed forth an affirmation: the same Thoreau who asked, "What does the West stand for?" also deftly observed that "if a man does not keep step with his companion, perhaps it is because he hears a different drummer." What Remington and Wister's inability to stay in lockstep with each other proclaimed was diversity, and Thoreau's advice to the man who could not "keep pace" was, "let him step to the music which he hears." Both Remington and Wister did. Had the two men accomplished their planned conquest of the West, their triumphal advance might have turned into a dead march. As it was, they moved together and apart to produce an elegy. Their friendship embodied qualities of the West itself—startling, unlikely, colorful, forever tantalizing in its possibility because forever unfulfilled.

Notes

CHAPTER 1

1. Frederic Remington, "Policing the Yellowstone," in *Pony Tracks* (Norman: University of Oklahoma Press, 1961), p. 114; first appeared in *Harper's Weekly*, XXXIX, January 12, 1895.
2. *Ibid.*, pp. 109–117.
3. Harold McCracken, *Frederic Remington: Artist of the Old West* (Philadelphia: J. B. Lippincott, 1947), p. 76.
4. Undated note of 1860 from Fanny Kemble to Sarah B. Wister, in the Wister collection, Manuscripts Division, Library of Congress.
5. Henry James, *The American Scene* (New York and London: Harper and Brothers, 1907), p. 387.
6. Owen Wister, *The Virginian*, Philip Durham, ed. (Boston: Houghton Mifflin, 1968); quoted by Durham in the Introduction, p. *v*.
7. G. Edward White, *The Eastern Establishment and the Western Experience: The West of Frederic Remington, Theodore Roosevelt, and Owen Wister*, Yale Publications in American Studies, 14 (New Haven: Yale University Press, 1968), p. 56.
8. The full title of this poem was "Brothers Again: A Poem Suggested by Decoration Day, 1877." It was delivered by Wister in June 1877 to a gathering at the St. Paul's School Library.
9. This was one of Wister's favorite metaphors for the West. An early use of it is in his notebook entry for July 6, 1885 (quoted in *Owen Wister Out West*, p. 31; cf. note 35 below).
10. McCracken, p. 28.
11. *Ibid.*, p. 28.
12. Letter from Owen Wister to Sarah B. Wister, December 2, 1877.
13. Wister to Sarah B. Wister, Easter, 1879.
14. McCracken, p. 29.
15. Frederic Remington, *Frederic Remington's Own Outdoors*, Douglas Allen, ed. (New York: Dial Press, 1964), p. 17. Quoted from Walter Camp, who quotes Remington in *Football Facts and Figures*.
16. Poultney Bigelow, *Seventy Summers*, I (London: E. Arnold & Co.), p. 302.
17. Wister to Sarah B. Wister, Easter, 1880.
18. Wister to Sarah B. Wister, September 15, 1880.
19. 1882 travel journal, July 16.
20. *Ibid.*, July 30.
21. *Ibid.*, August 15.
22. Wister records the encounter in his journal entry for August 14, 1882.
23. "A Few Words from Mr. Remington," *Collier's Weekly*, March 18, 1905, quoted in McCracken, pp. 34–35.
24. White, p. 96.

25. Wister to Sarah B. Wister, December 21, 1883.
26. McCracken, p. 37.
27. Wister to Sarah B. Wister, September 29, 1884.
28. Wister to Sarah B. Wister, January 12, 1885.
29. Postcard from Wister to Sarah B. Wister, July 2, 1885.
30. Postcard from Wister to Sarah B. Wister, July 3, 1885.
31. Postcard from Wister to Sarah B. Wister, July 3, 1885, 5:30 P.M.
32. Letter from Wister to Sarah B. Wister, July 4, 1885.
33. Owen Wister, *Owen Wister Out West*, Fanny Kemble Wister, ed. (Chicago: University of Chicago Press, 1958), p. 33.
34. Wister to Sarah B. Wister, July 24, 1885.
35. Undated entry sometime in July, in Wister's western notebook, 1885; deposited in the Western History Research Center at the University of Wyoming.
36. *Ibid.*, July 11.
37. Bigelow, p. 304.
38. Wister, western notebook, August 16, 1887; Western History Research Center.
39. Wister, western notebook, 1887; Western History Research Center.
40. Wister, *Owen Wister Out West*, p. 59.
41. Frederic Remington, "The Horses of the Plains," *The Century*, XXXVII, April 1889, pp. 332–343. "A Scout with the Buffalo-Soldiers," *The Century*, XXXVII, April 1889, pp. 899–912. "On the Indian Reservation," *The Century*, XXXVIII, July 1889, pp. 394–405. "Artist Wanderings Among the Cheyennes," *The Century*, XXXVIII, August 1889, pp. 536–545.
42. Wister to Fanny Kemble, May 7, 1889.
43. Wister to Sarah B. Wister, May 28, 1889.
44. Wister to Sarah B. Wister, July 25, 1889.
45. Wister to Sarah B. Wister, August 10, 1889.
46. Western notebook, November 19, 1889.
47. Wister to Sarah B. Wister, October 14, 1889.
48. Wister to Sarah B. Wister, June 21, 1891.
49. Wister to Sarah B. Wister, November 14, 1892.
50. Frederic Remington, "Buffalo Bill in London," *Harper's Weekly*, XXXVI, September 3, 1892, p. 847. Quoted in McCracken, p. 74.
51. Frederic Remington, "Military Athletics at Aldershot," *Harper's Weekly*, XXXVI, September 10, 1892, p. 882. Quoted in McCracken, p. 75.
52. Undated entry in Wister's western journal for 1893.
53. Wister, *Owen Wister Out West*, p. 182.
54. *Ibid.*, p. 183.
55. *Ibid.*, p. 196.
56. *Ibid.*, pp. 196–197.

CHAPTER 2
1. Wister to Sarah B. Wister, July 6, 1885.
2. Wister to Sarah B. Wister, July 24, 1885.
3. Owen Wister, "How Lin McLean Went West," *Harper's Monthly*, LXXXVI, p. 146.

4. Wister, *Owen Wister Out West*, p. 168.
5. Wister, western notebook, July 1873; Western History Research Center.
6. Remington, *Pony Tracks*, p. 162.
7. *Ibid.*, p. 166.
8. *Ibid.*, pp. 172–173.
9. Owen Wister, *Red Men and White*, Vol. 6 of *The Writings of Owen Wister* (New York: Macmillan, 1928), Introduction, p. *ix*.
10. Theodore Roosevelt, "What 'Americanism' Means," *The Forum*, XVII (1894), p. 199.
11. *Ibid.*, p. 200.
12. Wister to Sarah B. Wister, May 28, 1894.
13. E. S. Martin, "This Busy World," *Harper's Weekly*, XXXVIII (1894), p. 754.
14. Frederic Remington, "Chicago Under the Mob," *Harper's Weekly*, XXXVIII (1894), pp. 680–681.
15. Owen Wister, "The National Guard of Pennsylvania," *Harper's Weekly*, XXXVIII (1894), p. 824.
16. Owen Wister to Theodore Roosevelt, February 27, 1895. Quoted in Owen Wister, *Roosevelt: The Story of a Friendship* (New York: Macmillan, 1930), p. 38.
17. Montague Stevens, "'Front Name' Dick," *Cosmopolitan*, 1897, pp. 553–568.
18. Frederic Remington, "Horses of the Plains," *The Century*, 1889, p. 335.
19. *Ibid.*, p. 343.
20. Wister to Sarah B. Wister, February 12, 1895.
21. Frederic Remington, "Cracker Cowboys of Florida," *Harper's Magazine*, XCI (1895), p. 345.
22. *Ibid.*, p. 339.
23. Owen Wister, "The Evolution of the Cow-Puncher," *Harper's Magazine*, XCI (1895), p. 610.
24. Remington, "Cracker Cowboys," p. 339.
25. Wister, *Owen Wister Out West*, p. 197.
26. Wister to Sarah B. Wister, March 5, 1895.
27. Wister, journal and notes, entry for September 27, 1895.
28. Wister, *Owen Wister Out West*, pp. 249–250.

CHAPTER 3
1. Owen Wister, *Red Men and White* (New York: Harper and Brothers, 1895), p. *viii*.
2. Theodore Roosevelt, "A Teller of Tales of Strong Men," *Harper's Weekly*, XL (1896), p. 1216.
3. W. D. Howells, "Life and Letters," *Harper's Weekly*, XL (1896), p. 1133.
4. "A Few Stories," *Atlantic Monthly*, LXXVII (1896), pp. 264–265.
5. Wister, daybook, entry for September 18, 1894.
6. Wister, *Owen Wister Out West*, pp. 203–204.
7. *Ibid.*, p. 204.
8. *Ibid.*, p. 204.

9. Caspar W. Whitney, "Amateur Sport," *Harper's Weekly*, XXXVIII, December 1, 1894, p. 1150.
10. Remington, *Pony Tracks*, p. 161.
11. Theodore Roosevelt, "True American Ideals," *The Forum*, XVIII (1894–95), p. 746.
12. Owen Wister, "A Pilgrim on the Gila," *Harper's Magazine*, XCI (1895), p. 860.
13. Wister, *Roosevelt*, p. 39.
14. *Ibid.*, p. 39.
15. Wister, journal, entry for April 2, 1895.
16. Wister, *Red Men and White*, preface to 1928 edition, p. *xiii*.
17. *Ibid.*, p. *xiii*.
18. Owen Wister, letter of October 15, 1896, in *Babel*, Vol. 4, Library of Congress Collection. (*Babel* was the name Wister gave his eight-volume clipping and letter book.)
19. Nancy Huston Banks, "Owen Wister: Author of *Red Men and White*," *The Bookman*, II (1895–96), pp. 275–277.

CHAPTER 4

1. Arthur Hoeber, "From Clay to Ink," *Harper's Weekly*, XXXIX, October 19, 1895, p. 993.
2. Augustus Thomas, *The Print of My Remembrances* (New York: Charles Scribners Sons, 1922), p. 327.
3. McCracken, p. 92.
4. *Ibid.*, p. 93.
5. Hoeber, p. 993.
6. Owen Wister, journal, entry for October 17, 1895.
7. "American Art Association," *New York Times*, November 15, 1895, p. 5, col. 5.
8. McCracken, pp. 89–90.
9. Wister to Sarah B. Wister, August 31, 1897.

CHAPTER 5

1. Letter from Frederic Remington to Scott Turner, March 3, 1877. Quoted in McCracken, pp. 27, 28.
2. "With the Fifth Corps," *Harper's Magazine*, XCVII (November, 1898), pp. 971–72.
3. *Ibid.*, p. 970.
4. "The Military Athletics at Aldershot," *Harper's Weekly*, September 10, 1892.
5. Wister, *Roosevelt: The Story of a Friendship*, p. 59.
6. Quoted in Norman Foerster, ed., *American Poetry and Prose* (Boston: Houghton-Mifflin, 1947), p. 1154.
7. *New York Journal*, February 9, 1898, p. 1.
8. "President McKinley at the University of Pennsylvania," *Harper's Weekly*, March 5, 1898, p. 235.
9. Harold Martin, "The Situation at Key West," *Harper's Weekly*, March 5, 1898, p. 222.
10. "Wigwags from the Blockade," *Harper's Weekly*, May 14, 1898, p. 462.

CHAPTER 6

1. Edwin Wildman, "Frederic Remington, the Man," *Outing Magazine,* March, 1903, p. 716.
2. *Ibid.,* p. 715.
3. Owen Wister, western notebook, September 1, 1888; Western History Research Center.
4. Owen Wister, "An Electric Storm on the Washakie Needles," *Science,* m.s., XXVIII, December 11, 1908, pp. 837–9.
5. Owen Wister, "Timberline," *Saturday Evening Post,* CLXXX, March 7, 1908, pp. 3–44; collected in *Members of the Family* (New York: Macmillan, 1911).
6. Owen Wister to Sarah B. Wister, July 5, 1902.
7. Frederic Remington, "The Spirit of Mahongui," *Harper's Monthly,* XCVII (June, 1898), p. 53.
8. Frederic Remington, "Sundown Leflare's Warm Spot," *Harper's Monthly,* XCVII (September, 1898), p. 588.
9. *Ibid.,* p. 588.
10. *Ibid.,* p. 592.
11. *Ibid.,* p. 592.
12. *Ibid.,* p. 592.
13. *Ibid.,* p. 589.
14. Owen Wister, "Padre Ignazio," *Harper's Monthly,* C (April, 1900), p. 692.
15. *Ibid.,* p. 699.
16. Frederic Remington, "Massai's Crooked Trail," *Harper's Magazine,* XCVI (January, 1898), pp. 240–246.
17. T. Roosevelt to Frederic Remington, December 28, 1897, from E. E. Morison, ed., *Theodore Roosevelt* (Cambridge: Harvard University Press, 1951–54), Vol. I, pp. 749–750.
18. Owen Wister, "My Country: 1899," *Harper's Weekly,* XLIII, July 1, 1899, p. 640.
19. *Ibid.,* p. 641.
20. Wister to Sarah B. Wister, April 3, 1899.
21. Wister to Sarah B. Wister, July 17, 1899.
22. Owen Wister, "Twenty Minutes for Refreshments," *Harper's Monthly,* C (January, 1900), p. 238.
23. Wister to Sarah B. Wister, undated, sometime in 1899.
24. Owen Wister, "The Game and the Nation," *Harper's Magazine,* C (May, 1900), p. 884.
25. *Ibid.,* pp. 887–88.
26. *Ibid.,* p. 902.
27. Owen Wister, *U. S. Grant* and *The Seven Ages of Washington,* Vol. 11 of *The Writings of Owen Wister* (New York: Macmillan, 1928), 2nd preface to *U. S. Grant* (unnumbered page).
28. Letter from Henry James to Mrs. Whitman, a mutual friend of the Wister and James families, February 5, 1901; in the Library of Congress Collection. Mrs. Whitman sent James's letter on to Wister.
29. Frederic Remington, "Joshua Goodenough's Old Letter," *Harper's Monthly,* XCV (November, 1897), p. 878.

30. Frederic Remington, "The Spirit of Mahongui," *Harper's Monthly*, XCVII (June, 1898), p. 53.
31. Wister to Sarah B. Wister, July 24, 1903.
32. Owen Wister, undated 1899 notebook.
33. F. L. H. Noble to Owen Wister, February 7, 1900.
34. F. L. H. Noble to Owen Wister, March 21, 1900.
35. Unsigned review, *New York Tribune*, April 14, 1900. Quoted, *in extenso*, Wister to Sarah B. Wister, March 30, 1900.

CHAPTER 7
1. Wister to Sarah B. Wister, December 8, 1901.
2. Wister to Sarah B. Wister, August 23, 1901.
3. Wister, *The Virginian* (New York: Macmillan, 1902), p. 4.
4. Frederic Remington, "A Sergeant of Orphan Troop," *Harper's Monthly*, XCV (August, 1897), p. 327.
5. Letter from T. Roosevelt to Wister, March 11, 1901, quoted in *Roosevelt: The Story of a Friendship*, pp. 80–81.
6. Wister to Sarah B. Wister, May 31, 1901.
7. *Ibid.*
8. Preface to *A Bunch of Buckskins* (New York: R. H. Russell, 1901), p. 2.
9. Owen Wister, "In Homage to Mark Twain," *Harper's Monthly*, CLXXI (October, 1935), p. 548.
10. Wister to Sarah B. Wister, February 9, 1902.
11. F. J. Singleton to Wister, June 6, 1902.
12. "Books New and Old," *Atlantic Monthly*, XC (August, 1902), p. 277.
13. Wister to Sarah B. Wister, January 9, 1903.
14. "The Mind and the Book," *Atlantic Monthly*, XCI (February, 1903), p. 283.
15. "Chronicle and Comment," *The Bookman*, XV (August, 1902), p. 513.
16. Wister to Sarah B. Wister, August 5, 1902.
17. Henry James to Owen Wister, August 7, 1902.
18. Wister to Sarah B. Wister, August 2, 1902.
19. "Remington's Novel," *New York Times*, December 13, 1902.
20. Frederic Remington, *John Ermine of the Yellowstone* (New York: Macmillan, 1902), p. 3.
21. *Ibid.*, p. 22.
22. *Ibid.*, p. 146.
23. *Ibid.*, p. 161.
24. Wister, *The Virginian*, p. 501.
25. Remington, *John Ermine*, p. 288.
26. Henry James to Owen Wister, August 7, 1902.
27. Owen Wister, preface to Frederic Remington, *Done in the Open* (New York: R. H. Russell, 1902).

EPILOGUE
1. Wister, *Roosevelt: The Story of a Friendship*, p. 294.

Index

Abilene, Kans., 54, 70, 92, 94
Albuquerque, 109
Alden, Henry, 21, 26, 28, 35, 38, 45,
 72, 74, 98, 106, 108, 110, 118, 179
Aldershot, 214
"Americanism," 38–39, 40, 43, 295
"Apache War—Indian Scouts on
 Geronimo's Trail," 214
Appleton's, 164
"Appreciation, An," 319, 323
Arizona, 16–17, 20, 26, 37, 68, 107,
 108, 110, 115, 116, 120; Territory,
 16, 120, 269, 303, 320
"At the Sign of the Last Chance," 318
Atlantic Monthly, The, 24, 72, 98,
 302–303

"Balaam and Pedro," 30–31, 164, 273,
 286–287
Banks, Nancy Huston, 303
Barber, Amos W., 19, 172
Bayreuth, 2, 9, 10, 19, 28, 267
"Bear Chasing in the Rocky
 Mountains," 109, 115
Beauregard, Gen. Pierre G. T., 4
Bedford, Me., 15
"Before the Warning Scream of the
 Shrapnel," 238
Big Horn, Basin, 18, 73; Mountains,
 267; River, 27
Bigelow, Poultney, 2, 3, 7, 21–22,
 29–30, 229
Bookman, The, 121, 171, 303
"Boom in Tucson," 115, 118
Boston, 7, 9, 14, 16, 19, 35, 308, 323
"Breed, A," 320–321
Brett, George, 285, 291, 298, 299
"Bringing Home the New Cook," 320
"Bronco Buster, The," 70, 74, 155, 158,
 162–167, 170, 219, 237, 256, 259;
 photo by Hoeber, 163; sketch, 160
"Bronco In Central Park, A," 62
"Broncos and Timber Wolves," 61
"Brothers Again," 5
Bryan, William Jennings, 115
Buckner, Jessamine, 176–181, 214

Bunch of Buckskins, A, 283, 289, 291,
 293, 296, 305, 320
"Burial of the Biscuit Shooter, The,"
 169, 172, 176
"Business and pleasure were waiting
 in Tucson," 144
Butler, Pierce, 3

California, 28, 37, 41–42, 100, 266–267,
 273, 282, 285
Camp, Walter, 7
Canada, 116, 179, 277
Canton, N.Y., 4, 5, 12, 37, 214, 255
Caribbean, 172, 225, 235
Caten, Lawton, 9, 15
"Caught in the Circle," 275
"Cayuse, A," 63
Century Magazine, 22, 26, 54, 57,
 162, 303
"Charge of the Rough Riders at
 San Juan Hill," 237
Charleston, W. Va., 234
Cheyenne, 18, 54, 226
"Cheyenne, The," 283
Chicago, 1, 37, 40–43, 45, 94, 97, 100,
 109, 110, 157; railroad strikes, 40,
 42, 45, 58; Seventh Cavalry in,
 41–42, 45; World's Fair, 1, 37
Chippewa Bay, N.Y., 255, 274
Chopin, Kate, 272
Chugwater Creek, Wyo., 18
Civil War, 5, 54, 99, 214, 272,
 277, 285, 308
Cleveland, Grover, 219, 226
Cody, William F. (Buffalo Bill), 30, 37
Coit, Dr. Henry, 5, 7–8
Collier's, 284, 291, 292, 305, 319,
 320–323; Albert Lee, ed., 292
"Colonel of the First Cycle Infantry,
 The," 101–103
Colorado, 74, 94
Columbia River, 234–235, 236
"Coming Through the Rye," 314, 318
Confederate Army, 5, 54, 103
Cosmopolitan, 53, 166, 285
Courant, Yale, 7

The body text for MY DEAR WISTER is Times Roman; the text for
the magazine excerpts is Optima, both set by Holmes Typography,
San Jose, California. The book was printed and bound by
Edwards Brothers, Ann Arbor, Michigan. The paper is Neutralaid
Natural and the cloth is Milbank Linen from Columbia Mills.
Design by Arthur Andersen.